MORE PRAISE FOR

THE LIONESS OF BOSTON

"*The Lioness of Boston* is a treasure trove of art, sensuality, Boston history, and more. Emily Franklin has captured Isabella Stewart Gardner's blazing life and the light it sheds on the lives of women then and now."

— RACHEL KADISH, author of *The Weight of Ink*

"*The Lioness of Boston* captures the daring life and mind of the unforgettable woman who transformed American art and the city of Boston itself. This masterfully written work of historical fiction will remind some of Lily King's *Euphoria* and others of Melanie Benjamin's *The Swans of Fifth Avenue*. This is the best kind of novel—at once a deft page-turner and a thrilling love story about a woman's passion for an independent life—it will sear your mind, break your heart, and leave you forever changed."

— DAWN TRIPP, author of *Georgia*

THE
LIONESS
OF
BOSTON

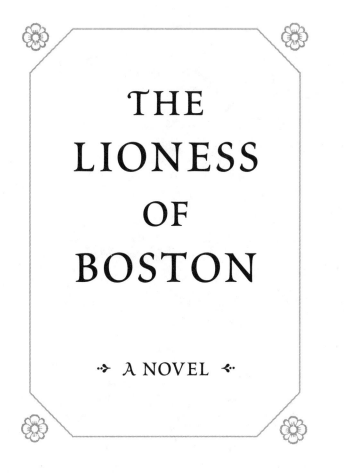

THE LIONESS OF BOSTON

❧ A NOVEL ☙

Emily Franklin

GODINE • BOSTON • 2023

Published in 2023 by
GODINE
Boston, Massachusetts

LIBRARY OF CONGRESS CATALOGING-IN-PUBLICATION DATA
Names: Franklin, Emily, author.
Title: The lioness of Boston : a novel / Emily Franklin.
Description: Boston : Godine, 2023.
Identifiers: LCCN 2022036555 (print) | LCCN 2022036556 (ebook) |
ISBN 9781567927405 (hardback) | ISBN 9781567927412 (ebook)
Subjects: LCSH: Gardner, Isabella Stewart, 1840-1924—Fiction. |
Boston (Mass.)—Fiction. | LCGFT: Biographical fiction. | Novels.
Classification: LCC PS3606.R396 L57 2023 (print) | LCC PS3606.R396 (ebook) |
DDC 813/.6—dc23/eng/20220808
LC record available at https://lccn.loc.gov/2022036555
LC ebook record available at https://lccn.loc.gov/2022036556

First Printing, 2023
Printed in the United States of America

*This is for HS, the friend I always wanted
and had the great blessing to find.*

Don't spoil a good story by telling the truth.
—ISABELLA STEWART GARDNER

PROLOGUE

1924

AFTER I am gone, everything will remain. Of course, aside from me—I am not intending to be morbid. Just firm. Keep the chaise at its tilt in the Yellow Room; let the Monk's Garden sit quiet. Do not disturb my fifteenth-century *Foo Dog with Open Mouth*: remember that night when you looked at it too long and I assumed—rightly, I think—you meant that I was the dog. Open, panting, unknown.

You recall, perhaps, those photos of me strolling with Happy and Zizi, the lions I borrowed from the Boston Zoological? Keep those.

I've been burning stacks of my letters, true, but how else to save on heating costs (all the better to fund the upkeep here) and at the same time disappear written secrets? People only know what you leave behind. Our exchanges have nothing to hide. Keep our letters safe—bind them with bows if you like.

And keep the samovar. Did you know I brought it back from the first trip with Jack and brought a matching one for Julia? And of course do not touch my *Return from the Lido* painting, 1884—though you did not advise me on that one, you later agreed; it was Curtis showcasing the elegance of Venice. But to me, he is offering up the water city's loneliness, too. See the woman, alone, in the gondola? See her simple white dress, dark hat, the protection offered by the draped cloth canopy, the gondolier level with the full moon as if to

say, here, here is the open, full world—only you, Madame, are not fully in it.

Try to locate my Japanese fairy tales in the Long Hall. Are they really for children—or more warnings for adults who must always find some semblance of hope?

Oh, pity me not. Ignore my losses, gaping though they still feel. See the *Virgin and Child of the Rose Bower*? After I bought that, I dreamed my boy and I sat under a trellis, his hands tangling in my hair, his watery gaze locking onto mine.

But we mustn't get stuck. Keep going. Read John Singer Sargent's letter (now sheathed in glass) about my portrait scandal. The postcards from Venice. Always, Italy drawing me in. Easier to leave behind tragedy and home in on the escapes.

And always objects. Why collect portraits, lithographs, etchings, a lock of Robert Browning's hair? Don't you see? We collect all that we are—we encase ourselves with high-society portraits or bone china and silver sets. Or we covet the collections of others. Or, as I learned, we gather so that we learn how to see, to look in order to let the eye's lens decide what we truly desire. The liquid conversation along the canal that morning you found me with only one shoe, lips raw from hours of kissing? Gone. Instead, arrange the bar glasses from that trip as though the objects will speak for us.

Keep everything the way it has been. Each lamp, desk, collection of chairs, canvases aching with gold frames. Nothing new will be acquired. Nothing sold.

Keep those ghosts with their bitter mouths, that first Harvard lecture (which, looking back, I think saved my life), keep the dancers and card players, my courtyard rife with lilies, men swooning over women and, sometimes, each other. Even a single novel, spine up, pages splayed. Do not wedge it back on the shelf. Hold it to its place. *I was in the middle of something*, I wish to say to anyone who visits. I was always in the middle of something.

Oh, if only we had a choice in which ghosts come to stay, traipsing in, slipping like smoke around those waist-high andirons bought so many years ago. I always understood objects more than people.

Should I have collected differently—not what is on the walls but what is in my heart? Did you feel I knew you, understood you, the way I understood Vermeer or Sargent? That I had gathered you as one of my group, my pod of misfits?

I think now that perhaps *I* was not understood then—not really seen. Yet I could be still.

Let others have their romances, lifelong love affairs. I have come to believe we all have one love story, and this is mine: my house and all of my different selves inside it, just like this.

BOOK ONE

✿

Belle

1861 — 1865

I

I STOOD BETWEEN the two enormous stone lions that flanked the entrance to Hotel Boylston. The left-side lion had its front paws pressed together, mane covering its shoulders as though it had a secret. The lion on the right stood frozen in ferocity: each muscle carved into action, ready to pounce.

"Shall we ride?" Jack asked. He looked toward the line of carriages, horses groomed and gleaming.

"It's only a short ways," I told my husband, the word still fresh, foreign on the lips.

He leaned in, whispering, "I thought maybe you were tired."

I smiled. "A bit." We had finally moved away from Jack's parents, which I desperately needed, but this meant taking up temporary residence at the hotel until, at last, construction finished on our home.

Today, as we did many days, we strolled to visit the site. Jack liked to gaze at the fine structure—six floors, herringbone wood inlays, white marble fireplaces, ceilings tall enough to make us appear doll-like. I liked to imagine my life complete inside.

We continued away from Tremont down Boylston past the new wrought iron fence that rimmed the Boston Public Garden, and cut onto leafy Marlborough Street.

"Pity not to be living in our home already," Jack said. I nodded

but did not smile—I had pinned so many hopes on the move-in and worried now that the house—or I—might not ever be ready.

Jack was a great bear of a man with sloped shoulders as though he needed to apologize for his size. He pressed up against my side, hinting I would be tired still tomorrow. Not that I was so beautiful as to be irresistible, because in truth I was quite plain in face and figure—but spirited enough to cast momentary delight. Jack and I had found each other during my visit with his bighearted sister, Julia, two years before. Engagement and marriage quickly followed. We had fit together easily, like the delicate sugar and creamer set we received as a wedding gift from the Astors; rimmed in gold, each had its function, but both pieces appeared as one on the tray. Yet being with Jack meant leaving New York, parting with my parents, which I had expected to find freeing and yet in reality found lonely.

"Just think," Jack said. "Soon enough we'll be able to socialize mere steps from our own house."

"True—and with the party tonight it would have been especially nice." I paused, unsettled at the thought of the evening ahead.

"You must be looking forward," Jack said, and when he saw the doubt flash on my face added. "If only to see how they've done such a stately drawing room."

"Any excuse to pry into someone's house," I said. "I only wish Julia were to be there."

"I know how much you adore my sister, but I'm quite sure everyone will love you here."

I twisted my mouth. Julia's wide smile was matched by her sure social grace. "While your dear sister and I were both considered smart at school, it might not surprise you to learn I sometimes let my wit run ahead of my grace." I paused. "As a result, I endured a bit of *combattre sans mains*."

Jack laughed. "And what's that?"

I sighed and leaned into him. "A thrashing without fists, as girls are wont to do."

He patted my head. "I do love you, Belle. And you've nothing to worry about here. I'm sure Boston will feel as I do—luckier for having you in it."

I hoped Jack was correct. But there, on the corner of Marlborough and Berkeley, the new Public Garden just in long view, I realized marriage had been the answer to a question I had not yet asked myself.

"Belle?" Jack waited for me to keep up.

I pulled my shoulders down, ducked my chin so as to appear demure. Since marrying, I tried always to make myself appear smaller. I'd been told by parents of friends, teachers, by my old school matron that for a diminutive person I took up space. They hadn't made it clear whether it was my voice or the way I walked headstrong into any room. I found myself trying to curl and duck, battling against my own edges even as Jack and I continued our walk.

"Boston is a fine city," Jack remarked, hoping I would agree.

"Yes," I said. "It is as though London and New York desired offspring, and Boston is the result." New York had been my early childhood, Paris my teenage years, and now with those behind, I tried to clothe myself in Boston as though it were a new skin.

Jack laughed. "Oh, Belle. You are a delight." He put his arm around my waist. "Tonight will be such fun for you."

I did not express my reservations. Another dinner party: everyone around an elongated table replete with silver and servers, thirteen courses, Boston's finest sons—who seemed to enjoy my company— and its daughters, who as of yet did not.

Evenings collected Putnams and Eliots, Amorys, Cabots, Lowells, Warrens, Hallowells, Welds, and others: families Oliver Wendell Holmes had summed up as Brahmins in his recent novel as though they were all interchangeable, elite without uniqueness.

I felt a growing despair with this; I wanted the belonging and yet loathed the neediness that ensnared me, the idea that to be integral meant being one of them, and by definition thus not myself, even if I wasn't yet quite sure of that either.

And tonight, there would be no Julia—best friend and sister-in-law. When Mrs. Julia Gardner Coolidge was present, hostesses at least feigned politeness.

"At least Joseph and Harriet will attend," Jack said. I took small solace in his brother and Joseph's kind wife, Harriet, who had the sort of quiet gratitude that overtook gentle women who married well.

. . .

Jack and I walked along Marlborough Street under the watch of unlit gas streetlights and elegant townhouse mansions, then turned down Clarendon toward the river, then right to Beacon Street. Only a few blocks at a leisurely pace, but an entire world to me.

"Isn't it funny," I said to him as I took in the expanse of land to the west, the river in view, the large homes cropping up. "Tidal bay, marshy flat—all gone. Filled."

"True. Just think—our children will know Back Bay as residential, where before it would have been only water."

"Swamp, I believe you mean," I said. Other men would have bristled, but Jack did not chide me for correcting him, and I loved him for it. He'd found my brashness attractive early on.

"I like to think of our future house rising from a swamp," I said. "Money came into the Back Bay along with landfill—funny that it's now fashionable to live here." Jack turned to me, grinning as he indulged my thoughts. "I imagine us in wading boots, tromping in old mud, reeds, polluted marshland now firmed up with gilt."

We neared the site of our home. I paused. From former swamp our brick Back Bay townhome emerged. Large windows gleamed at the front, multiple floors of living space, nearly complete, beckoned. The exterior stairs, railing, and walkway were last.

"You can change just about anything, it seems. Even the earth," I told Jack.

"I suppose so," Jack said. "That is rather a hopeful view." He pivoted away from me, suddenly more engaged. "Ah, look, it's Gilman!"

As renowned architect Mr. Arthur Gilman motioned his greeting, I waved until I realized he was nodding to Jack and had barely noticed me.

I stepped forward and interrupted Jack's handshake.

"A pleasure to see you again," I said, though he looked surprised at *again*. Men remembered names only when personally useful, but as I was no one in that regard to Mr. Gilman, I might as well have been any female. This sparked a tiny fire in my belly, and I tried mightily to tamp it down, but not before I said, "I am sorry to read of the delay

in your Boston City Hall building. It does seem to be taking longer than anticipated."

"Madame has an interest in city planning?" Gilman asked, a note of laughter in his voice.

Jack cleared his throat, uncomfortable. Mr. Gilman forced his gaze on mine until he unfurled the architectural drawings and turned his back to me.

As I was not included in their discussion, I instead looked at the house, which my father had presented us as a wedding gift, and touched the pile of red bricks near me. Stacked in groups higher than my head and wide as carriages, each set of bricks and stones seemed its own island. The Beacon Street address to the left of ours had a crosshatch pattern, the one to the right simple borders and rows of evenly spaced bricks. I wanted my own.

"Mr. Gilman? May we choose which pattern for the walkway?" I asked, my voice high and airy as though sent from a different creature, one with whom I did not identify.

Mr. Gilman laughed without turning to face me. "Is Madame a bricklayer as well as a newlywed?"

Jack laughed, too, and I fought the urge to glare. Men often think they are humorous, but mostly this is poorly masked rudeness. Mr. Gilman was known for his wit, every bit the bon vivant with his jaunty stance, the kind of man people excused because of charm and a well-groomed mustache.

As Jack studied plans held out of my view, I gathered my skirts in my arms and sidestepped around the stone and brick cities.

This would be our house: the place where we would build our life together. Our family. The path to the front steps and door had been dug, scraped, leveled, cordoned off with simple gray rope until the bricklayer came back from lunch, pail swinging from the crook of his elbow. This brickie would construct the path I would walk on each day. On which I would push a pram. Where Jack and I would begin our lives and—presumably—end them, walking more and more slowly on the bricks until we could not climb even the six wide stone steps unassisted.

"Jack?" I called. He did not respond. "Jack?"

He called out for me. "Have you been swallowed by the earth?"

I was not meant to shout but did so anyway. "Around the back—near the pathway!"

Before he found me, I began to reach with gloved hands for the odds and ends of bricks cast aside at the bottom of each pile. From those, I quickly mapped out alternating lengths of bricks in the center of the path and left room on either side so that a design of trees and branches, vines made of stone appeared.

"See?" I said, just as Jack, followed by our architect, appeared. "The stones can curve on the sides as though a reminder of water."

"Water?" Gilman said, taken aback.

I looked up at them, having forgotten I was in a deep crouch, skirt with ten-layer flounces on the dirt, white gloves grim with muck.

"Do you not see? Back Bay has been filled," Jack said, using my words as his own. I tried not to mind. He spoke with the dramatics afforded to men in power. "We are by sheer desire enforcing ourselves on nature, standing on water."

I stood up, aware then that I was being stared at by my husband, by the architect, by the workers returning from their street-side lunch. I pursed my lips. "Or, what used to be water."

Jack reached as though to settle me down. "She has ideas," he said, his pride overshadowed by embarrassment.

I wanted to shout. Not only ideas! This is my house. "Well, I shall be the one up and down the path most frequently—how much better if I've a say?"

Jack tried to steer the conversation, as Gilman bristled. "She—we—would like magnolias. One or two if possible. Just there."

He pointed to the small, enclosed garden. Once the tree grew to full height, we would see it from the front room, watch the breeze sway the blossoms. I imagined holding an infant, swaying, too, as though my body and the not-yet-planted tree were one.

"I see," Gilman said tersely. He gave me a look of fatigue and glanced at Jack with unmasked pity; poor Jack to suffer the likes of me.

Jack cleared his throat as a point of departure.

I did not shake Gilman's hand; my gloves were a disgrace. And yet I did not leave. Sensation churned inside me, rising like the tidal marsh that had until only a couple of years ago lived right here.

"I would very much like this pattern," I said. My tone was even and firm. "And arches." Gilman raised his eyebrows as though I had suggested brothel decoration. "You are familiar with the Athenæum, Mr. Gilman?" He nodded at me, annoyed or surprised or both that I had made the reference. "Like that."

But his surprise did not last long, for, like most men, he did not like to be outshone by a woman. "You must like Italy, then," he said.

I nodded, even though I did not know exactly what I liked enough to say—only what I had started to make with bricks.

He turned to Jack to explain, leaving me out of the details as though I could not possibly comprehend. "The Athenæum's an academic interpretation based on Palladio's Palazzo da Porta Festa in Vicenza."

Jack gripped my dirty hands in his. "Venice. Of course. Give her arches. Give her Venice."

I looked at the bricks I had set on the dirt, enamored with the idea of putting something down that would not be moved. Something that—were it not for my hands— could not exist in just this way. I could see it: my future self, husband heavier or grayer, baby in carriage and another besides, magnolia tree in full view as we walked the path. *I designed this*, I would say aloud. *I made this happen.*

"Make what she likes," Jack said, beaming at me—granter of wishes, magician, husband.

"Might be simpler to bring your bride to Italy," Gilman suggested. "Rather than to build to her specifications."

"You take care of one, I shall do the other."

And I was sure then: I wanted both a path of my own design *and* Italy. I looked at my scummed glove and wished I could kneel again, turn the bricks and stones this way and that. But instead I prepared myself for the slog of another dinner, the bouquet of Brahmins.

2

ONE OF many rules for dinner parties: none of the diners ought to feel superior to the others—and yet, I felt myself on the lowest rung.

We entered the drawing room on the heels of Miss Appleton, whose complexion glowed rosy atop her pale champagne dress, ringlets bobbing and dancing in the light like a sea creature—beautiful and deadly. Mrs. Amory, in green silk pierced through with tidy navy ribbon, embraced Miss Appleton warmly.

We waited a moment so as not to intrude, which was fine for Jack—men may stand and look around the room and are assumed to be thinking, perhaps measuring the room's dimensions. But women? Women stand and look foolish, as though we are lost.

Or, in my view, as though we are somehow always in the wrong place.

I wore a dress that had arrived the day before, sent from Douceur in Paris, where I had first visited with my parents and Jack's sister Julia back when we were still in school. We'd been fitted for matching day dresses then. Now I saw Miss Appleton take in the yardage of my outfit, a few too many folds for her taste, perhaps, nipped too much at the waist for Boston, lined with buttons on either side. I had thought the sketches glorious, different, and only now realized difference ought never be the goal.

Miss Appleton's eyes wandered over my dress as she held her stunning face statue-still. "How . . . unusual."

Beautiful people can afford a touch of cruelty.

Other guests arrived, comfortable in the house as regulars in the dinner party rotation. The room was grand in the understated Boston way—upholstered fine furniture, lighting neither too bright nor too dim, nothing too showy, nothing that appeared recently acquired, for part of the custom of this realm was to present the self and one's house as always having been this way. I was the only new addition.

My other sister-in-law Harriet had not yet arrived—and though I enjoyed knowing dear Julia had taken luncheon with my parents in New York before her long trip to Paris, I wished she were home now, with me. I searched the room for a kind face or at least one in which I might find solace.

"I wish we could expect my old friend Mr. Fay," I said.

Mrs. Amory looked aghast, then clicked her tongue to let me know she remembered well a flirtatious Boston evening he and I had shared long before my marriage.

"He's been appointed a second lieutenant," Miss Bradlee added, to further illuminate my ignorance of current social events while also passing silent judgment on my outfit, which glowed gaudy in the chandelier light, especially compared to those of the others: fourteen of us in total now that Harriet and Joseph had come through the carved doorway, women in subdued silks, men interchangeable in their suits, same waxed hair. I chewed my lip at the number of guests—twelve was the standard, thought to be ideal for dinner parties. That we were fourteen was an unspoken slight; we were add-ons.

"Yes, I'm aware," I said. "I mean only to say how lively he makes an event." Miss Bradlee clenched her jaw, and I mumbled to myself, "He will be missed." She looked at me a moment too long, her eyes narrow as though she, too, felt the wave of desire that rippled through my belly at the memory of Fay.

I had always enjoyed clever exchanges. I excelled at the act of flirting, but not the way I had witnessed other girls do so. What I wanted, what I desired, was not to be desired physically but rather

mentally, as though I held the key to a place vaster than my body. But as much as part of me had desired Mr. Fay when I was younger and now desired Jack's weight on my own bare body most nights, I was growing aware that I did not like to *feel* that desire.

Desire was another way of saying *need*—and I preferred the notion that I needed nothing. That I might be in my life—married, awaiting our new house, awaiting our as-yet-unborn children—but not vulnerable to the raw skin of desire.

From across the room, Jack gave me a happy look—he clearly thought I was enjoying myself, desire for what we would share back in our hotel suite communicated in his glance. Yet that was not my desire: what I wanted was to feel at ease and somehow integral, as though this evening—and I in it—were more than another in a series of sameness.

I sighed, and Miss Bradlee took it personally. We were led to the dining room, where acreage of tablescape awaited us. Arranged by order of importance, we took our seats. As a new bride, I was meant to be escorted first. I was not. I tried to meet Jack's eyes to share our shame, but he didn't seem to notice. Couples were split around the table, so I had no husbandly life raft.

We were not meant to smell the food nor examine each bite before delivering it to our mouths, and yet with little conversation directed my way, I found myself doing just that. How pleasant the aroma of baked cod, how rich the port-wine sauce in contrast to the sliced cucumber salad. I held my fork above the plate, pausing to wait for the sauce to finish dripping into enjoyable splotches on my gold-rimmed plate.

"Now the rain seems to have subsided, the Public Garden is worth a wander," Mr. Sears said to no one in particular.

Harriet spoke. "They've finished the pond, I hear."

"There's talk of bringing baby alligators to live and grow there," I said, which snuffed the conversation out. Harriet flicked her gaze to mine but then back to her meal. Harriet was always kind to me, yet she had been an Amory before becoming a Gardner, so had a firm seat at this table. Jack barely acknowledged me now—any public affection

was low breeding. With volume neither too loud nor too hushed, Jack turned to Mrs. Lowell and began an innocuous discussion regarding the dedication of the Arlington Street Church.

"Are you enjoying your meal?" Miss Appleton asked, leaning over Mr. Charles Adams. His wife, Abigail Brooks Adams, sat next to Jack. Everyone adored her: just the right amount of liveliness and loveliness and seven children to boot. I admired her spirit, though I was jealous of her position—not her station, but her level of acceptance in each room she entered.

"Mrs. Gardner?" Mr. Adams prodded. "Belle?"

"Perhaps she is caught up in her own thoughts," Miss Appleton said. Her tone suggested that I might not be enjoying my meal or the company, which then required my reply to be overly effusive.

"Of course this is a splendid evening! Wholeheartedly enjoying. Delicious." I went on, leaving the bite untouched. I could not tolerate the silence nor her disdain, so I spoke my mind. "It occurs to me that our plates are small works of art—and the table a larger one."

I swept my eyes over the expanse of cutlery, trays of bright greens and stewed apple, the roast transformed to a statue. "This house, this land on which we are presently sitting, was a swamp! Until people—men—decided to haul dirt and rock in and make it livable." I drew a breath, invigorated. "Today I designed—or tried to plan out—the walkway for our new home. And here, the kitchen staff and Mrs. Amory made art on the table." A few others stopped their conversation to listen to me as I rambled. Mr. Adams smirked, but his eyes held relief, glad I was not his problem, while Miss Bradlee clenched her spoon as though she wished it were a blade. She recoiled as I went on. "Of course it *is* temporary, the art of food. A meal is often so long in the planning and then consumed rather quickly in comparison."

I continued, disregarding Miss Appleton's souring expression lest I be trampled by the entire evening. Jack cut his roast with more vigor than necessary. "I think it marvelous, remarkable in fact, that so many people are gifted with creative visions—even the cook." It took any reserve I had not to stand up and march into the kitchen

to share my feelings with the staff right then. Mr. Adams laughed, amused, or at any rate saved from boredom. Miss Appleton stiffened and placed her spoon down without a sound.

"Yes, well," Miss Appleton said. Her face suggested someone had poked her with a fork.

Those two small words carried with them a sentence anyone at the table could have translated. Somewhere between the meal and the post-dinner drink, I knew word would spread about my outspokenness, my oddness that though I tried to curtail, I seemed destined to put out in the world. I tried to focus on the food again and forget my thoughts—or at the very least do everyone the large favor of keeping them to myself.

AFTER MULLIGATAWNY soup, stewed eels, fried sole in lemon brown butter, brandied fricandeau of veal with spinach, dinner rolls with sweet cream butter, apple compote, mashed celeriac, sweet pickles, Russian Jelly—which was actually aspic but our hostess gave it a jumped-up name made to make it seem better than it was—perhaps that was what the society ladies made of me—citrus in boiled honey, bergamot shaved ice, a tray of Stilton and Westport washed-rind, baked plum dumplings, and nougat almond cake, we dotted our mouths with serviettes and were finally excused.

Upon leaving the table, men veered to the dim library and women back to the drawing room with its yolk-yellow walls. The women arranged themselves like nesting fowl. I settled on a red velvet chair that had armrests made to look like golden swans. Unable to find a comfortable position, I squirmed.

Across the room, Harriet gave me a small smile that I found reassuring. Her husband, Jack's older brother Joseph, would likely be sitting near to Jack as the men smoked and discussed. The Battle of Fort Sumter, the brand new school—MIT—across the river, their families, who saw their role in Boston as agents of improvement. The Boston Brahmin: wealthy, elite, educated, bound by names and bland privilege. It was impossible to overstate the weight the names car-

ried, the industry and intellectual power the families controlled. The people gathered here, as had those before them and surely those who followed, would rule to their own advantages in perpetuity. Harriet and Joseph's presence encouraged ours, and yet Harriet and I were not treated similarly; she was firmly ensconced in the prominent Boston world and already with one child and another one coming. Money and title made for a certain island. Motherhood seemed another land—a place to which one gained access and, until then, remained quite marooned.

Large mirrors graced the wall in front of me and the wall behind—a trick done to make the room larger but one that seemed to me to offer reflections of other, perhaps more welcoming, worlds.

Mrs. Amory, formidable in her understated wealth, held sherry between her clawlike fingers, her head tilted toward Miss Bradlee, who glowed in her plum dress and the hostess's attention. I had not been offered a glass. Surely an oversight, Jack would have assured me, were he, too, stuck in the ladies' drawing room rather than tucked into the smoky library. Miss Appleton caught my eye and raised her glass to her lips, smiling behind the crystal.

"Do you know, Mrs. Gardner," Miss Bradlee said as she sat near— but not next to—me, "when you will move into Beacon Street?"

I wished for sherry, for something to hold to make me feel purposeful.

"We're told the end of this month." I watched her face for signs of interest, hoping to keep her talking so I would at least appear less superfluous. "In fact, we went today, and it's possible we might be in sooner: possibly in time for my birthday on April 14." She did not ask if I would celebrate, so I found myself rambling to fill the judgmental quiet. "I'll be twenty-one soon," I said. She offered nothing. I persisted. "All that's left on the house is the exterior brickwork. The walkway may take some extra weeks . . ."

Mrs. Amory gave a curt nod, glancing at the other women having other conversations and then turned back to me. "Is the landscaping not standard? Meaning, surely there won't be a delay over a walkway. Nothing Jack cannot encourage." She sipped her drink, the wine

slicking her lips until her tongue, serpentine and quick, whisked away any trace.

"I suspect the issue isn't with Jack." I paused, feeling my breath corseted, my limbs under layers, the room growing hot and close. "Rather with me. You're correct about the standard issue—those paths from curb to door each the same. Or nearly so." In my mind I saw the patterns—steady bricks announcing the way to a door that might be anyone's. "You see, today when I went to 152 I realized it might be better . . ." I caught her eye and retracted my words, "or more interesting if I had a hand in the walkway."

Mrs. Amory allowed a small gasp to escape her dry, pursed mouth, but kept listening.

I leaned in, conspiratorially; this would be the night I slipped into their circle. *How clever*, they would say of me, admiring my bravery.

"You designed the table pattern tonight, yes?" I asked, eyes bright. She nodded. "And Cook presumably chose the Barton apples for the compote not only because their tartness complements the meringues but because the color complements the linens . . ." I gathered strength, feeling more confident as I spoke. "Even your dress harmonizes with the oranges in honey."

"Oranges in syrup."

She nitpicked, yet I felt my spirits rise, as though I might finally be understood here in this room of women in their petit four pouf dresses and perfect hair coils. "Your vision for the table, for this dinner—it says something about you. About your mind, your views."

Mrs. Amory's cinnamon-colored brows furrowed. "And your path will say what, exactly, about you?"

I felt a smile growing. A hopefulness about this night, about 152 Beacon Street, about the world I had entered and the family I would grow in it. "I should think the bricks are a welcome path, one that brings friends and family to our house."

She looked around us, and just for a moment I thought she might encourage everyone to cluster around—that she might regale the clutch of women with my plans.

But instead I realized she looked to make sure no one could hear her words.

"For someone who is clearly clever, you can be so dim," she said. "Why bother designing a path on which no guests will ever step except out of obligation."

I LEFT the drawing room feeling slapped. It is one thing to imagine being shunned but quite another to have it proven. As Julia was not there, and Harriet sat quilted between Mrs. Lowell and Miss Appleton, no one minded nor came after me as I went to find Jack.

Outside the library, smoke and the rumbling of male laughter made me pause. I stood still, tucked against the Japanese embroidered wallpaper, hesitating to go in lest there be one more strike against me. And yet even from my perch outside the room, I felt more comfortable than I had in the decidedly all female room moments before. I could not reconcile the longing I felt and the demand made on me to fit in there with women who clearly held me in disregard. Why could I not join the men and their smoke, their jaunty legs with one ankle on the thigh in such relaxation as I had never known in public?

I could see bookcases filled with matching sets—novels I imagined most present had not read but which matched the tufted chairs in which men sat discussing issues. Jack was one of the pack; always the same no matter in which room he stood. His steadfastness, his sure footing, drew me to him. And the smile he reserved only for me.

"Tell me you've not gone to the other side," one said, and I realized he could be referring to the war in the South or the Charles River.

"Never," came the answer. In my high heels and shaking hands, I waited for them to finish talk of the Somerset Club, where of course Jack was a member.

"You're aware of the split." Jack's voice was clear now. "Political lines are being drawn."

Men spoke of federal government, of political suppression, even if only how it might affect their private club on Beacon Street but still—this instead of chatter. Instead of lacework or empty compliments in the drawing room.

I entered through a ghostly puff of smoke. My presence stopped

Mr. Sears in mid-sentence and caused the seated men to stand, the standing ones to flinch in surprise, and my own husband—upon seeing my pained face—to attend to me quickly.

"Do excuse us," Jack said to the trousered gathering. "Belle's waiting for me."

"Thank you for a lovely evening," I said as I backed out of the room.

My words were hollow and met with an equal lie. "Our pleasure—please do come again soon."

<div align="right">

12th April 1861
152 Beacon Street

</div>

My Dearest Julia,

Supposing this letter finds you recovered from what I understand in your recent note to be quite an evening at the Opéra-Comique. Perhaps *La Colombe*—the dove—has flown from memory. I wish I could say the same for the dinner we attended last night.

I wish you were returned to me now and we might talk through the debacle during the golden hour that will soon soak my front room. This is a sight—afternoon's final rays oozing over the marble table, the fringed gray velvet chaise, each book shelved, titles illuminated for a moment before the room and the sky outside go dark (rather like my mood just now). Should I stand at the base of our grand, newly white staircase and count each hand-turned balustrade until you come back? I confess I stood today, counting each slat in the herringbone floor, retracing the debacle of last night's dinner.

Oh, Julia, they were cruel. Boston's biggest names striking out like Medusa's snakes. You know my instinct has always been to be me. Why not be vibrant, even funny? Yet the more time I spend as myself, the more I feel shut out. Perhaps it would have been easier for me if I had stayed in New York.

Even Boston's architecture refuses to welcome. Houses shoulder to shoulder, each with tall, narrow windows and hidden gardens. Beacon Hill homes with their perfect brick and oldest cobblestone streets, their exquisite window boxes filled now with acceptable

flowers (likely the inhabitants have not grown them themselves!). I understand New York's grandeur and pomp, but I am perplexed by Boston's money-hush, expensive rugs with tatty edges to show the elite are so elevated they need not buy new. And the porcupine-quilled women rubbing their needled exteriors on my delicate skin.

Last night might have been tolerable if you had been there. Or an old friend. I thought about Richard S. Fay—and indeed let his name slip. Can you bring to mind his face? This was long before I was engaged. Fay's family and mine were old friends; he'd moved to Boston and been lauded as the city's soon-to-be leading beau. The night of his introduction to the eligible Boston girls—you were in Paris then, too, I think—my parents had arranged to bring me to town from New York.

Mrs. Saltonstall and Mrs. Coffin, whose looks matched her name, were not pleased back then when I surprised them during dessert after a dinner to which I had not been invited (how easy it is to recall stings from long ago—how lingering embarrassment and cruelty). It was felt I had unfair advantage, having known Richard longer. My presence was an insult. As with last night, they eyed my outfit with disdain. Where Boston girls were taut and reined in, I was adorned. Curvy and noticeable. I was New York. I had been livid.

Oh Julia, does that evening matter after all this time? Richard and I had left the party together, riding together in a single horse-drawn brougham. Could they hear us laughing all the way from that party to my parents' hotel rooms while Mrs. Coffin and Mrs. Saltonstall sat in the dregs of their party? Tell me—surely they do not still hold a grudge.

It seems my missteps have followed me into my now adult life, blocking me from becoming one of the social set. Will my presence in Boston matter? Jack and I did not discuss the party, though he suggested that if I am tolerant of Boston's intolerance of me, perhaps the city and I shall grow fonder of one another. Or perhaps when I am a mother, all will feel different. Jack might give my regrets—Belle is unable to join the dinner party as she is home with the baby. How I look forward to not being able to attend.

All of which is meant to convey how I long for your return to your 145 Beacon. How lonely Boston is without you. Perhaps other cities are better suited to being alone.

In other aloneness, Jack and I have not had any news to share. The suite I allotted for nursery (quiet, top floor at the back of the house to avoid carriage noise) and nanny go unfilled still—which leaves me unsure where I might turn my attention.

What happens if there is no child to cry out for me? What of me, then? At least one piece of good news: Harriet has kindly picked up the threads where you left off, inviting me to her sewing circle despite my growing unease at such a venture. Odd that one does not seem to gain more chances the more one ventures into society; rather, tone and worth are set so early one might barely understand the gravity. Still, Harriet is kind, and you are not here to walk shoulder to shoulder through the Public Garden, so I will do as I did in our *jours d'école* with you and forge ahead.

What I mean to say is part of me longs, truly longs, to belong. And still another part wonders at a greater land. While you and I were beribboned girls finishing in Paris, others never finished. What if the society of sewing circles is merely distraction from the past I did not lead? I did not attend Mount Holyoke Female Seminary. Did not journey to Worcester for the first National Women's Rights Convention—indeed, I did not even know of such an expression or toil as I devoted days to etiquette and French lessons and those pleasantries of walking.

Oh, how I wish I have given more time to becoming. Did we really believe finishing school would do just that? Perhaps my worries, my nightgown fretting hours, will dissipate if there's success with Harriet's introductions to the sewing circle (or my attempts with Jack). I shall keep you informed as I await your return.

Much love to you, dear sister-in-law and friend (might there not be a word to combine these?).

Yours,
Belle

3

OUR EARLY summer luncheon at 152 Beacon—windows open, freesia scented breeze drifting in—was long cleared away. Jack and his bother Joseph had spoken of shipping decline due to the war, of commerce in the East Indies and Russia, of possibly importing pepper from Sumatra. Harriet and I listened and enjoyed our chilled cucumber soup. I had wanted to talk about the Boston Society of Natural History, the construction just beginning nearby that piqued my interest, but there hadn't been a lull in which to speak.

Now Jack and Joseph had gone to the Somerset Club, and Harriet and I were due at her sewing circle meeting. We were meant to gather at the Crowninshields' house, crafting in great quantity garments for those fighting down south.

"Are they new?" Harriet asked, gesturing to my footwear. She held a potted iris I had gifted her for her nursery—a room soon to be filled with another bassinet. Harriet was delicate, with a neck like a goose, features just as birdlike but with eyes kind enough to make me smile even when the next task at hand filled me with a nervous ache.

"In fact they are new," I told her. Light blue boots with pearl closures so involved I kept the sterling silver button hook in my pocket. "I chose them to remind me of Julia's eyes whilst she's away. Though word arrived yesterday that she's back in only a few days' time."

"How lucky you are to have such a dear friend," she said, her face a testament to her enthusiasm for me.

"I feel the same of you, Harriet. Two sisters-in-law surely make up for no others." I had been the eldest of four children, but Adelia died at twelve; my brothers David and James were still in New York. I felt my sister's loss bundled inside me, though my parents never spoke of their lost child. I followed their example.

I turned back to my boots, admiring the watery tone, though one was meant to wear beige or peach to elongate the leg if a flash of ankle were seen. Which of course was never meant to happen—but one took precautions regardless.

I sat, patient, as I counted and closed each of the fourteen buttons. It was a long process, made longer by the fact that one really ought to put boots on before the corset; the awkward, painful way I had to bend went against nature.

"Might you prefer the other pair?" Harriet suggested. "Those are quite . . ." She did not like to say *bright* or *gaudy* and did not judge me for my own taste, yet she tried to shield me from the world like the good mother she had become.

"I'm afraid my standard pair might fail, too." I had written away for another set, patent leather: not because it was the fashion but because it afforded some tolerance of weather.

"I'm sure you know best," Harriet said. "And of course if the sewing circle cannot see that today, we must consider it their loss."

In the mirror, she checked her appearance, twisting a lock of hair so it remained curled; the liquid bandoline held well but not in damp weather. I thought to offer her a fixature I had concocted myself from rose water and quince seed and a touch of brandy—this last suggested by the maid—but I did not: it would be one more not-quite-right product that only shone light on my disregard for the styles of the day.

I stood up and pinched a browning petal from the iris. "We could forget the circle? If you are not quite feeling yourself?" It was a feeble attempt on my part, but the social effort with little hope of gain weighed on my shoulders. I often found my abdomen seizing with anxiety.

Harriet gripped my forearm with her gloved hand. "We shall go together and hope for results this time." I nodded and acquiesced. "Besides," Harriet said, with her potted iris wagging like a finger at me, "this is important work—really—we are making a difference with the dressings, the socks."

I steadied her plant and then locked my eyes with hers. "You know what I read might make more difference? Soap. For battle wounds. Perhaps we should form a soap circle."

She laughed but then caught herself. "Now that is exactly the sort of aside you might think in your own mind but refrain from saying today."

"I cannot fathom why such comments make others judge me. Is soap not good sense?"

Harriet's mouth twisted. She hated to cause me pain but also knew I did not want a friend who could not tell me the dirt thrown behind my back. "Belle." She pursed her lips the way she did when her tea was too hot, holding back lest she cry out. "It isn't so much your ideas, which while somewhat outlandish—"

"I hardly believe soap to be 'outlandish.' Can I help it if I want progress?"

"That's the problem—I'm not sure you can. Help it, I mean." Harriet faced me, and I looked deep into her brown eyes for solace, for the quietness that made everyone admire her, want her in their drawing rooms or circles. "I believe you are capable of nearly anything."

I smiled so wide Harriet put a gloved finger to my lips. I felt the leather linger after she'd removed it.

She went on. "But I do not think you are capable of keeping quiet. I do not think you are capable of just letting words pass over you, of just . . . allowing events to occur without somehow jarring them. Everyone is watching to see if you will settle into Boston life." She paused, her eyes intense. "Jack's standing allows entry, but time and time again you prove that you will not live up to expectations— rather each night or afternoon is unpredictable with you."

Her words stung, but only because they were true. "Why is that a sort of life I should like to live? Is my choice to sit in acceptance at all times or never to be invited anywhere?" I held her word *unpredictable*

in my mouth like a marble, rolling it on my tongue. I liked how it felt. "Perhaps I do not wish to be predictable."

Harriet sighed. "I know. I understand that for someone of your intellect, your view of the world—it feels so restrained. But you might try it. Once you've gained a proper place here, you'll find that some freedoms open up."

"I will do my best," I told her. Yet as we emerged into the warming afternoon, it seemed unlikely that would be enough.

A FEW days later, my spirits punctured by sewing circle silence, the visual skirmish I'd had with the ladies as they regarded my boots, I paced the hallway outside Jack's office with the *New York Times*, reading aloud. "A Boston woman's social position is defined by that peculiar institution known as the sewing circle. So far as it is possible in a democratic country, the sewing circle places its members accurately and finally. Not to be admitted to these mysterious coteries is a species of social ostracism of which the severity is perhaps fully appreciated by the native-born Bostonian."

Accurate and final would be the decree once it came.

"Must you pace, Belle?" Jack called from his desk as he tucked into sliced meat and buttered bread. I could hear him chewing. On the walls were small framed prints of the English hunt, sharply dressed men in coats, their thighs gripping their horses as they charged ahead. "Did you need something?"

I did need something but couldn't tell him.

There was no acceptable way to express my post-circle, post-dinner-party rage; I had no deer to shoot, no pheasant neck to strangle or to snap, no shipping contract to shred in someone's face as Jack had done the day before.

"I'm fine," I told Jack as I went to his lesser-used study. Tidy cases held Jack's precious objects: a chronometer made during the War of 1812, a silver Peg Tankard with a small lion at the top of its handle, a gorgeous sextant, a Dutch pendulum clock I'd given him as an engagement gift—now I wondered if I'd chosen it to mark time. To count the days until I found my next, somehow more real, self.

. . .

HAVING NO luncheon invitations the following days, I took to walking. Not strolling, but walks with a place in mind, outings with a purpose. See the zoo! Check the progress of the first fountain installation in the Public Garden with the first signs of autumn. Partake of scent testing in the perfumery. I set out each day, visiting the Natural History construction site at the corner of Boylston and Berkeley, admiring architect William Preston's steady but elegant stone foundation. Having a goal helped.

I felt that way in the bedroom, too.

The more I did not achieve what I set out to, the more determined I became.

The past few nights I had surprised even Jack by setting down cutlery midbite, dinner not yet concluded, and asking him to come upstairs.

At first, he was caught off guard, intrigued by my pressing up to him, closing the door to my bedroom, pushing him until he had no choice but to sit on the bed, face in line with my breasts.

The next night, too, he went along with my efforts much the same way he handled my public comments, with a tolerance that would likely one day run out. I didn't care much about being judged, and given his choices—be bothered by his unmanageable wife and become brittle and angry in our marriage or go along with the woman he was coming to know as spirited for lack of a better word—he chose the latter.

"Must you?" he asked as I again led him upstairs.

"The dromedaries at the zoological gardens are on their heat. And the lions. I saw them pawing at one another. Likely there will be cubs in the spring."

"And this breeding?" Jack's breath came quick and hot on my face as I pulled him into me.

"Yes," I told him. "I'm on a schedule just like the cats. Only without quite as many eyes on us."

4

"GOD FORBID you be cloistered inside—even in the rain or snow," Jack said the following week. His cheeks were flushed with cold, and soon his mustache would freeze, each end icy as it scraped my lips in greeting when he returned for the lunch he would take at his desk.

"Must you go out?" he asked, and my look answered him.

"You have work and the relief of coming home," I told him. "Allow me the opportunity to feel the same. I must go out. Otherwise I might never rise above the emotional drudgery of socializing and might just as easily stay in bed."

"Emotional drudgery," Jack scoffed. "You are something, Belle."

The wind ballooned under my wool coat as I gazed out at the parks on Commonwealth Avenue. They gave the illusion of country-side in the city, just enough greenery to make us feel healthy, I had said to Jack. Rather like a lie we tell ourselves. Those of us who prefer city comforts yet wish to feel as hardy and strong as those who tolerate the rural life.

The tree-lined malls gave way to vacancy for now, but Jack had told me of expansion plans, and I had heard our architect Gilman discussing projects at a recent luncheon—a new Jesuit college, a replacement for the National Theatre after it burned down.

Now icy air against my cheeks felt like the beginning of something. The papers said it would be a long time before the Boston Society of Natural History had its first museum visitors. I imagined the grand opening crowds queuing for admission and imagined, too, that I might be pushing a pram past the entrance. I watched a delivery of solid stone blocks that would one day be statues: Rhinoceros? Mammoth? I would keep checking. I lingered for only a moment as I made my way to Julia's.

When I pictured her face, it was always the younger version: the Julia from school, though she was now every inch a married woman, a lady in society. She and I had been devious, part of a group of girls huddled at night looking for suggestive lines in the pages of Flaubert, Baudelaire—of which there were plenty.

Julia and I were entranced with the idea of being seen. It was unseemly to be married and still court glances, to wish to be seen not only by men but by society. And yet I still wanted it. Julia knew how to play society's game and urged me to follow suit by memorizing the constantly narrowing rules. But to me, marriage seemed to bring with it an end not only of girlhood but of being in the world as a person with potential. I wanted to hold fast to that possibility—that there was more for me still.

In some ways I still felt like the girl I had been—unsure, aware of my legs underneath the layers of crinoline and skirts, my stockinged feet deep in blue boots. I unfastened a few coat buttons: my breath sharper the faster I walked. Walking was impeded by my bustle-cage, a slim bell of confinement that showcased my fine silk dress; it was the color of wet fall grass. I paused, autumn sun sliding under my bonnet, wind swaying the last of the colorful leaves overhead. I wanted to memorize the moment as I approached the path to Julia's house.

"How fortunate!" Julia said, arriving at the same time. Her eyes were bright; her usually pert features even more pronounced in the crisp air. "Just the person I hoped to see."

"And I you," I said, for if there was one person who had known me in most of my forms—new schoolgirl, travel correspondent by way of

embarrassing letters penned late at night as my parents slept, flirta-tious young woman—it was Julia. Now, as her sister-in-law, I was all of those rolled into one.

I looked at Julia—graceful, steadfast in her gaze and poise, shawl unmoving and perfectly arranged on her shoulders. She had found the role she had always wanted.

"I would ask you in for tea, but we've a crew of painters inside." She paused and, seeing my face, which must have given off too much disappointment, she added, "Of course we could spy on them." She raised her eyebrows to let me know she meant their ropy forearms, necks damp with sweat, the same determined look the dockworkers had worn on our school promenades in Paris. I raised my eyebrows back, but we did not mention lines of poetry that set off giggles, nor deeper desires that made us suddenly fall silent. Julia reeled in her younger self and added in a decidedly poised manner, "We might also check in on the dining room trompe l'oeil."

I wanted to see it, of course, to imagine myself in whatever painted world Julia had spread behind the sideboard, but I also wanted to pro-long the visit. "We could walk to mine if you don't mind the wind?"

Julia pulled her shawl tighter around her shoulders and hesitated. "Delightful." Then as she pulled the wrought iron gate closed behind us, she added, "Might there be lemon curd?" She paused and put a hand on her belly through her coat. "I confess I might be craving."

And I knew what she meant. As we walked, I could taste sweet and sour, sour and sweet, overlapping and competing in my mouth.

"PLEASE COME in," I told Julia, and led her inside. We stepped on the brickwork that brought me joy and pride each day—my own designs. Julia had not commented on it, or perhaps she hadn't noticed. I was beginning to understand that not everyone—even those I cared for immensely—felt the need to control their environments the way I did. Or they simply didn't notice bricks when there were wreaths on the door and red ribbons woven into sprigs of sharp-leafed holly on the entryway table to signify the cheer of the season. "We might take our tea in the music room."

Julia studied the entryway as she removed her shawl with one graceful motion, her every action fluid. Often when I was with her, I hoped her ease would somehow transfer to me, but as far as I knew, it did not. Oh, how I had longed for Julia's poise, a coy elegance I had never possessed.

Once I had visited her in winter; both of us and eighteen other young men and girls all piled in the sleigh we called Cleopatra's Barge. We sleighed all the way from Boston to the Forbes's house in Milton while Mr. Theodore Lyman, twenty-six, far older than we'd been and thus wise, had led us in revelry and song despite being such a serious Harvard scholar. "How lucky men are not to have to choose between being serious and fun," I'd said. Julia hadn't known what I meant. She had an ability I did not: she could simply enjoy a moment, where I found myself part in it and part studying it. I had no Harvard, no lab, no reportage to file the way Mr. Lyman did. The whole journey on that sleigh I had flirted and laughed—partly because I had a great propensity for joy when I did not feel judged and partly to cover my insecurity as Julia rode along but girlishly bounced and somehow made complaining of cold limbs adorable. I whooped and shouted with the boys and Lyman at the front, drinking beer. Julia was calm where I was not, smooth where I was tangled. Settled where I was unsatisfied. When we'd reached the Forbes's place, everyone had clustered around Julia to make sure she felt warm enough, hadn't been bruised on the bumps. I had brushed the horses alone.

As Julia and I now climbed the wide stairs at 152, I wondered when—if—I might ever be as gentle and smooth as she.

I led Julia to the second floor. In the music room, she chose a plump dandelion-hued chair; all the chairs were armless so as not to interfere with our hoop skirts. The walls were pale gray with silver damask ribbons of ivy, calm and elegant. I offered her more to eat. Julia tweezed a cress sandwich between two fingers, and I saw a glimpse of red on her thumb.

"Your skin," I said. She had raw, red peels of skin on either side of her right hand.

Quickly she pulled her hand back and dropped the sandwich on the plate that rested on her lap. She reached for the gloves she'd

removed and covered her unease with a smile as she shook her head. "Old habit," she said. "Never mind."

I stared at her. In school Matron had chided her for digging her nails into the tender skin on her thumbs. She'd chewed her cuticles in class when she thought no one was watching. I always watched. After being called out, she still gnawed the dry skin, tugged bits until her thumbs bled, but only in our room at night. It was the one act that betrayed her poise. I adored her for it.

"I thought you'd given it up?"

Julia swallowed and took a calm sip of tea, instantly poised again. "I have."

I let it go, not wanting to press. "Please, Jules, do have something to eat. You've gone a bit pale."

After a sampling of lemon and lime curd sandwiches, horseradish chicken and cress, the color came back into Julia's face, and what she had hinted at became clear.

"How lovely for you," I whispered. I did not have to lie to Julia— and she knew my well-wishes were real. The pendulum of outwardly happy and inwardly mournful.

Her declaration would mean temporary retirement from the social scene. She and her feminine illness would retreat from parties and luncheons, and I would see her only at her house with the outside world a mere wall painting.

Julia relaxed into my warmth, and her smile was immediate.

"You know I want nothing more than the same for you," she told me as she patted her mouth with the linen napkin.

We sat for a moment until I could not bear the fullness of it—my thrill for her that she would have another child to hold and the sudden unlocking of my own desperation, as heavy and unruly as an orangutan I once held at the zoo in Paris.

I stood up, pushing off the imaginary animal and turned to the room instead. "While you were commissioning trompe l'oeil, I've been rearranging the furniture."

Julia's eyebrows popped up. "Not yourself, surely."

I tilted my head back and forth, considering a small fib but then

decided against it; she was the closest I had to a sister and knew me too well. "Of course myself. Everyone else is too slow. But I couldn't move it *all* myself. I wanted that chaise there . . ." I walked and pointed. "And I wanted to put the mirror over there."

Julia stood and considered my ideas as she toured the room with me. "Oh and why not do so, when you're Belle! What could stop you?"

I gripped the marble mantel. "Actually, my rearranging was interrupted. The Amorys came here under the guise of toasting Jack's success in the Indies, but in truth they wanted to prowl our place. Especially Miss Susan . . ."

"And unhappy, still, I assume about your dancing?"

I gave a small shrug. "Would that still matter?"

Jack and I had taken a box at the Academy of Music, a luxurious renovation with velvet everywhere and a roll-up dance floor. Naturally, when the younger Amory had debuted, we had attended, and when Jack grew weary of dancing, no doubt partly due to the thirty-eight-course meal, he had permitted me to continue, which I had, with a delightful blue-eyed young man.

Now my eyes gleamed. I placed my hands on my heart. "I state once more I had no idea he was the prince!"

Julia let out a full laugh. "Did he not seem familiar, His Royal Highness Albert Edward?" She put on an English accent, to which I responded in kind.

"I must apologize, then, for stepping in on the fifth dance, which I understand now from our dear sister-in-law Harriet was to have been reserved for her cousin Miss Susan Amory, and also the fifteenth dance, which was to be Miss Hattie Appleton's." I curtsied with flair and on my way up caught Julia's eye. She shook her head.

"It seems to me one might find fault at you not recognizing him, but you can hardly be held accountable for the fact that men find you amusing and genuinely interested in their affairs of business."

"Still, I ought to be sorry for disrupting the dance bookings."

"You're not sorry at all." She grinned.

I stood, smoothing my dress. "Perhaps not. Anyway, when I told the Amorys about my design choices, Mrs. Amory felt my mir-

ror placement was poor. It would send the light to hit it just so," I touched my cheek, "making even four o'clock unflattering for my complexion."

"Harriet's mother might do well to take more sugar in her tea," Julia said.

"I am not quite sure that would make enough difference." I laughed.

"Even my brother Joseph, loathe to speak ill of anyone, has trouble with her sometimes. Quite a mother-in-law for him." Julia was protective of her brothers, Jack and Joseph, and I admired her loyalty to them as well as how she'd embraced both Harriet and myself as her marrying-in sisters.

"Mrs. Amory certainly does not care for me," I said.

A sharp intake of breath from my Julia made me stop speaking. She looked down at her lap as she seemed to eat the words she wanted to say and only added, "Oh, Belle . . . what did you expect? You can hardly act the way you have—the way you continue to do—and think you'll be none the worse for wear. You keep trying, but in such misguided ways."

I paused by the mirror, the gaiety slipping out of me as the light shifted. "Do you not sometimes wish things would stay just the way they are?" I stared at the room. It was the golden hour, those thirty minutes each day it seemed the world was tucked in, hues of all the peaches and coppers that illuminated hair and fabric and erased all signs of worry or decay.

"Stay like this? In such flattering light? Of course." Julia admired us in a shaft of sunset that caught the mirror's frame.

But I didn't just mean the golden hour. "I mean, if we could remain as we are."

"Well, if you don't care for the mirror's placement," Julia said, "I suggest you change it. You are the one, after all, who must look at it every day."

I knew that I wanted to change it, but I also knew that I wouldn't. As though this house was not yet mine, or the world wasn't. I noticed an awkward feeling growing daily—a racing heart, an emotional

seasickness I wished to express to Julia but couldn't. It was as though the city of Boston, the state of Massachusetts, the country, the globe had so much for me to see and to know and yet I knew only about drawing rooms and mirrors. I did not entirely like my reflection in them.

"No matter what the fashion," Julia said, "you'll make it yours." She paused. "You always do."

I did not know if she meant it as a slight or a compliment. I had made the path to the house mine. I had tried night after night to make my body respond to Jack's, and yet I feared I had little control over my own biological processes. Would there be a time when I felt I had made something of my life both inside and outside the house?

"I can't seem to help it," I told her. "Perhaps it's a skill I've yet to master." I went to show her and her blossoming self out.

5

Back in finishing school if we spoke out of turn or disrupted lessons, we had been given the task of untangling Matron's silk needlework threads—masses of slim ribbons in garnet, ferocious yellows, heavy blues. I remember sitting for what seemed or could have been actual hours filled with determination and rage and, nestled in there, hope as I followed strands under and over and back again.

In my bed at 152 Beacon, my insides felt as snarled and unwieldy as those knotted clumps. I'd been more than patient, diligent in my bedroom efforts and in nourishing myself and taking fresh air. The blocks of stone that flanked the Boston Society of Natural History were now recognizable as rhinoceroses. Foolishly, I'd thought the museum and I were both works in progress, that we would be built into new life at the same time. Now that I feared the museum would open before I had any results.

Month after month it had been the same. Only this time, I had skipped a cycle; I thought maybe the outcome would be different.

"Any news?" Julia stood at the doorway.

I shook my head. "How might one know . . . with certainty?"

Julia covered her teeth with her thin lips. "One simply feels . . . odd. And . . . " she paused, thinking. "And not alone."

Longing spread through me with her words. I sat propped on two

silk bolster cushions—green with wide white stripes—and I toyed with the cinched ends as I spoke. Julia came toward me, her own figure just a bit wider, her steps careful so as not to disturb the baby growing inside. She sat on the edge of the bed and reached for my bare hand.

"You're made of ice!" she said, and immediately set to pulling the duvet tighter around me, reaching for the quilt I had tossed on the chaise in the early morning when I had grown overheated. She relished the act of making me better. "Stay warm, and really, Belle—try and be calm. They say that's best."

"Who might *they* be?" I sighed. "The doctor came and he suggested broth and sugar water." I looked to the window, where the midday light fought against clouds. Jack was due back soon; he had reluctantly left my side for the office. "Do you not feel foreign in your own body, Jules? I suppose I feel stuck—sitting here month after month, waiting to feel whatever I am supposed to feel. To be sure. Were you sure?"

Julia sat up board straight and pondered. "I suppose. The midwife says it's natural to be—"

I felt confusion brewing. "What, exactly, is natural? Falling pregnant? Being unable to do so? Feeling ill and tired and yet desperate to keep feeling ill and tired?"

Julia tucked the blankets more tightly around my legs. "Dearest friend. You must find patience. If all goes as you intend, you shall need more of it." She squeezed my knee. "Now, in terms of Harriet's attempts at your social life. Have you had luck?"

I tucked my knees to my tender chest, searching in my body for signs of life, of a pregnancy I might announce first to Jack, then to Julia and Harriet, and then to the world as though to say, *Yes, I am one of you—I belong.* Or was the ache in my bosom the same ache that always ended with a monthly disappointment?

"We expect word shortly," I told Julia, trying to stay focused on our conversation and not on every twinge in my body. "Harriet has high hopes. Even Mrs. Bradlee seemed more hospitable last time." I whispered, though no one was in earshot. "I must confess I tried to

hide my latest pair of boots from her gaze. Perhaps that explains her tolerance."

"Or your winning affects." Julia grinned. Her shoulders sagged slightly.

"You must be tired," I told her. "Please do not sit here on my account. I shall be just fine with my thoughts."

Julia stood and fussed over the tray the maid had delivered and that I had not touched. "At least sip the broth. You will need your strength."

Either way, I thought but did not say, for fear Julia would scold me for my grim outlook.

"As you wish," I said, and reached for the cup. The broth had chilled, congealing slightly on the surface, which turned my stomach.

"I do feel a bit ill," I told her. She grinned with my confession and nodded encouragement. My heart pounded with hope, especially when Julia turned to go and, from the side, I could see just how changed her shape had become. "Many thank yous."

She turned back to clench my icy fingers and then left me in my room, which now felt altogether sunnier, as though Julia had given me her inner shine.

As THE sunlight began to fade, I wished for Jack to come home. His familiar weighted steps on the wide staircase, his whiskered end-of-day sigh, his eyes that still lit up when he saw me.

He appeared at the bedroom doorway breathless from taking the stairs too quickly.

"Such relief," he said. His hat tucked under one arm and a large parcel under the other, he took in the sight of my small frame in our large and pillowed bed. "Are you feeling quite well?"

I opened my mouth to reply, to tell him I felt well indeed and also to inquire after the parcel, which clearly weighted his arms, and yet, as I went to do so, I felt it.

A heaviness in my belly gave way and cramped. All hope lost again.

"Won't you excuse me a moment, dearest?" I said to Jack, and he knew from my face to take leave.

"I am sorry," I said to him, and the words slipped out like habit: no matter how many times my cycle tricked me into false hope, I felt devastation each time. This round, the bleeding had vanished only for a couple of months, but I'd clung to each and every physical change. The cycle of waiting and having no pregnancy, and trying feverishly and then having signs. Oh, and the thrill of having symptoms confirmed by Dr. Bigelow. This, too, had happened several times. We had thought for sure this time would result in a baby. Now a slim trickle of blood moved down my leg, Jack turned away.

LATER, WHEN I was tucked in by the maid once more—out of gloom, not actual physical need—Jack appeared at my bedside.

"Belle, how disappointed you must be."

I could not force a nod. Disappointment did not seem a large enough word.

"I brought you something," he said. "I had thought . . . well, only I had thought that you might be in bed for some time." He pushed the brown-wrapped parcel toward me carefully as though I might break. "And as such, I brought you some pages to pass the hours."

With both hands I received the oversized parcel and began unwrapping, first gently and then with more force. When the brown string would not budge, I yanked and gripped and ripped, unleashing my wrath on the poor paper. Jack did not try to calm or still my hands, and for that I loved him more.

Underneath the thick wrapping sat a great slab of a book. "*Les Fleurs Animées*," I read from the embossed front.

"J. J. Grandville," Jack said. "Parisian cartoonist. But do look inside."

I turned the pages, my mood skeptical, and yet found delight in the work. Each flower brought to life with clever artwork so that each plant and blossom had a body, a face, a personality. "Oh, Jack," I said. "How lovely. How thoughtful."

"I wonder if you might . . ." he paused, chewing the edge of his mustache. "Perhaps you might have better results if you adopted a more tranquil outlook."

I froze. "Are you suggesting this is my fault?"

He didn't answer, but patted my hand and pressed the book toward my empty abdomen. He had meant it as a pregnancy gift, and now it was one of consolation. We had imagined this baby a perfect specimen of life, ripe as the bright flowers and fruit in my book. And yet, leafing through the thick and colorful pages, I felt sadness dissipating: my eyes, my body, my heart pulled to the animated insects, personified flowers, the idea that life might be possible whether I was tranquil or not.

6

A WHOLE WINTER had gone in which I'd floundered, still child-less. Boston turned itself toward spring, one day warm, the next one's hopes dashed and chilled through. I'd stood for a long time admiring the Natural History building, where masons worked on the intricately carved street boundary. When the workers brought their breakfast pails to their laps, I continued on to the Public Garden, where the fountain would soon be sluicing.

Snowdrops edged the paths, duckling-colored crocuses nosing up to narcissus. I adored the garden for its pastoral setting right in the city. One felt tranquil amidst the lemon jonquils, and the meandering walkways let me relax as I went from pond to park.

"What kind of plants are these?" I asked the gardener as he clipped browning ends and pressed his trowel into the soil. Back Bay had not yet fully woken. I had risen early, taken only honeyed tea before deciding to venture out. "You must force yourself back into the world," Jack had said the day before.

And if I had no reason to be in bed, I would walk.

The gardener turned, surprised to see a woman out at this hour and more surprised to have this woman—me, I reminded myself—speaking to him.

"Pteridomania," he said, and I thought it sounded like he was

choking. "Ferns. Them here's a gigantic specimen, Madame. Brought from far off."

"Europe?" I asked, hoping to keep him engaged. The fern waved in the early warm breeze, as though personally welcoming me to the new Boston Public Garden.

"Oh, there's great ferneries." He addressed the plant. "You're a long way from home, ain'tcha." He then turned back to me as he took a long-handled brass watering can and drenched the soil. "Devon. Bicton Park."

"Are they all from there?" I asked. I took in the expanse of green, the newness of each flower.

"Here's maidenhair fern, and of course this one's a Boston fern— not grown in Boston if that pleases you to know. Grown in Ipswich—a greenhouse there. A cousin of mine has a few in Cambridge. Ostrich ferns here—see, like feathers?"

I breathed in as much air as my lungs could hold—early air fragrant with soil and the sort of hope that mornings brought. "How wondrous that mere blocks away from my house there's this entire garden universe," I said. He nodded. "Fern citizens managed by a kindly overseer."

"I'll take that title." He laughed.

"Does your cousin sell the ferns privately?" I chewed my lip, my fingers warm in their gloves. He crouched again in the dirt, securing one plant with a length of twine, patting others down firmly into the earth. I felt jealous of both him and the plants.

He gave me a look. "Cousin George might sell to anyone—just a matter of showing up."

"Is his greenhouse . . ." I paused, as though waiting to be overheard and shamed. "Nearby?"

Once more, the gardener looked at me. Not in the way some men did, as though wondering whether I might be sweet or savory, or as though I was transparent and useless as gauze, but as a curiosity. "If you fancy a journey and don't mind a crowd, his name's Swain and the house—well, you can see it from the Cambridge Line—horse drawn trolley. Crowded, but less bump than the Omnibus."

"May I ask you something," I said. I knew I ought to leave, both so he might return to work and so I might return to Jack, explaining my early morning absence. "There is a flower. An orchid. I've seen it only in the pages of a book." He looked intrigued. "Have you seen a lady's slipper?"

His face appeared to break open as though I had unlocked vital information. "Oh, Madam . . . Mrs."

"Gardner," I told him. "Mrs. Jack Gardner."

"If you might allow me, Mrs. Jack—I've got one to show you." He motioned for me to leave the gentle ferns and—though Jack might have disapproved—I followed him to the center of the park, over the tidy bridge to a thickly set group of trees. "See them? The trees are talking amongst themselves. Social lot, they are."

I studied the tree limbs, the spaces between them in which one could see the cloud-streaked morning sky. Even trees had more convincing social graces than I. "Mr."

"Valentine," he said.

"Mr. Valentine—may I ask what—"

He rummaged between two shrubby bushes, and I heard a creaking noise. "I've a small glass house in here." Then he turned to me. "Right from the pages of books."

There in front of me, housed in ordinary soil in an ordinary mossy pot, was the image from my library. "Hello, delicate lady," I said to the orchid, steady in her pot. The flower bowed at me, and I returned the favor.

Mr. Valentine, rather than laugh or turn me out of the garden—it was public after all—said, "Well, weren't that a nice introduction."

2nd March 1862
152 Beacon Street

Dear Julia,

As you are in bed, I feel quite sure of my duty to bring the outside world to you, even if I am also quite sure you will disapprove of my yesterday. On the word of a new friend, Mr. Valentine (yes, a garden worker, and yes, delightful in his demeanor and

respectful of my oddities), I ventured to the Cambridge Line. Just past Bowdoin Square but another world entirely. Why do we stay confined to our twenty-block radius?

First I walked in a straight line, determined to make haste to my appointment with ferns. But as I rode the tide of people— and it surely is a wave—I found myself carried along, human flotsam in a sea of costermongers offering bone-handled knives or bags of rags, women hawkers (I am not the only female to shout, apparently!) selling ropes of onion or piles of whelks heaped on ice. My hands were cold, and I couldn't resist buying a cup of saloop. I drank in its heavy, sweet orchid starch and sassafras tang as I walked.

Of course I thought I might pass out on the trolley: belly to back, shoulder to bird cage or walking stick or some child's sticky hands. That is the truth of public transport as I've experienced it: other people's bodies and smells, a potpourri of horrors, and yet I made it. I exited, all the while feeling very much alive in my unpopular boots, buoyed by a mission. Julia, these ferns are a miracle of nature: elegant and gentle and alluring as ladies one might hope to find at a tea. Mr. Valentine's cousin, Mr. Swain, kindly let me pay for four ferns grouped two to a pot, and then gave me an extra.

It was this extra plant that didn't make it home with me, as my curiosity got the better of me and I wound up following the smell of burnt sugar and the sound of stamping feet until I found myself amidst women in striped dresses, men on stilts, a juggler on one side and a high-wire act at least two hundred feet above me with the oglers to prove it as the acrobat stepped delicately across the wire cable while girls danced with ribbon wands and a collective of cats performed for their ringleader, a woman in a soldier's outfit.

I do not exaggerate when I say this was a dream and nightmare in one—and all the while me with ferns in arms as though I were one of them.

And this is maybe what I wish to say. I felt at home.

But just as I allowed myself the relaxation that comes with blending into one's environment, the easy way I navigated the chatter and sights, a sudden loud snap of metal shattered the

pleasure garden air. A collective gasp broke my reverie. I looked up just in time to see the acrobat fall to the grassplot. Upon his landing, someone sent for an ambulance volante. As crowds gathered around the acrobat's crumpled body—he was alive but only just I think—I came back into myself. What was I doing there? I shook myself awake from the fever dream and left the extra fern as a token of my hopes for the acrobat's recovery.

All of this is for your knowledge only, dear Julia. But know this: I'm still that girl, the one to take the wrong way back as I did in Paris, if it means seeing something interesting. Watching the graceful highwire walk and the acrobat's brutal fall, I am sure I must hang onto my old self. You disagree, yet even in Boston, or in marriage or what is to come, I must be me—or bring that self along for the ride. And it is a ride, is it not?

<div align="right">Ever yours—Belle</div>

Postscript: Now I'm not quite sure if I should dare send this letter, even to you, dear friend. Perhaps I ought to burn it.

7

I HEFTED *The Encyclopedia of Plant Life* onto the table next to J. J. Grandville's oversized book and paged through until I found the lady's slipper in both so I might compare. Having seen the real specimen the week before, when I had the printed images in front of me, they were flat. Not special at all. I would feel similarly if I allowed myself.

And now I sat in the parlor in the evening quiet of my childless house. I had lugged in an octagonal walnut table and a single chair. I hunched down as though I were somehow hiding in a forest or garden.

How might I survive the back and forth of wanting? Out in the world I felt stronger. At home I was reminded of what I did not have, of having been told there was a natural way forward for me, marriage, motherhood, all sure. Yet the nursery floor had no occupants—why had I not been told of that possibility?

At night, while Jack worked in his study, I liked to sit by the ferns. Huge potted plants with fronds dark as wet silk. I dreamed of sitting there one day, my belly so large it would be unseemly, and yet in the midst of the interior forest I had arranged I would feel as though I were as big as an island and just as untouchable.

Now the maid's bell startled me. I turned to find Harriet, a vision

in new-fern green, filling my doorway. She did not look comfortable; I stood up to greet her.

"What a pleasant surprise!" I said. Her face carried a look of disappointment, but I chose to ignore it. "How lucky I am to have such a dear friend casually drop by . . ."

Harriet took my hand. "Dearest Belle . . ." her mouth tucked in on itself as though she wished to sew it shut. "Forgive the late hour—Joseph accompanied me." She paused. "The sewing circle has sent their latest response. I fear the results are not as we hoped . . ."

For years I had tried for acceptance into their world. I wanted to have those words roll away like marbles on the hardwood floor. But I sat down feeling lost and foolish. Harriet crouched next to me, bracing herself on my knees.

My voice came out ragged and harsh. "If I have neither social circle nor child, what will I do? Retire fully to my bed?" I thought back to my day alone. "In the Public Garden last week, I looked at the flowers. Those buds—so hopeful pushing up through the muck and soil." I looked at Harriet. "I don't understand why it's difficult for me." Through the window, Back Bay's peculiar brand of quiet early evening slipped into the room. "Am I to understand I get only one chance?"

Harriet stood and went to the window, her green dress glowing with the sinking rays of sun that swathed across the bodice. "You had more than one, Belle! You had Richard Fay. You had the prince. You flirted with every man in the sleigh all those years ago."

"All those years ago—exactly!" I stood up, too. "And they enjoyed it—as did I!"

"Exactly the point. And it's not only the flirting. It's all of the social missteps, too. Miss Bradlee mentioned she'd seen you multiple times gawking—her word, not mine—at the Natural History Center."

"Museum."

"Belle, you take pleasure without thinking of the ramifications."

"And where are the ramifications for the men?" I spat the words, chest heaving. "Men may have agency to speak about anything, even

subjects about which they know nothing. And all the dalliances they desire. I am not allowed even a pre-dalliance."

"Missteps accumulate. And if you marry them with your strong will!—" Harriet looked teary. I was stung by her words as I came to realize I might forever be outside the circle. My body ached with hurt that I loathed; I was angry that still the outside world could get to me. "Oh, Belle. Have I wounded you too much?" Harriet knitted her brow in pain.

I tried to make her feel better. "No. It's right of you to try and correct me, Harriet." I put my hand on her shoulder. "I'm sorry Boston has such a long memory." I thought of the building site, how much I desired to create something new where there had once been barren ground.

8

MY SEWING circle shame lasted longer than I wished. Weeks later, determined to break the spell, I accepted an invitation. There was no sign announcing the Louis Agassiz Museum of Comparative Zoology, as though one had to be intelligent enough to find the rather disguised entrance. I was hot in my wool dress, yet I felt pleased, as though I'd gained entrée into a new land. I turned to my host, Mr. Theodore Lyman. He retained the air of competency and engagement he'd had on the sled those years ago. Whatever time and life had done to me, Mr. Lyman seemed unwithered. I wondered what kept men from appearing less ravished by daily life.

Mr. Lyman had of course invited Jack to join us, but when I pressed, he had accused me of finding the world more interesting than he did. I did not respond directly but rather apologized. I felt I was—still—disappointing him with lack of a child. We both had our failings, it seemed.

I wandered the cavernous room, my shoes scuffing the marble floors as I eyed the many glass boxes, each filled with a different kind of specimen. We had started with birds. "I apologize for Jack's absence."

"You are presence enough," Mr. Lyman said. I felt a shiver. Always Jack held the social currency. Was it possible my curiosity, my eye,

might be enough for certain realms? I fixed my gaze on a series of small pencil sketches, each more alive with movement than the next.

"And these sketches? Are they, too, from the trip you mentioned to Nicaragua?"

"Might I comment that yours is a rare focus?" Mr. Lyman said.

His face was adorned with rakish sideburns, full and ever so slightly unkempt; a relic, I imagined, from his time in the South. He would be setting off again as an aide-de-camp—and I felt torn hearing of his prior and upcoming service; he would make a difference.

"How so?" I asked, still studying the sketches, how the strokes looked like wind right on the paper.

"Here we are—surrounded by wooly mammoths, stuffed elk, the yak and here is Mrs. Gardner taken in by my palm-sized sketch."

I considered Mr. Lyman's words, then turned back to the sketch. "I feel you are not doing justice to the drawing," I said, and with my gloved finger pointed to the feather details, the cresting around the eye. "As though one might have the bird in plain sight—right near Mombacho."

"You were listening when I mentioned the volcano." He had described the animal and plant life clustered around Granada—Mombacho and Lake Cocibolca. How stunning the variety of climate sounded: forest with cloud cover, wild berries moist and in great number on the hills, too many orchids to name, a lake with fish the size of a tea trolley and just as gleaming, dry ground, and trees that stretch into the bluest sky. I grew envious. "Of course I listened. And when you spoke of your military service."

"Not all women do," he said with the curt tone of a scientist.

"Nor all men," I said, and moved toward a large specimen of coral.

Lyman touched the pockmarked edge. "That requires infinite seawater in order to grow, to survive. Constant acquiring . . ." " He paused. "Perhaps like yourself?"

I could not meet his gaze. "I suppose that's true. I want . . ." I choked on the words. "Knowledge."

"As do we all. Even here, at the lab, we hope to expand—perhaps you've read of Dresden?" He waited, but I had not. Not knowing, not

seeing, made my skin itch and caused me to feel more pressed in my clothes.

"Mimi and I had our grand tour of Europe, as you know—I believe I sent word when Cora was born." He turned to me. "Advice? Do not deliver a child in Florence! There is good reason why that city is known for its art and not its medical care." He laughed, and I smiled to cover my sinking heart—at every turn a story of someone having a baby, even in Italy.

"So," I said, "Dresden? What will pull you there?"

He led me to the back of the room where another door opened to reveal more collections. "What we hope will be acquired: an entire collection of invertebrates made from glass right in Dresden. A delicate pursuit to say the least!"

"First a grand tour, then a grand tour of glass," I said, and the words sounded morose, as though I were, like the yak and elk, stuck under a glass dome—never to go on a grand tour anywhere, doomed to be either trying to become pregnant or else pregnant and confined to the house. "How fortunate for you both."

"Indeed." He touched his mustache and seemed on the verge of pitying me, even though he didn't quite know why. "Shall we see the bird, then?"

"Yes," I said. "A quick look before I must return home."

I needed to see Jack, assure him I found him interesting or, if not fascinated by his steadiness, that I found a peace with him that was unattainable elsewhere.

We left the mammals and moved past crescent-beaked toucans, bee hummingbirds the size of my thumb. "How tiny."

"From the Isle of Youth," Mr. Lyman said, and looked wistful. "If memory serves, I recall that island . . . the sleigh ride to Forbes's house in Milton years back?" He looked at me, and I nodded, remembering. "A cold night with much laughter. Mostly due to your spirits, I think."

"You're too kind," I said. "Perhaps I thought then that I would forever live on the Isle of Youth." Would I be able to keep that younger, vibrant Belle, have her as part of my adulthood? We walked until I

stopped short, nearly smacking into a tall bird erected on a small wooden platform.

"We haven't boxed him yet," Mr. Lyman said. He looked around. "Of course, one isn't meant to touch the feathers, but . . . you may do so. Gently."

I made sure no one was watching and removed my right glove. Like one of Lyman's rare species, I, too, had sat stuffed and useless at the breakfast table. With one pale finger I stroked the electric blue face, the gold-fringed back feathers. "It's as though they're dipped in honey."

Mr. Lyman appreciated my awe. "Many antbirds are plain and feathered in muted hues. The ocellated antbird, *Phaenostictus mcleannani*, seems altogether different. See the pink legs?"

I allowed myself one more touch and then felt required to reglove, to tuck my awe and fascination away into my tight bodice. "How splendid, Mr. Lyman."

"A pleasure, Belle—" He stammered, but I did not correct him. "Eh, Mrs. Gardner. I hope this entices you to come back; of course, bring Jack should he, too, find ornithology compelling." He paused, addressing himself, or me—I couldn't tell. "There's much to discover. It makes the world altogether more pleasurable."

I turned to go, weighted with the desire to know and know and know. Then, as I stepped into the late autumn air, there it was: that newfound buoyancy from the pleasure garden, back to grace me again. Unlike those dreadful evenings of scorn, the visit had made me feel positively radiant. Was it possible I, too, would be kept from being boxed in glass?

<div align="right">

16th April 1862
152 Beacon Street

</div>

Dear Julia,
Though you are only a few houses away, I know you will be resting and do not wish to disturb you. I am just returned from the Boston Zoological Garden, where I have passed a pleasant morning with burgeoning friendships: Mr. Miles Louris, who

heads the program with the great beasts, Mr. Valentine, whom
I have previously mentioned from the Public Garden, and his
fountain-casting friend Mr. Grotberg. All in all delightful.
Now on to the reason for this note—I wish to express my
gratitude for the delightful birthday tea on Monday. Certainly
being with you, Harriet, and our mothers was a cheerful way to
turn twenty-two.

I felt quite gloomy with the party's end (thus my outing to the
zoologic): a sign of aging or merely that letdown after company
leaves? I suppose I am more social than I like to admit (slim are
the stacks of invites). My mother has since returned to New York;
my father gifted a beautiful photograph of her that I will cherish.
Mrs. Gardner gave me a sketch of her pergola at Green Hill for
which she apologized profusely, feeling it wasn't any good, but I
reassured her it was and, besides, my attachment to it would not
rest solely in its merits but rather because I care for the sketcher.
The silver cup from you will find pride of place on my mantle
next to the vase from Harriet; I do love that your cup traveled all
the way from Luleå with you to find its home with me. So thank
you, friend, for your birthday kindness; while there are delights
in larger parties, I do know I am lucky to have such a cherished
few. Is it wrong for a woman to want more? Not only friends and
pleasant outings. Oh, how I want and want and want—to study
the library arches and entertain and feel myself integral to the
world as though I am the walls of a house.

Always Yours, Belle

9

As summer nudged its way into warm mornings, all of Back
Bay in full leaf, Boston society emptied for Newport, for
the North Shore, for Maine. Needing to keep on with the task at
hand—which was feeling very much like a task, though I kept this
to myself—Jack and I stayed at 152 Beacon. I stood by the window
in our library breathing the ripe evening air, holding the *Atlantic
Monthly* magazine in my hands.

"I quite like 'Battle Hymn of the Republic,'" I admitted, as Jack
motioned for me to join him in the twin chair next to his.

Jack reacted immediately. "Some think her coarse."

"And still others believe her work to be important."

Jack's exasperation clouded his face. The simple evening he had
anticipated, his pretty wife's company by the fireside, the evening
that he deserved having spent hours at a desk in a well-appointed
office, had turned sour, my conversation demanded too much.

"If only I were Julia Ward Howe," I said, before I could stop myself.
She was fluent in seven languages and a serious scholar of philosophy.
I doubted very much if she would mind the rejections I had endured.
Or perhaps she knew them all too well.

"I grant her the song's popularity. And yet . . . her husband did
not approve of her poetry," Jack said. "Though I've never read it."

I hadn't read it either, but only because someone with the correct name had deemed it scandalous. Still another person at our dinner tables provided hearsay from still another party in which Louisa May Alcott—whom everyone thought might one day be a talent—said she had not read the poems because she did not care for Julia Ward Howe herself, though we all knew them to be of the same set.

"I'm curious about her book," I told Jack. "Perhaps I might find and read it."

Jack went on. "Some felt it to be quite . . . shocking."

I could feel his gaze on me. He desired me to be desirous, as heated as the poems neither of us had deemed appropriate to read, yet I also sensed he did not want to feel my desire overshadow him. "Shocking in a bedroom sort of way?"

"Yes, Belle." He moved closer in the chair. I leaned toward him to bring my mouth to his but felt again a burst of words from within.

I found myself blushing. "Sometimes it's as though I have been unaware of the world outside these walls."

Jack realized the kiss was diverted. "You finished in Europe."

I found the words. "What if I'm not finished? I miss Europe. I miss myself in Europe. I do long to be . . . elsewhere." I thought of Mr. Lyman's lab. "To explore."

"My dear," he said, trying to tamp me down with his gaze. He had the tone I had come to understand that men reserved for women— even those women they adored—the tone that suggested they could not bear the terrible burden of *knowing*. "You have a mighty task at hand—the most important task."

He reached over and placed his hand on my still-empty belly.

"And am I not capable of doing more than one task at a time?" We sat in uncomfortable silence until the captain's clock in Jack's study sounded a muted tone. I thought of the makers of that clock, the ships on which similar clocks had perched. I thought of Charles Perkins, whose ships sailed from Boston Harbor, toiling in rough water to pick up poppy plants from Turkey. The sailors who then went to China to sell the drug, pocket such profits, and return with silks for my dresses and tea for us to drink each afternoon. How I was in some

ways complicit. I thought about the Perkins brothers donating funds for Massachusetts General Hospital, the Boston Athenæum, doing such good, and yet how they'd also enslaved the Chinese population. Perkins's nephew Forbes used his share of the profits to build steamships and railroads I'd traveled on.

My sigh was loud in the awkward silence I shared with my husband. Did I know what, aside from growing a child, I was meant to do with my life? I did not. Yet I knew this. "I should not want to build a fortune or find meaning at the expense of the lives of others." I said the words to Jack, but they were equally for me. "Should I be fortunate enough to find a larger meaning in my life, I should like it to benefit others."

Jack sat long enough, saying nothing long enough that I wished now to undo the stitching of the evening. I wished to wash it clean, scrub the air of my words. How much easier it was to keep quiet, to say little, to acquiesce. To kiss him back without stopping to converse. I stood. My legs carried my weight, but my insides withered, deflated and empty of all my tasks. I placed my hand on his arm, hoping the touch would convey a tenderness I did not necessarily feel.

Jack sighed. "I apologize, Belle, if I misunderstood your intent. Yours is a curious mind, so of course you are intrigued by these complex matters." He frowned, and I felt it throughout my entire being. Perhaps he regretted marrying me. Or perhaps he thought nothing of the sort. But it is possible that we choose whom to marry far too young, when we have not yet become anyone. "I wish only for you to find peace—peace enough to have what you want."

"But what do I want, exactly?" I held my empty palms out and scanned the room as though I'd lost something. "To be accepted into circles or be pregnant and pram-centered, or to be informed?"

10

NIGHTS COOLED, Back Bay residents filtered back and unpacked summer trunks. One evening in late August, I watched the bustle as I walked with purpose to see what I thought of as my building, even though I had no claim on the Boston Society of Natural History. I walked the block in front of the building, then around, beholding the beginnings of the wrought iron gate—just hinges today, but soon, a finished product. I wanted to pat the fully carved animal statues and congratulate the workers, but it was Sunday and I the lone gawker.

That night, I woke up with a start. Our bedroom was blank with darkness, the air closing in on me as I gasped and reached for Jack.

He sat up midbreath. "Belle? What is it?"

I felt my stomach turn, my body foreign and disoriented in our room. All I could muster was, "Might I let go of Belle and be called Isabella?" More and more I felt *Belle* to be a silly nickname, a remote schoolgirl left back on the Isle of Youth I had seen on Lyman's wall map.

Jack furrowed his brow. "As you wish. But Belle—Isabella—are you unwell?"

I sat upright.

I stuttered over my words. "I know something," I told him. I thought of running, of my paper-doll selves attached by thin folds.

He placed both hands on my face, peering at me, though there was barely any light. His hands felt familiar and comforting. "Yes?" His concern leaked into his words. "I think we should summon Dr. Bigelow."

I sat up on my knees. "No," I told him. And so that he would not worry, I took his hand and placed it on my heart, which raced, and on my abdomen, which was not quite as flat as it had been.

"I think," I began.

"Belle?" This time I didn't correct him. He was too set in his ways already.

"I am sure of it," I told him. And I was. We lay in the darkness, connected hand to womb, a slim shaft of gaslight from Beacon Street touching the end of the bed.

"Oh my, oh my," Jack whispered. He rolled his head to face mine on the pillow we shared. "Isabella."

I was sure: at long last I was pregnant. I could feel something growing in me. Not only the baby, but another self, one I'd found on my walks, in the lab. Someone capable of progress.

II

WEEKS LATER, the morning sky looked like curdled corn flour milk and turned my stomach. "Jack," I called to him, "I don't think I shall go out today."

Jack came to the door with the morning papers under his arm. "Will you be well enough for tonight?"

He meant a gala in Copley Square. The sewing circle women would cluster and bloom in their dresses.

"I think not," I told Jack. "Please send my regrets and ask Cook to send up pottage—extra hot."

How pleasant to know Jack and I had triumphed. I could feel my body different already. And how pleasant still to beg off social engagements and find an excuse to read in bed. I waved Jack to work with nary a concern—the doctor could come later if need be. I pulled the duvet high to my chin and tucked myself away from the world. Despite physical discomfort, I was filled with emotional relief.

WITH THE soup, the maid brought a letter. The familiar jumpy script buoyed me, and I took the letter and soup to my tiny parlor. Oh, the life raft of Richard S. Fay's name, each syllable a reminder that I'd

had a life before all of this. And now my old friend had become a soldier, joined the 18th Massachusetts Regiment. I could picture his dark eyes, his full mouth and his focus as he listened to me speak, the information he told me as his equal rather than a pleasant yet useless woman.

Bittersweet to hear from him now—he risking his life whilst I sat tucked into my room. I had not thought to send a letter to him—and yet he wrote to wish me well. I sighed. What had I to offer back? Frederick Douglass's words I'd read in pamphlets? Fay found himself gone from Fredericksburg since his Major General Burnside had been removed from command, and he was now outside of Gettysburg. He did not mention details of conditions, and for that I was grateful, the soup now slopping against my stomach. He wrote of abolitionism, of the landscape, which, as we had once spoken of my affinity for fields and expansive views, he thought I might wish to see under different circumstances. And he wrote of camaraderie under duress. How given situations might inspire closeness not otherwise achieved.

I ached, and wished at once to be relieved from feeling ill yet also to see the land he described. To be more than I was. Was this the struggle I would face? Be penned in and thus a proper mother?

I wished, too, to converse. To tell him I supported his cause. That I thought perhaps Julia and Harriet would welcome me into their fold and I would be as a soldier in battle, forcing myself through tough conditions and battling with the world. Yet I did not write that— how belittling to a man at war to liken my routine ills to his daily despair. So what might I do?

Mr. Fay had an idea. I read on: he asked—subtly—if I might wish to send aid to help the sister of a fellow soldier he'd met come north. Could I assist in this regard? Fay suggested I find a name, someone who might be contacted, and I wrote one—a girl I had known in New York, Delilah Levin, with a sympathetic demeanor and a house near Albany. Perhaps she might help, I wrote. And within my return letter I slipped currency—*I do not expect to be repaid*, I told him. *Perhaps*, I wrote, *I will see you again when this terrible business is finished.*

Both of those ideas seemed unlikely. And yet, responding to him, giving money to a cause, felt freeing somehow. As though I had at least tried to help. As though I, personally, had transcended the confines of my bedroom and gone on to affect others I might never know. As though the world might hold more for me still.

12

Now that I was expecting, days sped along, turning like the carriage wheels out to Green Hill, Jack's parents' estate in Brookline, for an early winter family gathering. Set up on a hill, with arched porches and rolling fields, the property was a farmhouse dipped in elegance. Back when Jack and I had courted, and in those first years of marriage, I would ride one of their fine horses: my favorite an English thoroughbred called Swenson, whom I renamed Sweetie.

Jack's parents greeted us; it was easy to detect additional warmth from them now that I carried a future grandchild. Harriet and Julia and their husbands, already with sherry in hand, nodded hello. We dined on sturgeon and caviar, apricots laced with rum, endive and almond salad, pheasant Jack's father had brought from a gaming weekend and that had hung so long its ripeness turned my stomach for the first time since those early weeks.

Bundled into furs, we skirted the field, careful not to slip on the iced bricks, and went to see Jack's father's winter garden. The Green Hill glass houses and plant life were spectacular—climbing glories in jewel tones, ivy creeping on all sides, an interior pond the Gardners had constructed, complete with floating lilies and frogs who had missed their winter cue for underwater sleep and now croaked and sang.

"Would a slow, short ride be really so terrible?" I asked, wistful at the thought of Sweetie's muzzle, how warm he became even in the snow.

"You mustn't," Jack's mother said, her tone strong.

Jack agreed. "I'm quite sure it isn't recommended."

Of course they might have been correct, but I felt deprived. I had trimmed any socializing and walks, saw less of Mr. Valentine and his many species in the Public Garden, less of Mr. Grotberg the fountain caster, less of the amicable zookeeper Mr. Louris, and now I was forbidden to ride.

"One has to give up bits of oneself in order to have a family," Jack's mother said, under the noise of the greenhouse frogs. I frowned. The baby's acrobatics inside me were consolation, however, as though she—or he—and I were in the midst of a private conversation. The secret movements and my hand pressing back with each turn made a soft power bubble up in me; I had a language with this being that no one else shared. Harriet had caught me holding my belly and given me a knowing smile. Julia had been happy with my news—or, if not happy, relieved. I'd finally succeeded at a task so many found easy.

As the others left the chilly garden for cake, my father-in-law, John Gardner Sr., moved toward a side table, wrought iron and white with a marble top. "You recall skating at the Public Garden, Belle?"

"I do," I said. It felt ages back. Winter then, too, of course, but in a hoop skirt, small framed, my laughter swallowed by the cold as I had sped past the other girls, Mr. Gardner looking on.

"You were so determined," my father-in-law said.

"I had to be," I smiled. "You insisted New York girls held no ribbon to Bostonians—and I believe I rather proved you wrong."

Mr. Gardner motioned me forward. "I see that same determination now, riding aside, and . . ." He stumbled over his words and then reeled his considerable warmth back in lest he be too expressive. He untangled a small vine from his considerable collection, wrapping it tenderly around a small wooden stake. "Perhaps you might find room for these at your house."

"Hanging nasturtium," I said when he gave it to me. Mr. Gardner nodded.

"Tended properly, this one might grow to twenty feet," he said. "Imagine that."

"Imagine," I said, and followed him out, grateful for his words and the vine. Plants seemed like silent children, quiet but needing me just the same. The vine would be company during my lying-in period, those last few months when women disappeared from society, often bedridden as though the life inside us erased the outside world.

"How DIVINE," Julia said back in the conservatory, as she tasted the cake, a large round of sponge layered with jam and dolloped with sweetened cream. Her enthusiasm spread, and I enjoyed the mouthfuls, the plant by my side.

I found myself studying Julia and Harriet in their stunning dresses: both blue, as was the fashion today. This should have brought me joy since it was a favorite color. But instead it made me cross. I had worn blue boots and been scorned by the sewing circle and my sisters-in-law alike. Now I tried to convert my annoyance to pride—after all, I had been ahead of fashion, and that ought to afford a certain amount of smugness. Instead, I felt a building confusion—Harriet meant well and seemed to love me for the person I was, but Julia? She seemed caught between love and scorn; always I could do better. And now, with pregnancy taking over my body, I had expected a withering temperament to invade my character, but I found I still had spirit to spare. Perhaps one day I would be neither ahead nor behind fashion. Or perhaps one day I would not care either way.

I breathed in the blue around me: cerulean or mazarine, the color of inky sky, my dress with a tumble of flowers and garlands to distract from my changing shape, Julia's in turquoise edged with gold as though the sun were rising, Harriet in navy with gold as though she were setting. Just dresses, and yet all of us like sky and clouds.

I pushed away the urge to feel Sweetie's rippling muscles as we cantered over snow-streaked fields. Cake and friends and colors, one of the Labradors on loan for company, and a vine to grow. I would have to be satisfied with that.

. . .

Mrs. Isabella Gardner
Requests the Pleasure of Your Company
At a Small Day Party
Thursday, 1ˢᵗ of January, at 1 o'clock
152 Beacon St.

Try as I might, I could not just wilt into solitude. It was frowned upon to entertain while in such an unseemly state and at such late notice, but perhaps, like the color blue, it would become fashionable. I was convinced I should try once more; I would throw a luncheon. My belly took the shape of the silver dome we used to cover the Christmas roast.

I would not have music, even though I felt most relaxed with notes swirling around me. We had been to the Boston Music Hall in early December; I'd been stunned by the sheer enormity of the organ, six thousand pipes with sounds so rich my hair stood on end. But music on New Year's Day might appear too-too, and as I was determined to adhere to Boston's wills, my house remained quiet. No quartet, no pianist.

"Would you like me to save you a plate?" I asked Jack, as he left to meet his brother Joseph at the Somerset Club for whiskey or whatever Harvard men drank to usher in the New Year.

Jack wrapped a scarf around his neck and came to give me a gentle kiss on the cheek. "All I want is a happy afternoon for you. Even if women in your state ought not entertain." He paused. When I didn't respond, he pulled his scarf closer. "I think you ought to rest when all's said and done. Off your feet." He gave me a quick kiss on the cheek. As the cold January air whipped in, I closed the door behind him.

Jelly bombes were all the rage, so despite the fact that I loathed their rubbery exterior and oozy centers, I had the kitchen help make one—a bright cranberry sphere. And when it stuck to the mold, I donned an apron and threw together another dessert, my heart

thudding fast as the minutes ticked by, closer and closer to one o'clock.

I had always been capable of great fantasy: extraordinary images in my mind of the festivities yet to occur—Harriet rosy with laughter, Mrs. Amory somehow laughing, too, and the dreaded Mrs. Coffin and her daughter (married now with twins, and seemingly no worse the wear for never having landed Richard Fay), everyone tucking into the newly molded flummery I'd made, whose name even sounded joyous, and its color, orange-yellow like the potted daffodils on the table, would make everyone cluck with delight.

Like the dessert I'd made, there was more of me than one could see from the outside—only I did not yet know exactly what my filling was. What was I meant to do? I hoped this party and, soon after, motherhood would be the answer to this question. Yet there was a tiny flicker inside of me that had sparked long before, and it made me feel there was still more for me that might never be set aflame here.

The clock sounded a lone chime. One o'clock. I went to the front window to have a better view of the snowy street as carriages arrived.

One by one the late responses via footmen came in:

MRS. SALTONSTALL regrets extremely that a prior engagement will prevent her having the pleasure of luncheon with Mrs. Isabella Stewart Gardner on 1st January.

MY DEAR MRS. GARDNER—
I am exceedingly sorry to be obliged to decline your kind invitation for today owing to a prior engagement house in Concord. Hoping the weather will prove favourable for your day. Very Sincerely, Mrs. Shattuck

MY DEAR MRS. GARDNER—
Very many thanks for your kind invitation, which, I am sorry to say, we are unable to accept, as we have this morning heard of the dangerous illness of my husband's mother. My mother, sisters, and I are much disappointed, as we would have enjoyed your

company, especially given how admirable of you to host in your current state. We congratulate you upon your impending family expansion.

Very sincerely yours,
Sarah Forbes

MY DEAR—
I am doomed to disappointment! I looked forward to this enjoyable day, yet news came this morning, informing us of the death of Edward P—, my husband's second cousin. I have never met this cousin, but family is family, so naturally for some little time we shall be unable to accept any of your invitations. Trusting your party may be as successful as you wish.

Believe me, Yours very sincerely, Mrs. A. Cabot

MY DEAR MRS. GARDNER—
Thanks for your kind invitation. I should not hesitate to accept were my children well: our doctor has some fear that the siblings are showing symptoms of measles, thus I am compelled to decline it. I hope you may enjoy your New Year. Ever yours very truly—
Mrs. Hale

MY DEAR FRIEND,
I regret that I cannot accept your kind invitation, on account of baby Joseph being laid up with a mild bronchitis, which, of course, keeps me at home. Bravo for your grace.

With many thanks and kindest love, Yours ever sincerely—
Harriet

The snow never showed wheel marks. My front steps never revealed a pattern of boot prints. The front hall remained empty of visitors' wraps. I held my belly in a state of shock that became a rush of embarrassment, which then trickled to a flatness I saw in my face when I looked in the large hallway mirror.

Would I ever outrun my reputation? I realized now it was unlikely. And yet, feeling those secret kicks from inside my womb, I was not alone. I looked forward to when I had my own little ones and could

decline luncheons or dinners similarly. Jack's words were on the mark; I ought to rest. Then I would enter a new chapter: one in which I would rebuild myself.

One day I would burn the rejection cards in a fire of my own making. And for now I would not give those fustilugs the boon of my hurt. Besides, it was likely detrimental to the baby.

I took the untouched flummery and fed it to Barley, my father-in-law's Labrador we were minding while he was away. The dog and I sat on the floor of my otherwise empty house. The dog mouthed the pudding, splattering my dress with drool and falling morsels. I didn't care. I patted his wide head while the dog kept one paw on my lap, as though he knew of my disappointment and offered his beastly condolences. I could not force people to gather at my table—but I could throw myself into my life as a mother and hope that would suffice.

13

WINTER HAD given way to March muck, and now, at last, Boston's spring appeared, suddenly full and warm as though it could not hang onto the sad season. Whatever I felt about Boston rejecting me personally, its seasons and plantings welcomed me as one of the family. I adored the sweep of willow, the hopeful crocuses, the air that was both chilly and warm when I opened my window, and I relished the kicks I felt from inside. It was as though Boston could not quite decide if it wanted to remain with one foot in winter or jump ahead, and I loved Boston for its seasonal indecision the way I already adored this child who swished and turned inside.

As I was unfit for public viewing, front-weighted and given to tripping over my own feet, I spent more time at the house. Indeed, women were meant to remain housebound entirely for their last three months, and despite my instinct otherwise, I had begun to acquiesce. Giving in was both welcome—for I was indeed tired—and also worrying. There was a part of me quite distinct from the bold, public Belle-Isabella. A part that grew smaller and smaller the more she was kept indoors. I wondered if I might shrink to nothing if not given proper air and water.

Sometimes I allowed myself to venture out the front steps, if only

to admire what was becoming true: my vision of our house. The exterior cut stones were the color of weak tea; there was a mansard roof built to resemble Loire châteaux or the mansion houses of Paris that to me seemed perched like an odd and unbecoming hat on top of my otherwise charming home. We had a stately tower that protruded from the front, and when Jack wrote our address on cards, I often joked he might call it the Chess House.

Jack laughed but said, "It wouldn't be polite."

"You know, Jack, it's possible that being polite will have no significant payoff." He raised his eyebrows. I continued. "At least for me. The other day I watched Cook make new potatoes—"

"With cream sauce?"

"Yes, with cream sauce, Jack, but not my point."

He signed his name to a document. Upside down I could read *Sumatra* and *peppers of importing concern*. I wished I had official business. "And what might your point be, dear Belle?"

"My point is she made the potatoes carefully and exactly the way she ought to, the way it is demanded by the recipe. But she kept them under the cloche pan, refusing to give them air."

"And?" Jack peered at me as though trying to see inside. More and more it seemed as if he needed to know all of me, possibly out of love, possibly as a way of feeling sure of me.

"And the entire pottery burst." I clenched my jaw. "The same is true with pie, Jack. If huckleberries aren't given a clear pathway for their steam, it ruins the whole thing. Have you ever seen a pie explode?"

"It sounds messy," he said and then, peering ever closer, "and how is this to do with you and politesse?"

I wrangled my voice in tight, and it came out strangled. "It means, dear husband, that if I am continually forced to be other than I really am, at some point—"

Jack cut me off. "I'm sure you're far more controlled than that."

I clenched my fists. "Both you—and Boston—should wish for my control. A Belle Gardner explosion could, as you say, be quite messy."

. . .

As we prepared for the baby, I now found myself hovering over clusters of plants I arranged and rearranged on the balcony that overlooked the entrance. This afforded me a view of Beacon Street. I wished for a longer view that would offer up the Boston Society of Natural History building, which I could no longer visit. The opening date was set for next week, and I felt unduly sad about not being able to attend; how I longed to see the finished place in its full glory. Yet I took solace in my excellent Beacon Street block view: comings and goings of neighbors, workers, deliveries of brown-wrapped parcels with custom stamps—though these were often for me in my attempt to create a perfect nursery, French for elegance, English for practicality.

The maid stood near the balcony door, hands clasped in front of her. "John Gardner Sr., Madame."

"Belle—whatever might you be doing down there?" My father-in-law, who had taken to visiting weekly as a sign of devotion to our growing family, towered above me as I squatted, hulking over six small dishes I had taken from the dining room and planted with bulbs. "They're from the head gardener at the Public—his ferns had babies, and then more. Quite remarkable, really."

"Quite remarkable is your being so . . . far along and in your position," Mr. Gardner said, but he did not scold me. He never did. His voice matched his size, all of him rather like a map done in large scale—grand and, I thought, lovely. "Forgive my informality, Belle, but are you sure it's wise?"

I pushed soil into the small pots, making sure each root had a firm base, the tiny fronds sprouting just over the edges of each pot. "They were wedding gifts," I told him of the pottery. "Yet completely impractical for tea, as they've no handles. Japanese, I think."

He picked one up, and I felt my heart rate increase as I worried about the fern babies—when I'd told Julia my recent focus she had assured me it was natural. I was, finally, feeling what all soon-to-be mothers did—worry cloaked in obsession. Harriet, too, agreed.

Especially as she was trying for her third child this autumn. "How interesting to think of using the objects in such a way. You really have an eye, Belle."

I blushed and looked for where I might wipe my dirt-caked hands. My nails were short and soil-blackened: good thing I hadn't any social engagements. I paused as though admitting something. "I enjoy it."

"Planting? You come by it naturally." My father-in-law rose, pulled me to my feet, where I wobbled slightly before gripping the balcony railing. His greenhouse plantings were known throughout Boston and Brookline, envied, worshipped by even visiting dignitaries and Harvard botany scholars.

"Well, planting, yes, and perhaps due to my grandmother—her skill matched her enthusiasm. My father is Scottish stock—and from the sounds of it his mother could mend anything. Ride anywhere in any weather. Grow anything." I looked out at the street, the Boston day continuing despite my not being in it. "But more . . . than the act of gardening. I think I like making something. Items that were it not for me, might not ever be. Or might not be in quite the same way."

Mr. Gardner nodded. "A bit of the artist in you?"

I shook my head. "I think people use that word when someone is unpredictable or outspoken."

"I meant it as a compliment. Surely if you have the ability to see objects in ways other than their intended uses, you have artistic vision?"

I blushed. "I simply like art when I have the good fortune to see it."

He furrowed his brow. "I think you see it in places others miss." He paused. "Brickwork, for example?"

I grinned but did not entirely believe him. I wished to be both: a mother and someone who could attend the grand opening of the building I had checked on, visited with, watched grow from a parcel of flat scrubby land into a formidable stone fortress housing innumerable items. The Natural History gala would happen without me—I could read reports and might even hear revelry, but I would not be permitted to attend.

He smiled back and fixed his eyes on my girth. "But most import-ant, Belle, is the mother in you. Soon-to-be."

I looked at the potted spider ferns, how delicate and small they seemed from my standing position. "Yes," I said. "Dr. Bigelow says it's only a matter of weeks now."

14

HARRIET, BELL-SHAPED and flushed, climbed the last few stairs slowly, pausing for breath. "Why ever did I allow you to convince me to leave the house?"

I turned back to face her, using the banister to support my awkward frame.

"It's Day Ten!" I said. "Finally we might see our sister and Baby John."

I had broken from my pre-delivery quarantine—only one week to wait—to visit Julia. Only a few blocks away, and yet I had taken the carriage, feeling ridiculous and entitled at the same time. After all, I told myself, I must protect and keep myself and the baby away from any harm.

Jack's shipping contracts kept him working late. My work was only this: prepare outside world and provide inside womb.

When I felt the movements inside, I was overcome with warmth and what I guessed to be a sort of love, despite having only a blind introduction to this being.

Yet when the baby was quiet and my hours filled only with reading or studying which direction I had chosen for the bassinet or washbasin, I felt a slow trickle of disappointment. As though the years of my life leading up to now had been only for this reason—

and yet a marble-sized round of doubt appeared in my pocket. Was this all?

I journeyed to Julia's house, stopping for Harriet along the way, the entire outing delayed due to my having to convince Harriet to come out of her own sequester.

Yet Harriet had thought to bring a pull toy for older brother Joseph Randolph, and I was both impressed by her thoughtfulness and annoyed at my own lack of knowledge of how the world of mothering functioned.

Harriet climbed another stair. "Do tell me you will visit me on my Day Ten."

I gave her a look of acknowledgment. "Of course—but if you have this desire now and have yet to be cloistered away with only lukewarm tea for company, you need not ask why we've come to visit." I stopped on the landing, met by Julia's housemaid. "At last, we might see her."

JULIA, PROPPED on a veritable raft of pillows, sat upright in the large bed and seemed well rested after her convalescence.

"We've had a bit of a trial," she began once we had said our hellos. "Permelia's gone," she said, and when Harriet and I looked blank, she continued. "John's wet nurse. She started right away but—oh, disaster—her own baby hadn't enough. Such an appetite John has." She looked across the room at the nurse now feeding John. "Fidelia is her sister—lucky us. And she has plenty of milk." Julia slipped back onto the pillow cloud and arranged the laces on her dressing gown.

I studied the scene the way one might a list of French vocabulary, memorizing for a future exam: positions, how the nurse held the baby, how Julia's robe—made of silk—slipped off her shoulders, and how cotton, especially in summer, might fare better.

"Nearly done," Fidelia said, her chest full, the baby propped on her equally full arms.

I could not imagine such closeness as that of mother and child,

and yet here was a clever substitute with her breast fitted into John's mouth. My own baby slipped and turned in me as though vying for a better view.

"Imagine," I said to no one in particular, "having to decide between one's job and the sustenance of one's own child. How impossible a decision."

Harriet pursed her lips and tugged the blankets up to busy herself, while Julia sipped tea and shook her head. I would never learn to keep quiet. I wondered if this would eventually cost me their friendship. Fidelia's face betrayed signs of having heard.

Julia's nursery was cream walls, billowy drapes that rippled to the floor in silk puddles, a plump chair in the corner, a rocking horse with fine hair and green glass eyes, a waist-high wooden bureau bedecked with stacks of cotton flannel nappies and a porcelain bowl of pins.

Julia sat, waiting for her baby, and I stood, still now, a trainee at her side.

Fidelia unlatched the baby, mopped up his milky mouth, wrapped him in a layer of cotton muslin, and presented him back to Julia as though he were a crown on a velvet pillow.

My mouth opened, and before I had control I said, "What are the chances of motherhood being enough for me?" I looked out the window and imagined the Boston beyond, the ocean beyond that, whole continents I had yet to explore as though they were drying up, curling into themselves in a useless state like browned ferns.

"Dear girl, your blood is certainly turning with your condition," Julia said. And then when Baby John reached his tiny hand to her face, she softened. "Just wait—you'll see in time."

Harriet smiled. "And not long, from the looks of it."

Both friends looked to my body, my belly overwhelmed; to be a woman was to be at least mildly uncomfortable almost all the time. I looked at my two friends. I imitated Julia and Harriet's displays of serenity, but found the work of hiding my actual feelings all the time was real effort. Never mind the weight of a bustle or hoop skirt—or a man on top of you.

Julia held one hand with another as though bracing herself. Har-

riet held her own arms. It was as though all of us were trying to be happy, content, satisfied with exactly this moment, our female grace and gentility. But I felt a tiny pinprick of raucousness. "Do you not feel the desire to shred all of this—" and here I waved my hands over my awkward dress, unruly body, "off and ride the waves in a boat somewhere with a rolled cigarette and a drink?"

Harriet and Julia looked at each other and then at me.

Julia chewed her lip as she had always done to hide her revulsion. She caught herself. "I suspect your blood is filled with foreign bodies—and that you are having a boy. Isn't that what they say? If you dream of lilies it's a girl and boats it's a boy?"

"I'm not dreaming!" I said, and I meant to say it forcefully, for I meant what I'd said—that part of me wished to run off and ride a camel in a desert or become a sailor and find an undiscovered island. Only, I was marooned in my own dress. I could barely get up from a chair these days.

Harriet tried to redirect the conversation toward something more acceptable: her son. She told news of Joseph Peabody, now two, and of the name she might give to the baby she now grew—William—were he to be a boy. I had no tale to tell save for the books I had read and my growing unease, so instead I said, "You know, Mr. Lyman sent an article from the Harvard Zoological Society— and there seems to be consensus that the male seahorse delivers the babies." I paused. "Isn't nature funny?" I drew a long breath. "Some mothers can be quite . . . indifferent. Do you think human mothers are the same?"

Harriet came to my side and put her firm hand on my shoulder. "Are you worried you won't adore your child? Belle—you will. You will! I assure you—it just happens."

But I did not worry about that exactly. I tried to explain. "More that I . . . that I might not be enough for this baby. And, in truth, that the baby might not be enough for me."

Julia smiled, distracted by her boy. Then she looked up at me: an expression I had seen before from her, from Jack, from Harriet—even from my own parents. An expression that pitied me as though I pur-

posefully made life harder on myself by asking questions or saying things others might feel but kept hidden.

Julia propped the baby up on her shoulder and then offered him to me. "Do you enjoy speaking to these . . . people? The gardener, the zookeeper? Reading articles? Sometimes," Julia said, and looked to Harriet for support, "I fear your brain is wasted in your female body."

15

As I waited for the midwife, twinges coming at irregular intervals, I tried to recall passages from *The Mother at Home; or Principles of Maternal Duty*, which I had studied as though it would tell me whom I might become, but found I could not. I arranged my legs this way and that, the great hump of my belly protruding under my chemise, breasts threatening to pop out the front flap; I was a human circus, nearly laughable were I not so isolated. I waited, as I felt I had been waiting much of my life.

NESSA WAS Irish. "I came a few years back," she said, as she organized my limbs, my knees, had me sit straight-backed in front of her so she might begin the braiding. "After The Great Hunger?"

"Yeah." As pain ripped through my body, Nessa filled the air with words to overlap with moans over which I had no control. "Wouldn't you know, I've delivered triplets at sea and more twins than I can count, a singleton so large we had to cut him out—not that you need worry about that, small thing that you are. Your babies are often the size that your mum made—did you know that? Dr. Crumpler told me that. I studied under Crumpler—you know her? She was a nurse in our section of the city but she's in medical school now. She'll be a doctor soon."

I shook my head. I'd been kept in the dark about so much, even information about my own body and its processes. I half wanted to shout my annoyance to Jack, but he was at his club, awaiting word.

"She's Black. And a woman. Guess how many men wanted to listen to her? None." She emphasized *woman*, and I held on to the word as the pain subsided. "Dr. Rebecca Lee Crumpler. The first of our kind to be a physician." Nessa looked at me closely. "She's got big plans—aims to write a book." Nessa sounded proud. "She even told me the title! *Book of Medical Discourses*. Medical advice for women and families. I should think everyone will want a copy one day." She looked at me again, checking my face for pain. "Always and forever I'll carry it with me—once she finished it, of course. And you ought you have a copy of your own now that you've got a babe on the way! Guess you'll have to wait like the rest of us, though." Nessa studied my face and I winced. "Soon as she graduates, Dr. Crumpler's heading to Virginia to help down there." Nessa took in a deep breath, showing me with her hands that I should follow suit. "But oh, didn't she live on Joy Street nearby to here? And isn't that what she brought?"

I thought about Joy Street. True that it was close to here, but it was another world entirely with its African Meeting House. I thought of Dr. Crumpler, grateful, as my contraction abated, Nessa now focused on making a dead-center part on my head, braiding two long plaits taut away from my face lest the hair become a matting of tangles.

I must have flinched, because she pulled me back in line. "I've seen it before, I tell you. Hair gets knotted round a baby's toe—goes black with rot. That's that. Keep still while I finish, lest your own lil'un find herself with a toe tourniquet."

"It's enough to make one switch styles quite radically," I said.

Nessa shook off my concern. "We mustn't grow overly anxious— that harms the baby, too."

I let out a sigh so deep it rattled my chest. "Too much worry, not enough worry, long hair, sour foods, a dark room, months of doing absolutely nothing—the weight of the world is on the mother." I sighed again.

"Indeed," she said, and twisted the last of my braids in a point, securing them together at the back. "And all this before the baby's born." She paused, eyed the slow trickle coming from the sheets. "Let's get you to the tea voider—no, don't blush, that's your body doing what it has to do."

She dragged the towel horse closer to the bed and arranged sheets on it that would have billowed in the June breeze had we been allowed fresh air in the room. I looked to the window, where magnolias tumbled in the mild air, longing clearly on my face as Nessa shook her head and responded with one word: "Germs."

I nodded but felt deprived again.

"Your family physician . . . Dr. Bigelow? He mentioned chloroform," Nessa said, her strong arms lifting our heavy stoneware jug to the washbasin.

"He relayed the idea," I said, my heart pounding. The pains were pressing now, tightening as though the world gripped me and would not let go. Who needed a ribbon basket when one could be tortured perfectly well naturally? "On a cloth, he said?"

I gasped. Nessa did not react. "A few drops'll do, if you like," she said.

"I don't know . . ." My words were cut by a grunt escaping my mouth, for which I promptly apologized, and my *sorry sorry sorry* made Nessa laugh.

"No room for sorry here," she said. "More where that came from, I suspect." She plumped the pillows behind me. "I haven't taken it myself. Makes the women quite . . . relaxed."

"And that is not desired?" I asked, wishing for nothing more than to feel relaxed or, at the very least, that great barriers might press me from either side to keep me from splitting down the middle.

"Well," Nessa said. "Here's what Dr. Crumpler taught me about drug-induced relaxing. It's a bit . . . inconvenient. Men say relaxing, but that's not the truth of it. If you're comatose, you see, won't be of help to push when the time comes. Might I be so bold as to suggest you skip?"

Finally, something that made sense. "Thank the world for Dr. Crumpler's wisdom."

Harriet had told me to skip sour foods. My mother-in-law refused me port. Jack admonished me for wishing to ride. Strangers glared if I walked too quickly or leaned to smell the hyacinths growing in the garden, as though the mere scent would infect the baby. Everyone had a say about how I was to sit, to sleep, to eat, and what to do with my days. Even Julia begged me to cease singing, as it might disturb the baby. And yet no one had told me what to expect on the day itself: the details, pain, bodily happenings.

I had completed my lying-in, and now, even in the midst of searing pain, I wanted out. "I think I should like to leave." My words came in a rush. "I should wish to be outside. Or, now that I—" I sucked in air, "think of it, I wish to be finished with this entire mess. This is not for me."

Nessa gripped my shoulders and stared into my eyes. "Not an option at this stage."

"Is this everyone's procedure? We might all be forced to stay in bed?" I tried to fill my lungs to capacity and think of a calming situation. A view. I imagined greenhouses. Riding near the water. That early promise of Italy, Venetian gondolas and the painted ceilings of Florence.

"No, ma'am, not everyone performs like this." She washed her hands again, drying them on the first of a stack of clean cloths. "Dr. Crumpler suggests a chair."

I sat up. "A chair?"

"The other classes find it helpful," she looked at me, "for traction." It was as though she had said an elephant's trunk. She explained. "The pressure up through here . . ." she gestured to my womb, "might be better with leverage. Upright. See?"

I tried sitting farther up, propped on a pillow. It did not help.

"If you don't mind," I said, trying to find my voice, which I suddenly felt I had packed away months ago, "I believe I shall try it Dr. Crumpler's way."

"Not her way." She laughed and rolled her sleeves. "Your way. And this will be a success." She looked to the window as she brought

over the straight-backed chair from the corner and set about cleaning it. "Never have I lost a woman."

I shivered. She had lost babies, then, but I took heart knowing her record was better than could be expected.

All Julia had told me was that birth was an odd before and after—a slipping into chloroformed sleep that resulted in a day's passing and a baby by one's side. I did not sleep as Dr. Bigelow had wanted. Instead, I was present as per Dr. Crumpler's suggestion. And true as Julia had described, I went into that room as one person, and as I screamed, tendons taut, calves aching, as I clenched the sides of the chair, I knew I would emerge as someone else.

17

H<small>AD ANYONE</small> made an effort to inform me of the sheer pleasure experienced when pushing one's own child on a warm—but not too warm—morning, I would not have believed them.

For despite all of my desires to become pregnant, to make a family with Jack, I had not given much thought to what one might actually *do* as a family, and yet here we were; our family and Julia's and Harriet's all out walking, faces protected by bonnets, babies swaddled in prams, both Harriet's little Joseph Peabody and Julia's little Joseph Randolph a ways ahead with their newly found running skills.

Harriet pushed William Amory. I pushed John Lowell. Julia pushed John Gardner.

"Imagine all of them as cousins," I said. What swept me up most of all was more than having my own little Jackie. I puzzled over how to express it. "This feels," I began but had to stop to work out what I meant. "Usual."

It was the only word I could find, and yet it was not enough. Finally, I felt a part of a larger circle. Not only a girl, not only a fiancée or wife. Not a lonely socialite.

"We make quite a group," my brother-in-law Joseph said, and I nodded so hard I thought my slim neck might break.

"Indeed." I felt his words throughout my body, as though my

friends and I and our respective children and husbands were all a quilt, tightly sewn and planned and kept forever.

Jack leaned into the pram now and again to check four-month-old Jackie was awake or sleeping or warm enough or had air enough, the simple tasks of parenthood one found came rather quickly despite no prior job experience.

Joseph Gardner, Jack Gardner, and Joseph Coolidge kept eyes on the older boys and discussed Jack's ships and expansion to railways. I caught up to Harriet and Julia and, though the prams were wide, we managed to walk shoulder to shoulder as a threesome away from the Boston Aquarial and Zoological Gardens and back toward our homes.

The visit to the aquarial center had been one to which I looked forward, and yet it had fallen short. Of course I felt pleased with my companions, yet the image I had in mind of the place itself was rather like Lyman's Harvard, perhaps livelier. Instead, water squirmed with eels, a captive beluga whale appeared so miserable I thought of breaking the glass and freeing him, though he would have perished on the marble floor.

"Even the trained bears dampened the mood," I said to Julia. She seemed nonplussed. "Do you not find animals in captivity rather sickening?"

The Sphinx, a main attraction, had been a man with a tail standing upright on a horse forced into gold and ornate brocade. "I haven't thought of them," Julia said.

"I suppose it's fun for the children," Harriet offered.

I did not agree and yet did not wish to spoil the outing by being anything other than agreeable. "If ever I should have a public place," I said, focusing only on the positive, "I should think it would be tranquil and full of great beauty."

Harriet turned to me as if seeing me anew. "What would it be like, this place of yours?"

I thought a moment. Back to my father-in-law's gardens. Back to my first time in Italy with my parents when I had been girl enough to hold my father's arm, to lean into my mother's neck in the evening as the sun sank over the canal. "I would want it to somehow express

what I see in my mind. The grandeur of Venice, the magic of gardens everywhere . . ." My words drifted off.

"No tamed bears, then?" Jack nudged his way to my side.

"Surely not," I said, and reeled in any further dreams of such a fantasy.

We walked on, arriving to our neighborhood, which welcomed us with petals and sunshine slipping. Soon it would be autumn, and then Jackie's first winter.

John Gardner Sr. had purchased an entire block of Marlborough Street, and we walked past those houses. Brahmins would own all of that landscape, the next generations deeded an entire city simply by being born.

"Who might rent, do you think?" Harriet asked.

"A family wishing for a bowfront," I said, distracted by Jackie's small cry, my unease vanishing when he settled back into his drowsy state.

"Mind that stick," Julia said, wary of the stray branches the boys had collected.

"Jackie will be running with them before we've caught our breaths," I said to Harriet. "Maybe this winter we can have a large sleighing party." Julia stopped for a moment. I recalled my jealousy of her grace, her jealousy of my banter in Lyman's sleigh so long ago. "Harriet, you could be at the helm."

Harriet nodded, an easy smile on her face. "I should like that."

Julia smiled, approving. I allowed myself that same ease. Mild temperature, shade enough and sun enough, syruped ice shavings still fresh in my mind.

We arrived first at 152 Beacon and just in time, as Jackie had woken and cried from hunger. Down the path I had designed, magnolia tree in bloom, baby in a navy pram that bounced on the brick with its white wheels and elegant shape.

I bade farewell to my friends and felt my cheeks ache with happiness as I lifted Jackie inside.

· · ·

BLOCKS CARVED with letters stretched across the nursery floor. Autumn and winter had finished, spring again. The verdigris walls made the room feel as though we had stumbled upon a private forest, mossy and tranquil. I'd had to fight for that color, inspired by the dresses we had worn to Green Hill. The painters had used a biscuit color and scratched their heads when I complained and made them repaint it. Why all the hushed tones for babies? Why only pale stone or rose or liquid gray? Julia might be content with her clotted-cream walls, but I wanted my child to be surrounded by vigor, by sky and green.

"This is the letter *T*," I told year-old Jackie. I had gone through the other letters, rhyming and allowing him to hold, drop, or chew on the blocks, amusing him with a singsong voice.

When he tired of this, I picked him up and realized that if I were bored with blocks, so might he be.

"Come with me," I told him, though he did not yet have many words. Garbled sounds came, and sometimes I was rewarded with *Mama* or something that sounded such.

"This is the towel horse, made of mahogany." I let him touch and tap the wood, then moved on about the house. "This is a painting I bought when I was a very young girl. In Paris. You will see Paris one day, Jackie Boy. And eat escargot. Snails." He dribbled and laughed. "Sounds like a silly thing, doesn't it? And here is the platter on which we serve goose. And that . . ." I put the large silver serving spoon in his hand. "That is how we serve green peas. Which are an entirely other color than the green of your walls. Isn't it funny to have so many shades of one color?"

A throat cleared, and I turned to see Jack, amused, in the doorway. "This is not the nursery."

"Correct!" I said. "This is the dining room. And this is the sideboard."

Jack looked perplexed. "Is the nursery suite not room enough?"

"I read that even infants must be exposed to delightful objects— shown attractive things. Beneficial to temperament to hear pleasant names."

"What do you wish to be called?" I cooed to my boy, who held and mouthed a small silver cup.

And Jack approached. "Yes, young Jack, what will we call you when you're a fine man such as myself?"

I kissed my husband's slackening cheek. "Jackie? Will you still be Jackie then? Or mature, Jack. Or John?"

Jack slipped his arm around my waist and pulled both of us in for an embrace, smiles taking over all three of our faces. "And you, Belle, what shall we call you?"

I looked around the chandelier-dappled room, everything evening golden and coated and full of such pleasing objects and people. I thought of the nickname Mr. Valentine had given me in the Public Garden. "Perhaps I shall be Mrs. Jack."

This seemed to make him happy and, as I was the direct cause of his happiness, made me happy, too.

18

GREEN HILL in the flush of spring radiated glory. Suited for riding, I had left Jackie with his grandparents and aunts and gone to explore the Easter flowers, lilies of the valley up and blooming, their white bonnets tucked under as though they had secrets.

True, I adored the company of my group, but also it drained me, try as I did to please my friends. Besides, the opportunity to ride Sweetie proved too tempting—I wore my sealskin over-jacket on top and a skirt I'd shortened considerably, an idea I'd read about and copied, which had raised my sisters-in-law's eyebrows until I explained. The fashion served a purpose: shortened skirts meant fewer riding catastrophes, fewer tangled leads and lines.

I dismounted from my sidesaddle with the aid of the groomsman and came back into Mrs. Gardner's sitting room to find a place saved for me at the table, where Harriet and Julia sat engaged in cards.

I came just as they were discussing a party.

"He's turning three," Julia said, and had they not been playing Happy Families, a card game without numbers, I should have thought she meant her hand. But they were discussing a child's party.

"Who is turning three?" I asked.

Harriet hurried to rearrange her hand, while Julia stayed perfectly still as though if she did not move, I might not have heard.

They wanted to protect me from whatever party I had not been invited to, but their cover-up only made me feel more excluded. Besides, I already knew. Jackie and I had not received an invitation to celebrate Granville Fletcher, a stick insect of a child with a name that sounded like a medical procedure. I'd spied the hand-scripted card with pink-dipped edging that signaled a boy's party on Harriet's and Julia's desks during visits. Possibly we weren't invited because Jackie was of the younger set and our—as of now—only child, whereas both my friends had older children. More likely, we were not wanted.

"Come," Mrs. Gardner said. My mother-in-law's cakes were as famous as her husband's gardens, and she now offered a slice slathered with lemon curd. "Join us. I do hope your ride wasn't too challenging."

"A bit cold for spring," I said, and accepted my round of dealt cards.

I tried not to deflate—it was only a birthday party, after all. And here I was, legs pleasantly sore post-ride, my cheeks flushed, fingers warmed from my teacup, and a great hand of cards besides. I didn't bother complaining—yet I'd thought motherhood would open all doors for me.

Playing Happy Families had become a trend at outings—one collected complete families—Mr. and Mrs. X, Mr. and Mrs. Y, Bung the Brewer, Artichoke the Greengrocer, Chalk the Teacher, Chop the Butcher, Digg the Farmer, Level the Architect, White the Milkman, and soon one might have a whole set with one of the eleven families.

I drew Mrs. Finn, the fishmonger's wife. We played the game in the round, Harriet commenting on the cards and the weather, Julia admiring the furniture's new placement, Jack in the corner with his father, deep in discussion about the America's Cup and their investment in the yacht, which Mr. Forbes had built at George Lawley's yard—we would watch her launch, Jackie now able to stand and wave and speak a few words.

I looked at the cards in my hand: Miss Putty the Painter's Daughter and Mrs. Chip the Carpenter's Wife, wielding a hammer far too

large for her build. Was she en route to bring the hammer to her use-ful husband? Was Miss Putty with her gray pot of brushes creating art herself or simply ferrying the tools to her painter father?

"Why is it, do you think, the women in this game don't have cards of their own?" I asked.

Julia looked smug. "They do, Belle." She displayed Mrs. Stitch the Tailor's Wife.

I shook my head, feeling anger welling up in my belly. "The wife cards are only recognized for their relation to the men. What am I, Belle the Sailor's Wife?"

Jack laughed and rang an imaginary bell. "I'm only an investor in the America's Cup boats—not the actual sailor."

I rolled my eyes at his explanation. I wanted to pummel Jack's shoulder the way I'd seen men do when once as a girl in Paris I'd walked an ill-advised route back home past twin pubs and seen a brawl. Blood had splattered onto the dirt near my foot, and I had taken a tiny bit of pleasure at the minuscule dots on the hem of my skirt—too small for anyone to notice but thrillingly there for me to own, even though the fight had not been mine.

Harriet's husband Joseph tried to make peace by draping a wet wool of smugness over our hands of cards. "I think we would all do well to remember it's just a game."

I gave Harriet a look of exasperation. Jack sighed, and Julia cut me with her eyes. Wounded by her gaze, I kept on. "How might a woman be interesting and a good mother and a good wife and still be presentable?"

Harriet blushed for me, and Julia set about pouring more tea. Mrs. Gardner looked stricken but focused on her cards. The men hid behind their mustaches. My father-in-law had entered the room qui-etly while I was speaking and had listened attentively throughout my rant, and I adored him for it.

Parenting had made me sleepy, I realized. And now I was waking up, and I liked the feeling. There was a sad magic to being female, a disappearing of the self, combined with a glory that came from mak-ing everything appear easy.

No one spoke. The sound of teaspoons on saucers, the wind through the invisible window seams, the lifeless cards slipping against each other on the table.

"Is the point of my life to make everything grand for everyone else?" I asked Harriet and Julia, but really I was asking myself. Both my friends looked at me as though I had asked something in another tongue and, not understanding, patted my knee and gave me sad smiles.

It was easier for them not to address my outburst, not to consider what I was saying.

"Belle?" Julia said. Her eyebrows knit together in consternation. She pushed a plate of raspberry sponge at me, but I refused to take it. It occurred to me that my ideas were bothersome—not because they resonated with her but because they were disruptive to the very social order on which she thrived.

When still I stared at my hand, she nudged me with her knee. Her nudge was hard; she meant it to shush me, and to keep the game moving.

"Plotting your next move?" Harriet asked, looking impressed at my fortitude as though I had solved an unsolvable puzzle.

"Belle has always been caught in her own mind," Julia said.

I looked at Julia. "If I've been caught, then rest assured I'm trying to figure out how to free myself," I said, and arrayed my cards like a fan on the table. "And I am quite finished with this game." I stood up and gave my own withering glance to Julia. "I'm going back to the horses—at least they don't try to muzzle me."

"SEE," I told Jackie. "The first leaves are changing." The elms turned first, now wearing rooster's colors. I often brought him to the Public Garden, tended to by Mr. Valentine. We'd also visited Mr. Grotberg and his fountains, which would soon be empty.

"Boats?" Jackie pointed to the lagoon. In its center was a tiny island where ducks liked to nest.

"Yes, rowboats. We'll go on them when you're a bit bigger. Soon

it will be cold and icy, and the boats have to rest for the winter." We were there mere minutes before Mr. Valentine came over.

"Here we are, Master Jack," he said, and produced for him a stalk of pussy willow. "Touch 'em to your cheek. Aren't they soft?"

Jackie giggled. I ignored the looks from two women watching me interact with Mr. Valentine. This was the day of Granville Fletcher's party. I had shared my feelings about the party with Jack earlier. Rather than sympathize, he'd said, "Honestly, Belle? I find your anger at everything inappropriate and off-putting." In his office, Jack had held his pen like a magic wand, one that might transform me into someone easier. "Reuse the anger in a more productive manner."

My palms had gripped the edge of his desk as I leaned toward him. "I have never been quiet, Jack. That was your illusion. I was angry when you met me—I just didn't know it yet."

Now, in the park, I looked at the trees and at Mr. Valentine. "I adore that this is a public garden," I said, "accessible to all."

He caught my gaze. "You're more than the average woman—the average man, too. At the end of the day, you make your party, don't you?"

"You're a kind person, Mr. Valentine—and your sentiments are appreciated, if not widely held." I paused. "One day I shall have a large party—with champagne and doughnuts—and invite whomever I please."

Mr. Valentine grinned, as Jackie clapped. "I should like to be on that invite list."

"Of course you will!" I took Jackie's hand and hoisted him up into my arms, even though his carriage was nearby at the gate.

"Party?" Jackie asked.

I blushed as a question tugged at me: if motherhood, the thing I had assumed would grant me access to this land of mothers, of social beings, was not the answer, then what, exactly, was?

19

"LET 1864 be known as having been the best year of my life." Jack stood in the dining room, flute in hand, champagne sparkling on his mustache.

Julia and Harriet, their husbands, Jack's work friends, my parents and in-laws, all had dined and listened to Marianne Von Binker, whom I had invited to liven the evening: she performed arias in the music room and then joined us in the dining room to count the clock's chimes into 1865. Marianne Von Binker was a second-rate singer but a first-rate charmer.

"In four, three, two . . ." Harriet and Julia cheered together, voices full. I opened my mouth, but no words came out. Why could I not feel the same spirit? I had longed for motherhood, cherished Jackie, and yet felt a gnawing emptiness still. It was not enough. Or perhaps I wasn't enough.

A FEW hours before, we had kissed the children goodnight in the nursery upstairs. "Weren't Matron's bears charming?" Julia had recalled as we tucked them in, each with a new fur bear.

I'd explained to Harriet. "Our old school matron had a vast array of hand-stitched bears from Germany she kept on the windowsill . . .

like silent pupils." Harriet nodded as we left the nursery. "I found them odd lurking in the window back then, but don't fret. I did thank Marianne for her bear gifts tonight."

"They're in fashion," Julia said. "Don't be judgmental."

It hardly seemed a fair comment. I turned to her. "And you, Jules? I suppose I can be, but you're far from innocent in that regard." Julia didn't respond. I filled in the space. "Perhaps the singer tonight hadn't known what else to bring a child—or perhaps she collects bears herself."

"Perhaps," Harriet said, and the word seemed a gift. She was trying to put me at ease as we came down the wide staircase.

"Perhaps she brought a fashionable gift as a show of respect and grace," Julia said, smoothing the front of her dress though there weren't any wrinkles.

"Why do you think we desire particular objects?" I asked, as we had made our way to the dessert table, sugar cubes for a sweet New Year arranged in a tower. I had so many questions, so much that I longed to know. I looked to the small knobs of sugar as though they had answers.

Julia had barely heard me, so eager to head off to our party was she.

As THE evening drew to a close, Harriet approached me, placing a sugar cube dotted with candied violet on her tongue with uncharacteristic flair. Coats were gathered, carriages queuing in front. "This day, this party, these children. Oh, Belle, how thrilled you must be . . ."

Of course I was happy. Yet a slight but constant thought prickled my chest. Motherhood brought with it joy, true, but also a dulling of the self.

Jack and I watched as the last of our partygoers trickled out the door onto snow-streaked Beacon Street. We would take Jackie on his new steering sled the next day, and I did delight in imagining his laughter in the stark cold. I wanted to hold those moments of pure joy

with him, keep them like the glass globe I had seen once in Paris—always snowing, always merry.

"You have everything you wanted," I said to Jack.

"Surely this is all you've wanted, too, Belle," Jack said, weary. "You're a wonderful mother, and a delightful wife. You and Boston are growing used to each other, don't you think? You're doing a good job."

"What if I don't want that job?"

"Harriet and Julia are happy enough." Jack's face was red from drinking, his hair wild. He was not a man to raise his voice, but now he did, words booming. "Can you for one moment imagine what it's like to be me? To have a wife whom others reject?"

I stood unsure if I wanted to crumple to the floor or boom back. "I have imagined what it's like to be you: male and pale skinned and perfectly suited for society." I seethed. "It sounds wonderfully relaxing. Where do I sign up?"

Jack laughed, but it was not at my cleverness. "Why can't you just be normal?"

I did not give him the satisfaction of tears. "A question I've asked myself for twenty-four years."

THE NEXT morning I stood at the enclosed washstand in the nursery, which I'd installed in the name of progress. Dr. Bigelow had pressed upon me that we must keep hands washed. When I'd showcased the object to Jack, he marveled. "How clever you were to find it, Belle!" I'd felt a burst of pride and then paused—what had I really done that merited praise? Ordered something and had the bill sent as I'd stared out my tiny parlor window.

"See?" I told Jackie, who stood in a sailor suit and bare feet as I explained. "The maid fills the tank below, and water comes out the faucets above, and there's even a spot for soap!"

Jackie delighted in touching the spigot, the wind-chime sound of water on the brass sink.

"Time to close the lid," I told him, and he did so.

"More," he said, from his strong collection of words. He spoke in fragments, with careful elocution. "More." And then he tested a new word. "Again!"

And we did so again. We repeated the cycle of on and off, splash and dry, until I was quite sure either the contraption or my arms or my spirit would break. That was motherhood, too, tiny progress that took days, weeks, months to understand. I tried to cherish the time with him, knowing all too soon he would be running miles ahead of me in the park, then one day off to school. Another part of parenting I had found: simultaneously resenting the drudgery and longing for it not to end, knowing that when my boy no longer needed me I would be bereft. I redoubled my efforts and clung to my time with Jackie.

20

I HAD NOT left the house in six days. A storm raged outside, dumping feet of snow, blurring visibility so I see could almost nothing from the windows where I stood looking out, desperate for a reminder the outside world hadn't disappeared.

Jackie took the steps on knees and hands, eventually sliding down on his belly to the ground floor, where Jack sat poring over papers. He didn't look up when Jackie placed a block on his knee, kept reading when I kissed his cheek. We were companionable, playing with Jackie, having dinners, still sometimes joining together at night, but since New Year's I'd been waiting for Jack to notice I wasn't quite myself. Or rather, I was myself but a shrunken version, the self whittled away by motherhood.

I crouched near him, trying once again to physically counteract my prior large outbursts by shrinking my body.

"Still snowing?" Jack asked.

"I should think you know the answer to that," I said. We were not exactly trapped, though it felt so. I imagined Harriet glad for the enforced rest—newly pregnant and somewhat ill. Julia had escaped altogether, away in London for a month's time, her letters sporadic and filled with fun.

"Snow?" Jackie asked. Jack did not look up. "Snow?"

"Jack," I said, and he barely glanced up. My tone changed quickly into annoyance. "Your son is trying to find your attention."

Admonished, Jack put his work down and touched Jackie on the cheek. "Yes, snow."

"Sled again?" Jackie asked.

"No," I told them both. "It's far too much for an outing." A woman had trekked across the Common, tripped, and frozen to death right in the middle of the park. And a trio of sledders on Bill Hill upturned onto rocks. Disasters were everywhere outside, it seemed; better to stay inside by the warm fire, candles flickering on the mantle.

Jack turned away from our son again, to his papers, which had to do with his "collecting" ships. "Will you ever have enough, do you think?" I asked. "If I were a ship, would you still wish to collect me?"

Surprise rippled over his face. "I hadn't thought of it that way; it's not really collecting. It's business. Trade."

"Perhaps," I said. "But it's a collection all the same. The way you study the shape, the port history, who built it and where and with which wood. I envy that spirit."

Jack looked impressed with my thoughtfulness, until Jackie coughed. And coughed again. "Snow?" Jackie pointed to the window, but his voice was soft, feeble.

I touched his forehead. "Fever?" I asked, brow immediately furrowed.

"It's the fire," Jack said, shaking his head. His tone was dismissive. I bristled. "We ought to make sure he's warm but not hot." He set about knocking the logs into the ash, reducing the flame.

"I'll go get one of the advice books from the nursery—surely one of them must have information."

Jackie coughed again and looked up at me, eyes watery and large. I lifted him into my arms. He placed his hot cheek against my chest, and the three of us watched the snow fall, covering everything, making roads impassable with a delicate white, muting the lamps, creating a world in which we were not welcome.

. . .

SNOW CONTINUED, stopping long enough to give us hope the storm had finished, only to start again an hour later: thick wedges of ice on our front stone stairs, my precious walkway without a hint of path.

In the house, it was worse. "Twelve days inside," I told Jack, merely to make conversation over Jackie's small bed. Rather than a twin bed, I had brought in a master carpenter from Ireland, a friend of the midwife's, and instructed him to fashion a miniature bed for Jackie. Upon its completion, Jackie had giggled, testing out the fine mattress and new pillows, burrowing into the feather duvet, happy as a spring worm in new mud. Only now, spring and a happy Jackie were a world away.

Jack flicked his eyes to the snow-frosted window. "Might be the worst storm I've ever seen." Jackie coughed. We both turned back to his flushed face, the wheezing sounds from his mouth.

"We need to send for the doctor again," I told Jack. My heart pounded. I felt as though it were my lungs that ached rather than my child's. Under his duvet, Jackie slept fitfully, coughing, trying to turn, only to be defeated by his fever.

"Dr. Bigelow was just here this morning," Jack said, but did not take his eyes from our child. "Your worrying won't help him; women have such trouble with remaining calm." He looked at my frantic hands. "It's why you can't be a soldier."

I clenched my jaw. "You have no idea how strong my battle technique would be." I studied Jackie. "He looks worse." I felt panic rise in my chest. "Does he not seem worse to you, Jack?"

Jack attempted to reassure me, gripping my shoulders and staring at me full on. "He's strong. He's simply fighting a fever."

I shook my head and knelt by the small bed. Jackie's cheeks were velvet red, his eyelids an odd gray-blue, the color of rough seas. "I . . ." I could not manage words.

Before Jack could resume his appeasement, Jackie began a coughing fit, wet noises rattling his chest. I breathed in everything about my son—his hands, his red cheeks, his pleasing gaze. I promised myself: I would stop questioning everything in my life, stop blurting,

stop being anything other than perfectly satisfied, if Jackie were to improve.

Jackie coughed again, and I matched my husband's gaze. Jack flinched. He glanced outside, though snow blocked half the nursery window. "Fine. I'll send for him. I'll shepherd him myself if need be."

"Go quickly," I said. My legs stiffened in their crouched position, and I felt nausea building in my stomach. How could someone so small be so ill? After my insisting we stay home where we would be safe, the inside world had betrayed me.

21

A BOXWOOD WREATH tied with black ribbon hung on the door, a public-facing memento mori.

The mirrors were covered with black crepe.

The drapes drawn shut even as the March sun tried to rise.

The entryway clock stopped at his time of death.

Jackie's portrait was facedown on my bedside table.

It was not current practice to wear a memento for the first year of mourning. I did so regardless. In my hand I held a lock of Jackie's hair. It looked lighter in my palm than it had on his head. Softer. More fragile. How stupid I had been not to look hourly at his scalp, examine the nape of his neck, memorize his fingernails, the tiny nostrils that used to flare with pleasure when he rode the wooden horse in his room. I took the hair and wrapped one end with a pink ribbon I'd thieved from his sailor suit. I curled the lock into a brooch that opened with a gold clasp that stood out from the dark jet exterior. Jet was made from fossilized wood: exactly as hard as my insides felt, as though I were curdling from outside in, my organs themselves becoming fossils. Once I was lively. Once I was alive. Once I was alive and held my boy on my lap, pushed my lips onto the nape of his soft neck, breathed in his warmth and smell of grass, of sweat, of biscuit. Once, I was a mother.

. . .

My Truly Dearest Belle,
How might I even begin this letter except to tell you I write
this en route back to Boston. Of course we have heard, and I am
crushed not to be there for you in this dark time.
 We had expected to be back in time for the funeral—

I pushed Julia's letter aside and resumed sitting in the parlor, tea and
creamer cold, broth congealed, precious orange from one of Jack's
ships untouched on a plate, as though the objects and I were a grim
still life.
 Still Life with Fruit.
 I could barely rouse the strength to breathe.

I STOOD in the straw and muck outside the barn at Green Hill, in
front of a row of hung pheasants from the autumn's shoot: necks
limp, feathers ripe with ruby and yellow colors that mimicked the
fall leaves. Without Jackie the house seemed dimmed, every hour was
the hour just before the street lamps were lit. I had no words and no
appetite. I could not bear his nursery. I still could not bear undoing
his nursery.
 And yet the world had continued—Lee surrendered, ending the
war, Lincoln had been assassinated, slavery had been abolished, yet
the idea that one person could be worth more than another remained,
and the steamboat Sultana had exploded in the Mississippi, killing
over two thousand. We were all the pheasants—gorgeous with hope
and yet ruined.
 The feeling that I had mislaid something was ever present: not
only my grief—which I carried like a heavy beach stone in my pocket,
but another absence. Even at night when I turned over, searching
under pillows, in my bedding, I felt such gaping loss. Without Jackie,
without motherhood, what might I be?

22

AMONTH LATER, I stood surveying Harriet's shipwreck of a kitchen. Copper bowls, egg trays bumpy with blue speckled duck offerings, once starched linen cloths gone limp, a bowl of black treacle, a cane whisk leaning in a murky pool of egg white, small waxed paper parcels of East Indies spices Jack had given to me, a form of acquiescence to the baggy life we found ourselves inhabiting without our son. Piles of autumn apples from an orchard in Concord, flour in heavy sacks that had started to split, a wide-lipped bowl of small, brown eggs waiting for me to crack them.

"I knew you would be brilliant for this," Harriet cooed, swiping her hand across her face, the act of which left a flour streak like a washed-out thunderbolt.

"If you think you've succeeded in trickery, let me dash those hopes," I said. "You might have lured me out with tales of womanly woe, but you seem perfectly fine."

In a fit of pregnancy emotion, Harriet had dismissed Mrs. Annie Crumb, her cook, whom she'd brought back with her from London with the promise of running the kitchen; male chefs were in greater demand but also charged more. Now Harriet had gone and sacked Mrs. Crumb instead of giving her the day off.

"I hope for your sake Mrs. Crumb will understand your state and come back."

"I've had the morbs," Harriet explained of her pregnancy misery. "And she overstepped the mark, Belle. I'm surprised you couldn't hear from your house. A real collieshangie."

"Perhaps she was trying to protect you—from yourself?" I asked.

"I don't know. She's household help, Belle. Not one of us." Her voice was kind but exasperated—and she did not comprehend her own error.

I tried again. "The more I think of it, Harriet, servant life is female life." Harriet furrowed her floury brow. "Promise me you'll get her back and give her a raise."

"She's paid well."

"As well as a man in her position?" I asked. Harriet flinched.

"Fine," she said. "I'll do as dear Belle wishes. Now let's get on with our project . . . not that I fathom in the slightest how hot-water crust might come together in time for dinner. Or how a light crumb forms from such a slop of butter."

"Read the ingredients. I'll measure."

My desire for order, for making something from the scraps of her fallen dough, brought me out of my seasons-long mourning and into the small confines of her yellow-walled kitchen, where Harriet had informed me were baking both apple pie and another dessert, a tiny cake she seemed excited about. Truth be told, neither she nor I could recall when—if ever—we had amassed so much flour on our hands and sticky molasses on our fingers, yet I felt the tiniest glimmer of smile slip onto my lips as Harriet brushed her hair back from her forehead.

"You've gone gray a bit early," I told her.

"Ha—then you shall have to help me wash my hair when the pie is baking. I can't reach the basin myself." Her belly—hidden under piles of fabric—protruded such that she could not reach the table either. "Take these."

She pushed a pile of finger-sized porcelain dolls at me. I stared. "What on earth?"

Harriet beamed. "Frozen Charlottes. They're all the rage—cake decorations based on that poem? You know, the one about a girl who freezes to dea—" She caught herself. "Sorry. They're really quite popular."

"All the rage for lunatics," I laughed, grateful I remembered how.

"Honestly, Belle!" She flicked bits of flour at me, and I ducked.

"You're decorating with corpses. I will never understand society."

"You don't have to understand it," Harriet said. "Eat enough sugar and everything seems fine."

I sighed. "The sugar thrill is temporary, is it not?"

We would top the cupcakes with the strange, morbid dolls, and then they'd be chucked into the trash heap along with many other household goods. Harriet pointed to the bowl of eggs. "Now back to work with you."

I shook my head, but good-naturedly. "Am I an employee?"

"You could do worse," she said. "Now a pinch of salt."

I pinched and added. I had been round more and more, helping her get ready for her next baby. "There," I said, satisfied when the dough held together.

"It's called a cupcake," she said. "I suppose that means one must bake it in a cup."

"Whoever has heard of such a thing?" I asked, pulling the book toward me so I could read for myself. "She writes here that we might put bricks in the stove."

"What on earth for?"

I scanned the pages. "Use the bricks *to temper heat at the bottom*. Listen, you finish rolling—if you can reach. Then add the currants and molasses. I shall return—with a brick or two!"

I left my dear, flour-covered friend and went out Harriet's front door. Round the side of the house, I ducked—dress flapping in the bitter late October wind—until I reached the back alley. Sure enough, tucked against the corner near a few old barrels were cast-aside bricks. I reentered Harriet's warm room to find her crafting vines from dough. She skillfully wove stem over stem, clever with leaves that formed an intricate pattern.

"Harriet, you have skills we knew nothing about!" I said. "You're a regular Eliza Leslie!" Harriet grinned, though Smith had an entirely different upbringing from Harriet's. Leslie had been born to a mother who ran boarding houses, and had risen to cooking fame. "Do you know she's sold nearly two hundred thousand copies of her book?" I held the copy of *Seventy-Five Receipts for Pastry, Cakes, and Sweetmeats* as I continued, hearing my own wondering aloud for the first time in ages. "What do you think we all have in us that we'll never know unless we're dropped into a kitchen, or pub, a factory or harbor or all-male university?"

"There's my Belle," Harriet said, and gave me a full smile. "I knew you were in there somewhere." She paused. "All this time I believe I tried to help you by changing you—and it turns out I prefer the real Isabella to my vision."

I added a leaf to her pastry vine as I nodded. I imagined my body as a map. All along it had been accepted that the map was one page, and yet I knew—really, truly understood—there was more to me all folded and creased. When would those pages unfold? What lands or treasure lay flat and printed, waiting to be discovered? I imagined someone finding me and sticking a claiming flag in my thigh or uncharted territory. Then, with a breath so sharp I winced, I realized I was the explorer. The only one to unfold the pages would be me.

"I see you did not require my help so much as you thought," I told her.

She smiled at her creation. "Perhaps," she said, "I might be good for something after all. I ask you over to help you and you wind up helping me, Belle. You really are an inspiration." I took her floury hand and loved her for that.

HUSTLE. RUN. Quick. Each footstep on the cold sidewalk brought another hastened word to mind. Harriet had called for me again— she was two weeks early in labor and her husband still on his way from New York, hours and hours away by coach. I bolted from the

house in only a shawl, November air seeping into my skin through my layers as I approached her house.

All the excitement of my own labor seemed a distant memory, remote as one of the islands I'd read about in the Harvard archives. And now I would only see the efforts with Nessa, her stories of Dr. Crumpler, my own body's triumph as leading to nothing. I wished to remember my years with Jackie fondly—oh, to bring back a dappled afternoon in the park without shoving such thoughts away as though death lurked at the edges of each memory.

Yet, when Harriet, in bed before me, reached for my hand, I reclaimed each heartbeat of desire, each breathless push.

"How grateful I am for you," she said, legs splayed in her bed, though every inch of her was covered with sheet and blankets.

"Are you not roasting?" I asked.

"She's not a pheasant," the midwife said.

I turned to her. "I have it on good authority that a bit of fresh air is actually rather important for the delivery." When she looked skeptical, I whispered the dreaded word. "Germs!"

The midwife opened the window a crack, and Harriet thanked me. She continued looking at me longer than was normal.

"May I bring you something?" I asked.

She grunted and shook her head. "No. Only . . ."

"Anything, dear friend."

"You have a look," she started, but then a contraction seized her, and she halted her breath. She looked terribly pained, and I wished I could relieve her of it.

"I'll ring for the doctor," I said. Concern mounted in my stomach, rattling my chest with a familiar sense of dread.

Harriet breathed again, shaking. "Yes. Do." She paused and stared again. "Perhaps have him examine you, too."

Her words rippled over me with the suddenness of a downpour: of course. I hadn't eaten. I had slept in the middle of the day. My shoes felt uncomfortable.

Again.

I had fallen pregnant without effort, without it consuming me. A

ball of delightful warmth radiated from my chest. Hope, in its brilliant and unlikely air-balloon bubble, rose inside me as I went to call for Dr. Bigelow.

AUGUSTUS PEABODY Gardner.

Augustus Peabody Gardner.

Augustus Peabody Gardner.

I said his name three times, as he was Harriet's third and final son.

Her final anything.

I said his name as though he—with his tiny fists—might fight for her and bring her back into the world.

The delivery had come swiftly and taken Harriet with it, leaving Joseph with three young boys.

Every bit of despair came back, flooding my house, tides of grief rising daily. My own pregnancy—confirmed and already a few months along—proved a life raft of sorts. Yet only just. The doctor had worried I might rupture fully, and he cautioned this would be my last.

Most days I sat in my small parlor, ignoring news of the world, the headlines of hope and horror, thinking of Harriet's boys: young Joe with his determined brow, little William Amory with his quiet, singsong voice, baby Augustus, who would never meet his mother, never hear her carbonated laugh. The grief was nearly paralyzing.

And yet I could not leave Joseph alone too long. We shared the loss of Harriet. Of course, I did not compare our griefs—his wife, his children's mother. But oh, my friend. And I knew how rare it was to find one in the vastness of the world, a slender stalk in the garden of society's cruelty, her face forever a daffodil, all joy and possibility, our friendship's floriography lost forever. That was the truth; anything we'd shared was now housed only in my mind. I tried for the sake of the life growing in me to think of the daffodils, the cheer, the crocuses that would appear again in spring but found myself weighted in November, its blank days and frigid edges.

I touched the jet brooch I wore daily as though I might feel Jackie's hair through the hard shell.

"Go to Joseph," Jack had pleaded with me that morning. He had tried to comfort his brother but wound up standing by the fireside in silence or red-faced from too many drinks.

Out I went. Slowly now, on the path I had designed those years before. Careful, past the leafless magnolia. Plodding toward the Public Garden—bedecked in winter's glory, holly sprigs and poinsettias flourishing in the cold, cyclamen in hefty pots near the dry fountain. I walked. And walked.

I would help Joseph and bring new life back to my house; color would come back as it had come to the snowy garden. I stood looking at the poinsettia leaves, relishing their brightness, even in the snow. There was hope in flowers.

"Ma'am?" Mr. Valentine's voice startled me.

I bid him good day, but he did not move. Instead, he moved toward me and then stopped. His face looked pained. He stared at the ground between us as though embarrassed, his cheeks a shade lighter than the plants. I followed his gaze to the snow, only to find that where there had moment before been bright white, there now were red blooms.

Blooms growing and spreading on the early snow.

I doubled over, understanding then that I was the plant, the red, the blood.

He yelled for help as I crumpled to the ground.

My first twenty-five years done. The gardens would continue to grow, despite Boston's misery of sleet and wind, the last of 1865 ducking down as though humiliated for remaining in bloom. If I had no reserved place in society and now—according to the expertise of Dr. Bigelow—should never prove to be a mother, what was left for me?

"They're coming for you, Mrs. Jack," Mr. Valentine said. "Not to worry. You stay strong."

The vacant garden landscape was made of only gray, black, brown, and startling cardinal red. My very insides had ruptured as though turning my body inside out. I wished for Harriet. I wished for Jack-

ie's small hand in mine. I thought of the books I'd held on my lap for solace and curled up strangely on the snow as though my entire being was a question mark.

What now?

Mr. Valentine's face fell and tightened as he saw my pain, my sadness as infinite as the fountain spraying the memory of water.

"You'll be okay. Won't you, Mrs. Jack?"

Intermezzo I

AFTER I am gone, keep everything the same. Keep my brooch with his hair. Keep Childe Hassam's *A New York Blizzard*, 1890. New York or Boston, that painted blizzard is always in me. Keep the creamware *Mother and Children Figure Group* and imagine they are at Green Hill. Or the Public Garden. You may imagine what you like, but the figurine will always be in the Little Salon, exactly as I placed it in the gold and glass shelf where it cannot escape. The harp is silent now, but surely you recall when those notes of welcome sounded. Grounded and quiet, too, yet in full view on the mantle, are a seagull and a bluebird. They will never fly. The *Norwegian Spoon* I sometimes placed in my mouth, my tongue touching the metal that carried porridge to his mouth before his teeth came in. Keep the *Double-Ended Perfume Bottle* just where I left it. But do not touch. Do not disturb the last drops of my friend's scent contained within: so painful, so necessary to me.

That is the beauty of my accumulation and my directives. I gather. I decide.

Madonna and Child in the Chinese Loggia at Fenway Court, 1919. Thomas E. Marr & Son made the picture of the statue I placed in the courtyard, art made of other art, rather like a matryoshka. If only Zorn were here to paint the photograph of the statue, and then

Nadar from his Paris studio (oh, to go back to that party now) to photograph that! A Möbius strip of mother and child and art.

Witness: Rossellino's *Virgin and Child* and Rossellino's imitator's *Virgin and Child*. Why not have both? Imitation is still art. Imitation of loss is still loss. Imagination of loss is still loss. We capture in stone or on canvas such deep desires or devastations so as not to forget them.

Aren't we humans odd that way—decorating like the cave painters at Font-de-Gaume, forever keen to have flowers and fruit in a still life that becomes a still life again in our home. We keep cherished photographs as though we are determined not only to have the moment frozen but to remind ourselves of the pain. Continuous, stinging or bloody pain at time's haste, the inability to live backward.

You will call me foolish, tell me photographs are pleasure. And I don't fully disagree with you. But I mean to tell you this: hold one in your hand—it is your child, your wedding, your parents' house. All gone. We think we are capturing and preserving pleasure, but in truth we are only memorializing something ended.

You will understand or forgive my dictum: nothing moves. Don't you see?

I get to say, at least here.

Here where Sargent's *Spanish Madonna* defies its frame, serene and composed as though the edges of the piece will never get to her. She has taken control. Sargent had yet to paint me then, but see how this piece is the first whisper of my portrait—stunningly controversial, they said.

It won't be shown until after I am gone; I owe Jack that kindness.

And here, see Bellini's Venice work; oh, for those Venetian nights and that second portrait of me. I loved myself through Zorn's eyes, as though I were the fireworks.

Here is *The Virgin with the Sleeping Child on a Parapet*, 1470–1475. Four hundred years before I held Jackie, and yet there we are together.

See my face, bloated with doubt? How ruined I am, even with the golden hues and blue sky. The child is not sleeping. We know this.

So keep it where I mount it, tempera on poplar panel, in the cor-

ner atop a mirrored table: the focal point. A spotlight of loss shining out as though I am beckoning you, daring you, to count how many such images are contained in one building. Have you noticed?

Wander, take a tour of my lingering losses. Do you feel his weight on your lap? Allowing my words to reach you or him somewhere is my own kind of faith. Count. Do it. Do as I say and tally up the Madonna and Child pieces. Write down the number on a slip of paper and burn it to ash.

How many? Do you see his face, the smile I found in myself while holding him? Here is another. And still another. Say these words aloud: Madonna and Child, mother and child, mother and child, mother and child, mother and child mother and child.

BOOK TWO

❀

Mrs. Jack

1866 — 1875

I

"D ID SHE take her tea?" Julia asked.

"Hardly. Sips, perhaps," Jack said, his voice hushed against his hand.

"Not even one shirred egg for Mrs. Jack." As she did nearly every day, the maid shook her head at my breakfast tray, a still life of toast and soft egg uneaten, to my friend and my husband as I lay perfectly still in bed, one eye closed, the other collecting evidence of my visitors.

Oh, the visits I truly longed for: Jackie's unsteady steps over to the bed, his hands reaching for me, calling *Mummy Mummy Mummy*, the most delicious of sounds. Those words I would have consumed. And Harriet's quiet boots on the rug, the air around her laced with cardamom and lime, her face a bouquet of daffodils; all she need do was catch my gaze, and I would feel at once comforted.

Julia—dear, sweet Julia. Dutifully she visited. But the living cannot deliver what the dead have taken from us.

Jack sighed, sent the maid away, and continued to talk with Julia, whose dresses rustled as she came to sit by me.

"Belle."

I did not respond. The name was foreign now.

Julia removed her gloves and touched her warm hand to my cheek,

forcing me to look at her. First she looked stern, older. Then she grew teary. "Please—say something to me. Anything."

I opened my mouth. I had little to say these days but tried, if only to protect my friend.

"*The Ninth Wave*," I said finally, my voice as wilted as the plants on my balcony.

Julia's face muddled. "I'm quite sure I don't—"

"Ivan Aivazovsky." The name came out a whisper, but I went on, my eyes roaming my room. "We viewed his work on our honeymoon. A Russian. Marine works. Jack liked the boats . . ." I drifted, thinking of Jack holding Jackie's shoulders, his hands gripping a wooden boat we would set into the pond at Green Hill.

Julia pressed me. "Go on."

"Oh, it's a lovely work. Romantic in nature—and that light." I closed my eyes, thinking of it, of the people we'd been when we saw the painting. "Dark waves, probably a terrible storm. But light . . ."

Julia, overenthused, broke in. "Light in the distance—see? Yes, just as it should be, dear." Her tone smothered me. Were she to lie down next to me and sob or say nothing I would have felt understood, but as she insisted on cheer, I buckled, leaning further into the bed. "You see? There's always—"

I pushed her away.

"Oh, Julia. *The Ninth Wave* isn't hopeful. Rather, it's an expression that sailors use when—even after wave upon wave of misery, giant waves—another, worse one appears. The largest wave imaginable."

Julia seemed to shrink next to me. "Oh."

After a few minutes of quiet, she went to touch my face again, but thought better of it and departed without fuss.

Oh, those shipwrecked painted people, clinging to debris as though they might be saved. How little Jack and I knew of our lives to come at that exhibit on our honeymoon, the two of us gay and light-filled, nearly mocking the dark art. Those waves tossing, nature thrashing upon itself. In the center, an upturned skiff, a lone seaman clinging to the remains of what had been something whole and flooding.

This now was my bed.

Finest horsehair mattress, new metal coils underneath, linens ironed crisp. Daylight shifting into the room at a slant with the morning light, then brilliant noon, dim again by five.

All the while I had not moved.

How safe to feel confined within the bedframe as one might within a framed canvas. Was I not protecting the rest of the house, the streets of Boston, the greater world, from my own sorrow? How muted and comforting this idea of not leaking one's misfortune onto the walls or floor.

I dreamed of Harriet's children: Joe soldiering on perfecting his alphabet by writing letters to his mother who would never read them, quiet William Amory with his rosebud mouth and the small pats he'd given me when Joseph had roused the boys up the stairs to my bedside, baby Augustus asleep in his father's arms. Joseph had offered him to me—a small parcel of breath—to hold as I sat unmoving, but I could not bear the weight of him.

"MY CONCERN for you is growing," my husband said from the doorway.

Jack slumped with the weight of work and further with the look I knew now as disappointment. Another day in which he returned from work to find I had not ventured farther than the chamber pot in the next room. My shipwrecked life existed only in this room with this gray duvet cover and four damask silver and lavender walls, my own limbs pale and foreign as though borrowed from another creature.

He had read aloud to me from the book Dr. Bigelow had placed on the black marble mantle, *Beach's Family Physician and Home Guide for the Treatment of the Diseases of Men, Women and Children.* Jack used soothing tones one might use for a child or for an animal one wished would leave its cage. "You ought be . . . *amused with a variety of scenery; and take freely of exercise in the open air.*" He paused. "*Riding . . .* you love riding." I did not move. "*Walking. Gardening. Farming.*" Each word was a plea.

"Sheep?" I asked. "Ought I milk cows? This is modern world advice?"

He read more. "You . . . *should peruse interesting books, and converse with cheerful friends.*"

At the word *friends*, the plural, I turned away.

Jack waited a moment and then closed the book with a morose thud, taking it with him as he left. I heard Jack's voice in the hallway. "Something must be done."

ONE DAY, I awoke to waves.

Or rather, the motion of being rocked, carried out to sea.

"Careful round the stairwell," a voice said, as I awoke and then returned to sleep.

"We might not fit in the carriage," came Jack's voice.

"Mind the duvet and pillows," the maid said, clucking and loud, as I felt a whip of wind on my feet, which had broken free of the bed linens.

In fact, I felt as though my entire being were free.

"Jack?" I sat up, perplexed.

True, I was still safe on my mattress, but the thing itself was on the sidewalk in front of Beacon Street—with me on it.

What a sight—Mrs. Jack Gardner, bedclothes and all—on a deconstructed bed on the street. The papers would have a garish headline, but I would not be there to read it.

"Jack?"

Jack ignored me, instead giving direction to men in suits: porters, I realized.

"Careful Mrs. Jack's arms," one porter cautioned, detached but cautious as though I were an unwieldy object, an empty vase being transported.

"Be well." Julia leaned in to kiss me, her cheek cool, her hand gloved. "Travel safely—and return more fully to us . . ."

2

THE MEN smoked and sat on cane chairs or smoked and walked; the horizon in front of them rippled in marmalade hues or dusky grays depending on the hour.

The women stood at the rails, parasols barely clinging on in the fierce wind.

Women dressed for breakfast, for a deck promenade, for tea, for dinner.

Men wore day suits and evening dress coats. Stood in gray flocks, heads bowed, deep in discussion as they smoked.

I ventured out rarely, took some sea air, watched the people as though they were a species I had yet to encounter personally, and then retreated to our cabins.

The servers kept their faces taut, never showing fatigue or bother, even when the men left the newspapers on deck and they had to be chased down, suited servers rushing about like children at a park.

For seven weeks on board the men did as they liked, reading or walking or playing whist or all fours for money, arguing without embarrassment over Seward's Folly, the US secretary of state's purchase of Alaska. Men woke up in the morning without worry of how to be. They simply existed without needing to conform themselves to what the world desired of them. It was no wonder they aged better; the world seemed to ravage them less.

The women took tea in a glass-covered room, staring out at the men, whose bodies shook with laughter as they had glasses of beer, discussing whatever men discuss with one another, while the women stirred their tea without ever allowing the spoons to touch the side of the cup.

I was the cup. Untouched, disconnected from the sipping ladies, the men outside, the tea within. I did not desire anything and relished the deadness that a lack of need provided.

My cabin afforded a view of the water, which I watched for color, for chop, for anything to break the sameness that clouded my head. A sea monster. A whale. A giant squid the likes of which I had seen sketched in one of Jackie's primers. Yet nothing unusual appeared, and Jack's cabin stayed empty, as he remained with the men up on deck. I had left my life—the shred of it—back in Boston. So little remained there. And yet what lay ahead? What if I were to remain forever in the waves?

Jack had left the doctor's book open for me as though I needed more guidance. *Before getting out of bed in the morning, rum and milk, or egg and sherry; breakfast of meat, eggs, and café au lait, or cocoa; beef-tea, with a glass of port, at eleven o'clock; and a good dinner or lunch at two, with a couple of glasses of sherry; at four, some more beef-tea, or equivalent; at seven, dinner or supper, with stout or port wine; and at bed-time, stout or ale, with the chloral or morphia.*

I did not need rum, nor eggs, nor morphia with its liquid haze of dull regret.

It was easier still to think of what I did not need than to parcel out what I did, to settle on what might help me. My body felt boneless, ruined.

My hands across the bed linens found each other. I recalled making paper dolls in France with Julia, how each arm needed the next to stand. I imagined myself a slip of paper, proper care instructions included, lifting out of the cabin and through the porthole, out to sea, where I hoped the water would at least refresh my body, inform it somehow that there were bones inside, that I would one day stand whole.

• • •

DEPENDING ON weather, passengers were allowed access to the storage holds once per voyage. The spaces below deck were lit only by a few portholes, and I enjoyed the dank air when I had gone early in the voyage for a shawl. I took to sitting in my nightclothes in a rather hidden back stairwell past the first-class cabins, down one flight with a quilt around me. In the evenings, the place was always quiet. But now, during this late night when I could not sleep, a quiet rumble of voices, of glasses clinking, roused me from my perch on the stairs.

When I descended one flight farther, quilt still clutched in case someone was horrified at the sight of me undressed and out of the room, I felt a shock. In front of me, away from the grandeur of the rest of the ship, were people—maids, stewards, waiters—standing in groups or dancing, male servers with male servers, maids laughing and holding hands, drinking from flat-bottomed brown and green glass bottles.

At first, a few pairs of eyes were skeptical at the sight of me. One man turned his face away lest I be able to identify him. My cheeks burned. I had been rude to intrude, so I retreated a few steps. Then the party resumed, and I was duly ignored. Before I could leave, a man approached. I barely moved as he stood leaning onto the railing next to me.

"Leaving?" asked a server as he came upon my other side. He was clearly finished with his duties, another meal I had forgone.

Out of habit, I dipped my head. "Yes—I'm sorry for disturbing you."

He pushed his hands through his dark hair, his brows full, eyes bright and blue. He looked polished, though the brass buttons on his jacket were undone, starched collar loose so that his undershirt was in plain sight. He grinned, motioning to others, "It's only disappointing not to have a scene."

I looked at my nightclothes, a stain of mustard I hadn't noticed. "I suppose I am a scene unto myself," I said. The words felt small and real as the pebbles Jackie had liked to hold in his hand at Green

Hill. "Anyway, it's been a long time since I've been to a party. Even uninvited."

"You found our little club. Sometimes we call it Miss Molly's Cabin." He paused, locking eyes with mine. "Other times The Hold. Either way, it's hush-hush, you understand?" I nodded, picking at the edges of the quilt I had worried to shreds. "You seem at a loss for words," he said. "Has our party surprised you?"

I looked at couples—some deep in conversation, others embracing. They seemed happy. Or at least, content, free from work and the rules of above-deck life. "Perhaps I ought to be. Yet I'm not. I'm merely—" I stopped speaking. I could not see the water from the stairwell, but I could feel waves, rocking me the way I had rocked Jackie. I could hear chains clinking, the draw from the bilge, sounds of the underneath. "I was never one to be at a loss for words," I said. My voice sounded familiar, but I did not feel that it belonged to me. "But now? I do not feel quite myself."

He seemed to consider me. Not just my appearance, but the woman underneath. "Have this," he said, and offered me a rolled cigarette. I looked at it, unsure. "You've got only one life, right? Might as well enjoy it."

"Won't it shock you terribly, a woman like me smoking?"

"I've learnt not to shock easily." He gestured to the rest of the revelers—women smoked, and men danced and kissed. A pair of women clutched each other in the small space between two trunks. I accepted the cigarette, the smoke wafting into my hair, curling itself around me like sails as he slid a pouch of Watson & McGill Fine Tobacco from his jacket pocket. I watched with wonder as he expertly rolled another; my eyes followed his tongue as it traced the paper's edge, his fingers firm along the seam.

"Victor—come dance," a steward called to my new friend.

"Victor," I said. "I'm Mrs.—I'm Isabella." I paused. "Do you want to dance?"

Victor looked over his shoulder. "With him? No. Not if I know what's good for me. He's the sort of ratbag men loathe and women say they find tedious but secretly think of by themselves in the dark."

I felt my face stretch into a grin and realized how long it had been since I'd smiled. Then, just as quickly, the light inside me faded. Victor and I sat in silence.

"You missed her," he said as he struck a match.

I wanted to say that I missed everyone these days. That I missed hours, smells, biscuits, garden walks, entire seasons in my in-laws' gardens at Green Hill. But instead, I focused on his eyes, eyes that encouraged a question.

"Did I?"

"Millicent Fawcett."

I felt my spine straighten. This was not talk of weather. "Was she really on board?"

He raised his eyebrows, his face lighting up with knowledge. "Honeymoon." He drew on his cigarette and reached up, holding on to the heavy railing. "Still, she would have been plotting, I reckon. Women's education, suffrage, she has great plans, I suspect."

I inhaled, a smile again playing on my face. "Oh, suspect? And just what might this signify for a man such as yourself, who goes from one port to the next?"

"Do you not care for current events? Are you not one of the Informed?" He paused, looking at my bedclothes, my blanket, my feet, which until then I had not realized were bare. "Forgive my saying so aloud, but if you can dare be out of your rooms with . . . well, I just assumed you were above it all. Society's brutality."

"Lacking in social graces, I am not above it all, only firmly seated at the edges of the room." I paused, a wisp of my former dinner party conversation leaking out. I licked my lips—my taste buds had been dulled by grief, but now I tasted smoke and salt.

He gave me a pointed look. "And yet you still belong more than some." I heard his words and held them in my mind. He leaned into the banister with great caution, exhaling a great plume of smoke. "Do you not feel content in your cabins?" I shook my head. "Do you not feel content at the captain's table, where I have seen your husband?" Again, I shook my head.

"Poor you." His voice was part kind and part cruel. I could see in

this young man's face an echo of his childhood visage, and I wondered what he might have endured that I could not possibly understand. He seemed to consider me, too.

"There are those of us who do not feel as though they have a seat at any particular table on any particular boat," he said, and shrugged off his jacket.

I looked closer as he took in my unwashed hair, the pockets of dark that resided under my eyes.

Victor tilted his head. "I am of the belief that those who do not fit are stronger than those who do." He ran his fingers through his hair again.

I took another inhale of the male world, breathing smoke without shame. "I keep my rejections, my losses. Each and every one of them. A bizarre collection."

He looked over at the man who had asked him to dance. "We hold them with us, I suppose," Victor said. "And perhaps we find solace in unlikely places. Or people."

He looked at me, and I kept his gaze, grateful. We smoked another cigarette, all of our past selves and their desires at a tiny dinner party in the back stairwell of a boat tossing in the night sea as we approached Liverpool, where we would hardly pause before going to London. I stood staring at the water, the barest slip of light on the horizon.

3

J ACK ORDERED the driver to stop on Swan Walk near the
Chelsea Physic Garden, hidden behind hedgerows at the edge of
the Thames. I looked at the Physic Garden's founding plaque—1673.
Perhaps Jack thought that I would improve simply by being in a place
hundreds of years old, founded on the art of healing. All it told me
was that people had been suffering forever.

Strolling amongst periwinkle that had traveled from Madagascar
and that now were rooted in the rest of the world, we walked amid
woodland garden flowers and—the main reason Jack had wished to
visit—the Garden of Medicinal Plants.

He so wished for my health to return in an instant that he seemed
unaware that this was our first walk together in a year.

"Licorice root." He peered forward, reading from the small staked
placard. "For fatigue. Would you consider . . ."

And thus began an hour of Jack suggesting cures for my ailments,
adding them to the list of rums, eggs, morphias.

"Do you not notice I am walking?" I asked. Jack hardly heard.
"Jack? I required a mattress . . . and now I am in a garden. Could we
not appreciate my progress?"

I read plant information: Chinese *Cordyceps* for improved mus-
cle strength, willow bark and wintergreen for pain, meadowsweet

with its gentle white flowering fringe, and chickweed to reduce swelling.

"I am not swollen," I said to him. I wished to be gracious, to be tender, yet I struggled for the balance between the frail, pale woman unable to pry herself away from the bed and the one in the stairwell who smoked in secret, who felt herself above the world's cruelty.

"Should you like a garden one day, Belle?" Jack asked.

When he said my name I felt younger, though not necessarily myself. I had kept the nickname and suspected it would remain even when—if—I lived to be a frail, old woman.

"I enjoy gardens," I said, "and I appreciate that the plants carry more than one function."

"*Lavandula?*" he pointed. He expressed his grief only in taking care of me. "Used for relaxation, it says."

I breathed in, trying for patience as Jack tried to educate and to cure me at the same time. "I mean," I said pointedly, as I looked around the paths, "there might be calm to be had in *Lavandula*, but there's terror in some plants—deadly nightshade, for example. Or . . ." I pulled him toward a boggy row of *Eriophorum*, the tufts of which resembled cotton. I paused. "Seed exchanges. Do you recall my letters south? Have you considered the origins?"

Jack looked exasperated. "Slavery, Belle. I sit in rooms with men who—"

Carefully, making sure no passersby might see my actions, I pulled a single seed from the plant near me. "Seeds. Everything contained in one small bead. An entire world." I marveled at the tiny morsel in my gloved palm. Then I raised my eyebrows to Jack. "If slavery began the war, seeds were ammunition. The brutal men introduced the crop and needed to harvest it—only they distorted their power to do so. What they planted wasn't only crop, it was power and money and hatred and greed." I paused. "Plants are political."

Jack's mouth hung open. He steadied himself as we walked further.

"It occurs to me that you have an inner life to which I am not privy." He paused. "You and I have lost—" His voice broke, but

only for a mere breath. "We have lost a great deal. You especially. I wish only for your wellness. I am not sure what that has to do with cotton."

How could I explain myself to him? That I wanted something that I could not name. It wasn't to be found in a garden, although I liked gardens. And it wasn't to be found on board a ship, although I had appreciated the fresh air. It might be in that back stairwell.

"Somehow," I started, "the world is slowly opening. But I have yet to find my place in it."

Jack's head dipped, willow bent and wounded. "Am I not your place?"

I turned to face him. How simple that would be, to house myself within his walls, to become one who found their spot at society's table and knew themselves because of it.

"I need a purpose, Jack," I whispered.

"There is freedom afforded to those who accept themselves and their position," Jack said.

"Or lack thereof." I spoke carefully. "Do you not accept my roles as diminished? Have I no other use than to be your wife? As I am not—as I am unable . . . I will not be anyone's mother, Jack."

We had spoken of losing Jackie at the time of his death, but now Jack could barely think of him, while I needed desperately to recall each and every detail. The weight of him on my lap. The way his fingertips tangled in the very front lock of my hair when I went to him at night, although the night nurse was at the ready. Even that bout of domesticity I had gotten wrong. Why have someone else go to my own child when the very scent of him magnetized me?

"I worry I've lost you," Jack said.

I heard his words as they swarmed around me like bees, the smell of lavender, mint, sweet grass around us in the thrum of June.

"I am here," I assured him. I took his hand. "However, rosemary and calendula will not be my saviors."

"What will be, then?"

I knew from his eyes that he wished to be that for me. "A purpose. My purpose."

He nodded, though I knew he did not entirely understand. "You have work and clubs and life, and I have—well, that is what I must figure out."

WE LEFT the garden late.

There is no greater match for gloom than London at dusk. Gray-cast river with its oily slur, sunset choking on sludge. Workers with empty tin lunch pails, carriages drawn by tired horses, fatigued drivers with mustaches gone droopy at the sides, nannies with evening-fussy babies in prams the size of sea trunks, everyone at day's end, spirits deflated.

The water roiled with activity; men hauled ropes on board skiffs and coal barges, throwing their evening bottles overboard as cormorants dried their wings on the bows and black-tailed godwits dipped their orange heads into the murky river.

"Do you recall the summer exhibition at the Royal Academy?" I asked Jack.

"Of course," he said as he encouraged me to keep walking.

I stayed where I was, struck by the river itself.

"Isn't it peculiar how one might see the same place in a new light, over and over again? Think of J. M. W. Turner's painting," I said to Jack as the birds screeched around us. "*The Burning of the Houses of Lords and Commons.* Consider that next to—what was the other one?"

"Whistler," Jack said. "He's just left London for Chile."

"Oh?" I wondered how he knew—but then men seemed to be informed of one another's work details in ways that eluded me.

"He stopped by the Reform Club for a drink."

He did not offer more. I studied the water, the scene in front of us, as though I might find something useful. "While Whistler sees one viewpoint, I might find another. And J. M. W. Turner still another."

Turner had seen the fire break out and sketched it first along the embankment, then rented a boat and continued sketching from there. I imagined him drawing as he rocked the water of the Thames swashing against his boat as he viewed the South Bank.

Nothing I saw now was on fire, just the same gray that had murked my insides for so long. A stark and clear—but right now tiny—fire was just sparking again.

"Who would hire a boat and paint?" my husband asked.

"Sketch and then paint, you mean," I said, and then continued. "Someone who knew what he was watching and wanted to capture it."

Jack regarded me then as though I were the buildings caught on fire and he the one watching the ruin. "Come," he said. "It's late and we have supper."

4

As OUR trip continued, I felt wary of Jack's goal: he wanted only to have me well. Our trip—length, destinations—was governed only by Jack's desire to have his wife back. Weeks slipped by, a near-constant parade of social engagements meant to re-tether me to the world. I understood Jack's motivation, how closely he followed doctor's orders to heal the patient. Yet grief's veil was only part of what covered me—I grew ill at ease when I thought of my hollow life.

Now another social outing under the guise of normalcy. "How ghastly it is attending a dinner party when one feels as though even the marionette strings don't work," I whispered to Jack, who flinched. For me to go through the motions was at turns hurtful and draining, and I knew I was not able to carry off even a mediocre performance. Jack conversed with our hosts, whose names I hadn't bothered to learn. I tasted the tarragon sauce and studied the room.

Here were men seated next to women dressed bright as flowers, yellow as the daffodils Harriet embodied, aubergine silk, mossy brocade. Man, woman, man, woman around the table as though no other pattern could possibly exist.

The lustered chestnut shelves also had objects in pairs. Two green vases with twisted necks, empty as I was. And next to that two wide-

eyed spaniels, ceramic and unmoving, also like I was. The faintest hint of a smile grew inside my face as I realized I could impose my own emotions on the objects around me or vice versa.

"Don't you agree?" the mustache attached to a mouth on my right asked me.

I tried to come to life to respond but managed only a nod.

I tried desperately to ignore the room with its heavy curtains and flickering candlelight, to focus on the conversation the way I had in that merry lower hold on board the boat. I missed those waves. I licked my lips, wishing for smoke, for a quiet stairwell with a friend who shared his pain and seemed to understand some truth about me.

One of the American men at the table made it known that the roast was superb, and garnered agreement. I felt myself slipping away again until a French woman remarked that Lydia Someone-or-other would no longer eat meat in any form.

"She's gone the way of the mystics," another woman said. Lydia herself was not present; the safest time to speak about someone.

"Why, I believe she's taken to mixing prints and draping shawls over lamps . . ."

"I heard she traipsed to East London."

Traipsed held in it such scorn. What if Lydia had merely traveled, not traipsed?

"One of those places near the water."

"Imagine going there—after the tragedy at Regent's Park."

I turned to the mustache. "Tragedy?"

He tilted his head. "January. Terribly cold. A great throng of people skating, only to fall in en masse." He gave me a warning look, though it was June. "Thin ice," he explained. "So many lives lost underwater."

A familiar unease welled up in my chest. I did not enjoy being explained to. "How sad," I said, and added: "No doubt the heavy clothing weighed them down." He looked surprised at my thought process. "Perhaps they need to reduce the depth."

When I looked over at him, Jack had finished his brill, the parsnip puree, runner beans with parsley sauce, jellied vegetable marrow. He

placed his dinner knife and fork parallel on the gilded plate's edge and gave me a gentle smile of encouragement.

"So where are these mystical places, exactly?" I asked to no one and thus to everyone.

"East London. No place for decent women."

One woman gave a nasty smile and, sotto voce, offered, "Unless one's name is Rothschild."

This produced a laugh from another. I saw Jack's mouth twist; his habit when he felt one thing but did another. In this case, he said nothing.

The mustache took pride in explaining again to me. "I imagine you've yet to experience East London. Suffice it to say that for every bookstall and low-rent haberdashery one also finds unseemly sorts." He lowered his voice and his eyes. "Salons. Members of the occult."

"And what might one find in these unseemly rooms?"

I thought of the woman in their circle who had ventured, traipsed. What had happened to her to ensure that she was not invited to the party tonight? Tragedy? Or perhaps she hadn't fit in either.

"What sort of salons are they?" I asked.

A haughty look from the end of the table followed. Jack tried to will me silent with his eyes, but then his mouth twisted again— would it be better I stay mute forever, still boneless, or speak in truths?

"Perhaps this hasn't swept across the Atlantic," said the host, in her perfectly appropriate organdy-striped summer evening gown, "but the underbelly has taken to a particular kind of communication." She studied my face. "Some people believe they can commune with the dead. Can you imagine?" She locked eyes with mine. "Thinking one might receive a message from beyond?"

I looked at the silent ceramic spaniels and the woman laughed, but in the word *beyond*, I heard hope.

A WEEK later, by carriage, then by foot on the uneven cattle paths, on cobbled back ways and haphazard streets, past the Old Swan pub,

coal merchants, and boatbuilders, I found my way to a double-hung door on which was painted a small, gold-leaf symbol. Multiple circles with a triangle in their center.

My heart pounded, both from the journey and from the idea, from the smallest chance, from hope.

I knocked, and when no one answered I felt relieved—perhaps it was best to stay in this world; after all, I was myself only just coming back from the dead. But the door opened and a woman—true to dinner-party lore—in layer upon layer of fabric revealed a reception room.

"The Room of Disenchantment." She motioned to a chaise on which bolsters were piled. If one wanted to believe—and I did so—one might overlook the ragtag nature of the staging. I wished at once to move the furniture to better expose the two pillars at the far end of the room, but instead I took my seat amongst the peacock feathers, the tapestries cloaking the walls, the unlit gas lamps, the candles—big as Jack's forearms—that were lighted, offering shadows on every surface.

"We are beyond mesmerism here," she said.

I introduced myself, feeling society's rules in each step. I longed to shrug them away, to inhabit clothing or questions that suited me. But she did not reply with her name; instead, she urged me to sit, motioned to various pamphlets and objects on the table in front of me, and disappeared without warning.

On the table were a magnifying glass similar to the one in Jack's study, an elaborate astrolabe for stars or planets or measuring above the horizon, and several heavy stones, each with a natural white ring.

"All four corners of the earth," the host said, when she returned with a tray of tea and pushed a cup toward me. The tea itself looked ordinary but was served in a samovar that dwarfed the tray.

At once I was captivated by it; Jack and I had seen one on our honeymoon—solid silver, spout elongated as a crane's beak. We hadn't bought it. Now I fought the urge to empty the tea on the floor to see if it bore the stamp of William Eley II.

"You are caught," she said, watching me eye the samovar.

"Between this world and the next." I opened my mouth to disagree, but she continued. "Do you feel you do not belong?" She rose and went to a shelf I could barely make out in the dim light.

On my lap she placed a bleached bone, an ostrich feather, and a slim book of poetry. "Emma Lazarus," I read aloud.

The woman nodded. "Do you know her?" I shook my head. "She is also American."

"It's a large country," I said.

She ignored my comment. "These are German translations done by a woman. A Jew."

"Oh?" I did not know why this mattered. Why had I come? To drink tea and hold bones?

"She was here in spring." She pointed to a page. "See her letter inside? Strength is from suffering. If one makes it to the other side, as she writes, there is the possibility of fresh love, new hearts."

I found myself gripping the bone. "And what if there is to be no new life?"

She removed a glove and put her bare fingers—slim, cold as bones themselves—on my eyes, closing the lids.

"What do you see?"

I saw nothing. I took a breath as she asked and tried again. I saw spots, flickers of the candles behind my eyelids. I felt boneless again until, as she whispered words I could not decipher, I saw the spots turn to sunlight, the dappled Boston Public Garden beneath me. I could hear my footsteps, and other, less steady ones. I could see Jackie's boots. I turned my face toward him, the ripe peach of his face, the damp of his hair on his brow. It would have been summer. It would have been our afternoon walk, when it felt as though we had the entirety of the gardens to ourselves, everyone else shaded at home. It would have been just the two of us. Us. We had been a pair.

And then, quick as I went to hold him, to grasp the impossible velvet of his calves, a field of yellow. Harriet after Harriet, each in a yellow dress, hair uncoiled, face turned to the sun.

For one moment, my body left my body and I, too, was planted next to Harriet, the reeds of our legs in the earth, my body sheltering Jackie's.

And then such exquisite pain. My eyes flickering open.

The room felt darker, and I shivered. The bone on my lap had broken The feather was wet from my tears.

"Now," she said, "you are in this world until you leave it completely. Do you understand?"

I held the moments with Jackie and Harriet as though they were actual memories, as though they were frescoes forever steady on a wall in a house I had not yet built.

I looked back toward the table. "I should like very much to buy that samovar."

As though my host were expecting the ask, as though she'd invited me here for this purpose, too, she retrieved the object, poured the last of the liquid into her own cup, and held the pot out to me.

"I'm guessing you'd like its twin I have in the back?" she asked, but had gone to fetch it before I had the chance to respond. I would send one back for Julia. I had not heard from her recently and wanted her to know I had her in mind.

Now I held both samovars in my arms, their necks over my forearms like cuddling swans. "Thank you," I said. "For everything."

She raised her eyebrows and awaited her payment.

5

ANOTHER WEEK passed. How far away Boston seemed now that I had found some relief in the foreignness of being somewhere that wasn't mine. I was meant to meet Jack in front of Lord Byron's house, where the poet held the honor of having London's first historic placard attached, showing everyone who passed by that a great man had lived inside. I would not tell Jack about my adventure—he would never approve nor understand.

I passed the house on Holles Street and admired the signage. How brilliant to be a writer, to live a scandalous life of affairs, fleeing to Venice to escape his debts. Somewhere in the folds of my lessening grief there was planted a seed that had begun to sprout, a flower I had no reason to believe would fully grow. But if it were to push through the muck of spring, it might turn its head not toward the sun but toward wanting, toward desire itself.

Pausing, I took in the plaque, the house, the way the city sought to mark the importance of Byron's days. My feet once again felt solid on the earth, solid as the bolts that affixed the plaque to the exterior. Would I, too, one day have a plaque bearing my name? Or was that folly from my brush with the occult?

What, I wondered as I went to find Jack, was the difference between desire and fantasy? And how—if one could not write like Byron or Mary Shelley (who had no such plaque), could one bring to

life the dead and gone, or paint fires on the Thames as they burned—how might one achieve that status? "I am fearless and therefore powerful," Shelley had written. Julia and I had read the novel aloud to each other at finishing school in the hush of our nightgowns, bed candle hunched as an old woman. We were unformed girls then, scared of the story in the pages, of monsters of our own creation.

As I stood in front of the pillared house that did not bear Mary Shelley's name, I realized with a shudder that I must submit fully to loss or else stitch myself together as Shelley's monster had been made, the sum of my ragged pieces formed into a new whole.

I WAITED far longer than I should. When Jack did not show, rather than be defeated, I realized I knew where to find him: on the south side of Pall Mall, in a stone building that could have housed a small nation.

I also knew that I would be turned away at the door.

Yet my boots carried me on the sidewalk and up the wide steps to the front doors of the Reform Club. I did not allow myself pause, lest doubt and hesitancy stop me. Such a grand building constructed for men and their sons.

And yet—I had read the papers Jack had discarded on the breakfast table. In fine print were names I felt in my mouth as though they were beach pebbles, real and solid. Lucy Stone, lecturing in Kansas and New York about suffrage. The article relegated to deep within the morning papers, given as much weight as wedding announcements for the aspirational crowd, an advertisement for WM. Smith's new water closet patents, inns for those on moderate terms. And nestled therein was Susan B. Anthony, fighting for the same cause and yet not together with Stone because even in politics women were encouraged to be divisive, perhaps under the guise of spreading power, but when I had paused here with the slick of buttered toast on my lips, I wondered if perhaps this was another male ploy—weaken a movement by creating factions. The war was over, but rights for those of African descent were not secure.

I had no more than one foot in the cavernous entryway before two

doormen bid me good day, which was another way of asking me to leave, despite my having only just arrived.

I gave my best pursed-lipped smile and brushed past them. The only way for them to stop me would be to physically assault me, which they did, grasping my shoulder and arm firmly enough that—when Jack and I went to bed that evening for the first time that calendar year—we would see grapevine bruises.

"Jack!" I shouted, as one doorman, a look of great pity on his face as though this would soften his grip, pulled me toward the door. "Are you or are you not liberals here?"

A number of club members appeared. Indeed they believed themselves to be liberals; men roaming the club modeled on the Palazzo Farnese, complete with saloon and bedrooms and a library filled with books written by the members themselves. Jack had boasted of this the night before, so many volumes by so many great men who—were they to be lined up with their books—might be indistinguishable from one another.

Blushing and with great haste, Jack, bolstered by his contemporaries, hustled past the pillared side room and appeared with a cigarette in his mouth, surprised and taken aback at the grip on my arm. His great bearlike form was enough to cause the doormen to shrink back, my small frame unmoving in the center of the tiled room as the elite liberals watched with a mix of amusement and confusion.

"Jack," I said plainly, "I am ready to leave London."

"And we're ready for you to be on your way!" came a voice from the group of men who gathered there, moving in en masse as though an angry high tide and me the sand.

From the crowd alongside Jack, who began to usher me toward the door, appeared a familiar face.

"This is not just any woman!" Theodore Lyman bellowed. I had a flash of his laboratory, his knowledge of the natural world, my day with his sketches, how I'd stroked the bird's feather with my bare fingers. "This is Mrs. Jack Gardner, she of keen observational skills and scientific mind."

I did not think my occult room would qualify me for such senti-

ments, but I did enjoy the rippling of disbelief amongst the men—imagine, a woman who mattered, no plaque required.

"Mr. Lyman," I raised my hand and felt the corners of my mouth follow. "All the way from Harvard."

He and Jack shook hands as we three exited the building. I felt I needed both of them to act as body armor from the hateful gazes.

"I should like to think you will find me again in Dresden," Lyman said.

Jack turned to me. "I'm quite relieved to find you well enough to travel. Are we headed home?" In my ill health he had wished only for my revival, and now, on the street outside the private club I had attempted to infiltrate, he seemed to await my orders. I admit I liked the feeling.

"Not home," I said.

"Dresden?" Lyman offered again. "Might I lure you both there with invertebrates?"

"Has ever such a sentence been uttered?" I asked.

"Your wife has wit in spades," Lyman said.

Jack's mouth twisted, caught once again. But between what, pride and embarrassment? Had my wit been what drew him toward me during our courtship, only to frustrate him now? "My wife has many qualities to admire," Jack said.

"Your wife," I said, growing better at boldness, "would like to go to France." I paused, thought, and then looked at Mr. Lyman. "And then to Dresden."

Jack took a deep breath as though trying to reclaim the world outside the Reform Club. "As you see fit, Mrs. Jack."

6

"IT'S SILK," Charles Frederick Worth said.

"How lucky I am to meet you," I said to him. I'd longed to meet Worth, the father of haute couture. He'd been embraced by Empress Eugénie, provided one-of-a-kind dresses that defied expectations.

I could not help but admire the fabric, the colors, my own body within the careful stitching. "A work of art, truly."

Worth nodded. "In fact, that's true. Have you seen Titian? *The Rape of Europa?*" He fussed with the cuff on my sleeve. "I made a series of jackets . . . the Orleans Collection. Perhaps you might view? Please, hold still."

Only the day before, Jack and I had viewed his collection on live Parisian models, marveled at the women in front of us as they displayed their gowns like walking dolls. I had rejected each and every one of them, and yet to Jack's surprise, rather than be banned for life, Worth had himself asked me to come for a fitting in his Paris atelier.

What he asked of me was difficult. Holding still, I was beginning to realize, was no longer my forte. I had been mounted to my mattress, to my grief, to the boat, and then to London and now Paris, to not becoming anything that was expected of me and now, as I was fitted into a dress with a shockingly low neckline, I felt as though time had sped up. I needed to make haste to find what I might discover, the self yet to be.

Jack appeared, smelling of smoke. "Is it not a bit of a ravine at the front?" Jack said of my dress.

"Butter upon bacon, you mean?" I asked. Too much, too much, too much. I felt I was always too little or too much, never just the amount required.

Charles Worth paused, pins in his mouth. Both men awaited my response.

"For some it is sure to be too forward," Worth said as I stood, stuck between the colors and my husband's disapproval.

Was it possible to say what I thought without clouding it with what my husband or the world at large wished to hear? "I do not think it too much."

Jack's mouth became the parenthetical for his unsaid words. He did not object, but he did not approve either.

"Are you able to withstand the forces of scandal?" Worth said, as he began tucking the bottom hemline.

As I looked down, the tassel on my chest swayed as though it might be pulled to ring a bell. Only, I was the bell.

"I can withstand more than one might assume," I said. Tragedy brought strength, did it not? I pulled in a deep breath as Worth tucked the hem higher. "Consider me Paris," I said to Jack. "Rebuilt after war, relit."

"I might add a lace inset to the front." Worth stood to admire his own handiwork. "Still, even with that added bit of modesty, you realize it's six inches from the ground," he said, weaving daring into his stance.

"All the better for displaying the boots I have yet to purchase," I said.

Satisfied, Worth reached for a small piece of fabric. "The Charles Frederick Worth Collection." He displayed the tag, before starting to sew it into the nape of my neck. "Recognition where it's due, I say."

"Self-promotional," Jack said quietly.

Worth addressed us both in the gilt-edged, floor length mirror. "Who aside from myself ought to promote me best?"

．　　．　　．

OF COURSE I engineered a visit to see *The Rape of Europa* at the Orleans Collection. If I were going to wear Worth's dress that called those colors to mind, I wanted to be able to inform my critics of its origins.

I had not read Ovid when I was in school. I had read instead Madame Marchand's *Petite Livre*, which detailed manners befitting to girls. Fluent in French, I had read *Le Ménagier de Paris*, *The Good Wife's Guide* in which my feminine duties, my morals, and my present and future conduct were explained.

And because I had not read Ovid, I listened as Jack—dear, well-meaning Jack—explained the story of Ovid's *Metamorphoses* to me. "Europa is enticed by the bull, God in another form, so she climbs aboard his back," Jack told me, as both of us stood in front of the imposing work. "And he—well, he carries her off."

"Carries seems a gentle word." I noticed her raised arm, the way she tried to shield herself.

"He's Zeus. Or Jupiter, depending," Jack said. "Not that this excuses his behavior. Still, it's a painting. Based on a myth."

I moved closer. Cupid on a dolphin mocked Europa's arm. A sea monster menaced the waves. There was terror and beauty and fear in a swarm of colors and pain.

I turned to Jack. "You said the same of the Thames on fire. Are you not struck by the permanence of these works?"

I felt I was on the verge of figuring out a puzzle larger than the work in front of me but could not find the last wooden piece. I would have to keep looking.

"Shame you haven't the dress to wear in front of the work—perhaps you would blend in with the oils," Jack said, and pulled me toward him. I leaned into him, wondering if I would be swallowed by the waves or land flat on my back—or, like Europa, withstand the journey and rise above.

·　·　·

29th November 1870
Taschenbergpalais

Dear Julia,

Many thanks for the update on dear baby Harold Jefferson! I hope John and Archibald are enjoying their little brother and that you, dear, are well as the social season looms.

I write to you from Dresden. It is late. Jack is asleep after a delightful, if long, evening attending the first concert at the new Gewerbehausorchester. Hermann Mannsfeldt conducted, though one could hardly look away from his face to focus on his hands and baton. The man possesses a mustache that resembles quite perfectly the giant leopard moth caterpillar I had the pleasure of seeing today with Mr. Theodore Lyman, he of the natural sciences. Jack did not join us. Instead he took it upon himself to investigate Benz's combustion engine designs.

While he did attend the concert, we have not been arm in arm as we were in Paris. Julia, why did I think marriage an unchanging thing? I suppose I must learn that everything becomes one way and then dips or goes upward like the primers we learned to stitch—only, it would be far easier, wouldn't it, if nothing changed at all. Or boring. Listen to my indecision—should we change or remain fixed? I simply don't know.

On my own I explored the city (damage from the revolution is still visible) and, as planned, joined Mr. Theodore Lyman. Ted—for this is what I have called him—had mentioned glass invertebrates when I had the pleasure of meeting him back in Cambridge. Today, we visited Leopold Blaschka's glass workshop and the creatures within; his son Rudolph will join him soon— how lovely to have such a family tradition. The workshop was spare and orderly: the only detritus small knobs of glass floating in black buckets positioned in order to catch the cuttings from blowpipes the gaffers use to inflate the molten glass. Quite hypnotic to watch a delicate balloon of glass appear and grow larger. The unused ends are snipped with great clippers and fall—searing hot—into the buckets. I could not resist reaching into a bucket to examine for myself and felt I was exploring a new

underwater world with creatures as yet undocumented in science texts.

Lyman tells me they will soon supply Harvard's museum with lifelike glass botany and animals. Oh, Julia, should you ever imagine a more beautiful vision than light streaming through colored glass. Never might one think scientific models could capture such astonishing beauty, but as sure as I write, there is beauty to behold. I mean to say how moved I felt with these unmoving things, learning of a world and its inhabitants about which I previously knew nothing.

And yes, Ted presented me with a study. Not the models soon to be shipped but rather one of the miniatures used to perfect technique. I hold it now in my hand as though I am about to pray. It is fragile and requires a delicate touch—which I am learning.

Dear Julia, I will return to you shortly—and so long to smooth over past differences while walking in the park with you—Ever Yours—ISG

I ENDED the letter abruptly, as I had begun to doubt my ability to tell the truth. Words failed me. If Titian had returned to the world and stationed himself with oils in the corner, what might he have portrayed? A woman refreshed, writing her (remaining) best friend?

Or, indeed, painted betrayal on my face.

True, I held the unlikely beauty of the sea slug, patting it like I had the Labrador retrievers at Green Hill, all interchangeable in their cream coats, their accepting, drooling grins. Yet my story was false.

Concert, true. Glass lab visit, true. Yet edited out of my plunge into the glass bucket was my thievery. For I had held the glass ends bright on my palm—twists of cobalt, snail of yellow and clear, a coil of light copper the same hue as my nephews' hair—and decided then and there to pocket three to bring home for them. Not to play with—for who might bring a child a piece of glass? But as a keepsake. Something to hold when they were older and need to know fragility and hope, one that sent me out of the country and one that brings me back.

And, too, I had not told Julia about my time with Lyman completely.

Lyman and I had walked from the lab to a café for kirschwasser, a stringent coffee made with whipped cream that only confused the situation.

We sat pleasantly but, I felt, expectantly until Lyman tasted the topping, and it was as though he had tasted regret. Prior to this journey I might have noticed, but I would not have spoken about the noticing. "Mr. Lyman—"

"Ted." His body slumped as he brought the cup again to his mouth, where the foam rested on his mustache. Instead of humor, this only made him appear sadder, someone's forgotten toy in the park.

"Ted." I tried out the name. "It occurs to me how much research, how much effort was spent on those sea creatures. All in the name of—"

"Science?"

"I was going to say *knowing*. We like to know, don't we?" I sipped the drink, flinching at the mix of sweet and bitter.

More time passed as he finished his drink. "The taste of vanilla cream should be festive. Do you not agree?"

I nodded. "I assume from your face you do not find it so?"

He wiped his mustache with a serviette. "I apologize for being transparent."

I sighed. "Women are the ones with secrets. Men offer themselves on the surface."

"I've lost a child. Cora. Brain fever."

"You know about Jackie?"

We allowed ourselves mutual silences.

"I have a new idea," I admitted to him. Did I feel guilt at voicing this first to him rather than to Jack? Perhaps. And yet I persisted. "I have the notion these past months that we are not only the glass animals but also the cases themselves."

He did not ask about the weather or comment on the biscuits that sat untouched between us. He did not explain to me what I ought to have thought. He listened as I continued.

"What I mean to say is that we are the scientists, the . . . collectors."

"And what are you collecting?"

"I'm not quite sure as of yet . . ." I thought of Victor on the boat, of Emma Lazarus, whose poems I had now read, of the imaginary field filled with Harriets. Of Jackie's warm and welcome small hand in mind. "I believe I will find out. We collect memories, and that is what we can carry with us, Ted. You carry Cora, and I carry Jackie, only they will never age. We have memorized them for eternity."

He looked pleased and surprised, comforted and plotting. "Belle Gardner . . ."

"Mrs. Jack, they call me now."

"Mrs. Jack—come to Harvard."

"People speak of Harvard as though it's a country."

"It is, I suppose."

"One where women hold no papers . . . ?"

"No. Or . . . not no. Perhaps not yet?" A smile found its way to his face. "Come see my cousin, Charles Eliot Norton. He's just translated Dante's *Vita Nuova*. I believe you would be simpatico."

My interest piqued. I could not deny my desire to belong. "You do?"

"Yes. Intellectually," he said. "He would value your opinions— your ideas. I suspect you might appreciate his views on art."

"I could learn from him, you imply?"

"I know you would learn from him—he is the first professorial chair in art history in the country." He waited for me to stand before handing me something. "I also mean to imply he would learn from you."

Without betraying my secret—a quiet glee—I walked outside the café and waited for him to don his hat before he shook my hand.

Within my palm there was a glass sea slug. A creature so magnificent, so outwardly ugly and repellent to some, but magic to others.

I kept the creature secreted in my pocket, along with plans. I would return to Boston with my ideas, my new wardrobe, and my plans to visit the all-male country of Harvard.

7

WHEN ONE is away from home it is easy to reinvent the self. To imagine that self confident and clearheaded, stylish and somehow changed for good as one retraces daily routines. And it was true that when eventually I returned to Back Bay, I was somehow lit from within, like the deep-violet glass sea urchins in Dresden—alluring, glowing, needle-sharp. And it was true that Boston itself felt different—a renewed energy. Yet it might have been merely a new infatuation: simply the gloss of having returned home from far away. An understanding of just how large the world was and the relief of finding one's house still as one had left it.

The whirlwind of coming back: visits with the nephews at 147 Beacon—how they had grown and longed for tiddlywinks and baseball, their cheeks bright with cold in the park. With picture books splayed across my lap, we spent a rainy morning reading and having tea, and when they'd tired of placid play I had taken the skittles set Jack had purchased for Jackie and never used and set up a long lane of skittles shaped like penguins, regal in their dinner jackets. Shrieking and cheer ensued as we stood at one end of the long, parquet-floored corridor that led to the parlor. Joe rolled the ball and knocked down as many skittles as he could, younger brother William Amory was delighted to be the "getter," while Augustus and I—hand in hand,

which was my own delight—set them up once more. I had shown them the small glass snippings from Dresden. When I explained their provenance, they had such reverence—hushed voices, careful turns touching and patting the inanimate objects. They watched me set them high up on a shelf, where the sun might filter in and catch their colors. One day I would tell them the sorrows contained within each piece, my own and Lyman's, a song of sorrow the boys knew all too well.

But oh, the flurry of coming home and finding myself still in a foreign land: albeit my own house. Trunks unpacked, refamiliarizing myself with the rooms—my father-in-law's jade plant had survived, but the dried roses from a long-ago party had crumpled and gone brown. There were invites to answer, though they had been sent knowing full well I could not attend, post to be read, wrists aching from slicing each envelope with my engraved opener, reading each letter, finding notices long past, events we had missed in the lifetime before our return. For surely that was the feeling—I had been someone empty, gray, and crushed before the trip, and now, I hoped, I was someone new.

As I walked down the familiar steps at 152 Beacon, I fought mightily to keep that reinvention of the self and yet found myself slipping into routine. More than that, I felt doubt creeping up my calves—not that I had yet exposed my legs to the autumn air in one of the short dresses I'd brought back with me from Paris. They hung like stalkless flowers in the wardrobe, each wrapped carefully in tissues that had preserved the fabric and yet not as much my fortitude to wear them.

Julia met my arrival with great cheer and a wrapped parcel in her hands, which she thrust at me as she kissed my cheeks. "It's a novel," she said, before I could unwrap the paper and string. "You never allow for surprises!"

"You know I never cared for surprises. Life has enough of those, does it not?" She did not need my agreement. "A local, of sorts. Louisa May Alcott." She brought me inside. "It might please you to know I found myself poring over that final letter of yours and . . ." She paused. "I recalled your walks—alone—with your words of Dresden

and secrets." She gave me a scandalous look. "*Me débrouiller tout seul.*" The French of our youth brought me back to our midnight confessions at school. The maid carried in a tray with tea, and Julia reeled her flair in quickly. "It's from the Old Corner Bookstore. Enjoyable."

"The book or the shop?"

She grinned. "Both."

"I look forward to it," I told her, and returned the grin.

"The novel or the shop?"

"Both."

Outside, the leaves were at their brightest—jams and marmalades on branches as the autumn sky began its sleepy, dull-blue-hued bedtime routine. She got down to business. "And of course Eliza is thrilled you've returned in time for her wedding."

Jack and Julia's little sister was no longer little, but because I'd known her as such a young girl—a few years behind us in Paris—she would forever remain small-faced and sweet. "Please don't forget me," she'd said as she chased me down the stone pathway when I was preparing to leave school. She'd given me a small clutch of blue flowers, which I had wanted to dry in order to preserve them and her wishes, but they'd gone brittle, scattering leaves and sad confetti on my skirt.

And now she was to be married to Francis Skinner, another man of Harvard. And we would all gather for a day of tradition—pleated, gathered, veiled in white. I thought of Eliza's coronet of orange blossoms, her kid gloves, her white silk stockings and bows, the handkerchief embroidered with her maiden name initials as she became someone else. The next version of herself.

Would I, too, watch the spectacle of love and merger of wealth and feel I had become someone new as I recalled my own wedding day?

"Do you think," I said to Julia, "that Eliza is ready?" Julia looked confused and on the verge of hurt. "I only mean to ask—do you feel changed from the girl you were in school? And then again in your married life?" I studied the cup in my hands. "I have the feeling that I am on a great precipice but cannot view the other side."

Julia patted the book she'd given me and arranged her features the

way she always did when trying to appease my questioning nature. "Belle—you might do well to keep in mind the journey you've had. The fresh sea air." She locked her gaze on mine. "You do so strive and think—those are some of your blessings. And yet, how exhausting it must be."

We stood so she could greet Eliza at the door. "Perhaps it's not exhausting," I said, mischief on my face. "Perhaps the word you mean is exhilarating."

2nd October 1871
152 Beacon Street

Dear Mr. Worth,

I returned to Boston and had planned to write immediately, to describe for you the dresses' first outings in the world. Yet of course from this later date you understand there was a delay in my wearing them and, if I am honest, this is not due to weather— autumn still, those crisp afternoons of rustling skirts and leaves, evenings not yet shrouded in winter's starkness. Rather, I had put off wearing the gowns you so cleverly made for me with your name rightfully sewn in at the nape because my boldness (your words, I believe) floated away somewhere over the Atlantic. Also my good cashmere shawl, but that is another matter altogether.

I feared I had been victim to that great pitfall of travel, wherein one buys an item, indeed must have that item—glass vase, embroidered quilt, elegant bonnet, or stunning gown—only to arrive back in one's home to find the vase unwieldy, quilt gaudy, bonnet ridiculous and worthy of housing a collection of finches, and dress simply far too outré to risk in society.

And yet. I had been so sure in your studios, watching those live models with their grace and ease, turning as though on tracks and wheels like a funfair ride. So sure as you stitched me into a new skin.

And so, despite a dip in temperature—my husband's way of suggesting I might wear a more modest item—I donned the dress you mentioned had been inspired by Middle East enamels, spoon busk and compressed waist, gathered bustle with such elaborate

trimmings I admit to feeling, as I slid into the garment in my room, rather akin to the Queen's Christmas tree, garlands aplenty and with light reflecting from those tiny beaded mirrors. The blue of winter skies and a neckline that forced me to remember to meet the gaze of men. The length that revealed my blue satin front-lace boots and also revealed the tendencies of groups to produce gossip and judgment.

Jack and I had set out for dinner at the Appleton-Parker house. All the while—from dressing room to entryway, sidewalk to carriage—I grew more and more unsure. The doubts grew as we approached our destination. I nearly turned around, yet as I was eager to see the house itself, I continued.

As you might have done with your keen eye for detail, I marveled at the building's design, the curvature of the grand stairwell, elegant as a woman's neck. Two townhomes combined—a marvelous idea.

And as I paused once more in my post-travel doubt, a figure appeared before I might turn to leave and never have to bear the looks, the talk, the all-too-familiar sting of hushed voices speaking ill of someone as though they were somehow unable to hear.

Thomas Appleton himself descended the staircase as I climbed up. Have you met him? He's a cheerful sort, and one did have to admire his continued wit and demeanor; he'd taken on his sister's children after her death and proved a rather natural father, though he had no natural children of his own. One might almost think this would soften the self, give him an air of kindness.

I assumed Appleton would find me marveling, my gloved hands on the banister, admiring hexagonal plaster moldings and inform me, though I already knew it, that Alexander Parris had designed the place and wasn't he—with one fewer "r"—as grand as Paris.

And yet Appleton did nothing of the sort.

Instead, with a full and lengthy look at my gown, he turned to me as we met in the stairwell. "Pray, who underdressed you?"

"Charles Worth," I told him without so much as a ruffle. "Didn't he succeed brilliantly?"

Oh, if only one knew those people in one's life who help to nudge us onward, those who help us to find the courage to be

ourselves. Perhaps I shall collect your gowns and become a walking exhibit of your work. All of which is to say, dear Mr. Worth, I do so appreciate your eye toward the future—I only hope my future self might meet you there!

<div style="text-align: right">

With all affection,
Mrs. Jack Gardner

</div>

8

WE SAT at the table with clusters of yellow fruit in front of us. Even in autumn, the sun's heat crept up the edges of the greenhouse at Green Hill. Since the Worth outing, I felt more confident, even in my table posture.

"Bananas."

"Yes, bananas."

The children giggled. Harriet and Joseph's eldest, Joe, said, "I like the way the word feels in my mouth."

"Wait until you taste it," Jack said. He beamed at me, at the rest of us. After my recovery period, he rejoiced in this normalcy.

Jack and I had brought a crate of bananas with us to Green Hill, strapping it secure as awkward luggage on the way to Brookline. I had helped Julia and my mother-in-law, Catherine, to arrange the bunches of mysterious yellow fruit on the table as a sort of monochrome still life.

Jack spoke up. "We had the fortune of having green beans last week. In November!" His mustache gleamed in the chandelier light as his voice grew animated. "A new refrigerator train car—all the way from California. Such a long way for a small bean." He leaned in close to the children. "But delicious." My father-in-law looked interested but at a certain remove, more focused on the fruit at hand than

the news. Jack had been taking on more and more of the East Indies business now that his father was slowing down.

"And now bananas," my father-in-law said. "Here it is edging on winter, and we have a hot-weather fruit." He shook his head, amazed.

"Lorenzo Baker's a Boston man. A captain," Jack said as he broke off a yellow finger for each of us.

We held the fruit in our hands but had no idea what to do next.

Julia examined it. "Shall we slice it?"

My mother-in-law turned hers one way and then the next as though it were a glove and one end opened.

"Surely we don't eat the skin," I said. It was tough but smooth, appealingly colored like the thick cream at the top of fresh milk or the delft-blue gloves I'd sneakily taken from my mother's room and worn as a girl. I held the fruit as though checking for instructions.

Jack turned to Julia's husband. "It's rather fascinating. Captain Baker's got big plans—importing this, and perhaps other fruit. He's starting with these because they ship so well—look. Nary a scratch. Tropical Trading."

The men continued to talk about business, about Baker's plans, about the ideas of men who were not even present, while Julia and I set about cutting through the thick yellow skin until all of the children had an array of rings on the plates in front of them, using fork and knife to separate the outer inedible layer from the soft center.

My mother-in-law watched and said nothing but held her banana on her lap as the men talked around her, words of shipping and import flowing across her as she sat placid, until suddenly she snapped the banana and the peel burst open like a day lily—offering its fruit right there.

"No fork and knife needed, I suppose," she said, and bit into it with a smirk. I smiled at her small act of rebellion—using her hands to eat. She raised her eyebrows back but then put the fruit on her plate. I continued eating mine.

After the fruit, Julia readied her family to depart for Boston—she had received a coveted invitation to the Patriarch Ball in New York and needed to decide her wardrobe. I did not begrudge the lack of

invitation; Jack had assured me that so much of the list had to do with corporations, a business gathering masking itself as a party.

Julia gave the children extra bananas to take with them, and after our goodbyes, I allowed myself to be led away from the adult chatter by Harriet's boys—now five, seven, and nine—to Green Hill's library with its rows of leather and gilt-edged spines dominating the heavy room.

The shelves were organized and clean but did not make me feel invited to pluck a book out and hold it. It occurred to me that people arranged their rooms the way they thought they should be, as though a matron would come through and give them marks. It was a library and felt like a library, with its hush and oily smell, its Labradors flopped on the wooden floor, and yet I wanted more.

I wanted the green cover of the Alcott novel Julia had given me: Meg, Jo, Beth, and Amy and the line I had recently read—"What in the world are you going to do now, Jo?" as though the book—all of the books in the room—held the answer to that question. I wanted the shelves to call out to me—come here, read this, hold me, learn. I wanted a room to come alive, breath and history and all, and yet I knew this to be impossible.

Instead, I crouched on the library floor, where Augustus played with wooden pegs onto which Julia and I had painted faces. Now Augustus and I gave each one a name and a job, tucked one under the rug when it needed putting to bed.

I felt myself relaxing, enjoying the play until, from the corner of my eye, I saw my father-in-law's stare. Mr. Gardner Sr. gave me a mournful look, the one that conveyed what everyone thought—while I felt I'd made progress, gathered Jackie and the baby-who-would-never-be in the folds of my heart and finally begun to live, the world saw me as sad and childless, a lost and useless button in the pocket of day-to-day.

Harriet's boys and I walked to the large glass conservatory, where I continued to play with them: Augustus, who asked nothing of me but hand-clapping games, Joseph with his book of riddles, and William Amory, who had moved beyond rhymes and, as it was too cold

for hoop and stick, sat across from me practicing his letters but collecting words he found silly. Jack hung back at the entryway. "Shrug, begonia, mopey, Bartholomew, gigglemug—like Uncle Jack," Amory said, and looked at Jack's steady smile.

Jack watched us, and the look remained fixed on his face, but it was a facade, a trompe l'oeil sheathing the still-there fissures in Jack's heart as he took in the lisp, the child's tongue pressed to his mouth's corner from the effort of writing, the small boots.

There were always two parts of sadness, the inner one at truly hurting over not having a child of our own and the sadness imposed on us by everyone else. Society's expectations asked us again and again, do you not feel empty, do you not ache, do you not wish and wish and wish and wish?

I fought off the wrenching crows of gloom that threatened to peck at my scalp, my thighs, my breasts, and fixed myself on the scenery at hand. I would force the room to breathe with me. I considered the winter garden.

"See here," I said to William Amory. He set his ink aside, small fingers mottled like a tiny wildcat, and allowed me to lead him around the conservatory. Despite the gray month and day shucking its few hours of light, the large glass room maintained its airy lightness. "Warm climate plants grow even in winter in the proper setting," I told him. "Chrysanthemum, all the way from Asia." He touched the flower's purple petals, standing shoulder-high to the amaryllis.

"And what flower is this?" He pointed to straggled vines that hung useless as whiskers from a forged metal trellis. "Gray flowers?"

I loved that this child thought dead flowers were still flowers, still worth gawking at. "Those are nasturtium vines," I said, watching him as he tentatively touched the crumbling edge of one. "They're gray flowers now, but in April they'll be dangling orange, vines traipsing down like a waterfall of hair." I made waves with my fingers as though my own hair were the color of Harriet's, copper and sweeping down my back. "Your mummy had hair like that."

"She did?" he asked, but kept examining the vines.

"Yes, she did. Bright and fair, like light tea. Like gold."

His eyes widened. "Gold?" I nodded. "What else did she have?"

"She had a deep laugh, thick as new honey and it came from such a small body," I smiled as I told him.

"And?"

I thought about what to say. I thought about Harriet and how far away she was from me now, and how speaking of her, describing her, brought her back to me. "She had a collection of spoons—one small as your pinky and one large as your arm. I'll ask your father to bring them out of storage." I thought about holding the spoons now, each one cold on my palm, missing my friend and yet having part of her in that collection. "If Harriet had been a flower, she would have been daffodils—crowning the garden with her bright yellow and orange cheer."

"You could make a garden of everyone you know," my nephew said, and took my breath away.

"What a marvelous idea," I said.

"Marvelous," he said, and giggled. "That is a silly word. I'm adding that to my list."

9

AUTUMN THAT year was a reliable mixture of bright, colorful days that made me feel open and alive and other days where dark lurked at the edges and leaves skittled like street rats near my boots. I journeyed to Cambridge and let the carriage drop me near Harvard Yard. I paused, knowing I was not allowed in. I imagined stepping inside, listening to academics talk, and I wondered if I might have anything to add. I considered going in, then figured it would be mere minutes before I would be escorted out. I wished I had the nerve, sighed, and then walked on.

I made my way along the river, recalling my letter to Ted Lyman, who had made good on his offer to introduce me to his cousin, Mr. Charles Eliot Norton, now a professor at Harvard. Mr. Norton appeared to be a man gifted with great intellect and family name.

I thought about Mr. Norton's translations of great works, imagined the texts side by side, how striking the patterns of words must appear, and kept a steady pace until I arrived at Mr. Norton's house.

A small, tasteful placard read SHADY HILL. In front of me the off-season lawn spread itself over a large expanse—there stood in the center a graceful but solid house that seemed so suited to the grounds that it might have sprung up through the earth one past spring. To the sides were outbuildings—a stable, a large glasshouse partly cov-

ered in vines that needed tending, a small pond over which smiled a wooden walking bridge.

Mr. Norton appeared as I was ogling both the sign and the trees surrounding the area—true, the leaves were bare, but I had a mind for summer, when there must be a canopy of elm, maple, and copper beech as dark as plums providing the titular shade.

"What a wonderful spot," I said. "A country house in the city."

He followed my gaze, taking in the grounds through my eyes as we shook hands.

"I was born here," he said. "I'll die here, too." He opened the door for me to come inside. "One ought to be able to choose—at least in ideal circumstances. Don't you think?"

I had not ever considered such a thing. While part of me was caught off guard, there was another part of me that had suspected a world like this existed. A world in which I might be asked questions at the start. That I might gaze upon familiar views in such a way that their owners wanted to see how and what I saw.

"I simply cannot answer you right away."

"Are you not a woman who goes along with popular favor?"

"No, though I hardly think one man's opinion of death is popular favor," I said as I removed my hat and shawl. "However, if you were to give me more information I am quite sure I would form my own opinion in such matters as choosing where—"

"Or how—"

"Or how—to die," I said, and could not help but laugh. "What an introductory conversation."

Mr. Norton returned the laughter. "Ah, yes, hello, good to meet you, how do you want to die." He paused. "Not an entirely off-base communiqué."

We sat in front of a marble fireplace as large as a barn door, the flames already lapping the split wood, a metal grate separating us from the heat. A thoughtful arrangement of tea with both lemon and cream, sugar instead of honey, and a tiered platter of sandwiches, marmalade biscuits, and curves of candied orange rind—such a delicacy—with a tiny instrument shaped like a whaling spear.

Before I could comment, an imposing figure in fawn-colored trousers and a black coat appeared. The heavily bearded man inside them strode into the room, plucked a candied orange peel, and held it like a cigar before turning to greet us.

"Here," he said, and held out a book to Mr. Norton. "I ought to have wrapped it now that snow's coming—yet I did not."

Mr. Norton received the book, turned it over in his hands, and then, surprisingly, passed it to me. Awkward, I set down my teacup as well as the biscuit I had just taken a bite of. The book was emerald colored, decorated in gilt, the pages beveled.

"It's lovely," I said, looking up at the man's enormous cloud of beard.

Mr. Norton nodded. "Mr. Henry Wadsworth Longfellow, please meet Mrs. Jack." He looked at me as though I might correct him. "Mrs. Jack Gardner."

We shook hands, which led to the transferal of candied peel stickiness, which in turn made me gesture to the book with my chin so that I wouldn't ruin it. Neither man understood the gesture, and the book remained on my lap.

Mr. Longfellow blocked part of the fire as he addressed us. "They're binding copies of our translation in red as well as green. Which do you think?"

Mr. Norton sipped his tea and said nothing. I had no idea if this was an act of their friendship, thoughtful pauses, or if I was meant to comment. I made a decision.

"I would have both," I told him. "Surely if there are two bindings, one must have both on the shelf."

Mr. Longfellow regarded me as one might a tropical bird wandering into a cityscape. "I'm quite positive your view is correct," he said, and plucked another candied orange rind, nodded to Mr. Norton, and took his leave of the room without asking for the book back.

A maid brought me a damp cloth for my fingers, after which I studied the binding. "*The Divine Tragedy*," I read aloud, as I traced Longfellow's name on the cover. The interior pages listed James R. Osgood and Company, Boston. "I like to think of this being printed here."

"Not many readers consider the printing press." Mr. Norton took

a cigarette from a case, set it in his mouth, and lit it. Upon seeing my gaze settle on it, he paused and narrowed his eyes. "Would you care for one?" he asked.

I thought of the boat to Europe, the stairwell, and Victor. How lasting that moment of connection felt—two misfits somehow canceling out the term. Here, I felt as though I were being offered an opportunity—not only to smoke but also to join the group: people who entered rooms without pause, people who spoke about death upon first meeting, people who offered women cigarettes or asked for their opinions about books. "I would."

We sat and smoked and spoke of Dresden—where he was heading with his wife, who was pregnant with their sixth child—and art and the translation Mr. Longfellow had just completed of Dante. In the cat's-eye orange of the fire, Mr. Norton rose, took another book from a polished walnut side table, and recited to me in Italian: "'In that book which is my memory, On the first page of the chapter that is the day when I first met you, Appear the words, 'Here begins a new life.'"

I reached out to hold the book that bore his name. I felt the heft of Longfellow's book on my lap and the weight of Norton's words.

"Might you be interested in coming to some of my lectures?" he asked.

"I certainly would be," I told him. "If my presence wouldn't be too shocking."

"I like to think of myself as an awakener."

I looked at the fire. Would someone one day say that of me? Doubtful. "You have the fortune of being male and in a particular position to awaken."

"I hadn't considered that, though it's true." He paused, regarding me. "Being with books suits you. Someone might paint your portrait just as you are."

I shook off the idea. "If I were to be painted right now, I should be unfinished." I tried to explain. "You are an awakener? I am trying to be awakened. Only . . . this isn't a task easily accomplished. At least by me."

Mr. Norton flicked the end of his cigarette into the gaping fire,

where it caught and sparked. "Would you like a prescription for change?"

"If you happen to have one at hand, then yes." I mimicked his action, only my cigarette landed outside the grate and I stood up, rushing to save it from catching on the rug and proceeded to drop the book and rattle the teacups with my bustle in the process. I had visions of being slick and dashing and—well—male, only I had not the practice nor the outfit.

Mr. Norton and I laughed. He handed me the books. "Here. These seem to belong with you," he said.

I accepted the books and his warmth. "I had no such luck as my husband—or you—attending Harvard. I am having to educate myself."

He studied my entirety. "Perhaps you might consider trading gilded gowns for books?" I opened my mouth to protest, but he kept on. "I don't mean offense—I merely suggest that you are a woman of intellectual stature. And opinion. And what a shame to waste both on the nature of silks."

"I am of the opinion that there is room for both. Might I be able to choose a gown I favor as well as a book?"

"Well, I am of the opinion that one can choose gowns or even how to leave this earth." He fixed his gaze on mine. "But I believe that books choose us." He showed me out. "May you be chosen—frequently." I took in the words as the cold gasps of wind seeped through my dress, my bustle, my shawl. "And do come back and see me."

I nodded. I had the feeling this strange and candied afternoon was the beginning of something important—not only my friendship with Norton but a morsel inside me that was rather like the orange rind, bright but ultimately discarded, once bitter but now cloaked in a sweetness that had little to do with softening and everything to do with desire. Desire for more conversation, more books, more questions that tangled and made me untangle my ideas.

"I hope to see you soon—thanks for today," I said, and made my way into the darkening afternoon. When I reached the pathway toward the hill, he called out to me.

"Have you been yet to see the trees?" he cupped his hands to his mouth to carry the sound. I smiled, though he couldn't see me. The encounter was going to end as strange and wonderfully as it had begun. "The new Arboretum. Olmsted's done wonders!"

"I do love a good tree," I called back.

He continued to shout, though he walked closer to me. "Then you'll go mad for this place. Imagine a herbarium with a million specimens. Promise me you'll go?"

"I promise!"

He held his arms out as though he were a human weather vane. "Boston's really coming into its own, don't you think?"

I thought for a moment and then responded as honestly as I could. "I might be beginning a love affair with Boston but . . . it's also part of the problem."

"Boston has you in its clutches?"

"I'm not a woman to be held."

"I daresay I've a feeling Boston might not be able to contain you for long."

How filled I was—with autumn air, with words, with thoughts, with the image of myself in a city I might appreciate and that might love me in return. Words and volume rose within my meager chest. "And I do think you should choose," I told him as I walked away. He cupped his hands but this time to his ear, straining to hear me. I shouted, "We ought to decide how and when we exit. We certainly don't have any say in the matter of when or how we start."

I could see him clap his hands, and I would have returned the gesture had I not had my hands full of books.

10

THAT THE bookshop did not look like a shop was part of its charm. Directly on the corner of School and Washington Streets, its Anglo-Dutch roof made it look as though the building wore a hat turned up at the edges.

As I entered, I breathed in the curious smells: wax, ink, paper's woody burn, the smell of quiet, which I had not realized could be sensed by the nose, but as I made my way from one press to the next, I swore it so.

Towers of wooden crates bearing the stamp of TICKNOR AND FIELDS crowded the interior.

Behind a long wooden slab counter stood a pillar of a man writing in a ledger.

"Mr. Fields?" I asked.

He nodded, and was able to look directly at me while still writing.

"Mrs. Gardner. Mrs. Jack Gardner," I said, feeling my name botched in my own mouth. He did not register anything. "I met with Mr. Charles Eliot Norton some weeks ago. He sent me to you."

His eyes sparked with recognition. "Of course—of course!" He maneuvered his bulky body away from the counter and began leading me around the shop, talking and checking to make sure I was keeping pace both with his steps and his words.

"Norton's saving the review, of course." He checked my face. "The *North American Review*. The literary magazine?" He wafted his over-sized hands around the crates of books. "Oh—and I believe I forgot to say." He stopped abruptly and stuck out his hand until I pushed mine into his. "James Thomas Fields. Mr. Fields. JTF. I almost answer to anything these days."

I shook his hand and opened my mouth like a hungry fish to ask questions, but he took the ledger from the counter, closed it, and grabbed his hat and coat from the rack.

"You'll have to excuse me," he said. "I'm not really here." I must have looked perplexed because he went on. "I've moved on, you see." A veil of gloom came over his face. "Ticknor's dead—Norton's likely told you that? All in the name of books." He settled his hat tall upon his cabbage of a head. "Pneumonia. Caught it whilst helping Haw-thorne." He studied my face. "Nathaniel Hawthorne."

When I did not show emotion, he sighed and stomped over to a shelf, reaching high up and grasping a book.

"He's ill now himself," he said as he brought the novel down for me. "You'll be wanting to see that."

I wanted to disagree—only because I did not like being told what I wanted. However, I found, holding the book with its serious blood-brown cover, the title page in red-orange ink, that I did, in fact, want it. Tucked into the pages was a printed sheet of information for the seller. I read aloud from a review, ". . . glows with the fire of a sup-pressed, secret, feverish excitement . . . a fire that neither wanes nor lessens, but keeps at its original scorching heat for years." I looked at Mr. Fields as I shoved the book under one arm for now. "I was a girl when *The Scarlet Letter* came out."

"It sold out in ten days—the entire print run."

"And this book? Is this one a new printing?" I looked at the book again.

Mr. Fields shook his head. "No—that one's mine. My own from that initial run."

My interest was piqued. "And might I have it?"

He looked at me. "I'm not here—as I said. I'm moving on from

the retail side of books, you see. So you may not have it, as you say. I merely showed you that copy, but there are other, newer versions."

I felt a resolve building. I kept my face neutral but my voice firm. "I don't have interest in the new ones. I wish to have this one."

Mr. Fields grabbed at his beard: a habit some men had the way women worried the edges of their gloves. "You know Mr. Norton. He's one of the finest minds around, and he tells a story besides. Perhaps you can explain why this book—my book—should belong to you?"

I breathed in the quiet again and quickly arranged my thoughts. "There is the story within the book—Hester Prynne, her predicament, which I have heard about, though I haven't read the novel myself, having been, as I mentioned, young and in Paris and altogether . . . removed from the world of American literature. That story is available to anyone who might have the ability to read. Or listen, I suppose, if one were read aloud to." I held the book out to its owner. "But you see, there's another story. The story of you. Of this place. Of Mr. Ticknor, who you say is deceased. Of him knowing Mr. Hawthorne and traveling with the author and succumbing to death in so doing. But the book survives. This actual book, I wager to guess, has been held by the author himself, by Mr. Ticknor, and by you. And now, by me." I wriggled the book to see if he would bite and snap it back. "I want the story and the story's story."

The quiet engulfed us for a moment, and I waited with racing heart to see if he would snatch the book away.

He stomped to the counter and took a slip of paper, writing on it. He came back and presented it to me.

"There," he said. "An ordinary receipt of sale. For the grand sum of zero." He reached for the book, and I felt a twinge of pain at losing it. But he didn't take it from me, instead he put the bill into the pages. "The story's story has a story."

My grin was as wide as the book's pages. "Yes. I believe I shall keep it in there. Thank you kindly." I paused. "There's another book I'm hoping to find."

He pulled on his heavy black coat. "The next one's going to cost

you. But you're free to look around. Ring a bell and someone will come—eventually—and tally up your bill."

"And put the bill in the book?"

"That is up to you."

I pressed him further before he could leave.

"Margaret Fuller," I said. If I were headed into a land of books and knowledge, I ought to be prepared.

With his coat over one arm, he stomped again to another shelf—this one wedged behind a crate. "Remarkable woman," he said, when he located what I had asked for. "*Woman in the Nineteenth Century.*"

"It's very plain," I said.

"Some are," he said, and, shaking my hand again, departed.

IN THE carriage home I read Margaret Fuller's words. I read about men and women and the struggle for equality. I read much of the book and then skimmed through papers someone—possibly Ticknor or Fields—had kept inside the pages: a clipping about the Married Women's Property Act, recently passed. I thought of my own situation, whether I had my own money, or wages, or property—the books themselves, whether they were mine or always mine and Jack's. As the carriage bumbled on cobblestones and dodged ruts, I imagined Fuller setting foot into Harvard's library. How she had the reputation for being the best-read person—not woman, but person. Another clipping revealed her relationship with a Mr. Giovanni Ossoli—and her time in Italy as a revolutionary and a journalist. And her child with Ossoli. They had not married. I raised my eyebrows, though no one was there to see me.

And I read of the three of them—Margaret Fuller, Ossoli, and their child—making their way back to America, a small triangle of revolution, and the shipwreck fire that engulfed them all.

I arrived at 152 Beacon with my arms full of books, thinking of Margaret's body that was never recovered. My arms ached with the heavy spines against my chest, yet I felt a lightness knowing I had objects that were mine. I would find the perfect place for my books

at 152 Beacon: a shelf where they would socialize back to front. The whole act felt hopeful; my brother, David, had died only weeks before. As with my long-gone sister, there was little grieving, little discussion. I buried my memories of him in my purchases, placing between the pages a quick sketch of my David Stewart with his mouth made charmingly small, a trick from our childhood. I slipped the bill of sale in the book—9th November 1872—as a record of my own day as I thought about the weight of Margaret Fuller's story, the weight of the books in my hands, the idea that all objects held a story within. And that housing books might make my own house feel larger.

I STAYED up late reading, holding in my hands pages with words whose order other people had determined while Jack read next to me. I paused, my head alight with ideas when, from the corner of my eye, I saw a flicker.

Jack was by my side as the Boston streets seemed to explode with color. We rushed in our bedclothes to the bay windows in the living room. Below, on the street, were throngs of cattle, masses of people shouting. Down the street I could see flames licking a few mansard rooftops with their sloping sides.

"The fire boxes?" I said. The squat red boxes perched cheerfully in various places in the city. Jackie had liked to hold my hand and go around them.

"There must not be anyone with a key," Jack whispered in horror. They kept the fireboxes locked, giving only certain citizens keys. It had seemed reasonable.

"Where are the water horses?"

Jack placed his hands on the window, shocked. "I read earlier this week. They're ill. Epizootic flu, the paper said."

I stood on tiptoe and then climbed onto a chair and could see farther away an entire block of flame, the reflection rippling in the river.

"We'll be like Chicago," I said as I noticed people coming out of their houses to spectate.

Jack turned to me. "It will be one for the books."

The fire bells sounded. A loud blast made me jump. "Do we need to leave the house?" I asked.

Jack shook his head as he held my arm. "The brigade will pound the door if we must."

I held my book as Jack and I watched the world burn, worrying about local lives that might perish. I pictured Fuller's body floating. I pictured Longfellow watching the blaze, perhaps watching it with Mr. Holmes from Beacon Hill. Perhaps they would write about the fire and I would collect their words, for it seemed to me that the words—in English or Italian, French or Latin—were tiny life rafts in the water. Or they were water themselves, hurling at the fire. Whatever they were, I felt right then that words could be captured into books, that those books would save me.

As the sky seemed to catch fire, our exterior world burning, I found myself drawn to Jack. He watched me approach him in a way I had not done since trying to become pregnant. I did not think of the gaps between us, of the uselessness of sex when there is no goal of making something other than pleasure. As I walked to him, the sky changed from orange to deep red, the color of raw honey, the slick of which I imagined him spreading on my skin with his wide hands. I clutched him to me, my mouth bolted to his, moved against him as his hands gripped my waist, my breasts, his fingers inside me as though he alone could bring me what I needed.

I did not apologize as I might once have thought to do. Perhaps it was possible to stoke physical desire with the hunt for objects. Or it was possible I was the sort of person who could not separate the strands of my own wanting—if I wanted a first edition of Dante Alighieri's *La Vita Nuova* to go alongside Norton's translation, then I also wanted Jack in my bed. And if I had the book in my hands, owned it and knew it now as my own, well, then I might also want my husband on the floor.

He looked outside again; the glowing sky cast shadows on his face. He seemed older. I had thought of him as so solid as to be unmovable, but his voice filled with lightness, with a quiet joy. "I am not to be your world, Belle. And how small of me to think I would be. To wait

for that." He looked at me. "You clearly have desires—some I fulfill and others beyond my capacity. And so I will bring the greater world to you."

"And I will take it."

15th April 1874
Hôtel d'Alsace

Dear Mr. Norton,

Or should I address the post to Art History Department Chair—what an exciting position and well deserved. As luck would have it, your letter announcing your news arrived just before we set off for Paris. Now that we have arrived for our brief stay here, I have just enough time to respond before we go tonight to the art exhibit you suggested and before departing tomorrow for the Middle East . . . excuse the haste of this—

But the point of this note is to write—although I feel it worthy of a scream—that I have succeeded. At the auction you kindly noted in your letter, I positioned myself and have paid £2.13 for a stunning addition to my now quite growing collection of books. I had not intended to amass rare books, and yet it seems I have a knack for finding them, for searching and digging (for I certainly do not mind a bit of dirt or grime on my gloves) to find what—at the end of the day—needs to live with me. As a result, I've also found the competitive sport of bidding, which Jack was witness to last night at Sotheby, Wilkinson & Hodge. I enjoy this sport, even if it might not be my life's calling, and, truth be told, books have brought solace to me for some time in my personal life.

And now—imagine a gorgeous slab of rock set ablaze and you will know the book I now own. *The Divine Comedy*, crimson leather (crimson! I ought to bid for Harvard!) and gold, scalloped edges, hand tooled, those Venetian gilt edges so gleaming I might have to face the book backward on the shelf. And that would be my choice!

I shall have to end this letter abruptly, as the carriage is here to take us across to the art exhibit—how bohemian one feels, especially after reading the review in the paper. It should be noted

the review was heavy in its sarcasm, describing the impressionist exhibit as a show of five or six lunatics—and one of them a woman. A group of unfortunate creatures, they say. I admit that while this made Jack less inclined to see the work, it only pushed me faster out the door.

I do hope your family and travels find you well.

<div style="text-align: right">

Sincerely Yours,
Isabella S. Gardner

</div>

II

"You say they call themselves the Anonymous Society?" Jack said over his shoulder to me as we climbed the stairs. Others climbed with us, and still others descended the stairs, investigating us as we examined them. "Surely someone has a name."

The artists had borrowed a photographer's large studio not far from Place Vendôme. "The studio owner is Félix Nadar," I said. "Mr. Norton says his full name is Gaspard-Félix Tournachon, and he's known for any number of talents—photographs, cartoons, even hot air balloons." In my excitement, my words came out rushed. Jack, less enthused, lumbered.

Jack paused and smirked. "That's a talent?"

I smirked back. "If the papers call it a talent, so it becomes."

Nadar's studio was quite a space: a large building on one of the grand avenues, his name in oversized script announcing we had arrived. Jack and I continued to follow a line of visitors up the stairwell, my skirts gathered as my bootheels clanged on the metal stair treads. I slid my gloved hand along the length of the worn banister, searching out ruts and old paint splotches as though they might tell stories.

Past a trimmings salon—buttons and tassels awaiting their dresses, a garment manufacturer, and then double doors opened with

gales of laughter and smoke wafting like the perfect breeze of a season I'd never known.

Jack was immediately absorbed into the room in a burst of smoke and suits. My excitement waned as I felt the familiar illness of unbelonging. A sort of mute emptiness, as though I'd already been cast aside, rumpled as day-old newspapers, until a hand gripped my arm.

"Welcome, welcome. I'm Berthe Morisot. And you must be Isabella. You don't mind if I call you that?" She wore a dress with its natural form—no bustle, not even the style of a shrinking one—done in green the color of autumn moss after a rain. The dust ruffle at the bottom had protected the dress but suffered from its surroundings, having on it evidence of wet paint. This was not a room designed for women, and there were few of us in it.

I went to say Mrs. Jack, or advise her to call me Belle, as though she were Julia or Harriet, an old, easy friendship, but I found I did not correct her and tried to take in the busy room with its high walls set with paintings of various sizes, of men clustered like odd machinery parts, grouped together and impossible to figure out.

Berthe pulled me in, and after a warm wave to her husband Eugène, she broke through the cluster of men and introduced me to her brother-in-law, Édouard Manet. He hung back behind his beard and watched as people maneuvered through the exhibition. Berthe and Eugène had married late—she was thirty-three at the ceremony, she said—and yet what did that matter? Here she was a painter with an exhibition.

Berthe was swinging me around with quick reminders as to which name went with which man, when we quite literally bumped into a man with a narrow face and somber eyes. "Edgar Degas, I should like you to meet Isabella Gardner."

He nodded. "I've just had the pleasure of meeting your husband."

I could no sooner respond when Berthe twirled me around like the dancer in one of Mr. Degas's paintings; two were on display, and both showed dancers in practice clothing rather than the glamour of performance tulle. I nudged my way toward Berthe, only to come

side-to-side with a portly form. Berthe whispered to me. "Claude Monet. He's calling to you."

Mr. Monet waved me to his canvases, and in the midst of the twirl and smoke, I gasped.

There in front of me, captured as though my own eyes, my own hands, my own heart had any jurisdiction over oil and canvas—was sunrise over water. The Thames? The Charles? The specifics did not matter, and his title reflected the vagueness. The quality of realness infused with sadness. An understanding of each sunrise being someone's last, each wave pushing the color until it made one wonder if we understood color or water at all.

I turned to him and could not hide the tears welling.

"You understand, then," Mr. Monet said, and didn't press for more.

His was the painting that inspired the exhibition—*Impression, Sunrise*. Just an impression. And yet a solid thing. Our understanding of a moment without the need for distinct edges and crisp lines; I could have stared at it for hours.

But then Berthe had me by the wrist again. "You remember Renoir? And this is our friend, Mr. Camille Pissarro." She whispered, "He's rather our director, our leader. He's the oldest—forty-three!"

"There are so many," I said. I had not been to this kind of gathering before, and I could not help but smile, understanding I would not be criticized, ridiculed for my dress or comments, that the only social structure was not to have structure. Perhaps, I thought, I had found a different sort of dinner table—one at which I belonged.

"Nature without glamour," Pissarro said to Berthe. "That's what you have."

She looked at me. "He's kind, isn't he?"

"Morisot!" A woman in yellow from hat to foot burst across the room, and she and Berthe clutched each other and spoke in rapid French.

I turned to Mr. Pissarro and gave him my full name. "Only three names, I'm afraid."

His expression was flat. "Jacob Abraham Camille Pissarro."

. . .

"I CAN barely keep up with the dropping and changing of names here," I said.

I tried for the usual niceties—how pleasant the weather (is it?— he questioned), how lovely the turnout for his show (I cannot claim the show, he said), how natural his paintings.

"Yes—natural! That's exactly what I mean to do." He peered over his glasses at me and then removed them entirely as though they were someone else's or made his vision worse. "What relation have you to art?"

The question wrapped itself around me, uncomfortable as thick gauze in heat. "Am I supposed to know the answer to that?" My eyes roamed the framed and unframed art, the portraits, the landscapes, the road dotted with cattle and the islands with solid figures. "I suppose I only know what I like."

"And is that fixed, do you think?" Mr. Pissarro folded his arms across his chest. He was their leader and perhaps prone to asking questions, demanding his people think. "Or does what we like shift as we age, as we acquire experience?" He waited, and when I said nothing he added, "This isn't school. Of course, I don't mean to suggest there's a correct answer—I'm wondering myself, you see."

I looked at his orchard painting, the tree branches reaching skyward, the ground below brown and churned as though just ready to be planted. It looked unfinished, but I did not dare to say so. "The images are . . ."

His eyebrows suggested a dare. I did not take him up on the offer. "Commonplace?" he said. I nodded. "True. And also what I mean to do. And yes, we see the brushstrokes because that's the work I've done. Am I meant to hide what fills the hours of daily life—planting, collecting eggs, washing? Someone must collect the eggs, mustn't they?"

"I suppose so," I said. I pictured eggs appearing before me on the breakfast table. The solid yellowware bowl that hugged the clutch of eggs in the pantry where I rarely ventured.

"You seem lost in thought."

"I only wonder if you were to visit my house—in Boston—if you should prefer to paint a bowl of eggs in the pantry rather than the grand staircase."

He sighed and considered the offer. "Neither. I prefer the exterior. I paint wet on wet, you see. I don't care much for formality. For tradition." With a thick-knuckled finger he pointed to heavy globs of paint on one of his canvases. "Art ought not to have rules. If I want to show the drag of my brush here—" and he pointed again, "or the rut from my palette knife, I will do so. If Manet wants flatness on his, he ought to have it."

"You don't follow rules simply because the rule book is written." A smile spread across my face. "How interesting."

Another viewer tapped him on the shoulder, but he stayed with me a moment more. "We've found a group here. Nontraditional. But a group nonetheless." He paused. "We haven't a fixed name as of yet. And as to your earlier comment, I dropped the Jacob and the Abraham for reasons I'm sure a woman of your intellect can understand." Pissarro's eyes lowered to meet mine. "I want them to see the art, not the Jew."

I reached for his arm before he could turn away. "Are they not the same?"

"Mrs. Gardner," he said.

"Mrs. Jack," I corrected.

"Mrs. Jack, you really do see more than the average human. I do hope you put the sight to good use one day."

One day echoed in my chest as Berthe made her way back to me and Jack gave a tilt of his head from across the room, ensconced as he was with a tall figure in tweed.

One day I would see? And see what, exactly? I was already thirty-four years old. One day I would know my greater purpose? One day I might feel fulfilled? *One day* made it feel far off, as though I were only just dipping my toe into the waves.

I thought of Julia's ease in life, her days that fit as close as formal gloves. Her boys—four now since the birth of Julian Lowell—and

her social order. I looked at Berthe and the whirlwind of her spirit, which contained within it grace and sadness and art and purpose, all sheathed in the act of not being sure what she was doing, only that she wanted to keep doing it.

I wanted purpose. And I wanted to make something of my own.

"I thought I'd lost you already," she said, and beckoned me to where she stood near a sculpted figure: a stone man holding up a mask that was a duplicate of his own face. My instinct was to go to the statue and wrap myself around it, hold the cold stone against my body, lay my cheek on his chest. The feeling frightened me, as though I might not be trusted alone with such an object. Or perhaps it was something else. When I looked at Monet's sunrise I wanted to run my fingers over the heavy brushstrokes, wanted to feel the color—dried but vibrant—on my hands. I wanted, in a way, to consume the art in front of me.

Berthe saw my thoughts playing on my face and asked, "Do tell. Yours is a face that hides nothing."

I blushed, for I wished to be someone who might hide and—until that point—I had thought that I was. "I am merely looking at the art here and wishing—oh, it's ridiculous, my thoughts. If I were to say I feel like eating some of it, I'm quite certain you will ask me to leave and seek medical care."

She laughed with her whole body. "On the contrary. I should think you feel moved. Art makes you desirous. What more could we want?"

And then, seeing a tall man on the other side of the room, she shouted, "Zacharie!" And as we walked toward him, she explained. "Zacharie Astruc, sculptor, painter, and—" Her grip on my arm tightened. "And deadly to look at, don't you think?"

I ventured a stare, and yes, he was a sculpture in his own right. I was glad Jack was not there to see my cheeks color and the quick veil of uninterest I draped over my face to hide any attraction. As I shook his hand, I felt his fingers on the inside of my wrist and imagined his mouth there. These were inconvenient thoughts, and I swept them away, looking around the room instead.

Auguste Renoir sketched with his back to his six paintings on dis-

play as though he already knew the exhibit had been poorly reviewed. Perhaps they all did and the merriment was partly to keep them from throwing themselves into the Seine.

There was Paul Cézanne, whose paintings had nature, too, but a mathematical sensibility—houses, trees, a collection of flowers so dark and dramatic I would have called them a murder of flowers. And then, around a structural pillar, were Berthe's paintings.

She was not cloistered away from the others; in fact, her work was given no special light and no hidden corner. It simply hung. Oil, pastel, even watercolor.

"I use them all, like Degas, though he abhors the outdoors—what use is it, he says, when we have perfectly grand ballrooms, studios, and drawing rooms?" She turned to me conspiratorially. "Degas told me he'd rather paint in a hallway than a field—different perspective, I suppose one might say."

She pointed to the first painting. It was a harbor, placid but busy at the edges.

"'Feminine charm' the journalist wrote when he was here." Her face fell flat. "What do you suppose makes this harbor feminine?"

"I haven't a clue. Your name only?"

"Perhaps I should do as George Eliot does. Have you read *Middlemarch* yet?"

I nodded. "I have it on my shelf, actually. Perhaps that is our best shot—oh, look at this." My gut clenched at the tenderness depicted between parent and child. "*Woman and Child on a Balcony.*"

Berthe smiled a bit, then tucked her smile away.

"You see, Isabella when I paint that, there is no doubting my technique per se, but rather when they talk—and they always talk, for that is partly the purpose of art—they write or discuss how my subjects are women. Babies. Household lives, they say. Are we not all living household lives of some sort? Think of Paul's fruit—is a bowl of apples on a table not domestic?" She tried to smooth her hair at the middle part as though that would soothe her insides. "And when one of them—Cézanne or Auguste Renoir paints two girls under parasols, what are they then? They are portraits of men looking at girls, only we don't see the gazer. Do you understand?"

"So, your paintings are domestic, and theirs are art," I said, and knew it was true before she nodded. "What will you do?"

"I don't yet know. Perhaps I will give in. Paint scenes of dressing gowns and toilette tables with hairbrushes and mirrors without any reflection as my own joke—are we not all reflections of ourselves?" She laughed bitterly. "Or perhaps I will exhibit with them and years from now everyone will know Monet's name and Renoir's and mine will have faded into the impressionistic sunset."

"I'm afraid I do not know what to say. If I apologize it's too much, because I feel as you do. Consider even this building—how nice he loans it to you, and yet . . . he is a balloonist, a cartoonist, a photographer of some acclaim, I am told. So many things a man can be at one time."

"And you," Berthe asked me. "What is yours?"

"My what?"

"What is your specialty? What mark will you leave on the world?"

"Oh—" I felt my heart close up like a fan. Like a book. "Books," I told her, but the word came out as a question. She nodded, but her eyes questioned mine. Were books the answer, or was I somehow burying myself in someone else's work? I chewed my lip, unsure, and I took my leave to find Jack.

He stood next to an imposing figure who wore folds of tweed, a staunch black necktie. A man I did not recognize. And yet as I edged my way over, the figure turned and contradicted the outfit—for she was a woman.

"Île flottante—my favorite," she said. Her voice was strong, though she herself was stooped with age. I took in her serious face, her fixed gaze, her dreamy expression as she took a bite. "Clouds of meringue in shallow puddles of crème anglaise. Perfection, don't you think?"

I tried the dish for myself, dipping a silver spoon into the silken fabric of whipped sugared egg, the barely warm custard below.

"Miss Dupin is a writer," Jack said. "Miss Dupin, please meet my wife."

"Does your wife have her own name?"

I laughed and felt the cream on my lips. "The wife does," I said as

Jack blushed. As I stared at her graying hair, her dark eyes and wide face, I knew her identity. "Far fewer than you, however."

Jack's innocent interest seemed childlike in comparison to her poise. "What is your full name? Is it not . . . Dupin?"

It occurred to me then that Jack—solid, kind, wealthy Jack—had been born into a particular world. And he thought my world was the same. Yet Jack had experienced no shunning, no tempering of his words for polite society. True, we both had grief within us. But Jack was here, in Nadar's photography studio and, unlike at the dinners and the clubs and the tables where he most certainly belonged, in this place he was the odd man out. And this woman in a man's clothing was not.

"Amantine Lucile Aurore Dupin," she told Jack. And she smiled at me and shook my hand. "George Sand." She brought out a rolled cigarette and, to Jack's surprise, put a match to it. She exhaled and said to me, "Call me Aurore."

I turned to Jack, who seemed not to recognize her name. "George—Aurore—is a novelist."

Jack regarded the novelist's attire—flinching so that only I, his wife, noticed. He did not care for the men's clothing she wore. I ignored him.

I studied her. Her air of confidence. How she accepted herself. How she stood, strong as architecture in the space. She tugged at her jacket. "I'm not bothered at markets. At pubs. At clubs. And it's cheaper besides." She turned to me. "I had my portrait done here. After Chopin died. Nadar had me in my regular clothes. Champion for that."

"I should like very much to see that photograph," I told her. I wanted to own that photograph. Oh, how I admired her surety. As I breathed in her smoke, her male fashion, her aged face, I wanted to breathe in more of her. To keep part of her for myself.

12

25th September 1874
Jordan

Dear Mr. Norton,

I should like to inform you that I have hunted and captured Dante's second volume. Perhaps the binding is not as perfect as one might have hoped, but the Italian details are to be marveled at. I have had the book shipped to you to appreciate whilst I am away.

Presumably you are in receipt of my tome of a letter following the impressionist exhibit—for that is what the papers are calling that group now. They are also calling them failures; the work appears unfinished. I admit to feeling this same way viewing some of the work, and yet, upon further looking, I wondered if that might be the point. And if not the point, then perhaps the failure lies with the viewer for not seeing the work as modern and intentionally nontraditional. We must look more closely at things, don't you think? I've thought countless times about the end of the exhibit, my conversation with Berthe Morisot, of her painting *The Mother and Sister of the Artist*, which had hung between Cézanne's *A Modern Olympia* and one of Renoir's, which was of a dancer. Berthe said that she'd painted her pregnant sister, tried to disguise her misery with fabric. And there she paused, glaring at her brother-in-law Manet. She told me he'd come to see this painting

of hers, declared it "quite good." But then he took her brush and proceeded to repaint her very own mother. And then expected gratitude because of course he had helped her. Once I knew this horror, I made Jack go back for one more look. I could see it: the sister's white dress and hidden condition, the floral fabric on the settee, the purple flower limp over the vase, and—altogether different—her mother in black, book in hand, face detailed and pointed with malaise, her cheek reddened as though she, too, were embarrassed for Berthe. I admit I felt for her—who wouldn't? Her teacher, Camille Corot, told her painting would be a revolution for her, that there is glory in revolting.

Perhaps I feel this, too. When I think about her painting, I feel chilled that Manet's work would always overlap with Morisot's. If critics dislike it, the failure is all hers, even though the work is not. And if the critics adore her, she can never be sure whose talent is reflected.

Oh, Mr. Norton, would I be collecting books without your suggestion?

I PUT MY pen down. The desire had been there, but the kick forward was his doing. I remembered the last words Berthe said to me. "Men tell women who they are, and the women believe them."

I signed the letter and looked at Jack who was preparing now for a bath in the Dead Sea.

"Will you join me?" Jack asked.

"Of course."

Jack looked at the letter from a distance. "Mr. Norton is the lucky recipient of your outpouring?"

I thought back to being a girl and seeing painted nudes in Paris with Julia and her younger sister, Eliza. How scandalized they had been at the bare limbs, arc of arm, the thrust of leg. How I had stared and enjoyed it. Perhaps we were already the women we were to become. Perhaps we were all born with a certain degree of yearning. I thought back to the colors of my Worth dress and standing with Jack before the enormity of *The Rape of Europa*.

I did not wish Jack to feel left out, so I tried to explain.

"One feels as though there exists a private conversation happening with the viewer and the paintings—I step into their story, and they step into mine. I could have stayed for days at that impressionist exhibit. Weeks."

Jack nodded, thinking. "Perhaps you should have bought one—then you might look at it here, with me."

I looked up from my pages. Jack lacked the allure of the impressionist men, their cerulean splattered palms, their waxed and wild hair. My husband was not a visionary. But he was human and he was mine, no matter which hall or house or boat we were on. And he cared. He wanted me to be happy, even if he did not always understand what might make me so.

"I should very much like to have that art."

He chuckled as he readied a towel. "All the art?"

I laughed with him but met his gaze. "All the art."

WE TRAVELED, seeing landmarks, settling into familiar routines—tea, strolls—in unfamiliar places. Perhaps this was the point of travel, keeping bits of daily life to ground us while feeling also altogether stretched at the wideness of the world. How I might find myself while exploring the Middle East.

I took to keeping a journal—poorly—dashing off entries that remained unfinished or simply bled one into the next as we made our way through intense heat. I gave myself permission to scribble or only keep a few lines. What I wrote was not art left unfinished like the paintings, but I tried to employ the same lack of fixed rules the artists had.

Jack doesn't care for Jordan; feels it was filled with flies.

I admit I left him swatting at them and made my way to the riverbank with the bottle of lemon spritz we'd had at lunch—sour to cut the heat—and when I had finished it, instead of throwing it into the river as others had done, I filled it with water from the River Jordan, sipped it and filled it again, and managed to find a local boy to help seal it with wax and wood so that I might take it home.

Of course, Jack met this action with amusement and a lesser ver-

sion of scorn. "So many works of art to ponder and buy," he said, "and you bring home a bottle of water."

"I like what I like," I told him. For isn't this the way collecting should be, finding our own sacred relics?

We are leaving Palestine and its unchanging biblical moments. On to Syria.

Now in Tyre. Palms, obelisk, a few ships uncommitted in the harbor.

We have received word from the consul that Damascus will have to be skipped—for a cholera outbreak has struck. Wrote to Julia letting her know we viewed the place from safe distance—high upon hill. "We breakfasted and feasted our eyes, then plucked the strength of mind to turn our backs."

Baalbek—camped in grand courtyard of the temple!

Oh, our tents under Cedars of God in Bsharri. Queen Victoria wants to surround it with a high stone wall to protect the saplings—from what? From goats. Demigods and humans battled here—if you want to believe it. And I suppose I do. "If they fought anywhere, surely it was here," I said to Jack.

Tree giants and their offspring in Ouadi Qadisha stunned both of us as we stood dwarfed among them. Words are insufficient, one finds— how I wish I were a painter, for the images in my mind are exact and perfect.

June 1875

Dear Julia,

Nearly halfway through 1875, and we have reached Smyrna, where we shall board a steamer for Piraeus—

I stopped journaling and correspondence when the heat grew too much and when I grew ill from some piece of fruit that did not agree with me. I lay in bed, damp and miserable, wondering if this was a sign of things to come. Even after my stomach was restored and I was able to return to travel, a feeling of doom shrouded my mind.

AN OCEAN of sand.

I stood amidst waves as though I looked at water and only then realized I'd seen it incorrectly. And perhaps this was what I was learning—the moment I thought I understood myself, the world shifted from water to sand. The desert view of Monet's work.

I put my foot in the sand and felt it give way—solid and shifting at the same time.

I was good at noticing details: each bright poppy, curve of lip, particular typeset on a page. But faced with the great expanse of emptiness, I felt those larger dueling emotions, of contentment, which is always only temporary, and sadness, as I was always aware of everything being ephemeral. Such were the thoughts at the end of a journey—for what was I here and what might I be returning to?

And yet here was this sand.

Layer upon layer for so many thousands of years, layers that would outlast me, outlast the camel herd, everyone I had ever met or would meet. The sand would ripple and move but remain here, empty and fine, prone to ferocious windstorms that produced pink-hued tunnels and prone also to undoing those tunnels, seeping back grain onto grain.

Ahead a figure approached me, likely bringing me back to the tents for dinner—lamb stew cooked on an open fire and portioned into bowls so we would eat with our right hands.

I gave a small wave to the figure, who, as she approached, appeared to be floating on the sand, as I could not see anything other than her eyes and the top of her cheek. She looked misshapen. Her outfit gave the appearance that she had not stepped into it the way one did a gown but rather that she had been wrapped in it—gauzy muslin

that sheathed her body, her shoulders, her head, her legs. Upon closer inspection, her misshapen form was due to a large bulge across the front, and I wondered if perhaps she had her arms crossed over her chest in a small stance of defiance, which made me smile.

When we were face to covered face, she saw my focus on her form. She returned my smile—two women alone in the desert exchanging wordless conversation. From under the folds of fabric, the mere slips of cotton, the protrusion wriggled, and she managed to extract an infant, naked to the air and gorgeous as the sand and sky. Without warning I felt my heart buckle. The woman locked my gaze as I could not fight the tears welling in my eyes. She pushed the baby to me, and though each and every motion came with exquisite pain—for this was what I would never have—I held the other woman's baby. I held, for a moment, other lives I would never lead. The tiny fist circled my pinky, the infant's silken belly warm and full.

I closed my eyes to the sun, which slipped down behind the far-off dunes. I allowed myself to be given over completely to this baby, who would grow and become someone I would never know nor see again. I imagined us—the woman in her muslin wraps, me in my impractical Western apparel, the naked baby, the soaked-tea expanse of sand—as a painting. One I would only have in my mind.

And then she took the baby back. I felt my childless despair, the utter emptiness of my arms, the space around my body against the enormous continent of sand. As was the custom, I was offered a small welcome gift, a bolt of fabric, folded and woven, the color of old blood. She waited while I unfolded it into a square that billowed in the wind, growing bulbous and then concave. In the center, going through to both sides, was a gray square into each corner of which was a woven a cluster of small diamond shapes, some blue, some black. I thanked her and clasped her outstretched hand. We trekked in the wind, which held us in a quiet tunnel, toward the tents for dinner, where she would not be allowed to join us. I went to join Jack, looking again at the vast sheets of sand, wondering what more I might do with my life, if I might one day be part of something bigger.

· · ·

DINNER WAS warm lamb and rice pinched between thumb and fore-fingers as demonstrated to me. I had just put the bite in my mouth when a tent flap opened, allowing sand and wind inside, which in turn created commotion with the staff, a storm of words and language I wished I understood and yet caught the meaning, for what else to say except *you are interrupting dinner and letting sand in.*

"I have a telegram," the intruder said in British English, formal, though he was barefoot. He approached me but then turned to Jack, who sat next to me on the carpet that had been carried, rolled, and set unrolled upon the sand.

Jack wiped his mouth and stood to receive it.

As though he and I had no language between us, he read the words and then passed me the note so I might read it myself.

<div align="right">

Julia Gardner Coolidge
Boston, 1875 June 11

</div>

Dearest Brother,

I have hopes this will reach you and Belle—indeed we have telegrammed to all of the locales where you might be. There is no other way to relay this tragic news than to tell you this: our brother Joseph is dead by his own hand. You and Isabella must return at once to Beacon Street, where Harriet and Joe's three boys—your dear nephews—await you both. You are to be their parents.

<div align="right">

Ever yours—
Julia Gardner Coolidge

</div>

Intermezzo II

WE ARE more than the sum total of every object we keep—portrait, landscape, photograph, lock of hair, shoe, teacup, letter, set of empty chairs, enameled mother and child, fabric swath. But inside me each of these things has roots.

Where you thought there was no more space, I found room for more. For that first self-portrait that started it all. Rembrandt was twenty-three when he painted himself in a scarf and ridiculous hat. I know you told me to respect the cap, but it's plump and bejeweled and frankly awkward, because who are we at twenty-three or thirty-three or beyond; who is to say when we are fully formed?

And who was I to think I'd found my next self then? Are we not always finding our next selves? Isn't there hope in the *us* yet to come?

Consider that painting I saw in Paris after the Worth fitting: such a large sum, yet I knew from first sight I would one day own it. That I would morph into the self who would wake and look at the painting everyone else wanted but that I got. It is Ovid's *Metamorphoses*, and I am it. Undone, stolen, brought back, revised, playing, birthing my own Minos.

How can I describe it? The feeling of knowing something is ours. We like to think of these connections as happening in linear fashion, but in truth it is a crazy quilt of meeting and distancing and meeting

again until finally owning what we somehow felt was rightfully ours all along.

Perhaps I felt that about Crawford. That heady desire. I knew I felt that about the painting. I lusted after it. I needed it.

Just as I needed Botticelli's *The Story of Lucretia*, and I found exactly £3,000 for it, even though Lord Ashburnham wasn't keen to sell it. My desire prevailed.

What I mean to say is after I am gone, all of my desire will remain. My wantings always evident because I have made it so.

This is what I want you to know: life is not over when you are in a gaping expanse of desert with the sun slipping away and someone else's pity is your companion.

Wanting resuscitates us.

Life is not over in your middle years. For many, this is when we arrive as ourselves in the world.

Remember the shorebirds on the deck the one time I emerged from my cabin on the return trip from the desert to the UK to Boston? I sat hunched and cloaked with the woman's desert shawl around my shoulders, pulling it tight around me as the birds screamed. Were they terns? Cormorants with their prehistoric wings? Some other glass-caged stuffed animal from Lyman's lab? How they squawked. Communicating in some song I did not understand, but now, when I close my eyes, I can hear their refrain: *there is more there is more there is more.*

BOOK THREE

❀

Isabella

1877 ❦ 1884

I

17th July 1877
Alhambra
Beverly, Mass.

Dear Julia,

I write to you from the "Gold Coast" of the North Shore, with
its perfect lawns and high walls that surround mansions and
pedigreed inhabitants. But I shouldn't be critical. It was wise of
Joseph to purchase Alhambra after Harriet's death, for I know the
estate brings the boys joy, more so now with their father gone, too.
Two years in and you mustn't worry: Aunt Belle is still a natural
fit as substitute parent, even in summer when there's no school
and we are together all day long.

Many afternoons I take Augustus—Gussie now at age eleven—
for boiled sugar sweets at a small, fenced shop by the water. As
you are the far more experienced mother, please do not scold me
for this habit. For we are not only plying ourselves with sticky
treats but watching them make it; Gus is quite a serious child,
and I've felt it my honor to show him small joys. For what is life
without small, daily pleasures? So we watch the confectioners boil
apricot, lemon peel, green citrons. Such colors they are nearly
paintings in progress. We stand back and hold hands as they tip
the copper pots, spilling hot contents onto large trays. Gussie

leans forward each time as they roll and calm the now-formed autumnal haze of sugar into flatness and then deftly slice it into ribbons, which we then indelicately lick and chew all the way home.

We bring one sweet stick to Amory, who is the most social of the three, thirteen years and drawn to anywhere there's buzz about. He's bright and sharp; when William Amory refused to practice penmanship this summer, I mentioned it in a letter to a writer I met briefly through Charles Eliot Norton. This writer, who never finished Harvard Law, had a story in the *Nation* that I thought showed promise; his name is Mr. Henry James—and he urged young Amory to practice penmanship so he might also one day be a great writer. Certainly, the encouragement helped, and Amory is far more inclined to write if there's professional praise involved.

I appreciate you asking after all the boys—most pointedly Joe, whose sixteenth we celebrated recently. He seems to have made it through the tragedy of losing both parents. That said, he's private. Sometimes I find him outside, croquet mallet in hand, but instead of preparing to thwack the ball, he stares into the distance. Will I ever know what he ponders? He is always thinking and—no surprise—I am drawn to him for this.

Joe is not distracted by the glut of parties and the social set here; I confess I've found it a relief to be otherwise engaged. I've been busy with the boys—for I take my role with great weight— and I admit I've been lax in attending any dinners or fetes. Not that there are many new faces to meet here. And not that I am much missed.

Surely there must be a word in German for the act of leaving home with the purpose of a change of scenery, only to find one's whole life has made the same journey to the same place? How did I not know the six-block radius of people around 152 Beacon were also in residence on the North Shore? At the topiary park it's the same faces and strolling the garden or Beachwalk paths are the same calling cards. It feels like the anchor Amory likes to throw over the side of his little rowboat, a sudden tug downward. So many are content to ride a continuous carriage between Boston

and Beverly and back, trading houses for the season, perhaps venturing to Newport, but for what?

Am I doomed to my own ponderances like my dear nephew Joe?

I cover my own intellectual itchiness and his gloomy tendencies with a ride daily. Nature is a salve for him. Do you remember that autumn at Green Hill when I taught all three boys to ride, and you thought me heartless because I refused them saddles or gear? I am proud and not a little bit smug to say riding with only a blanket and girth made them strong riders indeed. Denying them the saddle initially firmed their seats, gave them control.

I suppose I feel a bit like that with the social set. Denied denied denied. And now feeling more firm about it—tall in the saddle am I. But it is easy to feel this away from Boston, with the boys a living garrison. Oh Julia, I admit I was at first horrified that you and your other siblings chose me as mother for the boys simply because I had no children of my own, as though that were the sole requirement—empty womb!—giving no regard for my ability in that realm. But I forgive you all because regardless of why I was selected as mother-in-place for Joe, Amory, and Gus, I love these children. Be assured, Jack and I attend to them as our own.

Jack has likely just brought to you a gift from me: a book of poems from Julia Ward Howe. She is now to live at 241 Beacon Street; I can barely contain my thrill! I am still collecting books, though increasingly wondering if it will sustain my interest. I hope you will find Mrs. Howe's work to your liking. Inspirational words. She visited here in June, celebrating with purple punch and various jellies the sweetness of Mother's Day for Peace, for which she herself is responsible. Such a wonderful proclamation. I found myself quite roused by the idea that all over the globe perhaps women might think of and support one another—can you imagine? It is difficult for me to think of Boston in that realm.

I look forward to our plan for a September outing in the Public Garden! Perhaps Boston is more creative a place than I give it credit for. Or perhaps I simply need to establish my place in it upon my return. Ever Yours, dear friend—Isabella

. . .

ALONG THE banks of the Public Garden lagoon, a line of large-wheeled prams, crowds of women threatened to poke the eyes of the men nearby with their parasols, boys in pink suits knelt by the water, pushing toy boats until they could no longer reach them, and fathers or uncles stepped in with long arms to save the day. As water fowl pecked at the reedy grass at the water's edge, I surveyed my own flock, grateful as ever for my boys and the way we had settled into life together.

"Summer's last gasp," Jack said. He'd been busy all those warm months and continued now, in and out of his office, dinners at his club most nights, which necessitated letting out his waistcoats. Routines satisfied him: he worked and socialized and then returned home for end-of-evening doodlekins with the boys and with me before retiring to his bedroom.

"Summer is always too fast," Amory said. He sighed, dragging a stick he'd picked up on our walk from 152 Beacon. "School."

"I like school," Gus said. Amory hit his rear with the stick.

Joe surveyed a group of young men by the fountain. "What's the point of it?"

Jack bristled. "Joseph." Young Joe's hands were shoved into his pockets as though he searched for something he'd forgotten. "You have this year and then you'll sit your entrance exam and—"

Joe's words overlapped, his voice thick with sarcasm. "And then I'll be a Harvard man." He bit his lip as the younger boys began to frown about the growing crowd around us. I gave Joe a look of encouragement—he reached for my hand just for a moment.

"And is that not a great pleasure?" Jack asked as though there were only one answer.

Joe didn't respond but looked at me, pleading.

"Jack," I said. "These are brilliant boys. True, they've got the benefit of Hopkinson's School, of Latin and Greek, but to what end? I believe that is Joe's point: If Harvard is the only destination for them, their world is already completed. Already finished, in a way."

Crowds jostled Jack, and he grew increasingly annoyed. "Tradition and honor are not to be scorned. Men have a duty to do their best."

"And women?" I asked. Jack cast his gaze away from us and over the swarming park patrons, all clamoring for a place in the growing queue. Joe seemed to wither. "It is my duty to show them the rest of the world, Jack." I reached for his arm. "Of course Joe may go to Harvard; I've no doubt you'll make sure of that—he's got the head for it. But we might also plan a trip for him." Joe perked up. "I should like to go abroad again . . ."

Jack turned. "You've only just got back."

I felt Boston's constriction already. "I don't mean to set sail this afternoon. But perhaps in the new year?"

Jack saw my fixed expression. "Provided the schoolwork continues?"

I nodded. Jack acquiesced. I gave Joe's elbow a quick tug—our secret public motion. He managed a slim smile. Then I turned to the other boys. "Amory? Gussie? Do not think you escape my grand plan of mind expansion." Amory dropped his stick. Gussie turned his small face toward me. "Thursdays we'll continue our outings to the Harvard Musical Association's concerts. I realize the hall's rundown, but the music gilds the edges. And this winter we'll read aloud."

"What shall we read?" Gussie asked.

We found ourselves surrounded by the swarm now, shoulder to back, hat to parasol. "We'll start with Dickens," I said, before someone's errant boot landed sharply on the hem of my dress, and I toppled forward onto the ground.

My three young, blond men quickly pulled me up, and Jack gathered me in his arms. "Are you quite all right?"

Joe brushed sand and dirt from my shoulder. "You've got it on your face, Aunt Belle."

"We should go home," Jack said. "You're quite a sight . . . When you said there were new boats in the park, I didn't know it would be a free-for-all."

"Well," I said, feeling a scrap on my chin, my gloves dirty. I knew

my face would be streaked with muck; my hem had torn. "It *is* free for all, Jack. And that's part of the pleasure." I surveyed the enormous scene: everyone in Boston waiting for their turn on the new Swan Boats.

"We'll be here for hours," Amory moaned. Jack gave an exasperated cough.

"No, we won't," I said. I scanned the crowd, determined to find my friend. "Come with me." I heard his voice before I saw him: familiar and comforting, even though we hadn't laid eyes on each other since winter. "Mr. Valentine!" I shouted. I turned to the boys. "He's the very person I hoped to find. And he'll help us with the queue!"

A group of onlookers watched as I held nothing back, hustling toward him. He met me between the graceful sweeps of Scotch elm and silver maple.

"Aunt Belle?" Joe asked. "Who is that?"

Jack muttered, "I should want to know the same thing."

"This," I said, when we'd gathered under a shady tree, "is my old friend, Mr. Valentine. Head gardener here." He shook hands with everyone, Jack pausing a tad too long.

Loping behind Mr. Valentine were two men I recognized, my smile spreading as I felt as though I, too, had searched my pockets and found what I'd misplaced.

"This is Mr. Grotberg," I told the boys of the man with piercing gaze, tweed cap pulled down hard; he was shy. "He made—created those fountains." I pointed to the grandeur of a mermaid with her strategically modest hair, the shell onto which she leaned. The boys beamed, impressed. The fountains were such solid things, ones that would remain long after Mr. Grotberg—long after all of us—had gone, and this moved me.

"Wonderful to see you, Isabella," said Mr. Miles Louris, my old zookeeper friend, smile alluring as honey in sunlight. He wore an oddly appealing outfit of striped jacket, trousers the color of old mustard, and a tempting mouth as an accessory. His hair had gone wild at the edges.

Gus, Amory, and Joe drew close to me in order to have a better

view of the men. Immediately, I, too, wanted to sit at the center of these men and have them share stories, have them ask me real questions, have them listen. These were men who spent their days with interesting sights, with enormous landscapes or beasts or sprays of water. These were men who remembered my name. Who held me in high regard for my brain and wit.

"If you're the one who plants all the things—" Gus began.

"Don't say *things*, it's crass. Say trees," Joe corrected.

"If you're the one who plants the things that are trees," Gus shot a look to his brother but then focused on Mr. Valentine, "what kind is that one?" He pointed to a tall tree near us.

"That's a Japanese larch. See its li'l cones? Come back in November, and we'll get a bunch for your mantle." He winked at me. I smiled; I'd decorated with them in the past. Jack looked away. "They call it karamatsu in Japan."

"Where one assumes you've never been?" Jack said.

My breath rose in my throat. How small big men can be in competition.

"You know so much," I said to Mr. Valentine. "Tell us more."

He didn't appear bothered. "And that one's littleleaf linden. And over there, right near George Washington on a horse—"

"Bet he uses a saddle," Joe whispered to me, and I gave him a playful nudge. Mr. Valentine enchanted him, too. "Aunt Belle made us learn without."

Mr. Valentine nodded. "Of course she did. Formidable woman, your aunt. Always treats everyone the same—equals." He did not look at Jack.

"Isabella Gardner isn't one to be taken lightly," Mr. Louris said. "And never one to be forgotten."

I wanted that to be true. But what would remain after I had gone? Piles of letters?

"Over there's a couple of silverbells," Mr. Valentine said to the boys.

Mr. Grotberg piped in, "Must be in honor of you, Isa*bell*a."

I laughed, and my voice came out loud, as though I were calling

from shore to a boat on which I longed to be. "I adore that. I simply cannot get enough of the gardens here, Mr. Valentine!"

Mr. Valentine caught my eye. I knew then that we both pictured in our minds a particular gray day in winter long ago, snow covered with blood as bright as poinsettias.

"What tree is that?" asked Amory, pointing to a small tea crab apple with its short twigs and flower spurs.

Mr. Valentine opened his mouth to answer, but a cluster of women to our right beat him to it. A woman in the center spoke, her pitch tawny and intentionally projected for anyone to hear: "And that one's Bawdy Gardner, the kind of showy planting that doesn't really belong anywhere."

I felt that old puncture, and looked to the three nephews and their silver-bright hair to remind me I was no longer that new-to-Boston girl so easily bruised. All the same, it stung. I waited for Jack to step in. He stood still as Mr. Grotberg's creations.

Mr. Valentine turned to the woman and her group, sweeping his hand toward the trees in their direction. "And those, Isabella, those are shady beeches."

I let out a great, loud laugh.

"COMING THROUGH, coming through," Mr. Valentine said. Grotberg and Louris cleared the path for us, parting the crowds waiting for a turn on the Swan Boats.

"Is this necessary?" asked Jack.

"You can go home if you wish," I told him, "but I promised the boys." I looked at the lagoon and the stunning sight before me. I wanted to enjoy the day, the children with me amidst genuine friendship. "Besides, have you even looked at the boats? They're quite miraculous."

Miles Louris spoke quickly and eloquently, as though wrangling words came to him the same way wrangling zoo animals must. "Robert Paget—that's him over there about to mount the swan." He chuckled. "See, there's always been boats here, but Paget saw an opportunity." He kept the boys rapt as we bypassed the crowds and

went straight to the front of the queue. "Here's what Paget thought: Bicycles, check! Boats, check! And then what was missing . . . boys? Isabella?" He frowned. "Jack?"

Bored, Jack's monotone cut the air. "I'll wager what was missing: a swan."

Mr. Grotberg took his cue to intervene. "Mr. Gardner, a man such as yourself might prefer the history of the George Washington statue." Jack perked up: less from the subject, I suspected, than the attention. "Come with me and I'll give you a story you can regale them with at the club tonight." Mr. Grotberg had sussed out Jack; the two men left, Grotberg turning to give me a small wave.

Mr. Louris went on. "Here's a boat-bike-swan."

Joe studied the enormity in front of us. A flat-bottomed boat powered by a pedal bike at the back. "How did he choose a swan?"

Mr. Valentine swooped us toward Mr. Paget. "Ask him yourself!"

"Ask me what?" said Mr. Paget, dressed for the special debut and breathing hard with excitement.

"Why a swan?" Amory asked.

"I needed something to cover the paddle wheel," Mr. Paget said. Crowds ballooned toward us, and a few people jeered at us, knowing we'd cut them off. "And I'd seen an opera . . ."

"*Lohengrin*!" shouted Gussie, and we all laughed in delight.

"You're absolutely correct, young man. Lohengrin's a knight, and he comes across the river and—"

"And he's pulled by a swan," Amory added. And then, to clarify, turned to Mr. Louris. "Our Aunt Belle teaches us things."

"Don't say *things*," said Joe. "Say *everything*."

I thought my heart would explode from happiness. I thought my face could shatter from smiling hard. "Should we worry about offending the others, who've stood here a long time for their rides?" I asked. I saw discontent on their faces.

Mr. Valentine whispered behind one hand to Mr. Paget. As they discussed, Mr. Louris turned to me. "Isabella." He tugged his hands through his hair in thought. "Might you pay a visit to my zoo one day?"

"I would love to!" I said.

"I have a lion I'd like you to meet," he said.

Joe leaned toward me. "Aunt Belle, you know the best people!"

I registered the weight of this comment. "I do believe I'm beginning to, Joe."

I was reminded of the pleasure garden, the excitement and fear swirling together, the deeper feeling that I was somehow in the right spot, that I was inching ever closer to being my full self.

Mr. Paget clapped his hands. The crowd hushed. "This is a special day, ladies and gents. A special day for Boston, and a special day for me, personally." He stepped on the first Swan Boat and beckoned me and the children aboard. "And, of course, a special day calls for a special person. Who better than Isabella Gardner to grace our maiden voyage?"

Wobbly and surprised and not a small bit delighted, I settled the children on the wooden and wrought iron benches that faced forward. Mr. Paget jumped behind the elegant swan, where he was tucked behind her wings. As he peddled, the boat began to move. Mr. Valentine and Mr. Louris held the boat lines, casting us off as gently we went out into the water.

I sat with the boys, looking out at the small island in the middle of the lagoon where ducks liked to nest and then back at the shore where the crowds cheered. They did not begrudge me. In fact, they seemed to welcome the spectacle of me.

Joe tugged on my elbow from his bench behind. I nodded without turning to see him. He'd had a good day.

Gus leaned against me. "Aunt Belle?"

"Gussie?" I held Amory's hand and felt the bare wisp of holding Jackie's, of promising him a boat ride.

"Aunt Belle, if we must keep on at Hopkinson's, learning and studying and Joe has to go to Harvard, what about you?" I turned to face him, squinting in that particular almost-fall afternoon light, as he pressed a single finger toward me, careful as though lighting a wick.

I faced my young nephew. "I should have to keep learning, too."

2

LATER THAT week, I took my breakfast downstairs, having walked the children to Hopkinson's School on the first day, despite their protestations that they were all old enough to go themselves. They were, and I told them they might start next week going together without their aunt, but for now they might allow me the pleasure—for this is what it felt to me—of walking a set of electric-limbed boys fresh from summer outside to their classrooms.

I poured my own tea. It was too hot, and I flinched, spilling. When some splashed onto the saucer, my instinct was to quickly clean it. Then I remembered what my grandmother, my mother's mother who had always had her hands in something—garden mud, clay for sculpting—had taught me. With my grandmother in mind, I lifted the tea-slopped saucer directly to my mouth. Having hit the cold porcelain and widened to meet the saucer's edges, the tea was the perfect temperature.

Slathering ginger-marmalade across a roll, I opened the paper. There, in *Town Topics*, was my photograph. I read the accompanying article:

Talk about a Sight! While crowds gathered for the inaugural Swan Boat rides (free and thus especially crowded), one person of note held

*no notion of queues. Indeed, Boston's own Mrs. Isabella Gardner flew
to the front and was welcomed by the boat's own creator, pictured
here behind the bird. Was she rumpled? No doubt. Her dress appeared
ripped, her gloves anything other than fresh. Yet—!—was she
grinning? Dear Readers, have a look for yourselves.*

As instructed, I took a look. There I was, being led by a swan. I could
do without Wagner's influence, but oh, that clever idea. To make a
bike into a boat and then the boat into a swan. And the three men:
Mr. Valentine, Mr. Louris, and Mr. Grotberg. Days later, and I still
was transfixed. And yes, when I looked closely, my teeth were all
showing, dirty gloves and all.

I read the final line, surprised and pleased: *Boston has made room for
the Swan Boats—now we must do the same with a certain someone.*

A FEW days later Jack knocked on my bedroom door. He snored
intensely now, great heaving noises that belonged to ensnared ani-
mals at night, so he often slept in his own bed, but came for a visit as
I ran a brush through my hair. He stood watching me.

I flirted with him. "What?"

"I get jealous, you know."

I turned, amused. "Of what?"

"Your attention to others."

"You mean the boys?"

He gave a sharp exhale. "I mean . . . everyone sometimes.
But more . . . how do I say? At the park, when you and Valentine
embraced—"

"It wasn't like that—" I put the brush down on my dressing table.

"Let me finish. It was two parts: One that he's a man who clearly
is fond of you. Two that you have a secret life. You know people I
don't, see trees or fountains or what-have-you while I'm—"

"At your office where I never go, at your club where I'm not
allowed, having conversations to which I am not privy?"

He recoiled. "Well . . ."

I shook my head, my long hair undone, loose around my shoulders. Unbound from clothing and hairpins, my body felt free. "It's the same, Jack. We can only ever know parts of people." I went to him. I wanted to reassure him almost as much as I wanted to keep pieces of my life only for myself. "You don't have to worry about Mr. Valentine. He's very kind. He helped me when—" I wanted to keep that between me and Mr. Valentine. He'd thrown bucket after bucket of water over the snow, melting the blood away, covering me with his own jacket so no one would see. "Well, he's a good person."

"Oh, I was put off at first by him," Jack said, "by your familiar greeting, but then I realized he's—"

I crossed my arms over my chest, eyebrows raised. "He's what, Jack?"

Jack coughed. "Well, the sort of man who . . ." I gave him a look. Jack enunciated his words. "The sort of man who will never marry."

"I like *those sorts* of men," I said. It was Jack's turn not to respond. I went back to brushing my hair.

"Must you flirt with them?"

My chest pounded. "I like flirting. But you misunderstand my intentions. You think it must only be about sex." I shook my head. "Perhaps part is about desire, but tell me, Jack, is there anything more exciting than being understood? Did it occur to you that my 'connections' are more about that than a kiss or a dalliance? I see these men for all that they are."

"And how do they see you?" he asked.

"They see me fully," I said, and when his eyes suggested he wanted an elaboration, I did not give it.

He came up behind me, pulling me into his chest. "I simply want to know all of you—is that too much to ask?"

I looked at our reflections in the dressing table mirror, but I didn't answer.

3

"DINNER UNDER palm fronds," Julia said to me. "Only you would even think of it."

As autumn pushed on, I insisted we set dinner in the glasshouse at Green Hill. Julia's four boys played soccer with Joe, Amory, and Gussie. Joe gave me our secret rippling wave. I watched my in-laws watch the boys. My in-laws were aging; this was inevitable and saddened me, my own parents also. I ached at the scales tipping them forward and me tumbling along with it, all of us in the next phase. But I also felt the cheer of Green Hill's glass solarium that housed not only palms but broad-leaf camellias with their glossy green and intricate flowers in pink, petal upon petal tucked one underneath the next. Earlier in the day, I'd suspended plants from iron hooks on the main girder, so the vines tumbled down, making my dinner plans exotic.

"Let's put the table near the orchids," I said to Julia. Julia raised her eyebrows at me. "Come on, Jules. We can lift it."

I took one end and she the other, settling a long serving table so that it rested beneath a graceful sweep of yellow butterfly orchids. We managed to heft it without breaking the glass, the porcelain, or our feet. We laid out stacks of dinner plates, shallow bowls for the potage, arranged a cluster of sherry glasses so close together they looked like bonneted women ready for church.

And there were so many forks, each with a purpose: dinner forks, luncheon forks, dessert forks, salad forks, fish forks, asparagus forks, pickle forks, olive forks. "Everything has its use. And yet I've not truly found mine."

"You have the boys. You have your books."

I sighed, knowing my face looked serious with the ache I felt. "Perhaps I should make my peace with it."

"With what?"

"This." I held up a lace doily.

Julia looked at me, caught between amusement and concern. "You're hardly a piece of delicate lace."

"In effect, yes I am. Pretty enough, but ultimately unnecessary." I went to her and spoke, close to her face. "I want to matter. Or have what I do matter."

She registered my words as a slight. "Taking care of our nephews does matter."

"I know. I know it matters a great deal; my comment is not a reflection on you or your parenting or my role in their lives."

Julia made a tower of teacups and saucers. "I'm just built differently from you, Belle."

The words were out before I could haul them back. "Better, you mean."

Julia placed an ornate, pearl-handled bread fork near the basket that would soon hold warm slices. Without looking at me, she said, "Do you recall the samovar? The one you sent from London?"

I thought of the room of the occult, the trance that had brought Harriet back to me. "Of course. I saw it, and right away I knew I needed to have it. And sent it to you knowing you would like it, too."

"That is where we part ways."

"Why?" I asked her. "You like things."

"Yes. But I don't feel a need for them. Or rather," she considered the position of the butter dishes. "If it is easier for everyone, if it keeps a day running smoothly, I am able to talk myself out of that desire."

I watched the light shafts through the trailing ivy. "I sent the

samovar to you so you would have a bit of me . . . and we would have matching samovars."

Julia's actions were pointed; each item she placed was immaculate and ready. I caught myself looking at her thumbs; they, too, were perfect. No peeling skin, no redness.

Julia's voice was even quieter. "Well, we aren't a matching set, are we?" She sucked in air. "Besides, it arrived at a rather inconvenient time." I frowned. She turned her back to me, spreading the serviettes in a fan. She looked quickly out the wall of windows at the boys. "I had another baby," she said. My breath stuck in my throat. "He only lived one day. Your parcel arrived the next morning."

"Why didn't you tell me?" I asked. My eyes welled up.

"Because it hurt." She turned to face me. "And because I knew you would hurt for me."

"I still hurt for you now."

"Exactly," she sighed. "You don't give up, Belle, and I want to! To let go of it. To let go of ideas or useless doilies. You question where I want peace. That's why you got in trouble at school. That's why the boys flocked to you—why my brother was drawn to you. You're orig-inal. You know more, ask more and . . . hurt more. It's not for me."

I touched her arm. "What was his name?"

"I will tell you, and then do not speak it again. Charles." She held her breath, then spoke again. "You hoard your disasters and your triumphs like your decor. You want and want. I am different."

I looked at the room I'd created, the greenery and dishes in har-mony. "Julia, for so long I thought if I might only contort myself into being just like you, I might be happy." I looked at her as my in-laws, our gaggle of children, and our husbands all entered the greenhouse. The indoor-outdoor dinner was every bit as stunning as I'd imag-ined: like a scene from a pirate novel, lanterns lit and plants swinging while the tablescape suggested a natural elegance. "But love comes down to acceptance. You must accept that I will never be like you. And you wouldn't dare to be me."

Julia stood in reserved quiet. I faced her head on. "Do you remem-ber your habit?" She gave a bland nod. "It was as though you were

peering underneath the skin: as though some unseen parts of you were lurking, waiting to be discovered." My eyes shone at her. I waited, hoping she might break free of herself.

She pursed her lips. "It turned out only to be a nasty addiction: one I buried." She paused. "Might you do the same with your own seeking?"

A sureness rippled over my skin—for though she might remain cloistered in her pretty world, I knew more. I smiled at the boys coming in as I responded, my voice clear as the sleigh bell that had long ago announced my arrival. "I don't want to. I know I've a greater use in this life. And I'll be damned if I let go until I find it."

4

I WAS OUT of breath; it wasn't far from 152 to the hulking build-
ing next to the Boston Public Library, but I fairly flew along the
bricks after a day spent packing trunks and readying the boys for
our departure the next day. I rushed so that I nearly blazed over
a young woman. She had piles of dark hair and a gorgeous, round
face. I begged her pardon, but she laughed off our mutual future
bruises.

"You must be off somewhere terribly electric," she said.

"A lecture," I said, and then, as a sort of test, added, "a Harvard
lecture. Charles Eliot Norton, the first professor of art history." She
looked intrigued, so I went on. "A lecture on Dante."

I stuck out a hand and introduced myself. She did the same. "Maud
Howe Elliott. I think you know my mother? Julia Ward Howe." I felt
a smile break across my face, my heart pounding at meeting her and
also at my own lateness. "We're at 241 Beacon now—your neighbors,
I think." She gripped my arm. "I confess to being a bit of an Isabella
gawker; I saw your photo in the paper after the Swan Boat opening
and dearly wished I'd been there to see the spectacle."

I swallowed hard. "That it was." I waited for her critique, her
ridicule.

"Impressive," she said. "That's what my mother and sister and I

said. Anyway, you're late, but please, do come for dinner, or lunch, or . . . do think of us when you plan your next spectacle."

"It was unplanned," I said as I began to turn away. My insides churned with excitement; a woman whose words had inspired me was my neighbor. Her daughter seemed to want to befriend me. My limbs felt foreign as I held my arms to my sides, afraid to disturb the pleasure of this chance meeting. "I must run," I told her. "And I do mean run."

She called after me, quoting Dante, "Stay your steps, o you who hurry so along this darkened air!"

"I'M HERE by invitation," I told a man at a set of double doors. He regarded me as though I were a fawn that had edged her way out of the forest and into academia; my gloved hand a little hoof knocking on the lecture room door. He shook his head. "It's already started."

"I was delayed," I told him. I fought the urge to apologize. Why did women continually do so, as thought we'd been conditioned from birth to apologize for our very presence?

"But you're sure you're where you're meant to be?"

I could smell leather and woodsmoke and, under that, tobacco and the heady scent of men absorbing other men's ideas. "Absolutely."

"I'm afraid I can't let you in, Madame."

I felt anger fanning out in my belly. "Don't *madame* me." I touched the door. "I can show you how to let me in—simply pull back on the handle and—"

The man at the door reached for my hands to pry them away.

"Mrs. Gardner!" The voice was deep and mellow.

"Isabella," I said.

"No, I'm Charles Eliot Norton," he laughed. "You're Isabella."

"Sorry, sir," the doorman said. "I tried to tell her—"

"That she's in the correct place? Thank you, Mr. Martin. Much appreciated."

As he held the door for me, Mr. Norton turned to me, amiable. "The person who is late controls the room."

I smiled. "An honor we'll split this time."

"I borrowed the room," he whispered to me. "It's a loan from the medical school. The benefit of having your cousin be president. Anyway, he's determined to move the whole school."

"Why might that be?"

"More science, he feels. He wants labs for students. Such practical thoughts; not quite Dante. And yet he's onto something; faculty need to keep learning, too. One ought not stop learning, don't you think?"

"I just said the very thing to my nephews."

Mr. Norton nodded. "Do you know that before he started, people didn't need to read or to write to go to Harvard Medical School? Well, over lunch he told me there'd been a sharp decline once he instituted that policy. And now—well," he looked at the room. "A building matters, don't you think? Where you see or experience something, not just the content?"

I let this settle in. Place mattered. Mr. Norton held the door, and once we were both inside, we parted. I was surrounded. Tiers of seats one above the next nearly made a complete circle, presumably for viewing medical procedures. Now I was the body. Not splayed, but feeling so.

Each set of male eyes, each pair of sideburns woolly or neat, every man either leaning back in his chair to show how easygoing his nature or leaning forward to demonstrate to everyone how keen he was, how clever.

Why had I come? I felt my instinct to flee kick in and turned toward the door, but Norton started to speak, and where I could have bolted, instead I quickly took the closest seat I could find. I sat next to a man—a boy, really, with hair he'd tried to tame with oil and wax that smelled like camphor and tea; a lock escaped, and he tugged at it as he gave me a quick glance.

"I'm here by invitation," I told him sotto voce.

"I'm not," he said. "I snuck in."

He gave me a sideways grin, and I returned it as though I might be looking at another version of myself.

. . .

1st April 1878
Shady Hill Cambridge

Dear Mrs. G—

I was very much disappointed when I called last week to find you were already absent from 152 Beacon, as I wished very much to bid you farewell. I do look forward to hopefully teaching your nephew Joseph at Harvard on your return. Yet more than farewell and my teaching wishes, I want to share news. The Dante Society is officially formed! I shall let you know how we get on; perhaps we will have the privilege of seeing some of your fine rare editions. I hope to hear often from you. With sincerest wishes for your health and happiness,

—C. E. Norton

5

JACK LEANED forward on the ship's railing as Calais receded. I stood with my hands on my hat, trying to keep it from being cast off to sea like a message in a bottle; what might my message say?

"It's been a lovely trip so far," I said to Jack. "I enjoyed being with Joe yesterday."

Jack nodded. "How did you find Reims Cathedral?"

"Loud," I said. But I hadn't minded. Joe and I had climbed, cheeks flushed, ears ringing, and he tugged on my elbow, finding the skin underneath the fabric of my dress. We'd stood where once a labyrinth had been. I had tried, pointedly, to tell him how much the place had weathered, as though buildings might symbolize a person. A body. He hadn't wanted to draw comparisons, I suppose. "Joe was better informed than I," I told Jack. I stared at the sea, recalling Joe's face as he'd told me: fire, fodder store during the Revolution, revolts. The entire rose window shattered in a storm. The bell-tower angel took a nasty tumble in a great wind. I asked him why he knew so much, and he'd paused. "I like a story of rebirth," he'd said.

"I do worry about Joe," I said to Jack. Jack turned, his hair dancing in the wind.

"I'm quite sure he's fine," Jack said.

I was not so sure. I had told Joe of my own propensity toward

gloom, how I thought travel opened up the soul, how necessary the break from Boston's confines. Joe had listened, patient, but asked where he might go to get away from himself.

"Perhaps he will fare better in London," I said.

Jack nodded. "And you, Isabella? Are you enjoying your holiday?"

I stepped closer to him, my shoulder fitting into his side: a comforting, familiar stance. "I am." It came out as a question.

"Sometimes I find I cannot discern whether you are happy or merely tolerating me." He looked out at the waves. "I will never be an inventor of Swan Boats nor a . . . lion tamer."

He meant Mr. Louris, the head of the Boston Zoological, but I didn't correct him. I placed a hand on the railing next to his. I pointed to a passing boat as we chugged out to sea, making for the deep-water berth of the Admiralty Pier in Dover. My husband's hair had thinned at the front, and strands lifted in the wind, offering a view of his smooth scalp. Even his underneath was unmarred. "You're steadfast. Reliable. Content."

"And you, Isabella?"

"Am I content? Yes. Is it enough? We both know the answer to that."

<div style="text-align:right">

13th April 1878
241 Beacon Street

</div>

My Dear Isabella,

How I enjoyed our walk and ample pot of tea that stormy morning before you left. Now I take my tea without you, though I am glad for the letter from France. I hope this letter finds your safe passage to London.

To-morrow being your birthday, I enclose here a mere token that I hope you will receive as a reflection (pun intended!) of my affection for you; this mirror is from my mother's dressing table, and its small size allows for carrying in a clutch. I thought perhaps it might be of use in your travels. Many happy returns of the day. Do let me know that you receive the parcel safely. When you return, I shall have you to lunch. I should very much

like to introduce you to some worthy artists; notably my writer cousin, Frank, who now goes by Marion Crawford. He is a most illuminating and dashing creature. With kindest wishes— I am, Ever your affectionate friend,

Maud Howe Elliott

1ˢᵗ June 1878
London

Dear Maud—In brief answer to your question regarding how many cathedrals is too many to see on one journey, I believe my nephews have given their answer: 19. Jack and I are rallying to enliven their spirits; he will show the two youngers the seaside, specifically (as I know you value specificity) the phasing out of tall ships in favor of the latest efficiency engine, while I will enliven my own spirits and Joe's with a race to buy a new (though very old) book.

Ever Yours—Isabella G.

20ᵗʰ July 1878
London

Dear Mr. Norton—

I send my perfunctory best to Boston and sincere best to you—I hope you have rummaged up enough support for a full course on Dante! In the meantime, a great catch for the shelf thanks to your direction: the first ten cantos of *The Inferno*. I felt a shock of pride and contentment at its purchase. Yet this feeling was short-lived. One of my young nephews looked at the book, which I could not help but place on my shelf here despite knowing it will require rewrapping for the trip home. My nephew puzzled at it and asked me what I thought about the fact that books face inward. What does it say about me that I collect these inner-facing worlds? Perhaps my nephews have cottoned on to something I must consider. We shall have to discuss.

I am tomorrow to go with Henry James to lunch and then to the Grosvenor Gallery on Bond Street, which Sir Coutts Lindsay and Mrs. Blanche Lindsay opened only last year but apparently is already known for its selections and showings. She was a

Rothschild, and I hear the endeavors were hers; it does give one hope. Or this one, anyway. For surely if I can collect books and become an honorary Harvard man, I might also find a space in this world for myself? Please do save a seat for me at the next lecture—

Sincerely yours,
ISG

6

Halfway through our time in London, we set out for the West End, to Grosvenor Gallery on Bond Street. From the outside, the place appeared ordinary: its entrance flanked by double sets of tall stone pillars above which arched more stone and, in the center of that, a cherubic face looking down at whosoever might pass beneath. I looked up at the face. She appeared bored. I gave her a knowing glance as Joe and I entered.

Inside, the boredom evaporated instantly. The gaping vastness of the room might have left us dwarfed but instead had me at once tranquil and invigorated; the walls were high enough that I had to tip my head all the way back to see where they met.

And on each impressive wall were carefully laid out paintings.

Joe disappeared—after his dark comment in Reims this gave me a clutch of panic—but a moment later came back, thrusting a brochure at me.

"I've not seen anything like this," he said to me, his tone altogether different than it had been in France. He seemed lighter now, perhaps due to being near artists and also our time together; I had the sense Joe felt always outside, and of course I identified with this and sought to bring him closer to me, to protect him.

I stood in front of a large watercolor. Transfixed, Joe was silent

next to me. I opened the brochure and read aloud. "Clara Montalba. *A Bit of Venice*. It's radiant."

Joe gave the barest motion of a nod. "It makes me want to be there."

"On the boat?"

"In Venice. On the boat or in the water. All that light."

Any response I might have had was interrupted by a suit wearing a man on its insides. "Mr. Henry James!"

"Mrs. Isabella Gardner." He exaggerated his steps, stopping short in front of Joe. "And this? Who is this important fellow?"

"This fellow," Joe said, at last turning away from Venice, "is Joseph Gardner. The nephew."

"The one and only Joseph? Your aunt speaks—or writes—highly of you. And your brothers."

Joe gave me a tucked in, toothless smile. "Probably you should take her at her word; Aunt Belle isn't to be trifled with."

Another man stepped forward. "Are we having trifle? I love trifle."

Mr. James thumbed to his right. "Isabella, Joseph, may I present Mr. James McNeill Whistler, or, as he's known in the art world, a man fond of trifle."

Mr. Whistler's glorious head of hair shone in the light, determined ringlets that jutted out with a preference for the left, regardless of his parting. His mustache belonged under glass in Ted Lyman's lab. I was transfixed by the tumble of vigor everywhere.

In turn, Mr. Whistler introduced the man to his left. "This is Mr. Henry Adams."

We shook hands as a group does, arms over wrists and still other arms, as though building a fire of limbs until enough contact had been made as to be acceptable.

Joseph went to wander the large hall.

Moving as an unwieldy, disorganized group, we clumped through the space. "Mr. Adams has just retired," Mr. Whistler said. This prompted me to give another look.

"But you're . . ."

"Thirty-nine," he nodded. "I know."

"He's mere weeks away from forty, though," Henry James added.

They had quick wits, fast words, sharp tongues; I loved every moment of it. I could barely contain my happiness at being at the center of such a whirlwind.

On the walls were oils and watercolors—some large as sails, others small enough to fit in a pocket. Sculptures, chairs, pedestals topped with carved wood blocks or decorative baskets—how I loved the art, the company, and the airy room.

"What might you have retired from?" I asked. And as he paused, I added, "The world?"

He gave a grin of acceptance. "Quite. Harvard."

"A world unto itself," I said.

"As are you," Mr. James said. He cut an imposing figure: elegant suit, body thick in the middle, eyes and ears always open to social chatter, nuance, even words unsaid.

"Isn't she just?" Mr. Whistler, angular and mustached, piped in. Mr. James toppled Whistler's remark with a swift elbow.

We stopped in front of a great slab of a painting, nearly four feet by five. "*The Love Song*," I read from the brochure, but the others knew already.

"Edward Burne-Jones," Mr. James said. "Solid fellow. I go quite often to the Grange. His studio." He turned to me. "If you might like to visit it one day?"

I looked at the painting. "I would not." I looked at the people depicted within the frame. "They appear sad. Or ill. Or bored. Is that love?"

The men laughed. I let the relief of having said my actual opinion with seemingly no repercussions wash over me.

"Rather like Titian, isn't it?" Mr. James said, drawn to the canvas so much that he faced it head-on, hands on his significant hips as he studied it, clearly enamored. The woman depicted looked on the verge of death from boredom.

"I much prefer Titian," I said, thinking of Paris, of my dress fitting with Worth, how the fabric and painting were stitched together in my mind. "*The Rape of Europa*, especially." My voice commanded

the attention of the others. "I believe it will one day hang in my house."

Mr. James drew a breath. "From anyone else I would say sheer fodder for lambs. But from you? It's possible. Only . . . is Beacon Street really that large?" He interrupted himself. "Ah, here's Coutts."

Coutts Lindsay, the Grosvenor Gallery's owner, strode over as though made of warm clay, pliable and elastic and clearly in his element as we continued to move en masse through the gallery. How it strengthened me to be moving as part of the crowd, integral to this core group.

"What say you to the goal," Coutts said to me out of nowhere. "of turning the Royal Academy on its ear?" I considered this as he went on. "Progress means a certain degree of outrage, don't you think?" Outrage. I swallowed this with a sip of sherry offered to me in a glass and whisked away just as quickly. Coutts continued, "From the ground up, the building, the art and even the arrangement of the art is unconventional."

"Yes, it's unusual," said Henry Adams.

"Aren't we all?" said Mr. Whistler, and the group nodded. It was not simply that I felt I was one of them—they, too, were of me. And the art—or the space itself.

"The aesthetic movement," Henry James was saying, but then found his words truncated by another glass of sherry.

Whistler spoke. "They give us space—not the chockablock full walls of other places, not art for history's sake, art for art's sake."

Coutts nodded. "And decorative arts! Furniture, crafts—why are they to be cordoned off in some remote locale? We want them here, with the paintings." I took that in also. The idea of objects rooming together, mixed art. "And we have women. Our goal is to one day have twenty-five percent of the artists be female."

I felt ragged with knowledge, my mind momentarily back at the impressionist exhibit with Morisot. "How important that you're examining, planning this in advance. Often, we are an afterthought. Or no thought at all." Nervous excitement rippled through me.

Coutts nodded. "My wife has brilliant ideas."

From behind Coutts, Mr. James mouthed to me, "Which wife?"

"See?" Mr. Whistler tugged my arm toward the wall. "Each wall has only one large painting—and each artist's work is grouped together. It makes much sense, does it not, to see one person's vision all at once rather than scattered, jammed so close that the viewer can barely catch their breath?"

Joe reappeared as though conjured by Whistler's words. "The whole place is rather like Tennyson's *Palace of Art*."

Coutts slapped him on the back, excited. "Exactly, dear boy— that's the inspiration for it!"

Joe followed Coutts toward a sculpture as I gripped my brochure for dear life. Mr. James tilted his head, hairless as a potato at the front and just as thick, toward me. He spoke in his between-countries lilt, conspiratorially low. "Now, we're coming up to the Wall of Whistler. I must confess, I might not be his biggest devotee." He cleared his throat and spoke even more softly. "Adore the man, but not the man's work, if that makes sense."

"Is it possible to distinguish between artist and art?" I asked, and went to look for myself. *Nocturne, Blue and Silver: Battersea Reach*. I said the title over again, my lips moving as though in prayer. The painting was an ode: gradations of gray and blue, plum and shadow. It was a prayer to water, to time, to the barest of light, the eventual fading of each day, of all of us.

Mr. Whistler sidled up next to me. "What do we think?" He whispered loudly, "Realizing it's terribly rude for the artist to ask the viewer and fix the viewer in a muddle: be honest or be cutting?"

"This is for me," I said.

Henry James rolled his eyes and crossed his arms over his broad chest; he liked to have his opinion be the opinion for all. Then, seeing a different opening, he said, "Isabella, perhaps you might like to see Mr. Whistler's studio at some point?"

"Yes," I said. "That I would like very much."

"Next time you are in London," he said. "I think I speak for Britain's entirety when I say how grateful we are that you return time and again to our tea-stained city."

I pocketed a card from Mr. Whistler with a promise to visit him. I pocketed the brochure with promises to myself to recall everything about the gallery. I bid everyone a fond goodbye, which Mr. James interrupted by saying he would see me sooner than the rest, as we would meet at Maud Howe Elliott's for lunch—she had written to him also.

Joe, his spirits much improved, linked his arm through mine as we exited. "It's such a large hall."

"Intentionally so, said Coutts," I told him. "Art needs space to breathe."

"Artists, too." Joe paused, looking at me. "And those who appreciate the art."

We walked close together as night crept around us. "I imagine my brothers are having a wondrous time with Uncle Jack at the shipyard." Joe took a last look back at the Grosvenor. "Uncle Jack says every journey needs a tight crew."

I thought of Henry Adams, who did not hold back his intellectualism with me, and Henry James, who regaled me in letters about his latest novel. And even Whistler, whom I'd only just met but knew I would know more of. I thought of Mr. Valentine and Mr. Louris and Mr. Grotberg with his iron castings. "Your Uncle Jack is onto something."

"Aunt Belle, do you prefer the company of men?" Joe asked. Each word came out with an elongated space between.

I puzzled over this. Did I feel close to Julia anymore? Had I to Harriet? There was caring between us, but not without reserve. Yet I felt Maud Howe Elliott would become a close friend. "I have a female friend or two." I chewed the inside of my mouth, tasting traces of sherry. "But I admit I find men easier. That they have ideas and speak them without harsh looks. I suppose I do enjoy the company of men."

Joe exhaled loudly. Our eyes met. I wanted to but refrained from asking him the same question. We continued down Bond Street. I tugged on Joe's elbow, our secret public hello, but he didn't respond. I was troubled.

"Joe, please don't hesitate to find your place in the world. I know

you're off to Harvard soon but—that ought not to define you." He dropped his gaze downward as he listened. "All along I've tried to make myself smaller. To take up less space." I filled my lungs with the night air, trying to take in the gallery and its art with it. I wanted to be that cavernous space; I imagined the gallery living and breathing, the buttresses my rib cage. "I've been told—and I believed it, sadly—that the problem was with me. That I was too big for the rooms. Now I'm quite sure I've been looking in the wrong places."

ANOTHER EARLY summer came to Boston, and with it, a lovely surprise note. I held it in my hands, which trembled.

> 1ˢᵗ June 1882
> Boston Zoological Gardens
> Dear Mrs. G— I do hope you have not forgotten Boston in your travels. For surely we have not forgotten you. As I mentioned, I have some colleagues at work I wish to have you meet. Let me know when to expect you. —Mr. M. Louris

I saved nearly all of my correspondence and most often asked for my letters to be returned to me, as though my words had only been borrowed and were due back for my collection. At first, this seemed as though I were proving something—people wrote to me, even when I felt friendless. Now there were certain people—Henry James, for example—whose correspondence was so frequent, I had stacks. Many of the stacks I took to securing with ribbons from my old trimmings basket.

Now I took Mr. Louris's note and walked to my sitting room, where, on the mantel, I kept a brown wooden box. In the morning sun, the painted satinwood shone, tulipwood and mahogany elegant on the sides; a delicate lattice of flowers encircled the box. Inside were other letters as yet unsorted, untied.

I sat in the tufted yellow chair with the box in my lap, paging through letters from the past couple of years.

29th January 1880
3 Bolton Street

My Dear Mrs. Gardner—
You say you like being remembered, and now I know Boston
has no choice but to remember you, Swan-like creature. What's
next, I wonder? More days & nights in London & Paris pass now,
but without you one cannot be sure they will be remembered as
agreeable. Sometimes I feel your presence at a dinner party or as a
daytime phantom. At times this makes the dinner or stroll all the
more bearable, for my running commentary has your ghostliness
as companion. I have no doubts we will Europeanize again soon,
and, before that, Americanize. You are dear and kind to me.
Look out for my next big novel; perhaps I shall immortalize us
both. Friendly regards to Jack and love to your jolly boys. Very
faithfully Yours, H. James

1st July 1880
Alhambra

Dear Julia,
Another summer finds us again at the shore. My parents and
brother James are visiting, the boys are home, Jack is in and out
with his new boat. The amount of effort required to have a simple
day out is quite ridiculous. Swimming costumes for the men,
woolen short-sleeves and skirt for me, sand pails and shovels for
castle competitions, flags for decorating the castles, an array of
sandwiches and bottled beer, wrapped parcels of warm sugar buns
gone too-soft in the heat. Chairs. Blankets. A canvas umbrella to
shade the parents. And everything covered in the fine muck of
sand. Hours to pack and to prepare for an outing that lasts half the
time. Still—summer, and one ought to be glad for family together
before they fly away to school and Jack and I go abroad again (yes,
again! Boston and I have an understanding, we do not loathe the
other any longer, but our amiability is built on time apart) but of
course I'll write. Glad your brood is well and happy. Yours—B.

31ˢᵗ August 1881
Alhambra

Dear Mr. Norton,

I have purchased the book, and I thank you for sourcing it. I admit
to feeling a letdown, however. The exterior is, as you suggest,
nothing special. But inside—a whole world of ornate colors
and intricate lettering. I relate. Perhaps I am experiencing the
exhaustion of buying pages for my shelves only to have them, as
the boys say, turn inward, when for so long I have struggled to
face forward, go beyond the world afforded to me. What next? How
to marry my vision of inside and out?

See you shortly in Boston. Would you be able to join us for
a night out? Specifically, the debut this October of a wonderful
musical opportunity called the Boston Symphony Orchestra? I do
hope so!

Isabella

9ᵗʰ November 1880
New York

Dear Mr. Fay,

Pray this letter finds you well, or indeed that it finds you at all
after so many years. Can it be that we have not seen each other
since that ill-fated dinner party in Beacon Hill? Likely you are
surprised to see my letter; I was surprised to find myself thinking
of you today. For who might predict these interruptions, our pasts
appearing to whisper hello with a familiar smell, to grab us as we
exit a carriage in New York only to feel sure we've been victim of
time's undertow; somehow I thought I would see your face in my
carriage. Only I did not and wound up instead my present-day
self at Sypher & Co. So disorientated was I, spinning with longing
to see you, my old friend, that I grasped onto something solid: a
finial in the shape of an eagle, gilded bronze wings out but not
open, alert at the top of a flag. What has the world made of you, I
wonder. What will it make of me in the end? I will hold this finial
as I hold memories of you, who knew the earliest me, the one who
had yet to know much. Perhaps this makes no sense to you, a finial
in place of you, an eagle the embodiment of hope and possibility
made tangible. Fondly—Isabella

I kept starting to organize the letters, then gave up entirely. The morning would be over soon, and I needed to respond to Mr. Louris. Or perhaps I would not respond and simply be bold, showing up to his zoo unannounced. I held his note in my hand and considered boxing it with the other letters, but did not. Instead, I allowed myself a few more minutes of reading, as though catching up on an old friend. An old friend who was myself.

29th June 1881
Alhambra

Dear Julia—

Thanks indeed for your letter of condolence regarding my brother's passing in April. Thanks, too, for the *Atlantic Monthly*. Despite my grief, I am so enjoying the installments of *Portrait of a Lady*, particularly as Mr. James is such a dear friend.

As are you—B.

22nd December 1881
Shady Hill

Dear Mrs. G—

I write with glad tidings for the season and good news. Yours is a presence most noticed at the lectures, and not only because of your gender; rather, after your excellent questions and comments regarding Aristotle and ethics, the Dante Society convened and would like to invite you to be a member. Please do let me know your thoughts.

Many Happy Returns—
C. E. Norton

2nd February 1882
New York

Dear Mr. Norton—

Thanks indeed for the kind invitation: I am beyond thrilled to be a member of the Dante Society! Looking very much forward to my next lecture with you! And to showing you the treasures Jack and I have found this trip: three tapestries, two Napoleon chiffoniers, used by the very same at Elba, and a remarkable Genoese velvet

portiere, which one day I should like to hang in a doorway, though Jack says this is impractical. Surely these objects have as much merit as a book: all contain stories and history. I should think Dante would approve (and you). Yours is an existence for which I shall forever be grateful. —ISG

17ᵗʰ March 1882
Cambridge, Mass.

Dear Aunt Belle,

I write with green hands—a new friend asked me to join him for a day out, which started before dawn this morning and involved turmeric, indigo, and a barrel, all of which resulted in dyeing the river green in honor of the 70ᵗʰ Saint Patrick's Day in Boston. We've already been written up in the *Lampoon*. Just as quickly as my spirits rose during that escapade, now they have fallen, as my new friend is not—I fear—the confidante I had hoped. Aunt Belle, third year wears on me.

At your suggestion, I have taken to walking the river before and after studying. While I take your words to heart—I am complex—it is also true that I am not your riddle to solve. Forgive the impertinence, but that is what you suggest. The usual cures you mention—sleep, a strong drink, walking in the cold air, taking solace in books or in nature—none of that will unwind the ribbons of turmoil in me. You ask if I am happy, and I know not what words to say. For all the true intellectual rigor, there is a facade here. And damned be the man who cannot keep it taut.

Best love—Joe

I slipped Joe's letter back in the envelope and sighed. It was always tempting to reread the past, to wonder. And yet now, in June, Joe's mood seemed quite summery. I sifted through the stacks of letters, shifting the prior year's words from pile to pile. I closed the box and decided what I needed wasn't to look back but rather to look ahead— first, to lions.

7

I WALKED TO the zoological gardens in a dress that had arrived only that morning. It had on its edges a parade of animals: pheasants, tigers, an elephant, deer. The lineup made no sense to me and was quite astonishing in its colorful nonsense, so I knew I must have the garment, which now garnered a few too-long looks from the matronly group that took the art of flânerie all too seriously.

I strode ahead, breathing in to full lung capacity, trying to retain my resolve and trying, too, not to worry about Joe. Jack assured me this was "a difficult age" for young men, but it seemed to me deeper than that. Joe and I both struggled: he at school, me with Boston, or perhaps that was facade, too. I blamed Boston, when truly I was flawed. Finally, as Julia had made clear, I had everything. I had a family, I had boys in schools, I was the first female member of the Dante Society, I had my friendships with Henry James and with Maud Elliott Howe, who had invited me to her house for a luncheon party tomorrow. I had full shelves of rare books, and I had an odd dress decorated with strange creatures. And yet.

"At last," Mr. Louris said. He appeared at the garden gate as though hinged to the wrought iron posts: all fluid motion and ready for my visit. I looked for the colleagues he had mentioned in his letter but did not see them. "Just the woman we've all been waiting

for." I looked around. There was no one in sight save for Louris. He motioned for me to come through.

"The camel house is there. Bear dens there. We have a flying cage that is really quite something."

I watched the animals fluster or rouse as we went by. "Do you think they mind?"

"Being in captivity?" Mr. Louris sighed. "There's no proper response. I spend my nights plagued by this question. If we don't show the people of Boston, or of everywhere, the animals of the world, how might they know of them as real? How might they save them from people hunting them, or find veterinary medicine for them? But to do so requires containing them." He looked at me. "And I'm quite sure most beings ought not be contained."

He came to a stop outside a pitched-roof building: a plain door that he opened with a large-toothed key. "I protest in my own way. I want the animals to have room to roam, so I'm asking for more funding from the city so their habitats might be more natural." He frowned. "But no one listens to me. I would have to give a public performance to get attention."

The door swung open with a heavy thud. We entered into a dark space, the sound of dripping water echoing. I imagined the creatures on my skirt cowering in fear.

A low growl emerged from the dark.

"And what exactly is my role here today?" I asked, overly aware of my own voice in the chamber. Mr. Louris gave a long whistle, and the growling increased. Another heavy thud cast a shaft of light across the floor. We were in a room no larger than an entryway; just me and Mr. Miles Louris and two enormous, shag-maned lions.

I did not move. Mr. Louris's lips rose on either side in a wicked grin.

A shadow version of myself moved toward him, pawing at him as though I had lion strength, rising up on muscular haunches to knock him down, put my mouth on his as his hands roamed my hair. But just as quickly, my shadow-self evaporated and went to join my long-gone younger selves at the back of that winter sleigh in memory. And

my present-day form stood firm as though I were no longer pliable. When would those selves merge into one? When would I reconcile my younger self—that risk-taking, bold girl—with my present self?

"Would you like to take Zizi and Happy for a walk?" Mr. Louris took two thick leather straps from a clip on the wall.

"Is it safe?" It felt like the question one ought to ask, though I did not feel afraid. I chewed at my lip. "We will be quite a spectacle," I said, my voice a warning.

"You came dressed for the part," he said, and approached the wild animals with such grace I caught my breath. In a delicate dance of man and beast, mane and leash, he led the animals out of the cage.

Once outside, all four of us squinted in the daylight and walked toward the front gate. There, where there had been no one, now gathered a few onlookers. Mr. Louris handed me first one lead and then the other. My skin prickled with excitement.

"Keep a steady gaze ahead," he said. He didn't leave my side as we continued out the gate and down the street, soon drawing a large crowd. City workers with lunch pails swinging, nannies with children who gasped in delight at their storybook come true, flâneurs whose strolling was suddenly interrupted. "You're a natural."

His melodic voice made me wish he would ask to me to run away, lions and all.

"I can only imagine what the papers will say," I told him. I felt sure-footed, as though I was exactly where I was meant to be. My arms ached from their firm hold on the lions. I gave the animals a smug look. One of them growled in return. I recoiled.

"I think Zizi is besotted with you," Mr. Louris said.

"I hope Zizi doesn't mind, but I can't tell one from the other."

With crowds now lining the walkway and carriages stopping short, horses balking, *Town Topics* and the *Boston Globe* were quick to follow. "I suppose there's nowhere to hide now, Mrs. G—Isabella? I apologize. I don't know quite what to call you."

I laughed and took in the lions, the elegant form of Mr. Louris, the crowds, my own comfort at the bizarre scene. "I don't know quite what to call myself, so it's within reason that you feel the same."

A reporter dared to come close to us. "Can you tell us the nature of this dangerous stunt?"

Mr. Louris paused. He looked at me, gave his lips a quick lick as though deciding the exact nature of our connection. The lions rested with me: their paws large as dinner plates next to my feet. Mr. Louris spoke to the journalist. "What's dangerous is keeping animals in tight quarters. What the men in charge need to do is build a larger space for these beauties." He gestured to the lions but also to me. "Don't such elegant and cunning creatures deserve a bit of freedom?"

Town Topics—*Mrs. Isabella Gardner Defies Death with Lion Promenade! Boston Zoological Gardens—a sight to behold for those few lucky enough to be nearby yesterday as a certain Back Bay Personality paraded not one but two lions—*

THE NEXT morning, notes were already arriving, people whose parties had no use for me asking if I was quite safe, if I'd recovered.

My Dear brave Soul, Henry James wrote in a letter I bundled with his others. *Pray you have recovered—from the gossip, that is. Will you arrive at Maud's luncheon with teeth bared? All told, your outing is safer than the Reform Club where I have stayed these last weeks, dodging boredom while tending to publishing* Portrait of a Lady *goes from serial to novel now. Note that Isabel Archer does not parade with lions. A point I plan to reinforce at lunch. H. James*

Earlier, Julia had come by breathless, worried, and a bit impressed. I had shown her a particular note, which she received with her placid smile before bowing out.

Mrs. Gardner, I thank you heartily for waking up my most ordinary afternoon, for I happened to be by the gates as you strolled through with Adam and Eve or whichever names are given to such animals. As they say: may you still blossom in perennial flower while I sit ripening in this leafless bower. Gratefully Yours, Oliver Wendell Holmes

Now I piled more calling cards and notes on the sideboard to read later.

The last line of the article read, *Mrs. Isabella Stewart Gardner—Too Wild for Boston?!* I clicked my tongue against the roof of my mouth and said to my own reflection, "Oh, they've no idea."

I left the news pages on the table for Jack to see when he ventured home from work, part of me dreading the not-talking-to he would give me for the outing with Mr. Louris; Jack's disapproval would be expressed in a symphony of sighs. I wiped my hands free of ink, and, still buoyed by my brush with wildness, went out to my brick pathway to begin the three-minute walk toward 241 Beacon.

8

OUTSIDE, I drew my veil over my face, to protect it from the sunlight and also to protect myself from being revealed. The lions or Mr. Louris, even those Swan Boats, all of the untamed creatures had nested in me, and I felt their beaks, their claws, their fur inside my chest as though they might break out of my skin. So I used the veil as a guard.

I paused under the magnolia, which bloomed only just; it had been a cold April, delaying all the flowers. Now earliest summer warmed the air; inside I set pots of nasturtium on the windowsills so they grew in delicate but hardy vines, and outside, the magnolia shifted its pinks and whites. The promise of sun and freedom made my skin prickle. I allowed a moment of stillness, looking up through the branches at the broken pieces of sky between. I thought of Joe and ached for his continual undercurrent of gloom. I thought of ocean waves tugging me out, away from Boston. The thought of Jack's sighs brought me back to shore. Only when my neck ached did I right myself; when I looked ahead I saw a figure.

The man stood doing nothing. Or at least that's how it appeared: as though he owed the world nothing. His was the kind of beauty people had likely pointed out his entire life. The kind of features that would be cruel in a painting because they were that appealing. He began walking. His stride long but slow: the sort of grace I found

magnetic paired with a disregard for who might be watching. Or per-haps he knew I was watching from under my veil, so his figure in light trousers and dark jacket seemed shadowy as he turned just for a second and looked at me. He was illuminated from behind, and I felt at once as though he might be propelled by the slipping sun into my arms.

When I lifted my veil, the sunburst had vanished and the man was gone.

DAZED STILL by the attractive man on the street, I barely reg-istered Maud and her mother's welcome to their home, only a few blocks from my home on Beacon Street, but a world away.

My hello to Mr. James and to the other guests passed quickly amid the artistic tumble I had come to enjoy at the Ward household: velvet chairs, vases of flowers placed in no particular order on what-ever surface might be available, tapestry in place of a door between entryway and dining room, a huddle of figurines on the mantle, and bowls of dried fruits and imported nuts that might have just been placed out for our benefit or that might have been there since the last party, and a chaise in leopard print that recalled my own brush with great cats.

I stood waiting for our hostesses to announce our seating: a long sigh of tradition that—so used to being last was I—by now made me numb. But instead of being ordered to chairs in a humiliating proces-sion of most-to-least, the guests began moving as one, feathers and frocks and buckles glinting in the afternoon sun that shone through the windows. We were attached in a fluid motion like one of the odd sea creatures I'd seen in Dresden.

"It's a toss-up," Julia Ward Howe said when we'd assembled in the dining room with its dark racetrack table and walnut chairs, extras pulled in so the room had the look of Jack's meeting offices if they had been decorated by an artistic courtesan.

"A toss-up?" I mumbled. I must have appeared clueless, for the man standing next to me turned.

"We're a human omelet," he said. "Mrs. Ward Howe means sit

anywhere we like, scramble." He held a peacock feather and waved it like a music conductor before choosing a vase at random and shoving it in with great flourish.

I grinned. "At last, a luncheon that won't suck me under its tide."

"We can't have both ocean and egg metaphors in one," he said, and reached out his left hand, which was adorned with a heavy ring on the pinky. "Oscar Wilde."

I tried to keep my face immune, but his outfit was that of a musketeer, his hair insouciantly floppy, and his gaze so intent I felt as though I were the only person or object in the room.

We scrambled, serving ourselves from a complicated array of dishes on the sideboard: sliced duck, endive salad with almonds, new potatoes in mustard sherry. Maud brought a bowl of berry compote out and placed it down, only to have her mother move it elsewhere. I arranged a plate and scanned the table for where I might sit, for it is one thing to dream of open seating yet another hassle altogether when one has the complication of a choice. I hesitated.

"I won't be ignored," Mr. Wilde said, and patted the spot next to him. Relief flooded through me. As we dined he explained he'd been in the States lecturing. He rattled off his lecture topics: "'Irish Poets and Poetry of the Nineteenth Century' in San Francisco, 'Decorative Arts' in June in San Antonio. 'The Relation of Art to Other Studies' in Hamilton, Ontario. Wherever that is." He studied my outfit, and motioned to my neck to suggest I remove the lace inset with a swift tug which broke the single stitch. I did so without asking why, somehow trusting his opinion. He nodded: better. "I'm thinking of writing another lecture—or essay maybe—on the importance of dress, and I abhor fashion. So there you have it. I dream of notoriety and for now content myself with the sad meal of journalism. Shall I send one of the lectures to you?"

I took a bite of cheese that I had slathered with molasses-soaked pickle. My mouth bristled, alive as my head with his ideas. "Yes, send me one. Though I warn you: I've a penchant for saving letters, so the pages might outlast us both."

"Save us all, dear woman, and burn, burn, burn. Never let them

see your evidence." He licked his lips and waited. "Which lecture, now that I've rattled so many titles off to you?"

I looked around the hodgepodge of a room. The people decorated the table as much as the place settings. "I should like to read 'The House Beautiful.'"

"Interior and exterior, art and objects? Consider the transcript yours. And now, tell what it is you do, for I can tell you are a woman of import."

I opened my mouth to speak, to at least comment on how good it felt to have him—a man *and* a man of import himself—ask what I did, or what I thought. But before I could answer, Wilde turned his gaze. "Ah, there's the fellow I met just yesterday evening." He lowered his voice and whispered to me. "Who could resist?"

The tapestry parted, bringing air and a latecomer through it. The conversation quieted as everyone looked toward the double-length dining-room doorframe. I kept facing Oscar until he knocked my hand with his giant ring, urging me to turn my head.

When I did, I felt my entire body clench. There, seeming to fill the doorway with his tall, elegant frame, was the man I'd seen on Beacon Street. His stare met mine and it was just the two of us, a pressurized compilation of our cells in the room, desire rising from my ankles to my belly, up to my breasts until my mouth filled with it. He did not stop looking at me.

Maud stood up. "Ah, Cousin Frank." She went to greet him, and as I blushed, she led him to the table. "Please meet, or re-meet, Frank Marion Crawford." Crawford did not move his gaze from mine but seemed to smile at the whole room.

The room grew quiet. "Frank's only just back from India, where he wrote for the *Herald*."

His gaze left mine, and I felt sickened by the loss. "I go by Marion. Or just Crawford." He stood, apologetic over his cousin's fuss. "Actually, I'm just finishing a novel—"

Mr. Wilde clapped. We followed his lead. "And, he admitted last night that he's well on his way to finishing another novel, too. Two." He held up two fingers. "I suspect this is a young man of great poten-

tial." Crawford was young, a decade or so younger than I. Maud and Julia beamed. I looked at my ravaged plate. Mr. Wilde patted the space between us, beckoning Crawford to fill it.

My chest pounded. I could scarcely breathe as Crawford gathered items on a plate and sandwiched himself between me and Wilde.

I could not speak. I could not look at him, for fear of ripping off not only more of my lace, but my entire gown, for fear of crawling out of my chair and into his. Caught off guard by my feelings, I focused my gaze on a small wedge of marbled cheese on my plate. Once, Harriet had confessed she'd eaten a wheel of cheese—all at once, all on her own. She had been unable to restrain herself, knowing it sat on the sideboard sweating through the muslin wrap. And Julia had spent an ungodly amount on a hat she'd worn once. And I had felt each rare book pulling me to its binding as I now felt drawn to Crawford's presence. It was as though the lions had pawed me open: my desire leaked everywhere.

Mr. Wilde, perhaps sensing my inability to cope, filled the air with pithy conversation. I heard bits of it: Crawford studying Sanskrit at Harvard, Wilde worrying about his reputation in England. Wilde had seen me with lions and asked if I considered myself wild. I did not answer.

Crawford turned to me after Mr. Wilde said my name. After we introduced ourselves, he teased out from me that I, too, attended lectures at Harvard, that I, too, had an eye for literature.

Mr. James, eavesdropping and no doubt jealous of the attention, leaned forward over the table and added, "Soon Mrs. Gardner wants to host a lecture à la maison. Isn't that clever?"

I swallowed and worried it was audible. "I hope to, yes. For why should such interesting and useful subjects be quarantined to academic halls?"

"Quite right," Mr. Wilde said.

Crawford nodded and worried the handle of his spoon, either testing the silver for smoothness or out of absentminded nerves. Either way, I could barely shift my gaze. Those hands. As though I were the cutlery: his thumbs pressing into me, hands sliding down my hips and

then up again, going higher and lower each time until he had memorized the route and each divot of my form, his thumbs with unpicked cuticles, perfect and clean, and attached to hands that now I thought of on my face, on my back, splayed like wings on my collarbone.

When people had begun to disperse for sherry and thimble-sized sugar-cream biscuits, and Crawford had thankfully moved across the room to speak with his aunt Julia, Mr. Wilde sighed. "I've pushed my stay. I'm due for another lecture tomorrow. And then another the next tomorow."

"Does it not feel fulfilling?" I asked.

"Yes. And tiring. On this circuit I've had to remind myself where I am, what I'm saying." He paused. "It's all quite fluid, the travel and the words. Not much time for building real . . . relationships."

"I've experience with that," I said. "Society can be cruel."

He narrowed his eyes. "But lions are accepting?"

He smiled, and I grinned back. "Perhaps I have more of a natural touch with animals." I thought of my books, of the objects I'd bought the last trip to New York. "Or things."

Mr. Wilde looked at the people patchworked around the room and, to my horror, repeated a similar sentiment I'd heard years before from Mrs. Amory. "Oh, clever girl, must you be so dim?" I felt the smack of his words, blush burning immediately on my cheeks. But he went on, a sympathetic hand on my forearm, his eyes bright on mine. "Groups don't form from the ether. It's a decisive act. You know what you like, that's perfectly plain—but it's your duty to gather around you what appeals."

I held my used dessert spoon in my hand, staring at it as though it were an additional digit. All along I had been rejected by the Amorys, the Bradlees, the sewing circles, and turned all that energy into collecting books as respite, when the true comfort was in gathering my crew: Henry James, possibly Mr. Whistler, Mr. Louris, Mr. Grotberg, the Howes. For all the circles in which I had never been welcome, it had never dawned on me that I might create my own.

· · ·

DAYS LATER, I found Jack had left early for work and placed *Town Topics* on the table for me to find with a new headline. *Mrs. Gardner Goes Wilde!* I read to myself. *Mrs. Jack Gardner was seen lingering on Beacon Street with a certain velvet-suited man. Mrs. Gardner's exploits continued as she and her "friend" Oscar Wilde conversed long after the luncheon finished.*

The papers were true. We had stood on the wide stoop in front of Maud's door long enough that my fingers grew stiff from the late-afternoon chill. Everyone had gone, including Crawford, who had barely looked my way after the soup. I'd watched him and his long shadow with a feeling of desperation I both loved and loathed. Finally, I told Wilde I had to return to Jack. He'd grabbed my hand and, pressed inside it, was a note I looked at now, my hands trembling.

Meet me. —F. Marion Crawford

9

A FEW WEEKS later, I sat with Jack at the table. He read the papers, sometimes commenting on the cost of coal or the shipping news, sometimes only flicking the pages with his thick fingers, annoyed at the content. Or at me—I couldn't be sure.

I read a note that had just been delivered.

Dear Mrs. G—
I pray this note finds you well and surrounded by kind beasts.
Assuming the lions are to blame for any delay in my hearing from
you regarding attending the final Asia lecture. Do let me know
what preoccupies you these days. —C. E. Norton

Jack scanned the note as I set it on the table. "What does occupy you?"

I spread jam on a piece of toast, and then, having nothing to do to distract myself from the note that I could still feel in my pocket—*meet me, meet me, meet me*—I slathered still more jam until the toast buckled. "He means the course of lectures I've been attending. On Asia." I looked Jack right in the eyes to force my breathing to calm. "I'd like to host a lecture here."

Jack's mustache twitched—neither sold nor offput by the idea.

"If that is what you wish." My hand holding the toast shook so much that great blobs of jelly fell to the plate. Jack stared. "Are you ill?" His voice held a distant concern. He looked at me, suspect.

"Why?"

"You're trembling."

I pushed an image of Crawford's hand holding the soup spoon all the way down to my feet, but it rose up to my groin. I stood. "I have a telegram to send. I'll walk it over."

Jack stood. "Nonsense. Tell me what it is you wish to say, and I'll walk to the telegraph office myself." He waited.

I thought of the note. Of the spoon. I looked at Jack. "You might say . . . 'Dear Mr. Norton, I write to express my great interest in the Asia lecture series you hosted and which I gratefully attended. I should like very much to continue by hosting Professor Edward Sylvester Morse in my home on Beacon Street. Please would you do me the favor of asking him. I never tire of learning—always, ISG.'"

"ISG." Jack raised his eyebrows, expectant.

"It's not enough to go to lectures, Jack. If I'm to be integral, I need to host."

The Presence of
Mr. and Mrs. Jack Gardner
is requested at the home of
Thomas Jefferson Coolidge
315 Dartmouth Street, Back Bay
For Post-Symphony Cheer before the Summer Season

20th May 1882
152 Beacon Street

Dear Julia,
How lovely to spend time with you at the symphony. What a necessary addition to Boston, this orchestra! One can hardly imagine the city before the symphony's existence. Rather a new thrill for me to receive an invitation; perhaps society gossip papers haven't "ruined" me!

Your dress was perfect, and you simply glowed with health. And how busy your family life now—and what charming young men you've raised. I do raise a glass to your efforts, for it is all I can manage to keep up with ours. I took your advice regarding Joe's solemn attitude, and now, as you expected, Joe is enjoying his further degree at Harvard's Bussey Institute. Perhaps he will be happier with a hands-on profession such as veterinary medicine. One hopes! And Amory and Gussie are studying and looking forward to summer.

I shall be in Newport in a few weeks' time. My friend Mr. James is already there visiting with his friend Miss Edith Wharton and will further introduce me to artists and writers who flock to the shore for ocean breeze and the gossip the wind brings with it.

In the meantime, I do hope you can put in a word with Mr. T. Jefferson Coolidge. As you and I stood for so long in front of that stunning painting last night, I cannot rid my head of the image of Mr. John Singer Sargent's *El Jaleo*. In the night I tossed and turned over the dance, *el jaleo, el jaleo*, my mind kept repeating. I did ask to buy it outright from Mr. Coolidge (you are shocked and horrified by this, I can hear the gasp now). My offer was summarily dismissed, but not without a tiny twinkle in the owner's eyes. Even now I am in rapture of the couple in the painting, their clutch, the music unheard yet heard all the same by the viewer. Mark my words, dear Julia, one day I will have *El Jaleo*. Ever Yours—ISG

IO

NEWPORT IN summer displayed for all who ventured there a delicate, vicious sweetness, rather like an intricate layered cake painstakingly arranged with fresh berries soaked in arsenic.

A few feet away, Miss Edith Wharton, finished with her debutante season and engaged, her shoulders and body displaying her smugness about that fact, stood speaking with Mr. James. She did not address me—not the worst snub I'd faced—though Mr. James had made a fuss over my arrival. Jack had gone to the boats already, leaving men who preferred land to tend to the women. One of these land-faring men was F. Marion Crawford, and I could see him in one of the fan-shaped chairs, one leg crossed over the other as he spoke with an interchangeable Brahmin.

In a linen dress the color of seafoam, a summer-weight straw hat emboldened with dried flowers shielding my face, I stood leaning into my closed parasol. The point dug into the carefully groomed lawn. The Vinland Estate had only just been built at Ochre Point for a tobacco heiress. The house was red and heavy and impenetrable, like the whiskey-soaked men who, too old or heavy or bored to be either boat-bound or affable with women, anchored the arched and shady porch as though the season didn't matter at all.

But it did matter. It was hot and sticky, and my dress confined my

body's heat so that my skin prickled. I could feel sweat rimming my bodice and longed to undress in front of the sea or in a bedroom that afforded an ocean view with a steady, salty wind.

I looked at Crawford and thought I saw him look back at me.

Of course, nothing had actually happened with Crawford.

He had not pressed his thigh into mine at the lecture I'd attended the week before, at which he had sat on my left while Jack sat on my right, Norton nodding to us both from across the room.

And Crawford had not let his fingers graze my knuckles as I held his novel *Mr. Isaacs*, which he had given to me outside the lecture.

He had not kissed me, had not pulled me to him in front of everyone or no one, and this fact threatened to break me.

Which is, of course, saying something physical *had* happened. Because wanting it was something already. And the gaze. When I looked at him as he stood and began to walk toward me, my mind immediately electrified with words, with wonder—what would he say, what would he ask, the sure warmth of knowing I fascinated him.

Nothing had happened. Except everything had. When I walked the same familiar blocks at home, it was with his voice in my head. And when I slid into my own sheets, imagined conversation followed.

Nothing had happened, I reminded myself as Crawford walked toward me, a sketch set in his hands.

"I'm going inside. Miss Wolfe has been kind enough to allow me use of the side suite for an afternoon of art." He gestured with his wooden kit, the brass buckles glinting in the sun. "A bit antisocial, but with this view . . ." he looked at me and then the ocean in front of us. "How could I do otherwise?"

I watched him go inside. Nothing had happened; I said nothing back.

THE SUITE was alight with sun and breeze that took the sheer curtains and flung them out and back like gauzy lungs: each new gust an expectant sigh.

I approached Crawford and his ink and paper, his sketchbook and

charcoal, his fingers smeared with it: the same fingers that wanted to hold my chin, my chest, my bare shoulders leaving traces of him on my skin, the sketch studies of what was to come.

He dragged the charcoal across the page, and there in front of us was a duplicate window. I imagined us both in the sketch, flattened and alone, safe on the paper.

"I often prefer the studies of art," I told him. "The practice is sometimes more fulfilling than the finished work."

He nodded and kept sketching. "Agreed. Why not frame the process instead of only the results?"

I listened to the sound of waves slapping the jagged cliffs, the barely audible noise of gentility below: cutlery clinking on plates, flutes filled and toasting, self-referential cheer, wind whipping the edges of white tents, harp and brass music, everything a swirling, fleeting summer soup.

In the room the wind picked up, the drag of the charcoal on the paper felt like nails on my skin, and my own breath came out fast and noisy. Crawford kept his back to me while he finished the window sketch, and then, without warning, stood up and turned to face me. We stood not speaking, just looking at each other. In that moment I felt all my earlier selves rush to meet me; I deserved this. Finally, I stepped toward him as though nudging a door open with one toe.

There were distant chords from someone playing Bach somewhere, and now the time signature of his hands on me: a first kiss. How long it had been since I'd had a first kiss. That was a desire long given away to time and marriage. And as we stood with hands touching, knowing the inevitable contact, I knew he would not initiate.

So I leaned forward, my intentions clear. His lips grazed my ear. "When you leave I know I will long for you."

"Maybe I won't leave," I said as I slipped my hands around his back. I put my lips to his neck as the music continued like a deep ache, an already forming bruise on my heart, I could see it. Running away with him. Waking in bed to pages of his writing or art scattered around my loose hair. His gaze on me, waiting.

I felt the coursing of sex and Crawford through me, a wave of everything missing and sacred and my old self on the sleigh ride tap-

ping me on the shoulder. *I'm still here.* He held my face in his hands as the music built downstairs. I did not think of being caught out. Caught with him. I thought instead of this great pleasure. How part of me was already missing him, though we were together still. Crawford slid his charcoal thumb from my mouth down my chin, following the slope of my neck as he pulled me closer into him. His mouth met mine, and it took all my self-control not to ravage him. I thought of the lions, and pawed at his chest as our kissing grew more heated. One of the curtains gusted up, encircling us in its gauze. I lifted my seafoam green dress as though I were a wave breaking onto him, and he slid his hands under the fabric as we sank to the floor.

I did not think of myself as a forty-two-year-old married woman on the floor with someone more than a decade younger. I did not feel anxious or sullied as I slid my hands under his loose white shirt. I did not even allow betrayal to enter my mind, for after all, any long marriage holds within it myriad slant-betrayals: crushes across the dinner party table, taking the last leftover pudding when one knows it to be the spouse's favorite, uneven grief over losing a child, a preference for yachts because they cannot speak, cannot disrupt the social norms, the exhaustion of living with one person and having them as the only option, seeing their work as folly, making a hobbyist of a person and their passions.

I felt pleasure I had never known before and could hardly bear the desire welling up in me as I pulled Crawford on top of me, the buttons on his shirtsleeve heavy on my skin as he put his mouth to my ear, his breath ragged as he called my name again and again.

3rd September 1882
3 Bolton Street, Piccadilly

Dear Mrs. Gardner—

A thousand thank yous for your letter, which I know I am overdue in answering, especially given the circumstances of Newport, et al. Please do share news of your "friend." No doubt this will urge me out of stale crust London and into the realm of dreaming of Venice and romance and anything other than my tasks at hand. I

am, as always, writing or attempting to write. There is no other occupation for me, alas. As of now, poor Daisy Miller continues to struggle as she makes her way from novel to play. You, too, dear Isabella, must focus on the future and tell me your plans for your next trip, which I very much hope includes me at least on the outskirts and, should the place be of disrepute, then on the in-skirts. Mr. Whistler has asked after you, so perhaps consider a cross-the-Atlantic stop-by one day soon?

<div align="right">Your very faithful friend,
Henry James</div>

Post Script:
I'll be in Paris for the autumn months, leaving here the 12th.

<div align="right">16th September 1882
Alhambra</div>

Dear Esteemed Novelist/Playwright Henry James—
I found an old issue of the Sun; summer houses do seem to collect relicts—papers, letters, defunct lives. I report to you that before they went back to school, Gussie and Amory and I finished a juvenile novel, *The Clock that Went Backwards*. It concerns two boys and a machine that permits them by way of a device to go back in time. Perhaps this is what I feel with C—, a slipping back to my younger years, that tantalizing hope and possibility not only in my body but in what I might mean to the world; it sounds grandiose, but perhaps this is the way with all affairs? As though every possibility and choice were on a board in front of me, the self who stayed in Paris and painted or who came to Boston but did not marry and instead became something else. Who might I have been?

Is it C— or my time-traveling self I seek?

Either way, we are packing up the house for the end of the season and travel tomorrow back to Beacon Street. Once we've settled, I will hopefully begin preparations for the lecture. By then you will be ensconced in Parisian life and will have forgotten me due to a fog of Camembert and triple crème. Yet I shall remain—

<div align="right">Ever Your Friend—ISG</div>

II

I SPREAD A woolen blanket on the tough, cold sand on the beach
behind Alhambra as Jack leaned down to collect four rocks: one
for each blanket corner. The North Shore was especially windy in
autumn, winter teasing with backwind, and yet a hint of old summer
in the lulls. We arranged the cold-day picnic in the companionable
silence that felt as familiar as breath; in fact, I adored it. Not only the
quiet but the well-oiled machine of our coupledom: I could steep his
tea to the correct shade without his asking, he called me out to the
porch to ring the brass bell one final time knowing I liked to both
start and end the season in this manner, he flung the sheets onto
the summer furniture the same way each time, his big arms gently
settling the fabric on the chaise, the sofas, and my dressing table, his
actions made a breathy sound that comforted me.

Now he sat waiting for the plate I readied with the remnants of
summer: meager candied lemon rinds atop honey smeared rolls just
a tad too hard on the teeth, a waxy end of cheddar, a tin of candied
apricots someone had brought as a house gift and that we had never
opened until now. We faced the low tide together.

"I enjoy days like this," Jack said.

"Me, too." I took in the silvery light, the way the air seemed to
cling to any trace of heat. "I find sometimes I'm remembering the
days as they're happening."

Jack turned to me, his mustache illuminated. "Perhaps because the boys have grown so."

I nodded. "That's part of it. Time takes on a speed with children. And they're not children anymore." The tang of sweet apricots slicked my teeth. "Isn't it odd, though, to feel as though one is already remembering a day while it's still occurring. I mentioned it to Henry James. He called it 'rather an elaborate form of nostalgia.'"

If someone were to paint us then, what would have been captured, I wondered. Our knowledge of each other was everywhere in evidence: Jack's ample buttering of my hard roll, how he saved the best piece of bacon, how I gave him the center square of the citrus bar, as he cared not for edges. Or one might frame the scene as pure folly: cold air sliced under my chin, leaving my skin raw, sand blew grit into the butter and made for an unpleasant sandwich, determined gulls invaded, and we eventually abandoned the meal and walked to the water's edge. Would a painting capture guilt? Buried pain? The endurance required to sustain a marriage?

"The open expanse reminds me of Whistler's *Nocturne*," I said. Jack looked blank. "That painting from the Grosvenor Gallery I told you about. I'm on the chase for it. I should like to return to London soon for it. But this view . . . I wonder how many more outings we'll have."

Jack skipped a rock along the water's surface, and it bounced four times before sinking. "You've got a morbid streak, Belle."

"I can't help my nature, Jack."

He shielded his eyes, looking out at the bay. "No, but you might just focus on the sun."

"What does that mean, exactly?"

He chose his words carefully. "It means, I like to think of what I have rather than what I do not."

It was possible he knew about Crawford. Also possible he loved our companionship too much to say. "I have it all in view, Jack." A thought came to me, solidifying as it arrived. "I might be finished with books." My breath came fast as I had a fleeting image of Crawford looking up at me, his hands on my thighs. "I mean finished with books as a passion."

Jack's expression soured, and he looked away from me out to the glimmering water. "And just what other passions have you in mind?"

My heart raced. Did he know? Was he aware and felt he would rather not challenge me with Crawford? Or did he know and could not be bothered to care?

"I have a few areas of interest," I said, and then, because Jack looked away from me and his distance scared me, I added, "travel, for one. And if Mr. Norton agrees to my—our—hosting the lecture, I'll find renewed passion for Japan."

MAUD'S FATHER, Samuel Howe, had been the founding director at Perkins School for the Blind and she had been born there, so when she suggested I meet Crawford there a few days later, I agreed. I could not help but think of the students with their tactile books and rigorous sports programs, learning and navigating the world despite early belief by society that to be blind was to be an invalid. It was progress. And yet I also recalled the way the Perkins shipping money decades before had helped enslave an entire Chinese population. Such a conflict—good might come from money, but it did not undo the damage.

Crawford sat at a desk, writing. We met in the gold-dust air, old papers scattered in front of him, and I was both in my own body and above it, seeing us as an unpainted picture, Sargent's *El Jaleo* but after the dance, when the guests had gone and the boots were off, the relaxed ache after bodies have worked hard together.

Sometimes we were lazy enough that he would take me lying down, both of us with our shoulders on pillows but our bodies entwined from the waist down. I liked this way the best because we were side by side with our heads turned, looking at each other in the stifling July heat or in the beckoning chill of October, the kind of gauzy afternoons of skin and warmth that cannot last, though we tried our best to consume as many hours this way as we could. I felt twenty years old or one hundred, young and wild, ancient and serene in my skin: a momentary bouquet of selves all gathered in one act.

Later, as the carriage pulled away from the stone-walled Perkins estate, I still felt intoxicated by my interaction with Crawford. After

each encounter with him, whether physical or not, I needed days to detoxify my system. And that leeching was rarely successful, as I found the craving reappeared without warning.

The Gardners Jack and Isabella
Kindly request your presence in their home
152 Beacon Street
as they host Professor Edward Sylvester Morse
formerly of Imperial University Tokio in a Lecture Series on Japan
10th, 18th December 1882
8th January, 9th February, 28th March 1883

12

"How funny to be meeting and not at your house," I said to
Maud. November air wove itself into my wool shawl, making
me shiver.

"Nor at yours," she said.

She had assembled a group of us: Sarah Orne Jewett, who brought
her own short story for us to read and critique. I had read her work—
all focused on her locale in Maine—in the *Atlantic*. Also there were
Mrs. Barrett Wendell and Annie Adams Fields, whom I gathered was
a good friend to Sarah Jewett (so close, in fact, that they were now—
after the death of Mrs. Fields's husband—sharing a place together).
With us was a novelist, Margaret Deland, and now Mrs. J. Temple-
man Coolidge joined us, out of breath and ruddy with cold. If only
my earlier, younger self might have a view of the me of today: how
welcomed I felt.

We stood as a group at the front of Boston Dry Goods, a large
three-floored building beset with seven arches at the front. Inside,
we moved without pause through the goods on offer toward a back
stairwell, which led to a large room on the second floor that streamed
with late afternoon light. There had been, since the war, Ladies'
Ordinaries—places in hotels women might meet if not accompanied
by a male. The only one in Boston was the Tremont House, and I'd

never ventured there—partly because the establishment wasn't gen-
teel, which back then had ruled out Harriet or Julia, and, more to the
point, I hadn't had a clutch of female friends to bring. My mother had
written about the Astor House in New York; that city could support
more of everything and bigger besides. Boston was the reserved older
brother: slow to change and small in doing so.

"My first Ice Cream Saloon," I said, nearly giddy with excitement.
These sorts of saloons, too, were places for women to go, with friends,
or mothers, or daughters—even alone.

Maud found a worker, who gestured us to two café tables. Sarah
Jewett did not hesitate to push the two tables together so we would
have a tighter group. No one raised an eye at her for doing so. In fact,
there were no men to notice us at all. We were out of our respective
houses with no one who might comment on or harass us.

"I'm quite overwhelmed with this," Margaret Deland said, taking
a seat.

Amazed, Maud said, "One could even imagine coming here on
one's own."

I thought of my adventures alone on foot, the pleasure garden,
or Mr. Valentine's cousin Swain's fern greenhouse, my walks in the
Common or my continued visits to the Zoological Gardens to say
hello to Zizi or Happy or Mr. Louris. "I enjoy going out alone," I said.

"We should follow your example," Annie Fields said.

"But you should bring me with you," Sarah Jewett said playfully
to her.

"Yet then I wouldn't be alone," Annie Fields said.

I inhaled their quick conversation and acceptance, noticing
printed cards on the tables that listed possible flavors. "So, we're to
order ice creams?" asked Margaret Deland. She handed each of us a
card.

"It reads like poetry," I said. I put on the voice Crawford used
when he read aloud to me in bed, melodic and soft as though there
were nowhere else to go. "Quince & Vanilla, Sugared Cream, Lemon
Meringue Ice, Almond & Honey, Cherry with Licorice Bits, Boiled
Treacle Swirl."

Maud faux-fanned her face with her hand. "Why, I'm hot under the bodice."

"I'm glad for this," Mrs. Barrett Wendell said. "Have you taken notice of the fad for women to 'eat lighter'? It's horrid. Last week I had an entire luncheon party refuse the pudding."

Maud looked thoughtful, her brow furrowed as she studied the printed card flavors. "What is this female aversion to *real* food? Must we skirt around the edges of what is edible the same way we are forced to do so in life?"

I felt the words before they burst from my mouth. "I'm tired of being on the edges." The group turned to me, nodded. "Quite right, Gardner," Margaret Deland said, and I did not refrain from smiling wide.

We ordered, which entailed each of us watching the next decide the flavor, the size of glass for the portion—I noted that once Maud chose a midsized glass, the next chose small and then the rest of the party felt the need to also order small, which in turn made Maud wonder if she'd made a mistake, but then she said she would likely refrain from consuming the whole thing, which then made her prey to exactly what she had railed against moments before.

It was exhausting.

"Asking women to consider portion size is simply subordination," Margaret Deland said a bit later, stretching the word out like seaside taffy as she slid another spoonful of honeyed almond into her mouth.

"I haven't heard the word in that context," I said. These women did not make me feel silly for not knowing, for asking questions.

"I mean to say that we are put in our place time and again, sometimes in ways we might not know until we study it later." Margaret Deland took another bite, thoughtful. "Subordination of desire . . . if women are encouraged to want less, to taste less, we will accept less. And loathe ourselves for the very act of wanting."

There was quiet as we each tasted the ice cream dishes before us, savoring privately. I thought of Jack now at the all-male St. Botolph Club, the thick amber of the Reform Club's air. "And men keep

the lusty items, the ales and the cheddars, the heavy desserts, for themselves."

Maud nodded. "We cannot be trusted with deep tastes, you see. Who might predict what women will do with too much flavor!"

Margaret Deland was quiet, tasting her ice cream. "I should like to bring others here."

Maud nodded, understanding something I did not. "We might organize another outing?"

My eyes went wide, confused. Maud explained as Margaret nodded, happy to have Maud's encouragement. "Margaret and her husband, Lorin, are remarkable people, really. They live nearby to us: on Mount Vernon Street." She gestured out past the large windows to where Back Bay nosed up to Beacon Hill, gas street lamps already alight and haloed in the cold November fog.

"You mustn't make it more than it is, Maud."

"What is it if not great?" Maud said, fueled by sugar. "This woman here," she pointed to Margaret, who blushed but accepted the praise, "takes in unwed mothers and their children and keeps writing all the while."

Instantly I was in awe. And in another instant, embarrassed.

For what did I do, really? I had my nephews, but that was hardly the same. I had an appreciation for art and literature. I had a worthy collection of rare editions and a solid marriage I was bruising with an affair that allowed me to live through someone else's art. But what else?

It was my turn to blush. "That is truly remarkable. You should be proud."

Margaret gave me a warm smile. "I don't have time to feel proud. Mainly just fatigued, but it's rather a pleasant sort, if that makes sense."

I nodded. I wanted the fatigue of making something or making a difference to someone.

"After I'm gone," Margaret said, "those children and their children will still be here."

"As will your writing," Sarah Jewett said. "I write because I'd go mad with the thoughts otherwise, but also it's because—"

Annie Fields overlapped with her. "Because it does leave a mark on the world. Those pages are there, the ideas are up and out of your own head. Aside from a relief, it's a heavy goodness to carry around, that feeling of leaving something other people might experience."

This was a group in which I belonged personally, that I understood. And yet in terms of work—well, I had none. And this realization wounded me deeply; my belly ached from understanding that I was every bit as keen in the mind as these writers and activists, yet my actions did not display that. Or at least not yet.

Annie Fields pulled her gloves on, hurrying. Sarah Orne Jewett said, "We must dash. Off to Norway and Italy and—well, just about everywhere." She looked at me. "What plans have you made for yourself, Isabella?"

Maud interrupted. "Isabella has a lecture series on Japan at her very own home—and a long, admirable list of people attending." That was true: there were familiar names, Sears, Coffin, Coolidge, Peabody, Bigelow. And it was a form of greater acceptance. Yet there was more I needed to figure out.

The others said their farewells and exited with promises we would meet again. Maud placed her spoon into her glass. She patted her trim form, somehow boastful as she admitted, "I don't have much of an appetite for sweets."

I licked my spoon clean and thought of Crawford's tongue cold and liquored on mine. I would talk to him about subordination, about flavor, about craving.

"I have an appetite," I said. I imagined Crawford's face as I looked down at him when he was inside me. "At times it feels insatiable."

Maud and I studied the bill of receipt for the ice creams, which listed the order and each flavor and its price.

"How extraordinary," Maud said.

I reached for my string-tie clutch, which had nestled like a velvet kitten in my lap. "Shall I pay?"

Maud shrugged. "Why, that would be lovely. And next time, I shall take you out. We are such modern women."

I smiled and left the currency. Maud linked her arm through mine. "Isabella, my favorite creature. I must tell you . . ." She looked

around as though making sure we would not be heard. She raised her eyebrows at me. "Society is talking."

I sucked the cold evening air into my nostrils and did not alter my gait as I might have in the past. "Society can talk all it likes. I don't listen anymore."

<div style="text-align: right;">

11th December 1882

Newton, Mass.

</div>

Dear Mrs. Gardner—

I write this note not as your physician but as a friend. I wish to thank you for the initial lecture at your house. With the touches of Japanese flowers, the vase, and the carefully prepared duck parcels, your keen details were everywhere. So moved was my son Sturgis—whom you recall was studying at Harvard's newly moved medical school—that he has decided to take leave of Boston. He shall be journeying to the Far East before the lecture series concludes. Perhaps another parent might face this with concern, yet I see in my boy an electricity that rivals New York's Pearl Street Station, incandescent and filled with power. I send my gratitude for evening last and the evenings to come, and for the brightness you inspired.

<div style="text-align: right;">

Sincerely Yours, Believe Me—

Dr. Henry Bigelow

</div>

13

CRAWFORD AND I continued. We met at the Boston Public Library, festive for the holiday season with garlands draped around its room of maps both ancient and modern: worlds I had yet to see. We met in winter-chilled music rooms and in tired and empty January lecture halls, sitting side to side as Crawford read aloud from his work in progress, a novel called *Dr. Claudius*. We met in the Arboretum with its gorgeous skeletal trees and stunning paths, its swell of hill and dip of land still brimming with out-of-season plantings. I commented on Frederick Law Olmsted's choices, agog at the sheer number and variance of trees, the way it would forever be a part of Boston's landscape the way Mr. Grotberg's fountains would harmonize the Public Garden. I longed for that sort of change, for that kind of permanent presence. We had an afternoon of cold and ragged pleasure near a clutch of maples deep within the arbor's shelter.

I explained to Crawford my relationship with Mr. Norton in further detail, how I trusted him to have not only my best interests in mind, but my mind itself. We met in my sitting room reading the *Globe*'s mention of my "personal academia," the lecture series achieving a quiet notoriety. We met by the fireside in Maud's study, and as much as I loved his hands on me, the way he would pause just before we kissed, what I loved most was hearing his voice when he read.

I knew the words had a story of their own, but somehow I was able to let them circle me as though his voice and the plot were all for me. This was true whether he read alone when we were barely clothed or in a hall at a public reading. What I mean to say is that I was as addicted to his art as I was to him.

20th December 1882

152 Beacon Street

Dear Mr. Wilde—

Gratitude is in order for the lecture you kindly sent to me. Such a privilege to read. Appreciated, too, is the list of your possible further lectures, and I am taking the initiative of sending another suggestion for your consideration. We spoke of fashion and its display of both society and current reflections on daily life (true, the invention of pockets initially helped workers and now helps me keep out of sight used handkerchiefs or secrets, including yours, which I will never tell). And yet consider this: architecture. I do not mean solely buildings and landscape, but their positioning. When next you are here, visit the African Meeting House. Gaze from it up the hill to the white church. Then you might write about how many black residences are down the hill on Joy Street below the white homes. Surely not a coincidence? I wonder if the placement of high up and lower down in the houses and church is a suggestive (and immovable) of the way human worth is valued (or not) by society. If I were architect to a building, I would position it away from Back Bay's innate hierarchy. A dream, but still, one I might tuck into a pocket.

With Affection—

Isabella Gardner

14

CAMBRIDGE HELD fast to the grim part of winter. Gone were holiday wreaths and boughs. In their place, crusted ice and the misery afforded humans when left with mere hours of daylight.

I had time before my lecture to brave the cold, so I walked up Massachusetts Avenue. Across from Harvard's imposing gate was Leavitt & Peirce, a new Harvard Square establishment built for the pleasure of smoking. Captivated by the window display of pipes and handsome wooden chess sets, I opened the glossy black door and went inside. The floors were white and black, the walls a deep green as though one stood in an elegant forest within a library.

A wave of pine and tar and cinnamon immediately beckoned me further, entrancing me so that when I heard coughing I jumped slightly. The male utterances were not in front of me. Rather, another cough made me tilt my head up so I might see if the cough came from an angel. It did not. A murder of men in dark jackets leaned over a wooden railing that rimmed an upstairs gallery. Their plumes of smoke gave an appearance of delicacy, but their grumblings were harsh. I smelled their scorn but did not inhale it.

"Why've you come here?"

"You're in the wrong place, Madame."

"Madame must be looking for the dry-goods store down Bow Street."

I craned my neck again to the gallery above, where each and every man had interrupted their games of chess to look down on me. Then I approached the triple-length wooden and glass counter, where Mr. Leavitt or Mr. Peirce—for they were interchangeable to me in their black aprons and caps—stood quite baffled by my presence. I did not allow my face to betray any show of nerves.

"Perhaps Madame would like to purchase something for her husband," he said.

This met with nods and happier grumbles from above. This was a concept the men could understand.

"I wouldn't send *my* wife," one of them called down.

"My husband didn't send me," I clarified, strong in my honesty.

"A gift, then?" asked Leavitt or Peirce, raising a suggestive eyebrow. "For someone else . . ."

I could have turned and been out in the cold, leaving them to laugh at me. I could have shown up early for the lecture, having a seat saved as always by Mr. Norton. Instead, I surveyed the offerings in the display.

"I would like to buy some rolled cigarettes." I gestured to their Bonsack rolling machine, a tombstone of a thing in one corner. No one moved. "So. I. Might. Smoke. Them." Still nothing. "Myself."

"Is Madame Spanish?" the shop owner asked, as though this would surely explain my behavior.

While he wrapped my parcel, I took a slip of paper and wrote a note on it. Then I placed it on top of my hat so all the men in the gallery would read it:

Pity Your Wives

I took my paper sack filled with my unusual request and went across the street to Harvard.

1st February 1883
152 Beacon Street

Henry James DEAR—
If you flip the page you will find my notes from yesterday's lecture, which I attended with Mr. Norton; by now one might think Harvard immune to my presence, yet it is not so, as

we heard a group of graduate studies students refer to me as disruptive. Sitting in a dress in a lecture room saying nothing is wildly disruptive, I suppose. So if you wish to know about the new discovery of Klein bottles from the man himself, please turn over. And if it requires further explaining, as I admit it did for me, I will tell you thusly: You are familiar with wine bottles (there is a pause here for a joke, but I cannot quite form it). Those are two-sided, with no way to get to the other side without somehow making a hole in the glass. A Klein bottle is different—no edges. No lip. So it is one-sided (rather like certain affections appear to be becoming, note I am not elaborating). The bottle has a glass swan neck, which feeds into its own structure, rather like sadness or desire feeding back on itself. Its inside is its outside. I should like my inside to be my outside, too. Perhaps all great loves are Möbius strips of doom. Perhaps my affair is the bottle: a non-orientable surface. Fascinating to look at but rather complicated also. And of course, far more delicate than it appears. Here's proof I duplicated from the slate:

$$(x^2 + y^2 + z^2 + 2y - 1) \; [(x^2 + y^2 + z^2 - 2y - 1)^2 - 8z^2] + 16xz \; (x^2 + y^2 + z^2 - 2y - 1) = 0$$

Oh, pray, excuse my morbs
—ISG

15

MARCH GAVE way, buckling finally to the temptations of early April, just as I had given in wholly to the whims of my affair. These surprise uninhibited days of earliest spring were always Boston's way of coaxing its inhabitants out of doors. I shared cigarettes in the parks with Mr. Valentine and Mr. Louris, while Mr. Grotberg, prone to the wheeze, abstained. I knew I resided in two worlds: one, my safe and beautiful home, and the other a dangerous, hazy emotional whirlwind where I braced myself fiercely, determined to remain in both.

My relationship with F. Marion Crawford was another life, another still-possible self I'd never allowed myself to imagine: a self who lived quite far from the conventional marriage and life I had built. I knew it was merely a painting, an image I would carry with me, yet I lived as though it were real. When I pictured a future with Crawford, it was all I could do to anchor the fantasy with toast and coffee or ordinary correspondence keeping. It was as though the whole of it existed or would exist in a world where nothing was quotidian—just a brilliant haze of breathless kissing and time in bed in a state of forever half-dress in which we had just had sex or were about to, he singing or reading to me and I giving in completely to feeling and to the art of his mouth. Would it be possible for me to live in such a continuous

disheveled state? Artists lived that way—women together as lovers or men and their beaux, fluid marriages in the French countryside—yet Boston remained conventional, and I in it.

2nd April 1883
241 Beacon Street

Isabella Dearest—

An utterly incredible night of learning. I confess to being swept up so in the subject of Morse's discourse that I left without asking a pertinent question (imagine for a moment my not asking something pressing—surely as miraculous as China's Great Wall). While I have your focus reading this note, I know you well, you are by now rightfully saddened by the finish of an extravagant final evening of intellect. In place of that emotional fatigue, I suggest a journey this coming spring. Why not venture to the Orient? You will see in front of you all you've learned. And have space from our admittedly constrictive city.

Please say you will go and bring a certain guest with you. I'll hold Boston until you return to share the knowledge you acquire. You are surely the conduit through which Boston will electrify. All affection—Maud

16

"SHOULD WE travel soon?" I asked Jack.

"And here I was thinking you'd done it—finally adjusted to the pace here. You seem so . . . settled these days with the lecture's success. Buoyant."

Guilt bobbed me up and down as he said that, knowing my affect was due in large part to Crawford and kept afloat by Harvard and Norton and Maud's progressive group of women.

"Sturgis Bigelow wrote from Yokohama," I said.

"Perhaps you ought to go . . . with a friend or two," Jack said. "There's enough for me here."

I could see it: the journey stretching out for months, my whole life on the other side of the world, my romance tumbling into markets, worshipping shrines, learning of new spices, of smoky teas, of weavings and traditions I did not yet know. I imagined Crawford on an elephant. I imagined my new artist life carefree as a shawl blown overboard, and then, just as quickly, imagined the shawl soaked in the waves, drowned.

If Jack knew of my dalliances—and that word pained me, for it sounded so light, so sweet like the ice creams enjoyed by women in public—he did not say. Did he tolerate more than his share? Had I tolerated his devotion to work, to his staid acceptance of everything society held? I became aware of the cognitive labor involved in our

marriage. We had household help and Jack's income, but everything otherwise fell to me: lectures, travel, coordinating our nephews' schedules, managing their well-being with letters and parcels and visits. Sometimes this felt a valid justification for my behavior. Other times my face burned with guilt.

"Perhaps you're right," I told Jack. I would invite Crawford. "The trip would do me good."

Dearest Isabella,
As I write this the night of April 3rd is finished, but I have yet to sleep. I picture you mere city blocks away but far removed from my bed. I picture us soon to board our ship for faraway lands and grow restless with desire. I write, hoping the next novel will take shape, your voice or some trace of you in its lines. How facile for readers, friends, to grow enamored with the easy parts of my person. You embrace all of me. The same for you, Isabella. Rest assured now and forever that while your strength and brain and wit drew me in, it is the broken part of you that wounds me, tethers me to you. And I know you see the same in me, the swampy murk behind the smile. C—

THE CLOSER the trip drew, the longer Crawford's tether felt. Our meetings were fewer; there was packing and preparation, choosing of wardrobe. There were quick visits to Gussie, who had won a history award, and to Amory, who had, as ever, a veritable dervish of a social life, and to Joe, who continued his veterinary studies, finding solace in animals who required no explanation from him.

The less I heard from Crawford, the more into myself I drew. I was a Klein bottle feeding back on myself, my own aching traveling through my glass neck, fragile and morphing into desire. I wrote to him. A long letter bloated with ardency and language he would likely find banal, but I asked him to meet me April 14, my birthday, at the Arboretum, between the oak and the flame azalea, where we'd spent an icy afternoon in February.

Now the meadow was erupting with green, the conifer collec-

tion with their all-season confidence, the Explorers' Garden with its umbrella trees, and the paperbark maple with its peeling trunk that had me close to tears. I was the tree, or we shared a skin.

I waited.

I stood leaning into the peeling bark, wishing I were a poet, or a sculptor working in great twists of metal, a stone carver chipping away marble so that smoothness remained. But I was the paperbark maple; I'd picked the wrong tree under which to meet my lover. I liked to think of myself as oak—durable, heavy, a strong wood for floors and shelves.

But I was the paperbark, desperate and ripped apart by the spring wind that picked up as I stood, legs aching more with each passing hour.

This was how I spent my forty-third birthday: tearing off bits of peeling bark, bits of cuticle skin, my thumbs ragged as Julia's had been in school, red and bloody, blood I smeared back on the tree to prove I'd been here, waiting.

At home, I hastened up the stairs for a bath, feeling sure I was dropping parts of my actual body as I went: goodbye to my heart, farewell to my limbs that had embraced and been embraced. My arms could not hold the weight of all my splintered parts. I was broken again.

Jack knocked on the door but did not enter as I slid my naked, ravaged self into the scalding water.

"Are you quite well? You were out for ages, Belle." He breathed hard from climbing the stairs. I could picture his protruding belly against the door. "Have you had a good birthday?"

I did not respond.

I allowed the excess water to slip over the side of the copper basin as I submerged. Underneath was quiet, my ears blocked from spring birds, from Jack's breath, from the already-too-distant memory of Crawford sliding onto and into me like water itself. How would I free myself from that sinking?

I bolted up, gasping. "Now that you're asking, this hasn't been my best birthday, Jack."

Jack opened the door a sliver. I could see one of his eyes, the edge of his mustache. "Would you like a gift?" he asked. I nodded. "Perhaps you would like my company in the Far East?"

I waved him in the room. He approached me carefully, the way one would an injured beast. I covered my face with a mound of my wet hair. "You are a tolerant man, Jack."

"I won't ever let you fall so far down that coal pit that you cannot be dusted off and made right again." He placed a wide hand on top of my head. "The world is large, and there is much to find. Isn't that what Professor Morse tried to convey?"

I pulled my knees to my bare chest, aware of the delicacy of my frame, the easy way it felt in front of Jack. It was not desire. But it was warm and immovable. "We'll explore the world together," I said as though testing the idea. Jack nodded. "And come back once again changed."

2nd July 1883
Yokohama

Dear Maud—

Fascinating place, furious pace of trip. Suffice it to say after leaving San Francisco on May 31 we arrived June 18. Weary with journey yet pushing on from Yokohama with its busy port, having spent time there with Sturgis Bigelow, who is now studying Buddhism, possibly permanently relocating. I suppose this is one of the benefits or hazards of travel; one might become rapt with the culture. The Japanese residences are a miracle of space and washi-paper screens, the botany, too, will stay with me long after we leave. Returning with my travel album as well as a dark sauce that we tasted, which is contained in a large barrel that, while practical for its purpose, to me is a thing of beauty. An end table perhaps. Keep me alerted to Boston's news, and do let me know if it misses me. And you asked—no, I shall not be reading Crawford's latest novel. —Isabella

1ˢᵗ August 1883
Kyoto

Dear Mr. James—

As you know my correspondence pile is substantial, and your
frequent additions to it make me happy. Did you know I recently
took to the art of letter-cutting? I have cut the pain out from me,
just as I've desiccated his letters, clipping only phrases that will be
neutral for all eyes and for my heart. May I suggest it as a salve for
the wounded in love. Snip and clip, and a love letter reads like a
bill of sale. Highly recommended.

Helpful, too, is the miracle of walking with one's longtime
spouse through the bamboo forest of Arashiyama. If solitude, joy,
grief, and ancient knowledge were sprouted from dank ground,
this place is their garden. I will return with woodblock prints on
paper, though none will capture the spindled height of bamboo,
its hollow strength, the fronds that cast speckled shadow on the
ground as one tries not to make noise while walking so as not to
disrupt the harmony crucial to life here. This one hears again and
again—balance, order, acceptance of space as a thing itself. We
leave Kyoto for Tokio soon, then Bombay before England.

An aside: My zookeeper friend wrote to tell me of the death of
the last quagga—not quite a zebra and not quite a horse. Rather
like me. Except now extinct. Someday we all will be, and then
what? What remains of us after we are gone?

I shall wait for your response, knowing I have lost you
temporarily to Italy, as one does. Yours—ISG

17

FAMILIAR IN its gray drapery, England welcomed us without much ado. I fretted over Jack, who still mourned his mother's passing the previous autumn. We were often at our best abroad, as though we escaped ourselves or the selves we were in Boston, and yet in mourning, Jack had aged. Indeed, everyone seemed pushed into the next phase of life. I had written to Theodore Lyman right before we'd left Japan, telling him I'd placed an order for *Forest Flora of Japan* as he had suggested—the book due out next year. I'd seen some of the pages and they overwhelmed me with the notion of gardens—and strengthened my determination to have a garden of my own one day. Lyman's letter informed me of his ill health, which was worrying. In fact, I seemed to excel at worrying. So while Jack went straight to his club, I set about turning my worrying into acquisition.

James McNeill Whistler's pristine smock suggested he was not slathering what appeared to be the twelfth layer of paint on his canvas but rather that he was a part of an altogether spotless profession.

"You're as clean as a banker," I told him.

"Bankers are not clean," he said.

I held the ribbons of my hat, which felt in danger of blowing off my head and into the Thames. Never failing to disappoint with its gloom, London had turned up a shadowy morning that I'd spent

watching Whistler. Now it was an equally gray afternoon. I wanted to compare it to the colors in his *Arrangement in Grey and Black No. 1*, but as he was not yet finished being ridiculed for the portrait of his mother, who'd stood in for a no-show sitter, I held my tongue and felt smug about it.

He placed another dab of brown, which, due to the lack of color in the background, appeared brighter, alluring despite its darkness. A rather immaculate bridge.

"Bridges, not bankers, duly noted."

"A toll bridge, originally," Whistler said. "And soon to be razed. Imagine something so solid being demolished. Makes me feel a fool for painting."

"All the more reason to paint, actually," I said. "Surely if Old Battersea Bridge will be erased from sight, it's better to have proof of it?" I studied the sketches he'd done for practice. "Truthfully, I prefer your rendering to what I see right in front of me."

"Waterloo, Battersea, Old Westminster, Old Hungerford. I have an odd love for bridges."

"Why?" I thought if Norton were here he would wax philosophical about the nature of connecting one piece of land to another, and if Henry James were here he would roll his eyes and regale us with his journey over the Boston and Providence Railroad Bridge, which he compared to a tongue leading the way to the teeth of Edith Wharton's wedding. "Perhaps you simply find pleasure in their design."

Whistler turned to me. "You know, I believe that's just it. There isn't more sentimentality or meaning. I simply like them. Busy or still, the miracle of design, of suspension."

I looked again at the sketches, more like outlines, less solid. He hadn't even filled them in. "I like a sketch; rather like how a taste is often better than the entire meal. Will you keep it—just like that?"

He turns to me, still immaculate. "You know, Mrs. Gard—"

"Isabella."

"Whatever the name you go by, you don't get to say; it's not a commission."

I tugged on the ribbons and removed my hat, allowing my head a moment in the gloomy, warm breeze. "I know. I just prefer it this

way, somehow not quite figured out." I turned to go, "You know, I'm not one to comment on your mother's portrait. But you know how I feel about the nocturne. I want . . ." I thought of how to say it. "I want to give it a home. A permanent one."

We looked at the bridge set to be demolished. A loud horn sounded, causing his hand to stutter with the brush and a clear line of deep brown to grace the pocket of his smock. I smirked. "You know where to find me."

A few days later, at my hotel, the porter presented me with a tubular sheath of thick brown paper tied neatly with string. The sending address was 21 Cheyne Walk.

In the comfort of our suite, Jack helped me examine the contents. "'Etching and drypoint printed on paper; the *Old Battersea Bridge*.' And see, he's put his signature in the corner."

Jack frowned. "It's a butterfly."

"A signature can be anything."

I prepared to wrap the sketch again when I saw a note flutter out from the paper. *I know you desire* Nocturne, Blue and Silver: Battersea Reach. *Consider this a bridge between us—perhaps next time I see you it will be yours. —JMW*

13th May 1884
Venice

My Dear Joe,

Your letter proved most interesting, not only for its length but also for its daring content. Regarding the Hasty Pudding's Hernani show, bravo! A welcome amusement for you—I always feel more at ease when I know you are merry.

Coincidentally, the Verdi opera based on that play premiered in Venice, which is where I am just as of the last few minutes. Venice's sea slick and color call out like sirens, domes and buildings seemingly floating, as colorful as autumn in Boston. How might I explain loving a place I've barely been, like a lover from afar whom one can already imagine being with at night (in reference to lovers, I shall burn the letter from you). Your uncle Jack and I sit now in St. Mark's Square for citrus ice and pigeon

viewing, not really in that order, and of course gawking at the
gondolas (and their gondoliers) along the Grand Canal.

We soon arrive at Palazzo Barbaro to call on expats Daniel
and Ariana Curtis and their son. Hold down the fort with
your brothers, do not dwell entirely in the past (I speak from
experience), and allow heartache to simmer and then fade out; do
not get sullied by its remnants.

Thank you for the update on our home team. Please go to a
Boston Reds game and say hello to Dupee Shaw for me—or better
yet, since Shaw has already gained glory for striking out 451
batters, tell the whole team they've a huge fan an ocean or two
away. If it were up to me, society would embrace the great ballet
of baseball as they have the Boston Symphony Orchestra; are they
not both integral to the fun and culture and camaraderie Boston so
wishes to cultivate? Perhaps one day Boston will unite itself around
culture and sport and leisure: a happy weaving for you to consider.
More soon, dear Joe, and until then I remain—

Your Devoted Aunt Belle

15th May 1884
Palazzo Barbaro

Dear Maud,

What might I tell you of Venice that has not been documented by
Titian, by Shakespeare? Palazzo Barbaro puts forth its dilapidated
elegance from the first glance. Confronted with a fading painted
exterior—blue edged in gold, no doubt actual gold that has lasted
centuries—one exits a canal gondola, climbs a handful of stone
steps built into the canal walls, and stands before a gaping door
such as one would find on a castle. From there, it only gets better:
the Barbaro's courtyard is a wonder to behold. Why must we
be content in Boston with thatch, shingle, and brick? Here is an
interior courtyard as though the garden has tired of being outside
and wishes to come in and play. Oh, the tastes: limoncello fizz,
limoncello cordial, limoncello ice, etc.

Henry James demanded we visit the Curtises, and I am content
to report he did not lead me astray. Jack, prone to heat headaches,
has been taking much time upstairs, but Ariana and Daniel are

masters of touristic pleasure: tours of private art collections, antique shops under bridges one might never again find, and a rotating guest list for dinners. My favorite is their son, Ralph, whom they call Rafe. He is the embodiment of limoncello: blond, tall, citrus-tart. Rather reminds me of Joe—only if Joe were happier. He wishes to be a painter, and I told him he need wish no more: he is one.

I've bought a delightful painting of his entitled *Return from the Lido*.

Please give your mother my regards—we leave for home soon. What will Boston think of us having stayed away these many months? I shudder to guess. All Friendship—ISG

25th July 1884
London

Julia Dearest—

I have only just learned of the terrible news. As I console Jack, I must also write to you how sorry I am. Your father meant a great deal to me; part of him will forever be in my mind, as though he is one of his own orchids. I have him to thank for my initial love of gardens. We all loved him a great deal. Of course we will move to Green Hill straight away upon our return; to call it ours would be an honor. Remember those early card games, long rides, glasshouse meals? How odd when one finds oneself in the next phase of life when one had hardly noticed the slippage. I do hope you are recovering from such a tumultuous year and that your family provides solace. All love to you. Yours, B—

1st August 1884
London

Dear Mr. Norton,

I mentioned to you about Ralph Wormeley Curtis. I gave him $150, which seems a fair price for such extravagance as he captured in his *Return from the Lido* painting. Shall I admit to you that it is not only his technique I admire, for there is no disputing that; it is personal. For I am in this painting, whether he intended it or not.

You will see this water. This boat. This gauzy woman. The

gondolier dark in his hat against the sky, which sighs with morning. There is the sun. Or you think it's the moon. It doesn't matter. Four birds have found breakfast: something unseen. On land a hawker prepares for the day. Small in the background, a junk ship's sail is the color of tired apricots. And the woman in the boat, what is she thinking?

Is she mulling over losses? Is she wondering if life has finished with her and she may as well have been mulched for the meadow in the Arboretum? When you see this painting, know what I know—there is Isabella Stewart Gardner in the first gondola of the morning.

I wandered the cuttlefish alleys and shielded my eyes from water so sun-sparkled it threatened to ruin me for Boston winters, finding a part of myself in Venice. A deep-rooted sense I belong there or it belongs with me as though I carried it with me when I left.

I suppose that is what this trip around the world has shown me: travel cracks open the globe, shows us people and forests we would never otherwise experience, but ultimately it must also hold a mirror. I like the person I am in Venice, yet I wonder if she can exist only away from Boston, if that city and I will forever tussle. And this cadre of yours, if they are such brilliant minds, will they change my life, will I add to theirs? Somewhere, there is a way to attain grace and tranquility with a firmness that does not involve capitulation. Won't you help me find it?

<div style="text-align: right;">

Your Good Friend—
Isabella Stewart Gardner

</div>

~~Crawford.~~

~~Crawford.~~

~~Dear~~ Crawford. It's August, two years since that breezy room in Newport, your hands leaving traces of charcoal everywhere. Oh, had I only known those marks were indelible.

I write this letter knowing there is every chance that I will never send it. I've penned missives to you in my head these past many months. And have not given your ghost the satisfaction of writing them down. What can I tell you that you do not already

know of me? Do you think me still the same, a replica of the woman you left wandering the trees and undergrowth in the Arboretum? Are you still the same coward? The word brings me fury I have tried to bury in the genteel quiet of bamboo forests, the shocking rain of French Indochina, the sheer lint-gray of London. In Japan I learned of Kintsukuroi, the art of golden repair. Imagine this: a delicate handmade bowl dropped and broken. Now imagine an artisan, someone skilled and kind, someone patient. Someone who shows up. This person collects the pieces, bonds them together with lacquer, then dusts with gold. Now imagine this bowl not only useful again but shocking in its glory, each crack and repair forming a unique whole.

Now imagine I am that bowl. And imagine you will never touch it.

I write this on the ship back to Boston, where I return without Whistler's *Nocturne* but the promise of "perhaps next time." I do not doubt that he will show. That there are others who will show up for me.

I am reminded of Whistler's Venice etchings, drypoints I purchased of lagoons I've now seen, busy squares in which I myself walked, harbors hulked with gondolas. And, too, a larger sketch of a Venice doorway, the mouth of it open and ready, a doorway to whatever is next for me. —Isabella Stewart Gardner

Intermezzo III

AFTER I am gone, all my selves will remain. You may bring out the portraits again.

They'll not wound anyone—not Jack, not me. Not the boys, men now, the ones who survived. Not Boston, even after our tumultuous decades—my running away, its cobbled history luring me back, my passion finally alchemized into pure pleasure that I then gave back to the city.

Here are three Isabellas on canvas:

Sargent. The me that caused so much scandal: gossip papers saw the diving neckline but did not see my sitting for Sargent those cold January afternoons, Jack not yet humiliated in public, the pearls he'd given his wife painted by another man.

Zorn. The me of Venice. Always, the bloat of joy there. The fireworks outside only because I felt them inside. See it on my face? Zorn—a joy from the moment we met at the world's fair—and just as integral to my life as another miracle on display that day: the lowly zipper. Each zipper ought to be exalted: the easy up and down of gowns, trousers shed in hotel rooms, Venice's slip of moon, the dank pong of cuttlefish washed away by champagne.

Sargent again. First and last. And that champagne gala. In this last white gauzy portrait might you afford a moment for this old woman?

Might you see her not only as this crepe-skinned self, lined and aching with the emptiness of years leeched away? Might you see her—see me, for we are the same—might you regard us with compassion, with the pleasure that she finally found that night of the gala and each meager night that followed, burning letters and eating crumbs, yet gorging herself all the same on the feast of riches acquired and set out for you—dear viewers—to see for eternity?

You may have all the portraits.

After I am gone, each April 14, you will sound the large brass gong. Trail nasturtium from each balcony—haughty, vibrant orange. Announce my birthday with sound, which, unlike certain people, will always show up as long as anyone (I'm not fussed who) bangs it. Imagine it's my voice clonking and booming hello and goodbye all at once.

BOOK FOUR

❀

Isabella Stewart Gardner

1886 — 1903

J OE AND I hunched our torsos over the railing; the looming
 threat of waves, of losing our balance was no deterrent to being
together in a place that at one moment was quiet and without any
disturbances save for the wind tourniquet around us and at the other,
with gulls and the clang of bells and our own steamship's bellowing
horn, a circus of noise. In other words, the perfect place to conduct
conversation one wishes to keep private.

The truth was, Joe had been suffering for some time. All spring
we'd hosted tented lawn events in the serenity of Green Hill's trel-
lised garden: cello suites and canapés amidst lilies, en plein air paint-
ing lessons for Maud and our crew. *Town Topics* had reported that I'd
alienated myself once again by having Thomas Eakins speak about
his untimely resignation from the Philadelphia Academy of Art due
to his use of male nudes in a mixed-gender class. Always, I invited
Joe. Most often, he declined.

"Come meet a new friend," I'd told Joe when I'd gone to visit him.
I relayed news of Dennis Bunker, an artist I wanted to support whom
I'd met through Maud. Dennis drew me in with his first comment
about the gallons of blue blood he would have to consume to survive
Back Bay. He was young, willow-limbed, and determined to drop one
of the letter *N*s in his name to "be different." He already was, and

he spoke to me of his love for his male friend. I was touched by his confidences.

I had told Joe that, for my support, he wished to thank me by painting portraits of all of us: Jack, me, and each of the boys. I admitted only to myself that I wished Joe to arrive, dashing in his windblown outdoorsy tweed, to stun Dennis and perhaps win his heart. I supposed I wanted to act as cupid or provide both men a sort of friendship to rid my nephew of his suffering. Joe had never showed.

Now I looked at Joe on the boat—windblown, handsome, right next to me, though miles away in his mind. A few weeks before our departure I'd gone to meet him on the North Shore in Beverly. He wanted me to see a large farm he planned to run himself, tending to the animals with his own hands. We'd mounted horses, gone for a ride in the fields, where it already felt like late autumn though it was only early September. He'd worn a full riding outfit and looked the part of gentleman farmer, yet he reeked of loneliness. I had come home aching with worry.

Jack had stepped in, as always, trying to mend me, to repair whatever was broken. I thought of the shattered Japanese bowl seamed with gold. Jack's idea was this: we would bring Joe to London, socialize him with my crowd. And then continue on as a family, joining up with Amory while he studied in Paris. The travel cure had worked for me; surely it would for Joe.

Now Joe's hair flipped as though waving frantically to get the attention of the entire dark ocean. The sea was stony-faced in return. I offered my elbow toward him to see if he would pinch the skin as he'd always done. He did so, and the ritual gave me great comfort.

"I remember a trip like this," I told him. We faced the waves as though looking at one another would simply be too much to bear, sea salt on open skin. "I'd lost . . . a child." From the corner of my eye I saw his jaw clench. "And then . . . a baby. Or, a near-baby. I'm not sure what one calls something that hasn't yet to be and will not ever that one loves regardless. And I'd lost your mother." The horn sounded. "I was in pieces then, Joe. Travel allowed me to forget myself, to find myself again. This is what I wish for you."

Joe let go of my elbow and gripped the railing. "Do you remember those glass animals you brought for us?"

"The ones from Dresden?" I gave a happy nod.

"I have all three. Gus and Amory, well, they might have been interested in them, but not in the way I was even then, Aunt Belle." He looked out to sea.

"They're delicate," I said, desperate to save his mood. "But strong. They've got filament inside."

"I didn't keep them because of their beauty; though it's indisputable. I wanted them precisely because I knew the process of their fabrication. Even with the filament, they're so easily broken." He leaned farther out toward the water. "Gorgeous and ruined."

I lay my hand over his on the railing, and he didn't pull away. "You're not ruined."

He shook his head. "It's a matter of time."

What I wanted more than anything was to save him. To be the cleat and rope that kept him from going overboard. Those strange glass undersea creatures unfit for the light of day; I'd taken them because I was one of them. We both were, and it was intrinsic to our survival to figure out a thicker skin, a better shell, another tentacle to adapt so we would not drown.

<div style="text-align:center">

~~Please Join~~
~~Isabella Stewart Gardner~~
~~12th October 1886~~
~~for Luncheon at~~
~~The Athenæum Club, Pall Mall, London~~
~~Kindly reply~~

Please Join
Mr. Jack Gardner and his wife
12th October 1886
for Luncheon at
The Athenæum Club, Pall Mall, London
Kindly reply

</div>

? (forgive me) October 1886
Cheyne Walk

Dear ISG—

Enclosed please find *The Little Note in Yellow and Gold*, which I made following "your" delightful party. In case you do not recognize: it is of you. Chalk and pastel, so do keep the tissue covering lest you get yourself all over yourself. I did receive the 100 guineas for it. Consider this in lieu of the *Nocturne*, with which I am not ready to part. Yet isn't that useful in some respect; for if we have what we want, then what might we do? I do hope you find your face as charming as I do. Or at least as charming as a bridge.

 [butterfly] and if that means little, James McNeill Whistler

15th October 1886
Near Windsor

My Dear ISG—

On train—excuse octopus scrawl. No matter how cruel the world, I will always be one side of your luncheon buttress. Sadly, as you and Joe now know, Mr. Wilde could not be the other buttress, due to imprisonment at Wandsworth. I do not mean to make light; we are all v. concerned and feel injustice is the rot of modern society. Yet I do thank you for the kind party in my honor. Or rather, I thank Jack, who of course was not even present, for being the best invisible host. On behalf of my gender I apologize for the continued defeat of your kind. But rest assured, Ms. Violet Paget was taken with you, and I've passed along your card so she might meet you and Joe for a round of who-is-more-outrageous. I do look forward to our hinted-at meeting in Venice. That water lulls me at night, far away though it is, and I feel with some assurance that Venice means something to you that neither of us might yet know. As for what will keep me busy while you take Jack and Joe to Paris? After *The American* and the grand tour within the serial (now book), I'm aware of an alarming tumor inside myself (note: my health is fine, I refer to an artistic rendering of tumor), a darkness that will likely express itself on the page—a governess, her two charges, a remote estate. What, as they say, could possibly go wrong?

I conclude with perhaps the most important news! As you have desired and as you have asked, I have made a word-of-mouth introduction of you to the painter John Singer Sargent. He wishes you to come (with me) from the Albemarle to his studio this Thursday to view for yourself Madame Gautreau. Hopefully this suits you, as when one considers Sargent's wounded ego and my leaving Saturday for out of town and your departure the following day, I fear this connection hangs in the balance. Do not bother responding. I shall be at the hotel at 3.15 Thursday and bring you to this susceptible artist. Ever very faithfully—Henry James

2

VIOLET PAGET moved from one shop to the next as though powered by a coal engine, steaming and furious, down one leaf-strewn block, through a small Chelsea walk, and then back through Lowndes Square, where she pointed to a white stucco building. She took my hand and pointed again, making sure I saw what she saw. "That's where Kit and I first lived. Not recommended. Our neighbor had a cat who liked to watch us in bed."

"Perhaps the neighbor transformed into the cat precisely for this purpose," I said. I could feel it: that alive tingling of banter, the forward motion of knowing art and its makers, of the joy I experienced feeling slightly—but not all the way—untethered from Boston and life there.

"That is exactly what Kit and I decided." She turned away from the buildings, marching us through the small park where children chased birds and fatigued nannies watched, where streetlights would be lit in a few hours; the daylight minutes collapsed this time of year. "And then we moved to Italy. You've been?"

"Yes, but not for a while."

"You must remedy that pronto. Come stay with us if you like." She raised her eyebrows. "If you don't mind being thought a rubster."

I gave her an apologetic look, but she brushed it off. She'd likely been called that a long time and had taken the wounding term back, wiped it clean the way one might a knife soiled with one's own blood. "I don't mind."

"How unusual," she said. Violet wrote under a nom de plume, Vernon Lee, and dressed the part. Currently she wore a full suit and was on a mission to find her beloved Clementina Anstruther-Thomson—called Kit—a plate on which she would put figs. Watching her made me wonder if I had been meant for that, if I ought to pursue an alternative life with artists: a solid coupling or fluid sex in a house with two women or various stages of crushes with men, a novelist like Crawford, a potpourri of people who woke up and knew themselves to be more than the sum of their societal roles.

I asked, "Would not any plate hold the figs?"

"Yes. But no. I want a fig plate." Looking at Violet's fingers as she splayed one hand against her narrow chin—the same chin I imagined Kit holding in her hands—I saw a callused bump of skin on her middle finger. All her years of writing had literally changed her body.

What had changed my body? Motherhood? Crawford? Oh, I loved him, and he'd torn parts of me like the paperbark tree's layers, but he had also been a distraction. Vernon Lee, Margaret Deland, Oscar Wilde: these were people who did their work no matter the cost to their safety or heart. I had moved on, but felt that in healing the skin, I had slid back toward that old, new-to-Boston self, allowing myself to reinhabit that early girl's delicate form—when in fact I had weathered so much I had to remind myself of the strength I possessed.

Violet picked up a red enamel bowl and studied its chipped bottom, then set it back down. "Have you always known you wanted to write?" I asked. "Have you always been the person you are today?" The questions sloshed out, and she tolerated me by giving me her full attention, despite the allure of the jewel-toned glasses on a shelf in front of us. "Do you not wonder sometimes what your life might've been like if you had been born in another year, another era?"

"These are worthy questions, Isabella. Allow me to chew on

them," she pointed to her mouth and mimed the act, "as we conduct this most important search for Kit's fig plate." She gave me a sharp look.

I laughed. "How lucky we are, to live in a time when such an object exists: a plate whose sole purpose is to carry figs."

She looked at me as though I were the one being silly. "True. All manner of lucky." She turned away. "Did you know I'm an expert at the harpsichord? And aside from art theory, Kit is an expert at fashioning feasts out of bread ends and figs and sardines. I write. She writes. And by a miracle of bravery and cruelty and necessity we live openly as lovers in Italy. I'm haunted by her when I'm apart from her. And she is haunted by figs when away from those, and what better activity for our mutual hauntings than to roam the streets of London calling, 'Fig plate! Fig plate!'" She did so now, drawing attention that she laughed off. Her bravery took the form of humor, which had come, I suspected, from years of pain.

"I wish my nephew were with us," I said. Joe had bowed out, claiming an errand. Violet handed me a plate for inspection.

White and green, with a scene of courtship. I shook my head. I had wanted Joe to meet Mr. Wilde at lunch. To sit with his velvet-suited, peacock-feathered glory and liken him to another of the Dresden creatures. Yet he was locked away in hard labor. Joe had met the stunning and affable Ralph Curtis, and the two had spoken with their heads close together, but then Rafe had left before pudding. Joe had met Violet but not Kit, and I felt, watching him watch the very single Henry James, the not-single but alone at luncheon Violet, and Mr. Whistler, so entranced by his own work he did not touch his prawns, that Joe did not come away with the message I hoped to convey.

"Your nephew," Violet said. "He gives one the impression of . . . Does he have a . . ."

My hands wandered the shelves of an antique store. "Joe is . . . sensitive."

Violet nodded. "You're a good mother to him."

"Aunt."

"You're a good mother to him," she said again, her words landing hard on my chest. "He'll come to it in his own time or he won't. That's the way of it." Violet and her pen-persona Vernon Lee regarded me curiously. She spoke softly. "We are all always ourselves. We are all born at the wrong time, Isabella. It's up to each to fashion a life out of the time period in which we're dropped."

I moved aside a lantern and a rickety chair, reaching high on a dusty shelf to find a small, octagonal plate that was plain in the center, traipsed with vines on the edges. Perfect for figs. I handed it to her.

"You, Isabella Stewart Gardner, have an eye for detail." She beamed at the plate and went to pay for it, calling back over her shoulder. "Just what will you do with it?"

I watched the shopkeeper wrap the plate that would have a singular use, holding perfectly ripe Italian figs for the two women who had made their careers and found each other. I had wanted Violet to have a clear answer for me, to tell me what I needed to do, but she could not. I was the only one who might do that.

JACK LEFT a few days early for Paris, hoping for some time with Gus and Amory at the Musée National de la Marine. Joe and I would meet them in two days.

Regarding himself in the mirror for what had to be the tenth time in an hour, Joe slicked his hair.

"You'll have none left if you keep at it," I told him.

He gave me a wry grin. "I could say the same for the silk at your bustle."

I stopped fiddling. In truth, the bustle was ridiculous, a mockery of itself. Fashion seemed to do that each time. If gloves were made long as a statement, let them grow ever longer until they reached up to the shoulder, at which point one looked rather like a squid. Or if a neckline were to plunge just so, let it then fall into the abyss to be gossiped about for five minutes in the papers. So, too, was my bustle an extraordinary waste of fabric. "There's barely room for both of us in here with my protrusion," I said.

"Let's hope Mr. Sargent's studio isn't a tiny, squalid place," said Joe.

I nodded. "And just where will you be whilst I'm in the squalid space, unable to move for my bunion-shaped bustle?"

Joe looked in the mirror again, and I met his gaze there. "I will be out."

I gave him a smile he returned, and my heart soared.

"SLOW DOWN," Henry called up to me. I was half a flight of stairs in front of him, my skirts gathered in my arms, fabric swooshing as I kept going.

"You go faster," I said. "If my bustle and I can move swiftly, surely you might manage."

"A man of my stature can only climb so quickly. Or slowly." He caught his breath on the landing. "Besides, it's not as though Sargent's paintings are running out the door." He shot me a look and knocked beneath the brass plate that did not announce a studio but rather a clockmaker's space, now defunct. I traced my finger over the letters. "Everything grows obsolete at some point, Isabella."

I frowned and knocked again. Watch repair became a studio, cafés became haberdasheries, a bank became another bank; why couldn't something remain itself forever?

I knocked once more. It was true Sargent's paintings were not selling well, largely due to controversy. Sargent had been set to be the next big name in portraiture; he possessed technical facility with brush and color, and this melded with his background—born in Florence but to American parents who had sent him to Paris to study. He'd achieved the beginnings of a golden career, one in which he might never wonder about his next commission. Until *Madame X*.

We heard footsteps behind the studio door. Henry turned to me, hand on my shoulder as his breath finally regulated. "He's susceptible."

"Meaning?"

"Meaning," he pursed his lips and looked at me the way I'd looked

at Gussie when he'd tried to take more than his share of boiled sweet sticks. "Meaning . . . don't charm him too thoroughly."

"One wonders if you are promoting him or warning me off."

"Perhaps both."

The door opened to reveal a man who had a handsome face that looked as though it might have spent time in a vise and then been released: narrowed and smooth save for the formidable red-hued mustache. His hair and beard were four shades darker. His eyes were the color of Atlantic waves and just as unpredictable as he looked at Henry and then at me and shook our hands, leaving each of us with similar marks of paint.

"As though we're triplicates separated at birth," I said, and held my hand up to show him.

Sargent gave a cough-laugh. "Come in, Mrs. Gardner. Mr. James."

His left hand held both a palette and a clutch of at least ten brushes. He returned briefly to a work in progress. I noticed a worn patch of floor from Sargent going forward to the canvas and back, detail and distance. A dance. *El Jaleo.* Those dancers I coveted in Coolidge's house.

Sargent's Tite Street studio had a scrappy Oriental rug turned on the diagonal, a couple of lacquered screens behind which one might change for a sitting, a small platform where the sitter might be arranged, and a series of chairs, chaises, lamps, and vases. A tapestry as large as a bed graced the south wall. Floor to ceiling windows on the other side made even the cloudy day outside provide light. A full-sized piano was wedged in the corner of the room. The keys were bloodied with streaks of vermilion paint as though a great beast had died on the ivory.

Henry saw me look at it. "He plays. Concert level, really."

Sargent ignored the compliment. "I've been working on this." He led us to a heavily oiled canvas where his own face looked back at us. This painting showed why he'd been so successful early on; it was stunning. Alive and real and altogether important, and with a certain flair that spoke to me.

Henry toed my boot, and I realized I'd been staring too long. "Phenomenal."

Sargent nodded, pleased, and reached for a rag soaked in God-knows-what and handed it to me. When I looked surprised, he reached for my hand himself and cleaned the paint off. I swallowed audibly. He ignored the noise and flicked the rag to Henry, who gave a sour smirk and did the job himself. The whole space intoxicated me: not only the furnishings and art but the air, which smelled of chestnuts soaked in liquor. I sniffed.

"Venetian turpentine. I use it to thin the paint and make it fluid," Sargent said. "Wonderful, isn't it?" I nodded. "Likely deadly, too, but we can't have it all, can we?"

In the silence, we three regarded the large painting that leaned on the wall near the piano.

"Have you quite recovered?" Henry asked Sargent, while we looked at *Madame X*.

"I travel with her." Sargent thumbed toward the painting and shrugged. "The scorn can't last forever, can it?"

I took the liberty of wandering the studio, looking at studies, at canvases half filled with oil and half-bare sketches as though the subject were only just coming into being.

"Scandal burns hot, but it can't last," I said.

"And this from a woman who walks lions," Sargent said. "You give me hope."

"So you've heard of me, then?" I asked. This pleased me more than it should have. Then I deflated. "They were not my lions."

Sargent had painted Madame Virginie Amélie Avegno Gautreau, a Parisian by way of New Orleans, known for her beauty and milk-perfect skin; she'd posed for artists of great renown, including Antonio de La Gándara. Oh, Sargent's portrait of her was luscious. No one could fault his obvious skill in bringing out her radiance. But they faulted Sargent completely for its directness.

"Who would have thought society would cower at décolleté?" Sargent asked, weary.

"Ah, everyone?" suggested Henry.

Madame Gautreau's portrait revealed not only her hennaed hair and eyebrows, but much of her milky skin, with bare shoulders, bare arms, a dress low-cut and tulip-chested so it appeared she was growing up and out of the black velvet and transforming into a nude Venus.

"Her mother begged me to take it down," Sargent sighed. "And I didn't."

He'd been clever and stubborn, a dangerous combination, and refused to withdraw it from the Paris Salon show, instead renaming it *Portrait of Madame——*.

Henry cleared his throat. "Mrs. Gardner—Isabella—has long followed your career. She is, I'm sure, happy to make your acquaintance. We shouldn't take up too much more of your time."

"The pleasure is mine," he said.

"Do you think it was the skin that mattered?" I asked, and Henry rolled his eyes, embarrassed for my forwardness, though he knew to expect it.

But Sargent was not flustered. "As you might imagine, having lost so many commissions following the Salon, I've given this a great deal of consideration. And I don't think it was purely the amount of flesh on the canvas. People tell themselves stories about what is real—my beautiful wife is my wife only—and stories to make life more palatable: my wife is faithful, for example. All I did was show what I knew to be true."

"Both?" I asked.

"Yes. More than one thing might be true at the same time," Sargent said as he led us to the door. I looked over my shoulder at his self-portrait, the beginnings of others only half done. What parts of myself would be true on canvas? "I only paint what I know."

What would people know of me one day? I stopped at the doorway. "Will you ever come to Boston?" I asked, and watched his red mustache twitch. His hand still bore our paint mark.

"Are you asking out of general concern for my geography or something else?" Sargent asked.

He was going to make me ask: wanted to hear the words aloud. I

thought of Madame X and of the piercing gaze his real-life eyes had on mine now.

"I wish to see myself on canvas through your eyes. Would you consider a portrait?"

I WAITED in my bed at the hotel for the sound of Joe's key in the lock. It never came. I hoped this meant he was with a friend, perhaps in that friend's bed finding comfort or joy or indulging in passion that might sustain him as we crossed the Channel the next day. He could find love and live as Violet and Kit did: Joe and a charming man on Joe's new farm on the North Shore. I could see it. Smiling at this vision, I slept soundly.

I woke to find a crumpled, half-penned letter I had missed when I arrived back.

15th October 1886

Dear Aunt Belle,

This is another bit of fuel for your fire. I burn I burn I burn and nothing will help. Do me the honor of burning my letters. Better, burn all your letters. What's the point of keeping words that make us stuck in the molasses of past wrongs? I will never be—

"JACK?" I spoke into the new telephone, the weight of it like an anvil in my hand. The receiver did not fit well under my hat, and I removed it from my head, not caring about the dreadful state of my hair, the looks accumulating as I shouted to be heard over the transatlantic wire.

"Belle?"

"He's gone."

Several seconds of crackling passed before I repeated my words.

"I heard you," Jack said.

"By his own hand," I said.

Jack's words were choked. "Like his father." He sucked in air, the

effect of which was like pressing my ear to a heavy shell the way I'd done with the boys on the beach at Alhambra. It made me ache. "I don't understand it; we brought him to Europe."

More crackles. "Jack." I was breathless with shock, annoyance numbing my cold fingers. "Please do not make this about you and your 'simple' solutions. You want to fix everyone as though slapping a holiday on it always works." Another hotel guest tapped her foot, waiting. I glared at her.

"Biology," Jack said. "Faulty biology."

Anger rose up inside me. I thought of Violet and Kit, happy but quarantined in another country. Of Oscar Wilde. "Intolerance killed our nephew. And for that I blame the world."

<div style="text-align: right">

31st October 1886
London

</div>

Maud—I've been plagued with grief over my mother's death.
She was without pain and revealed no suffering, yet those left on
earth do feel such. Hold your own mother tightly after you read
these words, for I cannot and will not hold my own mother's hand
again. I will not inhale her lily of the valley scented neck, nor
feel her quiet confident gaze on my face. How might I be in this
world without her in it? Will I forever see her in lilies? I ought
to be grateful for that, for the hummingbirds who darted at the
vine flowers out my window in Bombay. They were her favorite
creatures, so I feel she is somehow visiting me. I hope for them
daily, even in winter.

<div style="text-align: right">

—Isabella

</div>

<div style="text-align: right">

5th November 1886
Kennebunk

</div>

Isabella, Dear Girl—
Do not be surprised by the postmark. I visit now with our
painter/writer friends. I wish I could eat some of your gloom
myself. I wish instead to peer in, to tell you I am not alone in
my longing for your return—in fact the city seems shrouded

recently, as though the Isabella flame that helps keep it bright has
extinguished. And, quite selfishly, I miss you. I do not wish to add
to your suffering, yet feel I must pass forward news you would
hear upon your return and that I do not wish to set you back
should you manage to leave some grief in the ocean.

It is this: my cousin Crawford has married in Constantinople.
I can hear your wounds from all this way. He married Elizabeth
Berdan, whose father you likely recall was Union General Hiram
Berdan. But do not let the Berdans burden you. Oh, dearest, please
say you'll stay in Boston for a length of time when you come back.
Will you?

Always, Maud

7th November 1886
Southampton

Maud—Forgive the brevity of this letter. The news of C—well,
it stabs but the wound is not fatal. I take comfort in the idea of
memorializing as an act of art itself. If we keep and capture on the
page or canvas, are we not admitting to the world the importance
of our own memories? As to Boston and remaining within its
clutches, I cannot say. —ISG

8th November 1886
Southampton

Dear Mr. Norton,
I have from you two letters and am greatly delayed in answering,
but by now you understand my reasons; I managed to get Gus and
Amory settled again in Europe and am now returning with Jack,
once again on the water and once again bereft.

I did meet Sargent and confirm his miracles on canvas. I've
thought of young Denis-with-one-n Bunker's conveyance of my
family in his portrait, the last marker of Joe alive. I imagine that
seeing Denis, who does so remind me of Joe, will strain my heart.
And I have thought, too, of the impressionist exhibition years ago:
the laundry Morisot depicted, how those garments would be now
in tatters. Of her sister's pregnancy—preserved forever in her
painting.

I am sorry for the excess of words herein; I've not spoken much since finding out of my nephew's and my mother's passing, and I find myself wandering through my own mind at all hours. Surely unhealthy, and yet not unproductive, for here is something to which I keep returning: art is not so much the memory of the truth (I picture here Joe, smiling). It's the memory of what we wish those moments were. Think of the many painted shipwrecks captured so lovingly in the light. The water menacing but held at bay.

I think I should like to collect those moments. I mean to explain somehow the connection I feel between art and memory. A Museum of the Mind. How lonely to be wandering the hallways of one's brain, images on view only to myself. If art is the outpouring of history, the afterlife of memory, where might I, just one solitary creature, embrace it?

You are the wisest man I know and one responsible—good or bad—for unleashing such thoughts of mine into the ether. Please tell me if you have an answer. —ISG

15th November 1886

Cunard Line Communication,
Passenger GARDNER, I.S.
 ISG. I have a possible answer. His name is Berenson.
 —CE Norton

3

IHAD EMERGED from my living casket into Boston's spring. I stood arranging the many portraits Dennis Bunker (now back to his original spelling) had made of my dwindling family—I set them on the mantle one day, only to move them the following to my study, to then bring them and the ferns from my late father-in-law, still housed in Japanese cups they'd long outgrown, all the way to Green Hill, where I grew unhappy with their placement. Nothing quite fit. Jack's solution to this had been to thrust drawings at me: an expansion from 152 Beacon to the house next door, which—as a surprise to me—he'd purchased, with plans to knock down walls between to make one larger house.

This ought to have pleased me.

All it did was make me feel as though we would be growing fatter architecturally, yet not solving my discomfort. I'd realized something, admitted it to Norton at his last lecture—I wanted to stitch together art and memory, but I did not know how to do this.

And today, Norton said, he would introduce me to someone who might help.

HENRY ADAMS, whom I'd met at the Grosvenor Gallery with Joe, said hello as I stood waiting outside of Lowell House. He gave me a

wave of acknowledgment, but when Mr. Norton appeared, flanked by two young men on either side, Henry Adams frowned. He did not lower his voice, so even I could hear him say to his companion, "I detest them." *Them who?* I wanted to ask. Adams was rumored to be on the verge of publishing terribly important pages, so respected was he in the governmental and academic worlds. "The Jews," he told his companion, loud enough for everyone to hear. "They hold us in their gold-stained hands."

The men around Mr. Norton stopped in their tracks but said nothing. My legs moved before my mind caught up to where they carried me. I faced Mr. Adams. "Gold doesn't stain, Adams. Intolerance does, however."

I turned away from his gaping trout mouth and found myself surrounded by Norton's cadre.

"May I introduce here the wise and witty and—as you can see—outspoken Isabella Stewart Gardner. She knows what she wants, and she makes it happen," Mr. Norton said.

"From your mouth to God's—or the Lowells'—ears."

One man stuck out his hand. "George Santayana." He turned to the others. "She means the Cabots speak only to the Lowells and the Lowells speak only to God."

The men laughed. Mr. Norton moved us away from the glaring Mr. Adams and the lingering crowd.

"So you're George," I said, and Santayana nodded. "Did you know my nephew Joe Gardner?"

Santayana frowned. "I did. I'm sorry."

One of the other men, tall, curled hair overgrowing his collar, stepped forward. "We all did. We were his friends." He stuck out a hand. "Charles Loeser."

The man next to him, so blond his mustache struggled to be seen, was next. "Logan. Logan Pearsall Smith." He tossed his chin back toward Mr. Adams. "It is the wretchedness of being rich that you have to live with rich people."

Mr. Norton explained. "Smith's a man of many—many—words."

Smith bowed to me. I curtsied back. "I live on the very edge of my charm," I said to him. "I shall join you in your wordy abyss."

Smith smiled at me but pointed at Norton. "You didn't lie. She's a keeper."

"Of what, secrets?" I asked. I knew among them there would be many, some the same Joe kept.

"Of secrets. Of us," Loeser said. "For if one collects secrets one must also collect the souls."

The last man rolled his eyes at his friend. "Forgive Mr. Loeser for his waxing philosophical; it comes with his master's degree. Sadly, his wonderful sister isn't here to thwack him."

"I forgive you all," I said. I had the distinct feeling of an embrace, not at all sexual, but as though I had been invited onto an already warm sofa, a blanket and tea at the ready, words and wit waiting. I turned to the last man. "I'm Isabella Stewart Gardner."

He nodded and reached for my hand. "Bernard," he said.

This was the man Norton had most wanted me to meet.

Smith cut him off and spelled. "Bernhard Valvrojenski. Of Butrimonys."

BERNARD DUG an elbow into his friend and turned back to me. "Formerly that. Now Bernard Berenson. Of Cambridge, municipality of Harvard." We shook hands. My face must have asked a question. "Easier for Americans to spell. Besides . . ." His eyes flicked back to Lowell House, where Mr. Adams still stood.

"So, as I understand it, this is an extraordinary group," I said to Mr. Norton.

He confirmed with a nod. "And now it's yours."

14th April 1887
Shady Hill

Dear Isabella—

May you never fail to surprise. Thank you most wholeheartedly for including me in your "night under the stars" birthday celebration at Green Hill. If a better way exists to welcome

the season, I cannot imagine it. My great joys, however, were not the waterfalls of nasturtium (you say scarlet, I say orange) hanging in your greenhouse, not the oysters on platters the size of an operating slab, not the numerous candles floating in stone fountains you managed to import from Japan and still more candles floating in a metal fountain cast by Grotberg, the effects of which were illuminating and breathtaking. What I mean to say is that the company you keep is of utmost importance. And I thank you for feeling as I do, that Santayana, Loeser, Smith, and Berenson are as bright as the candles and carry the weight of the fountains. If I were a betting man, I would wager you and Bernard Berenson will matter a great deal to each other. But I am not a betting man, so leave this to you—C. E. Norton

Town Topics: *15ᵗʰ April—She's at it Again! Isabella Stewart Gardner of Green Hill, Brookline, or is that 152 Beacon, or is that 152 and 157 Beacon—one can barely keep up with this Woman's Whereabouts—seems to have added to "The Isabella Group." With her penchant for artists and intellectuals, Boston marvels at this woman's uncanny ability to collect such creatures. And Speaking of Creatures! The setting for a birthday party fairy garden dinner last evening would not have been complete without lions Happy and Zizi, a collective 840 pounds between them. I note that even the lions are both male.*

I WALKED under a muslin sheet to the newly connected second home that had expanded 152 Beacon. Jack studied veiny cracks in the horsehair plaster.

"It was a bigger project than I might've thought," he said. "But still, there'll be more space for all your trinkets."

His word choice hit me. "They aren't trinkets," I said. I put my hand on the creeping crack where it forked toward the pocket doors of the former library. I could picture my silk scarf, my Japanese bowl, the glass animals all housed. "They're my . . ." I did not know how to

describe my accumulations. "Jack? I need a check," I said, and before Jack could ask, I added, "For Berenson."

Jack didn't look at me. "An odd grouping tonight. Nice enough, I suppose. Maud's a character—not that she was the biggest of them."

"I don't find it odd." I stood fast, my voice hard. "I don't think Joe would have found it odd."

"Well, we couldn't possibly know that, could we?" Jack lifted the still-dusty sheeting between the two residences so we could leave the possibilities of the new place and go back to our well-worn world. "Perhaps it's not all of them. I just don't care much for that fellow—"

"Which one?" I asked. He hadn't bothered to commit to memory the names of my friends; rather the way men like our old architect Gilman hadn't bothered to learn mine. They were not useful to Jack. I asked again, "Which one?" Likely it was Smith, flamboyant and fun, perfect for me and off-putting to Jack.

Jack gestured: a finger down the sweep of his nose. It was a vulgar gesture. Such a small motion that contained every bit of loathing Jack had never and would never experience.

"Well," I told him, "I'm sponsoring him. Berenson. Bernard Berenson." I looked at my own features in the music room mirror and thought of Violet and Dr. Crumpler, people judged before they'd even moved or spoken.

"He'll take your money," Jack said. He paused. "My money."

I bristled. "I think he's got great promise," I said, before leaving my husband alone with the empty chairs. "And Jack? Don't ever gesture like that again. Not if you want me to still think of you as a good man."

29th June 1887
Venice

Dear Mrs. Gardner—

Only a genius could find a new way in which to write about Venice. We left Parma, where I filled my gullet with Correggio after a full meal in Milan of Leonardo's *Last Supper* (a surprising

painting; it was all I could do to look away from the hands). Also, Leonardo's *The Lady with an Ermine* sticks with me—did you know the owner disliked the original blue background so had it retouched black? And *Portrait of an Unknown Woman*—not, I think, what a portrait of you might be titled.

You need not apologize for your husband's views of me. Sadly, I am used to such innate distrust. At the core, Jews are people who value tears. We do not court sorrow, yet it finds us no matter where we hide. And truly, if one values art, one must value a certain degree of suffering, thus I am well-suited to the profession. Whatever profession this actually is or will be, I cannot guarantee. Your patience is appreciated. Writing does not flow out like blood but instead clots—before I've managed anything worth keeping. Perhaps I ought only to write letters to you, as those seem to be flowing freely. Your letters are always encouraging. What shall I do? What shall I be? I feel often as though I have a grip on nothing useful save knowing about art; your support fills me with guilt and also a shard, cutting as it is, of hope.

<div style="text-align: right">

Yours Sincerely—
Bernhard Berenson

</div>

<div style="text-align: right">

15th November 1887
Newport

</div>

Isabella Fair and Friend—
Before I return to London for good, for both Boston and Newport fit like a borrowed suit (uncomfortable and showing either too much ankle or confining my belly), I write to ask a favor. Please hold out your lovely hand in friendship to our mutual friend, John Singer Sargent. He is here staying with Mr. H. G. Marquand on Rhode Island Ave. all November, the whiff of Venetian turpentine permanent on him, and with a stained jacket but quite a sight for these eyes. He seems content to spend his hours in all manner of rooms, provided those rooms are in larger houses with ever larger names of note. I admit to being slightly jealous of his finesse with his brush. He will travel to Boston for some months this winter. I trust you will be friend to him for us both.

<div style="text-align: right">

Affectionately Yours—
Henry James

</div>

Town Topics—2nd December 1887—That fascinating young American artist, once popular in Paris, has been the guest recently of Mr. and Mrs. E. P. Boit Jr. of 170 Beacon Street. But Beacon Street talks, and I hear Mr. Boit was called out of town. Wishing to avoid scrutiny, his wife refused the painter in her house and suggested to her neighbor, Mrs. Gardner, that she take him in her charge in the interval. Boston, I hardly need confirm that the excitable Mrs. Jack accepted. It would not be Isabella-esque without more than a simple yes, so when Mrs. G showed up in her carriage, the staid blocks of Boston saw the pair ride out together to her Longwood estate, laughing and joyous on a carriage bedecked with ribbons and slippers as Isabella Gardner herself threw rice out the windows as though celebrating a lune de miel, as it were . . .

4

SARGENT HAD delivered a screen for me to borrow that I now
kept as my own, one worn in three panels that depicted a rural
scene: cocks and peacocks, a wooden house in the distance, a man
and woman in the midst of conversation with an official whose plum-
age rivaled the birds'.

I emerged in the January light from behind the screen wearing a
Worth dress the color of dried blue ink.

I paraded myself in front of the screen until Sargent noticed.

He stood and then sat and then stood again, uncomfortable. "May
I remove this?" he asked of the drawing room drapes. I nodded. "May
I move this?" He motioned to a chair with his foot. I nodded again.
"May I ask you to stand over here?"

I sighed. "Do whatever it is you need to do, and move anything
you require."

He began a slow and methodical rearrangement of the room, its
furniture and objects. He removed the curtain, only to find ice and
snow caking the windows. He barely glanced at me, which made me
feel I ought to dance in front of him, shriek for attention.

When he had quite destroyed and then resurrected the entire
space, he gave a great sigh. He approached me as one might a feral
creature, hands behind his back as though waiting to surprise me

with a net. He moved close to me, and even his breath smelled sweet, that turpentine allure, chestnuts and cinnamon. He stared at my face so close that it was as though he studied me down to the cellular level. My mouth opened as though we might kiss. Instead, he gripped my shoulders.

"This color will not do," he said, and swept me back behind the screen, where he flicked through a number of gowns and rejected all of them. He sighed again. "Find something darker."

I stuck my neck out, fowl-like, frowning. "This shade is called midnight. Is that not dark enough?"

He shook his head. "This week is sketching. Next week, when we're painting, it will be past midnight." He smiled seductively. "Surely you appreciate such late hours."

I raised my eyebrows. I'd heard wisps of rumors about his time in Newport, his proclivities with his subjects; for what is more intimate than truly being seen, than capturing someone's likeness and then consummating that act? "I love a late hour. As it translates to color, of course." I swallowed as his gaze roamed the length of me as though about to digest my form.

"What I mean is . . ." he paused, breathing fast. "Wear black. You'd be surprised how much radiance I can pull from it."

A WEEK later, the stack of sketches had grown. Sargent swore as he trod the now-familiar path from easel to vantage point. "Look at me."

"I am."

He shook his head. "Look. At. Me."

I sighed, feeling my cheeks flushed. The process ought to have been simple, doing nothing, standing for a sketch of my own features, but he kept sketching visions I disregarded and only grew more determined with each of my rejections. He'd shown me at least eight, possibly twelve studies, and none had had suited me. "I am looking!"

Charcoal streaked his red mustache, his broad strokes made scratching sounds that I imagined on my back, my neck.

"Better," he said.

He turned the page to face me. There, flat but true, was I. Nodding, I gave a small smile. "Yes."

He nodded back. "Tomorrow, we paint. You'll wear black."

"Agreed," I said. "But tonight? We go out."

DENNIS BUNKER stood like a lighthouse, blond hair a beacon calling us to him as Sargent and I walked on the snow-covered cobblestones to meet him behind a defunct storehouse, rats skittling in the cold, divots filled with manure and shattered bits of beer bottles and paper.

"So, this is what 'the other side of town' looks like," Sargent said. He'd painted Dennis, a "fast portrait" of flamboyancy that was matched only by the fact that Bunker made a painting at the same time, both men seeming to thrive on the fast strokes, the bits of paint that flicked onto my carpet (which I scolded them for but secretly loved).

Dennis Bunker's *Chrysanthemums* was thirty-five by forty-seven inches and held in it every bit of spring and summer missing from my life in January. Bright pink, deep maroon, white streaked with apricot, green so lush I wanted to lick it. In contrast, Sargent gave Dennis the gravitas he longed for: on canvas he was not a young dandy but a handsome, delicate-featured man depicted in what Sargent called "Rembrandt's light." "Light goes across the face," he'd explained, "and leaves a triangle of light on the dark side across the cheek." He turned to me. "Surely you've seen Rembrandt's self-portraits?" I had not and now felt I must.

Now the three of us shouldered the aching cold as we approached the golden light of a warehouse, out of which clamored grunts and heckles.

"Are you taking us to a cattle auction, Dennis?" I asked.

"Yes. No." He put his arm around my shoulder, and I felt as though Joe had come back to me. "Altogether louder, smellier, and more entertaining."

We entered what had most recently been a meat warehouse: obvi-

ous by the massive metal hooks that dangled from the ceiling as though we were all a school of fish about to be caught. Built into the floor were drains down which blood and entrail remains had sluiced. We stepped over dark red stains. A boxing ring in the center of the space took up most of the room. On its perimeter were wooden folding chairs and seats made from wooden crates set upon more crates to form a series of rising benches. On the side of the room were men in boxing gear. Grimy windows caught the street lamp light, giving everything a murky quality matched perfectly with the smell of stale beer, sweat, and menthol. I sniffed. Dennis leaned toward my ear.

"Liniment," he said.

"It smells rather nice," I said.

"You're a strange woman, Gardner," Sargent said admiringly.

"Menthol oil mixed with alcohol," Dennis said. "Blocks a bit of the pain, apparently."

I looked at the sheen on one fighter's body. "And likely creates a bit of slippage when the glove makes contact."

Dennis looked impressed. "Who knew Isabella Stewart Gardner to be a man of sport? Well, there not being a Harvard–Yale game this year due to 'unnecessary violence,' where else was I to take you for sporting entertainment?"

I clapped my hands, rubbing them together for warmth but also like a child awaiting a sweet. "Tell me everything!"

Dennis placed a hand on my shoulder and leaned in conspiratorially. "Now that chap there is Thomas King, the fighting sailor. Drinks his weight in gin before each bout. And that one's John Sullivan. He's the heavyweight champion of gloved boxing—"

"Undoubtedly the biggest star in the sport," Sargent said. He smiled at Dennis so intimately I wondered about their time together. Perhaps their mutual painting had made them enamored.

"And the highest paid—" Dennis settled into his seat, wedging us next to him, with me the center of the small human bouquet.

"And perhaps the most fit," I added. The man's shoulders were bollards, his torso thick with muscle, arms roped with strength. If only Jack had known where I was—and he didn't, for he was settled

in for another night at the St. Botolph Club for supper with other men who wore suits and did not make a living by punching men openly but rather by gutting them with deals.

"And he's one of yours," Sargent said.

"What does that mean?" I asked. "Do you mean to suggest I should broaden my circle to include broader shoulders?"

Sargent smirked. "A local. Born in Roxbury, did some time at Boston College." We watched him duck the rope and enter the ring. "Knocked out eleven guys in one hour."

A chant rose through the crowd, "Boston Strongboy, Boston Strongboy!"

John Sullivan's mustache cloaked any smile he might have had. He held his gloved hands above his head.

"What must it be like to have your name chanted?" I asked Sargent.

"You would know better than I. We don't have much of a cheering section in the painting world," he said.

"Three minutes, one break!" shouted the club officiant.

With the noise of clapping, crowd grunts, the sickening smack of glove hitting skin, it took some time for me to notice an undercurrent of murmurs.

"Seems you've been found out," Sargent said.

I followed his gaze to where a reporter sat, scribbling and smirking, looking directly at us. "If only one could make a living at scandal," I said.

"He does," Dennis said of the reporter. "At any rate, is it worth it?"

I looked at the startling scene before me: men old and young lined the board riser seats, so enthralled with the fight that they leaned forward as though tethered. In the ring, Sullivan and his opponent swung and ducked, caught in a violent dance. I thought of *El Jaleo*, the couple light against the dark background. That was what Sargent meant, his technique would afford the lightness, the clothes didn't matter. As the fighters moved against and with each other, their hooks drew blood that splattered the floor, a deadly and entrancing painting I would remember long after the noise had faded.

• • •

SARGENT PAINTED me in black. I emerged once again from behind the screen he'd given me, and he met me in silence, actively approving—in contrast to Jack's silent neutrality the night before about my boxing match attendance.

Sargent arranged me standing with my hands clasped in front of my waist in contemplative innocence. He removed the long length of pearls I'd draped over my neck and instead tied them around my waist for a bit of interest. He gripped my chin in one hand and tilted my head until he found the angle that pleased him. With one finger he moved stray hairs away from my eyes.

He began. I stood. He kept going, looking at me and the canvas, me and the air, me and the canvas, with no words between us until I could scarcely bear it.

"Tell me about what you're doing," I said.

He did not look at me. "I don't like to talk about it."

"About what, exactly?"

"My process."

"You'd think for three thousand dollars one might be treated to conversation," I said, perfectly still. I found a near-sexual charge from being his subject, from remaining poised and unmoving. I tried again to engage him. "Will you finish it with varnish?"

He capitulated. "Varnish isn't necessary, but it makes things look better. Or rather . . ." he swiped the canvas, removing paint, which he wiped on his palette, then repeated the action. "Rather, the surface looks better, but not all are of the same view. The more I work on it, the more it builds up, and black can look gray and dull, so you need the gloss of varnish." He redid the same spot again. "It can be a trauma to varnish when one didn't plan for it. It beads up or leaves holes. It can prove acidic as vomit."

I shifted to my left foot, giving my right leg a break from standing. Sargent immediately froze, looked at me and said, "Stop."

My body listened, though I wanted to break free of the portrait's hold. "If I'm to be trapped, you can speak."

He controlled me and I controlled him, an erotic dance in my very own sitting room. "I tinted the whole surface of the canvas with umber last night. I stained it, and then with a more opaque version of that same color . . ." he looked at me and then back at the easel, breathing through his nose so that his mustache flurried, "I made an outline of your whole figure. The shape of your head. Your eyes. A scribble of leg now covered with your dress." He paused. "Even if I won't show your legs, I need to know they're there."

I pictured him picturing me and felt a surge of desire. He beckoned me over. Timid, I stepped slowly toward him, almost afraid to look at what he'd done. I'd asked him for so many versions of the sketch, what would this be?

But on the canvas, looking at me, were my blue eyes, my clasped hands. Part was filled and part was bare.

"The archaeology of the painting is there, but it's not the finished product," he said.

The underlayers were brown like earth and showed up, voluminous and golden. "I want this," I said.

He motioned me back to my pose. "I like painting friends more than commissions."

"And where are we in that?"

"Both, I suppose." He made broad strokes on the canvas, which I felt on my bare neck. "I don't fit anywhere, really. I succeeded in England, but only after that debacle in Paris." He held a clutch of brushes and walked away from the canvas before he came back to it. "The truth, Isabella, is I'm not a real artist. I paint only one small set. The top wealthy layer of cream one can hardly stomach."

"And is that what defines *real*?"

"Walter Sickert would say so. He paints *real life*. Dark and strange. I'm thinking of his *Cumberland Market*, his nudes, his grit. I've missed it by turning away from the sinister." Sargent continued to paint. "Isn't it funny to think he and I both saw the same things, both spent time with those impressionists—if you doubt me look at Sickert's kick line of dancers and tell me it's not Degas making them move."

"And what makes you move?" I asked, keeping perfectly still.

He sucked in full lungs of air, then noisily exhaled. "Velázquez most. He's magic. Up close, glops, wads of sloppy paint. Then you back away . . ." He added more to my canvas. "And they congeal into fully volumized, breathing images of a being." He studied my face. "I took his brushwork."

"And what do you do with it? Do it better?"

"I couldn't make it better. So I make it my own." He bored his gaze into me until I could feel my thighs ache with longing. "I make it a dance." I shuddered, thinking of *El Jaleo* as Sargent went on. "Then you consider Manet. He also loves Velázquez, but what he took away? That flatness. Figures painted in a void."

Without moving, I said, "I suppose we all take what we need from art."

Sargent went on, mumbling now either to himself or to me, his voice melodic and soft as eyelashes. "I don't use much oil. And my palette is a marvel, if I dare say. A calliope I manage to produce from little: vermilion, burnt sienna, white, yellow ochre, cobalt blue, emerald green, and black."

"And you're painting in sections?" I watched where he was on the canvas.

"I paint wet into wet," he said.

Desire built in me. I thought of Crawford's fingers slipping into me, the two of us ruining the papers on his bed, crushing his words, the way we'd ripped the pages, torn at each other.

"I paint so it all goes together . . ." He backed away from the canvas, paused, walked back to it. "The trick is to make it look as though it just became . . . as though there's no labor involved in becoming and one just arrives on the canvas fully formed."

"You do make it look easy," I told him. "What a gift." I thought of my journey from new bride to right here in this winter-dark room. Who would I be next and finally? "Some of us have to work at it."

5

Mr. Jack Gardner Invites You
to View the New Art Gallery
at the St. Botolph Club, 115 Commonwealth Avenue
1ˢᵗ February 1888

PARTYGOERS CIRCULATED in a golden glow like dust caught
in light: Julia Ward Howe and Maud in the corner with Sarah
Jewett, Julia and her boys—now men—with glasses in hand, and my
Gus and Amory, who had come all the way from his Head of School
post at Groton for the event. Swarms of Back Bay and Beacon Hill
elite roamed, while Jack and our nephews stood in front of Thomas
Wilmer Dewing's *Lady in Yellow.* Jack seemed enamored of the work.
There was no doubt of its merit, effective in its conveying of the aris-
tocratic subject as pretty. Palatable.

Sargent whispered to me. "Note Dewing's meticulousness. The
subtle texture of her dress." I nodded, consulting the pamphlet. I
would pay the fifteen hundred dollars for it and went to secure the
sale as a gift to Jack.

I knew my own portrait was to be revealed in front of nearly one
thousand people, and I hastened to the end of the gallery, where the
curtain over the canvas had drawn a crowd: Jack at the front as the

host. Yet on my way, I stopped short in my tracks. Tarbell's *Mother and Child in a Boat* had me paralyzed. With her right hand she gripped the edge. Though the boat was half on shore, this young mother was unsteady as though the craft would topple and she would follow, her daughter tumbling overboard with her. And though I tried to reassure myself she was safe, caught forever in the boat, the baby secure with her, panic rose in my chest. I thought of Jackie and his fevered cheeks, his cold hands one day in the Public Garden, the hopeful pucker of his lips as he clutched a toy boat to his chest.

"Isabella Stewart Gardner!" a loud voice called.

At once, a slinking sound of velvet and silk rippling onto the inlaid floor. Sargent's portrait of me, unmasked. All bodies in the room faced the painting as my portraited self was revealed and, as though they were on tracks, all bodies then turned to face me.

There was I: resplendent in black with pearls, hands clasped, alive and bright-eyed, closer yet to becoming. The heart-shaped neckline was low but not too low. My mouth formed a smile that was met with disapproving faces. Murmurs rippled through the crowd as they'd done at the boxing match when Sullivan had gloved his opponent's face so hard four teeth flew out. I recalled their graceful arc, the blood caught in an equally beautiful and disastrous spray, and now, looking at the crowd of people gathered—friends, family, patrons, and reporters—I realized they were not enamored of my portrait. They were horrified.

JACK SAID not a word as we rode from St. Botolph to Brookline. He spoke nothing to me as we exited the carriage. He moved like the Man of Stone I'd seen at the pleasure garden, all fists and thumping, pounding the cold ground as we went inside. He held the door for me, but the anger on his face told me he did it only because he'd been well-trained.

"Jack—I . . ."

He walked out of the entryway, leaving me in the dark next to a large cylindrical vase I used to store walking sticks and umbrellas.

It tilted now, knocked over so it leaned against the catchall with its unanswered post and Jack's hat.

"Jack," I called again.

His face, barely illuminated in the moonlight, appeared in the arched doorway between where I stood and the dining room. His words were slow and deliberate. "I never want to see that painting again." Now he did not appear angry, just wounded and flat. "Do me that one favor, won't you, *Mrs.* Isabella Stewart Gardner?" He waited for me to nod. "Now come to the dining room, for I believe we've been robbed."

1ˢᵗ February 1888. 11:38 p.m. Police Report: Gardner Residence, Green Hill. Silver sugar bowl, large silver cream pitcher, small ditto, hot milk jug, pepper pot, coffee pot w/stand, 2 butter plates, ice cream knife, tea strainer, gold-rimmed egg dishes (2 sets), silver frame. Damage to one window noted upon homeowner returning from "night out at gallery." Mr. Gardner reports no jewelry or other valuables taken. Mrs. Gardner, upon listing of items missing, asks if "robbers were stealing or throwing a breakfast party." Upon further inspection, Srgt. Det. Reports further missing items: butter knives (8) w/pearl handles, card case (silver, engraved with initials), an engagement gift. Mrs. Gardner responds, "When items are stolen they steal you along with them."

2ⁿᵈ February 1888—Town Topics—If you haven't seen the latest society portrait (and who hasn't?), you've missed a great deal . . . of skin, that is. Known for his always-feminine portraits, John S. Sargent has managed a handsome portrayal of Boston's own Isabella Stewart Gardner. And what a painting it is: revealed to an audible collective gasp, this is not a shock to pass quickly. Mrs. Gardner's skin can be seen from her décolleté nearly all the way to what some are calling "Crawford's Notch."

8ᵗʰ February 1888—Boston Herald Daily—Regardless of what one thinks of the portrait, or indeed of Mrs. Gardner herself, there can

be no denying the woman's importance as a Boston fixture—will she stand the test of time? One can only guess.

I DIDN'T know which bothered me more, the continued fascination with my portrait or the idea, per the *Herald*, that I might not last in the Boston landscape. But for all my perseverations over this, Jack was merely dour. Weeks later his mustache still drooped as he moved, phantomlike, through the addition as though the two houses had always been one.

"Jack," I said, "I have an idea." I stood, slightly stooped in front of him. He sighed and looked at me. "The first is, I want to assure you, I've put the painting away." I sighed now. "It will never see the light again while you are still on this earth."

He finally met my gaze and nodded: a tiny bit pleased. "And?"

I crossed my arms over my chest, a stance he despised for its innate haughtiness. "And I've booked us passage. What was it you always said, the cure for a battered heart is time away?"

18th March 1888
Seville, Spain

Dear Mr. Berenson,
It likely will not interest you that Jack finds our hotel "basic and somewhat dirty," and it might not be of import to you that each breakfast brings with it oranges the color of sunset that I eat with my hands, but it might be of more interest to you— given your ever-growing art expertise—that we've made our first "significant" purchase. *Madonna and Child* by Francisco de Zurbarán. I plan on hanging it in my own bedroom. We are off to Venice, which fills me with a comfort I cannot describe except to say it is a homecoming, though I am not of it. As always I remain—Isabella

18th April 1888
Palazzo Barbaro

Dear Maud,

Enclosed enjoy this photograph. I should think so, as it fairly
sums up my Italy thus far with its passion plays and my birthday
tableau vivant at Ca' Barbaro, which you hold in your hand
now. Henry James, the now quite aged Robert Browning,
Claude Monet, Charles Norton, Bernard Berenson next to James
McNeill Whistler, myself, Rafe Curtis and his parents, and even
a smiling Jack Gardner, who is at his best here. I ran out to the
canal and dragged two willing gondoliers to join us to complete
our Leonardo *Last Supper*. Quite true to the original, we spread
ourselves 15 feet by nearly 30, garments rather than tempera
on stone, but arranged to mimic: bread rolls and plates, arms
outstretched. I will let you imagine who played the center figure.
Truly, is there anything better than an Italian spring? —ISG

PS You asked of keepsakes and purchases: I have secured a lock of
Browning's hair and put it in a moonstone locket.

29th June 1888
34 De Vere Gardens

Dear Isabella,

What a wonderful Mrs. Jack-in-the-box surprise to have had such
weeks together at Palazzo Barbaro. How I admire your ability to
traipse about the globe with friends, Romans, and countrymen
alike. I apologize for sending you out to antiquities shops alone.
Yet some of us press on, working away. Do not think I begrudge
you. More I envy you. And I did finish *The Aspern Papers*, which,
my bank account wishes to report, will be serialized in the
Atlantic Monthly. Isabella, one thing I wish you to consider: I have
known you a long time, and, as you suggest, our letters could fill
a tomb (and would indeed amuse the dead). Never have I seen
you more alive, happier, and steadier than in Venice. Perhaps you
might find a way to bottle it and bring it home with you.

Do not fail to be punctual in your reply. Yours—HJ

20th December 1889
Vienna

Dear Isabella—

Such a delay in my writing: all apologies and best wishes for
the holiday season. I gather you had the pleasure of seeing at
Green Hill "our group" minus me. Redirecting this note now to
London, where I think you've been for the sad occasion of Robert
Browning's funeral. I continue to find work at museums; my
graduate studies have begun to pay off, at least in my ability to
recognize value in art and, in so doing, calculate value both for
art's sake and for economic.

You ask about my "becoming American," and I answer you
this: with my name change I accepted a new identity of sorts.
It requires a letting go, an abandoning of the old selves in some
respect. The key—for me at any rate—is to keep that slim old self
as one keeps a shadow, knowing it could pop out on any given day,
appearing longer and darker. I will never shed being a Jew, you see,
name change or not. My cousin was Katzenellenbogen and now
Samuel Katz. My sister, Senda, plays basketball and has published
the first guide to women in the sports, but she will never be only
author or player, always the "foremost Jewish" player. I suppose
I will always be a Jewish art historian. My shadow haunts me,
integral to me though it is. What about you, Isabella, what haunts
you? My best wishes, believe me—Bernard Berenson

14th February 1890
London

Dear Isabella—

I realize you are now headed once again to Italy, as though you
and an entire continent are magnetized, and I am ensconced with
Lady Macbeth's portrait, yet I want to write so that, upon your
return, you might offer your hand in friendship to a friend of mine,
Dodge MacKnight. He spent much of the past two years at an
artist commune in Bouches-du-Rhône with Vincent van Gogh,
whose work has begun to sell in Paris. He's now in ~~Providence~~
~~Mattapoisett~~ Cape Cod or thereabouts. Dodge is a most agreeable
human, and his watercolors pell-mell on the paper will be met
with your favor. If you are wondering about the enclosed clutch of

glass grapes, I saw them and thought of you, glowing and dark in that dress, and, as I've not said it before, I regret nothing of that time and less than nothing for the resulting painting, closeted though I understand it to remain.

So, please promise me that one day soon you will find Dodge. In the meantime, accept this bunch of <u>not</u> sour grapes you might keep on your desk to remind you always to shine from within, no matter who the onlookers might be.

<div align="right">

Yours in Friendship—
John S. Sargent

</div>

<div align="right">

1st October 1890
Henley-upon-Thames

</div>

Dear Isabella—
I hope this letter finds you settled back in Boston and that there still remain traces of our fun at the Henley Regatta. I write with gratitude for your calm demeanor on the houseboat Sunbeam, keeping me company while I painted. When you shouted your cheers for Oxford's Balliol College, others clapped for the team, but I clapped for you. I can still hear the unpatented Isabella Stewart Gardner enthusiasm. I am once again reassured by our open conversations, the nature of which I can have with few others and which I also know will be kept in confidence as always—

<div align="right">

Ralph Curtis

</div>

PS Please find enclosed my gift to you, *Henley: The Regatta, 1890*. It would please me greatly if you would hang it.

<div align="right">

8th March 1891
Rome

</div>

Dear Mrs. Gardner,
I have yet to receive the photograph of your Sargent portrait, so this leaves me to assume you wish me not to see it. My hope is employment at the museum here in Rome. We will linger while I assist a few collectors out of Newport; Mr. T. Davis wishes me to advise in his search for art objects. With Mary's allowance and these funds I remain able to stay. Should you wish to look into more "masters" I might be able to help.

<div align="right">

Your Friend—Bernard Berenson

</div>

6

BEVERLY WAS not far from Boston, a fact made clear at breakfast when Jack read aloud to me in the presence of Maud, Sarah Orne Jewett, Annie Adams Fields, and Julia, who could not make sense at all of the two women sharing a bedroom at Alhambra. Still, that fact was not as notable as what Jack told us.

We ate toast with quince jam as Jack read the July 17 news, crumbs spewing forth like damp exclamation marks as he did so: ". . . the unique, the only Mrs. Gardner, exposing as usual a generous surface of her famous flesh tints." He slapped the paper down, but Sarah reached for it, continuing with delight.

"Oh, yes, commented one of the other concert attendees," she read. "And Mrs. Gardner was good enough to let me see a good deal of her."

Jack shook his head. Not angry but exhausted by me, he left to talk to his boats, which would cause him no remorse.

"I'm off," Julia said, after she'd cut the top of her soft egg off, peppered it, and consumed it quickly as though afraid it might come back to peck at her. She gave everyone in the room her toothless smile. "May your days be bright."

Sarah gave her own offering. "I'm writing about a woman called Lady Ferry. Should keep me busy."

"Lady Ferry, how charming," Julia said.

Sarah explained, "She's dead and haunts a little girl and befriends Death himself."

I HAD planned to pass the day as I had the others: taking one of the wooden canoes far out to the quiet patches beyond our cove, where I would be met by only herons and fish and seals who cared not a whit if I were gowned or naked, laughing or in tears as I dipped my feet in the water and wished I were in Venice. I thought of Clara Montalba's painting *A Bit of Venice*, which I'd seen with Joe. He'd longed for that city.

And now what I wanted was Venice, always Venice, with its intestinal tangle of streets and ribs of bridges: the city a body I wanted to inhabit, its map an outline of my figure.

What I longed for was to return, to wander those arterial chambers by the Grand Canal, stumbling upon masterworks that had not been seen—as my portrait would not—for decades or centuries. Ones I might write about to Berenson.

What I wanted was the money to do so. Money that did not involve Jack. That carried with it no whiff of judgment, no shame.

And, just like that, as though the herons and fish and seals heard my cry, I got it.

LAKE CHAMPLAIN. 17TH JULY 1891

MRS. J GARDNER [STOP]

REGRET TO INFORM OF FATHER DAVID STEWART'S

DEATH [STOP] HEART ATTACK [STOP]

YOU ARE SOLE HEIR [STOP]—

—RICHARD THEODORE PETERS, ESQ.

Western Union Telegram

. . .

I SAT in one of the cane chairs Joe had picked out with me the first summer we'd lived at Alhambra as a family. The other was filled with his ghost. And another with the ghosts of my parents, on whose laps I wished to sit, despite being a grown woman. How could I wish to be their child and a mother to my Jackie and to Joe? How large a table would I fill with missing people? I watched as another ghost, Harriet, trailing daffodils, served us lemonade with its sweet sting.

The ocean out the plate-glass window nearly burst with gauzy late afternoon sunlight. Water is a nasty chameleon. One moment you were on its sheen, smooth as a seal, sunlight rippling, and the next a dark lake filled with shoes lost overboard, secrets sunk, like a body or two.

Jack put his hands on my shoulders, bringing me back to the waking world. "An entire fortune," he said. "Whatever will you do with all that?"

I said nothing. Outside, the water shifted to purple in shadow, a veil of grief over the cove. There was none of that Venetian jammy hue here, no gondolier to carry me out in sorrow or back in glee. I pictured Henry there now, and I pictured Sargent painting him, bringing light into the darkness.

I tipped my head and looked at Jack upside down, which was how my world felt. "I don't know yet," I said. "But for starters, tomorrow I shall take the new train from Pride's Crossing and visit one Dodge MacKnight."

DODGE MACKNIGHT worked not in Providence or Cape Cod but in a small cottage on the Southcoast near the mouth of the river in Westport.

What had once been a farm outbuilding with an arched thatch roof now held an artist studio. Cutting across the double-height open room were exposed wooden beams from which hung a globe naked of its base so it swung like a lonely planet in a singular universe. There were white walls creeped with moss, large windows, their sills lined with glass pickling and fruit jars empty of their contents and filled

instead with bouquets of brushes arranged in order of size and point tip. A thick slab of stone that looked as though it had been heaved from a garden walkway acted as a counter. On it was a plate housing a pig pile of blackberries, a waxy wedge of cheese, its rind the color of a child's green eyes, everything soft and gentle as though not wishing to shock the viewer with its palette. Easels with thick paper clipped in place had water in all of its forms: river, lake, rain, puddle, as though all were of equal merit and infinite colors were possible.

This was not Sargent's darkness. This was all light and refractions from several crystals that hung from fishing line in the smallest of the windows, one by what had surely been a stall; hay and its dander still clung to the air in the sun slipping through the window and softened where I stood in summer-weight boots, beads of sweat on my upper lip that I dabbed away.

"This was a birthing barn," Dodge MacKnight said to me from the doorway. He held a small block of ice in a red enamel pail as though it were a worker's lunch. "As promised, Isabella."

Dodge's welcome meant everything—he'd greeted me as an old friend, had me wait on a once-elegant velvet tufted chair while he finished a watercolor sky, the room hot and close with light dancing on the wide-beamed floor. I felt as though he'd been waiting for me. And really, is there a better feeling than that? I had no mother, no father calling me home, no lover greeting me with eyes desirous, body hot, no child with their face pressed to the front window wondering when I would return. But I had this day. I looked at the river-in-process; I thought of Sargent telling me about making a whole from disparate parts, but this was different. "Your work . . . it feels as though you don't . . . how might I say this?"

"With words?"

I smirked. "As you wish. I realize you don't have every stroke arrive on the paper at the same time, but it feels fully formed—not only the finished ones . . ." and here I pointed to a winter scene, snow white and violet, an old fence breaking out of the ice with nowhere to go, "but the process . . ."

He nodded, the ice pail swinging from his right hand. His nails

were grubbed with color; his hands were immaculate. "The parts are what interest me. The flow itself. Water moves. Snow moves. I like the idea of trying to wrestle landscape into stillness, only to have it ignore my pleas."

Across the room, a shock of color drew me in. Violet again, plummy purple under brilliant turquoise and emerald, sand leaning into the water in a partnership of calm and roil; wheat-hued beach grass and scrub touched the sky. I wanted it.

Dodge saw me looking. He ignored my focus.

The ice was reward for us both, and he chipped it with a small pick. "You collect the shards and put them on the berries."

I removed my gloves and did as he asked, heaping sharp ice onto plump dark berries until the pile threatened to escape. Dodge reached above my head to the plank shelf and grabbed a white bowl with a chipped lip and dumped the ice and berries inside. "We'll make a slurry."

He handed me a tool with round, sharp slats meant for some other purpose and motioned for me to use it. Tentative, I pressed into the berries and they began to explode into the ice, mixing to form an icy sludge. Once I saw the color, I grinned.

"There you have it," he said. He found two teacups, wiped them with a kitchen cloth, and then scooped the mixture into the bowl. "Let's go outside."

We walked and drank the icy berry mixture, our mouths stained, my dress slightly, too. Jack would think the dress ruined, but I would treasure the minuscule dots of blackberry the way I held Dennis Bunker and John Sargent's splatters on the rug like secrets. We walked over brush that scratched my legs through my stockings, over sand so fine it seemed to be made of sugar, and along a path that wound from the birthing shed studio to a gaping inlet.

"The Bay," I said. It was the water in his painting that had gripped me.

He nodded. "The painting is really Belle-Île, but it's also here. And also all the bays. That's the other point for me, everything I make is everything I've made or seen before. So I title it how it makes

sense for others, but in my mind, it's The Bay The Bay The Bay The Bay The Bay . . ." his words floated out to sea as we walked back. He held the empty teacups, dripping the last of the purple sludge on the sand.

As he washed the cups, I stood in front of *The Bay* again.

"Watercolor is a process out of control. People think it's a weak medium, but it's just—unexpected. The paint pools in certain places, and I make it have . . . gravitas, I suppose you'd call it. I like the balance, that dance of thinking it could be ruined at any moment and then that ruin is what you wanted all along."

"I want it," I said. "The ruin and the painting."

He joined me. "It was offered for sale at an exhibition . . . Doll & Richards Gallery in Boston this past March."

"And I missed it."

"We can't any of us be in all the places at once. Perhaps you need someone scouting out pieces for you."

"Perhaps I simply need to buy all of your work."

He laughed and shook his head, color on his cheeks. "Yes, an entire house devoted to me and my 'process.'"

"Not a whole house. A room, perhaps." I looked at it again and then at other paintings: water forms, lanes with empty landscapes, mountains gone blue in the inky light. "Even your palm trees are wary."

"True. Even the fronds seem to be saying, what am I really?" He frowned. "Van Gogh understood me. That was a loss, leaving him. Out of fashion for me to say, but I miss him. I will always do so."

I stopped at another work that pulled me in. "What's that one?"

"Nothing." He drew a canvas over it.

"Are you sure?"

"It's the idea of an idea just now. A stream in Valserres."

"Will you go back?"

"I'm not sure."

"If you do, or even if you don't, I'd like it. This painting."

He looked at me. "You want to buy in advance the idea of an idea of a painting."

I had my own funds. I could do what I like. "Yes. I believe you will go back, but even if you were to leave it as is I should frame it and hang it and look at it daily. I would have a desk right nearby and watch the lonely current."

"Watercolor is good for motion."

I raised my eyebrows. "Or the idea of motion?"

He looked at me, puzzled. Then he gave a decisive nod. "You have my word, Isabella Stewart Gardner. *The Stream* will be yours one day."

"And *The Bay*? May I purchase it today?" I asked. He nodded. "And will you keep in touch?"

He received my card and pocketed it. "I'm off shortly—Mexico this time. I'll write from there."

"I should like that," I told him. "And now I have to leave you." He looked at me expectantly. "I've another stop—New Bedford."

MY GRIEF slipped away with each step on the cobblestone, past the chandlery and the Seamen's Bethel where the doors were open to reveal stark pews, the waterfront rammed with boats. The Pacific steam whaler Orca, sails slack and billowing in the whipping wind until the crew bound them. I passed the boardinghouse where Hetty Green roomed. They called her the Witch of Wallstreet for hoarding her fortune. The wealthiest woman in the country, she'd written to the papers explaining that having—not spending—her money gave her the greatest pleasure. That women ought to learn about money the way men did, that we ought to find our pleasures and keep them. What would mine be?

I walked by row after row of oil casks on their sides to my right and, when I turned up Broad Street, shops selling whalebone corsets, canes, whips and lashes, colorful boxes of Soapine Whale dirt killer depicting the imposing creature spouting as it dove into heady waves.

Despite Jack's offer of help with my grief and with my new fortune, I relished the solitary trip. I thought of Dodge MacKnight and found myself at Albert Pinkham Ryder's small studio up a flight of exterior stairs above Bay State Fisheries, which consisted of only one

room that smelled of haddock; the man himself was entirely focused on his easel. I stood, coughing and scratching the gritty floor in an attempt to get his attention, as out the window, merchant ships cast off lines, fishing schooners and salt harvesters made the harbor a living, breathing entity all its own, forever in motion.

Ryder's work, which I'd heard about only in passing, had all the motion of the harbor but depicted natural scenes empty of people, a vacancy created by autumn and moonlight, a dead bird, a broken harpoon. His palette was burnt and autumnal, a match for the gloom I carried.

"Hello," I said.

"Hello." He held a metal tool and brush in the same hand, working a taffy-chew size of brown paint into the canvas. When he stopped, he scraped the tool against his palette and then went back to paint the same spot. I stood for a long time waiting for him to interact with me, and he only went into and out of that same part of the canvas: a clutch of brush growth alongside a narrow inlet of water.

"I should like to buy one of your paintings," I said, thinking if I were blunt he might break his concentration to negotiate.

"They're not finished," he said.

I looked at the other work, some of it framed. "Surely this one, framed and titled—?"

"Nothing's ever really finished," he said. He moved from his current canvas to the framed one in front of me and, studying it for a moment, went back into it with his brush. His focus shifted from the easel to the painting I'd thought was already quite complete. "I rework. And rework again."

"And is this a local scene?" I asked.

Now he looked at me. "Local to my mind, yes. But out there . . ." he pointed with his brush toward the harbor. "No. I don't study nature. I study my own thoughts."

I wanted to own one of his thoughts, and I stood for a long time watching him and then asked again. "They're not finished yet," he repeated. His eyes and brush let me know that finishing was not his goal and might not ever happen.

I walked out empty-handed: my fortune untouched.

• • •

2nd November 1891
Green Hill

Dear Amory,

How pleasant to pass a day with you at Groton and to see your
excellent work; you are a born teacher and so good with your
pupils, one (this one) wishes to go back to school to experience
your dedicated passion in mathematics and Greek. I speak for
both Uncle Jack and myself when I say we are greatly touched you
should be planning to dedicate the new chapel to Joe. Keep well
and know I remain—Your Proud Aunt Belle

27th February 1892
152 Beacon Street

Dear Mr. Norton,

I write to you in all hopes I might rely on your discretion. Having
been for the season in Boston and New York, I had the pleasure
of finding a cousin (v. distant, but still), a Mr. Thomas Russell
Sullivan, who has given up a quite successful business track to
focus on his—also quite successful—short stories. You may
have met him at the luncheon after which the Polish composer
Scharwenka played his own work? Regardless, I've a clutch of
artists and musicians, yet my literary men are few (I do not seek
comment for this). I would like to keep him as friend and also
support him, though I doubt he would accept my help—I write to
you with a proposition for his membership in the Dante Society.
I enclose herein dues for that should you be inclined to move
forward. —ISG

5th September 1892
Venice

Dear Isabella—

Many congratulations again to you and Jack on Gus's wedding.
May he and Constance Cabot Lodge find many years of (scandal-
free) happiness together. I hope they enjoy the set of bowls. For
what conveys happiness more than bowls? Bowls of soup for a long,

prosperous marriage. As expected, my part in your renting the Palazzo Barbaro brings such pleasure!

And too quickly my pleasure there ends. Your lovely husband just escorted me to the station, and I am filled with woe to leave. The Barbaro is a phantom, and you, Donna Isabella, are an exquisite legend. I will always think of you that morning when you'd been up to God-knows-what in the Harbor Office, but how fantastic of you in your sea-green dress, hair piled high, to gondolier your own boat, rowing for all to see as we sang fake opera. Likely we woke horses and fishmongers alike with our poor rendition of Tirindelli's new opera, which I hope will be as big as the ruby ring Jack bought you (will you still be able to lift your hand to write back to me, I wonder). Five carats is big enough for a salad. I thank you for your hospitality, and do regale me with your news and upcoming Paris trip. My condolences that Venice must end for you with the Curtises returning to their house. Meanwhile, there is no better place for antiquities, and you seem to derive great pleasure from those.

<div style="text-align: right">

Yours with Affection—
Henry James

</div>

<div style="text-align: right">

25th September 1892
Palazzo Barbaro

</div>

Dear Mr. Berenson,

I hope this letter finds you well. I am happy to know of your museum position. We have just had a visit in Venice from T. Jefferson Coolidge, who is now happily ensconced as American minister to France. The sad news is that he still is refusing to allow me to purchase *El Jaleo* from him. The happier news is that he accompanied me and Jack on our many outings, discovering wood carvings and old furnishings, and was integral in assisting as we rescued a large stone basin that was on the verge of being dropped onto the Grand Canal! You worry about its value; I buy what I like because I like it, not worrying about fakes or frauds from the dealers, and I believe we've been lucky in this regard so far. I commissioned Joseph Linden Smith, who studies now at the School of the Museum of Fine Arts in Boston, to paint the

entrance arcade of the Barbaro so I might gaze upon it when I am not here. I do think it terribly important to support those who wish to be artists, not only those who consider themselves already there.

Where all of these items will live upon our return to Boston I do not know, but as we are off to Paris to-morrow I will push that thought away and return to your letter for more details of your writings. I do look forward to more news—ISG

5th December 1892
Hôtel Drouot, Paris

Dear Mr. Berenson,

Someone told me that pleasure could not be explained. Tonight throws light on a question I struggle to answer. Jack and I learned about the auction of Théophile Thoré-Bürger's estate at Hôtel Drouot, a grand mansion of a place that is now for dealers, not tourists, and decided to attend because of a particular painting. *The Concert* by Jan Vermeer was up for sale. Yet I knew that my presence, my female form, no matter my means, would not allow me to win. And if I am honest, there is pleasure in winning— the object of desire either human or inanimate. I asked a dealer, Robert, to bid. He did not know how to proceed, when to call it quits. I told him I would attend the auction as "spectator." Having been to a boxing match, I found this evening not dissimilar, so heated was the fighting for vases, for paintings, for a deacon's bench that spanned one entire wall. Chairs were crammed in tight around a center where the auctioneer stood in trousers and waistcoat, spittle flying as he flew through the items on offer. My signal to Robert was to be my handkerchief. He would bid and bid until I lowered the cloth suddenly from my face, and then, if the bidding tired, he was to go up by two hundred francs to secure the buy. I had bought already this trip Whistler's *Harmony in Blue and Silver: Trouville* for 600 guineas, which is great value.

Jack dined at Café de Paris with Ralph Curtis and met me at the auction, his breath still with the whiff of liquor. He arrived just in time to see Robert win on my behalf, and now I am the owner of Vermeer's *The Concert* for the reasonable sum of just shy

of 30,000 francs—only so reasonable because he is not widely
appreciated.

And Berenson, let me not leave you there, for I need you to
know this: the money is not the thing. The art is not the thing
either. Neither is the chase, though I did enjoy the sport of it.

When I saw the brochure, the Dutch work held me captive
in its light, the girl at her piano, her friend or sister singing, the
man—a teacher?—between them. I recalled my own lessons,
my mother's hum as she passed by me: her scent, that mixture of
vanilla and rose and something perfect that is only my mother's
and which I will never, ever have back and could not bottle.
Oh that incredible, terrible sadness at the impermanence of my
mother's own smell, the way her particular hands felt on mine
as she would correct my finger positioning—for there is always
love and criticism mingling with mothers—and oh for the love of
anything I wanted her right back next to me. And my father, too,
not yet home with those notes glowering in the music room calling
him back to us.

<div align="right">That is the thing, Berenson.—ISG</div>

7

A WEEK AND a half of travel from Boston in the summer heat
found us arriving in Chicago, which was hotter still. Beren-
son had recommended we loan a painting for the World's Columbian
Exposition, encouraging me, with my growing "significant" collec-
tion, to let others view it.

"It's terribly important for the city's economy," Jack said as we
hurried to the six-hundred-acre grounds. We had no reason to rush
yet found ourselves skittling, excited. Indeed, I felt invigorated. Jack,
out of breath and ruddy in the August afternoon, tipped his hat at
the world's fair entrance. I stood, impressed, at the foot of what was
being called the White City due to its array of white stucco buildings
erected for the fair. "They say it's to celebrate the four-hundredth
anniversary of the New World being discovered . . ." Jack shook his
head. "But it's business. And smart at that. Chicago is a city still ris-
ing from its own ashes, the devastation of the Great Fire," Jack said,
breathing hard as we stood side by side.

"That was years ago," I said.

Jack nodded again. "True, but it killed them." He turned to me
with the fair program in hand. "Surely there are devastations that
claim us all for years at a time?"

I met his gaze but kept silent. If this was his way of broaching the

subject of Crawford, I did not take the bait, instead pushing that old devastation down into the pit of my belly, where it refused to hide and, instead, all these years later, nestled in my groin.

"I should like to wander," I told Jack.

"Agreed," he said, and watched me study the program.

"Perhaps I'll go to the Women's Building first," I told him, possibly as an appeasing gesture. I did not have to chase the strongmen, the jugglers, the elongated stretch giant who walked past us now. "See you at the Fine Arts Committee near our painting at six?"

"Until then," Jack said. "I'll be in the yacht designs—as though that might surprise you."

I could count on him to be always himself, nothing more, nothing less. He grabbed my arm. "Do be careful, won't you?" His face looked suddenly serious. "There's rumors of a murder—" I nodded reassurance.

I walked alone. Jack's warning had scared me, but the truth was, a single murderer at an enormous fair was really no scarier than being a woman anywhere in the world.

The roof of the Manufacturers' Building afforded a view. I stood with my hands on the fence, looking out at the expanse of fairground large enough to be its own city—all designed by Frederick Law Olmsted, who'd done Central Park and Boston's Arboretum. I swallowed, thinking of lying with Crawford on a day as warm as this one and then flashed to waiting for him on my birthday, the paperbark maple with its torn, lonely skin.

The area where I stood looked out at the Court of Honor and the White City's stucco, the huge-scale exposition with everything symmetrical, fountains spraying into the summer day, grand basin at its center stretching flat and reflective. All the buildings, steps, and domes were beaux arts and balanced. At night each path, step, and fountain would glow with electric light—I felt as though I were lit from within, too.

As I made my way across the grounds, I walked past the Palace of Fine Arts, its pediment hopeful with decorative carvings and steady in stone. Olmsted lived in Brookline now, near Green Hill. I thought

of his office, the first professional office of landscape design, and close to my own home now. It felt important.

Here there was beauty inlaid with oddness, a stunning building near a midway with giant Chicago wheel and prize games, wandering donkeys and camels, a Hall of Inventions with a wonderful new way of joining fabric edges called the zipper—I would write to Maud and Henry James promptly with an innuendo about the ease of undress that invention would afford. There was a breakfast food called Cream of Wheat and a slip of sweet rubber gum one chewed with no hope of swallowing, just chewed and chewed the Juicy Fruit until one's jaw ached. There was Pabst beer and near to that a display of countries, of states—Idaho with log cabins, a replica Liberty Bell made entirely of fruit. My eyes reeled as I walked to the Women's Building. I roamed it, listening to women discussing and talking amongst themselves about the work on display—all of it by women.

Jack surprised me by being there. "I was checking on you," he said.

I appreciated his care but wondered if it was kindness or suspicion. "Well, here I am at the Women's Building."

"It was even designed by a female architect," Jack said, as though everything were sorted.

I consulted the program and the placards. "Sophia Hayden. MIT's first four-year woman architect. I wonder if people will remember her name?"

Jack tugged on his mustache. "At least it's *some* progress, Belle."

I nodded—time and again I'd been told I ought to be happy with what I had. A morsel is better than nothing. "The fair is six-hundred acres, with two-hundred buildings, Jack. It's wonderful that a woman has a single building. But it's not enough." He opened his mouth to convince me otherwise, but I kept going, repeating what I'd overheard. "Not to mention the fact that she was paid one-tenth of what the male architects were paid."

Jack's mouth snapped shut. I did not further exacerbate the conversation by pointing out the Women's Building was attached to the Children's Building to devote equal space to education and proper child-rearing practices.

"I'll leave you to it," Jack said. He put a hand on my shoulder, and I could feel the heat from his skin through my dress. "But mind yourself."

I made a face of disgust, fought the fear that followed, and promised I would meet him—safely—later. Inside the Women's Building, the painter Mary Cassatt had a mural that depicted women advancing through history. Did that fill me with hope? It did, yet it was a hope impossible to hold on to; the building and her mural would be knocked down in November as soon as the fair ended.

As I strolled, I understood. Olmsted had his parks. The Boston Symphony Orchestra had its hall.

I, too, wanted something permanent.

WITH MY belly full of corn popped in a giant black kettle and crisped with sugar, I made my way to the Fine Arts Committee. Inside, I sought refuge from the fading heat at the end of the Swedish Pavilion. A man on a ladder was hanging a picture, and I stopped to look at it: A crowded trolley bus like the one I'd ridden to buy ferns years before. Women shouldered together as the vehicle moved. They were tired, their gazes outside of the trolley itself, entirely removed from the slouching, sleeping man to their left. Grays, blacks, the dark brown of a belt satchel, a sheath of light beaming onto one woman as if to remind her the day was not yet over, tired though she might be.

"*The Omnibus*," I read aloud. The man on the ladder nodded. "Do you know this painting?" He nodded. "Do you know the painter of this painting?" Another nod. I grew impatient. "Might you tell me the painter's name?"

He hopped from the ladder and came to me, sticking out his warm, tough hand. "Zorn. Anders Zorn. Me."

1ˢᵗ September 1893
Lexington Hotel, Chicago

Dear Julia,

I purchased a most miraculous painting by a young man (33) named Anders Zorn, a Swede of such talent, particularly of

portraits. May I suggest you write to him on behalf of your large and lovely family and set up a session posthaste before he's booked for the coming months! Ever Yours, B.

2nd September 1893
Lexington Hotel, Chicago

Dear Maud,

I purchased a most miraculous painting by a young man (33) named Anders Zorn, a Swede of such talent, particularly of portraits. May I suggest you write to him and set up a session posthaste before he's booked for the coming months! His wife is perfectly charming and comes to sittings! Ever Yours, ISG.

3rd September 1893
Lexington Hotel, Chicago

Dear Mrs. Boit and Daughters,

Greetings from Chicago, where I purchased a most miraculous painting by a young man (33) named Anders Zorn, a Swede of such talent, particularly of portraits. May I suggest you write to him and set up a session posthaste before he's booked for the coming months! Ever Yours, B.

19th September 1893
Chelsea, London

Dear Isabella—

Knowing your enjoyment of a certain boxing match, I wonder whether you wish to create a rivalry in the art world. If you encourage everyone to sit with this "Zorn," whom might I paint this winter? Have you forgotten me so quickly or overlooked my nine (9!) portraits exhibited at the world's fair? All fine to say I've captured a Vanderbilt and be done with it, but lest you cry too bitterly over my fortunes, know I will be waiting to meet with you again—for we will do another sitting one day. For now, I've a dozen (12!) commissions for the family of Asher Wertheimer.

Take that, Zorn!

With all great affection—
John S. Sargent

8

I ARRIVED BACK in Boston to find two notes. The first was
addressed to:

<div style="text-align:center">

Mrs. Gardner, Esquire
Well-known lady in high life,
Boston, Mass.

</div>

I showed Jack; it did not have an actual address, and yet it had found
its way to be delivered to 152 Beacon Street. This gave me a plea-
surable pause when I thought of the few invitations I had received
early on, ridicule now alchemized to renown. I opened it and read
aloud to Jack, who stood, travel weary and swaying slightly under his
own weight, still carrying his briefcase. The house was crowded with
deliveries: I could see the paintings we'd bought wrapped and lean-
ing against the wall, a few other boxes, *The Story of Lucretia*—made
mine with Berenson's acquisitional finesse and a few extra hundred
pounds—had not found a place. My beloved objects were encroach-
ing upon me.

"Mrs. Zorn and I would be delighted to join you in Venice," I
read, and side-noted to Jack that I'd invited them straight away after
two delightful days of talk at the fair. I went on. "Isabella, you dictate

when, and we shall be there. If, as you say, the place is part of your soul, perhaps a painting of you in situ is in order? Looking forward entirely—Anders Zorn."

I smiled at Jack, thrilled with the note. I could already picture the fun we'd have as a foursome in Venice.

"Another man for the Isabella Club?" Jack said. His words were flat, unadorned, but they stung.

I chewed on his accusation. "For us, Jack. For us. Did you ever stop to consider what our lives would be like without my 'club' as you call it? There would be no lecture series, no Palazzo Barbaro nor regatta with your beloved boats. So yes, Zorn is now an official member of my 'club.' But never forget you benefit from my collections."

When he had gone, I looked at the second note. The card was small, the envelope bore only my name and "152 Beacon, Boston." The penmanship—immediately recognizable to me—was tight and even and snipped at my heart the way I had, years earlier, snipped apart the author's letters.

It is a long time since I have heard from you, the letter read. I stopped, caught my breath, pressed it to my heart as though I were bleeding and it would staunch the wound. *Is it wrong to be jealous of an entire country? Italy has you, and I do not.* I thought of Palazzo Barbaro's shaded nooks under the arches, the courtyard laid out square by square, sun-flooded, and could not keep myself from picturing lying on those squares, heat in the tiles on my bare back, Crawford weighing me into the ground, though we had never been there together. *Venice has laid claim to you. Might I share its grip, even if only briefly? Will you do me the honor of meeting me in New York?*

TWO WEEKS later, I arrived. The hotel had only just opened and was not notorious for parties or teas or dilettante debutantes, and, as such, afforded a quiet place to meet. And yet, as the hotel consisted of two hotels built side by side on Fifth Avenue, I stood at the Astoria and it took five minutes for Crawford to notice, having himself been at the Waldorf.

We shook hands, which felt proper and painful and started a slow rot building in my chest. It was poison to see him.

"I shouldn't have come," I told him. What was the human instinct to revisit old loves, to split apart wounds that had healed, gnarled and uneven but healed all the same? I looked at his face and then, feeling tears, looked away.

"It's lovely to see you, friend." His words were platonic, but his eyes betrayed them.

It was the same charged air around us. Oh, those youthful kisses that flashed so in my head. There were slight pleats around the corners of his eyes now, such as befriend a man at forty; I knew time had passed, but my body didn't register the passage, so the desire started rubbing itself like a cat against my ribs.

I shivered, though the November day was clear and sunny.

"I have a room," he said, as though he'd been waiting to see if I would ask.

"How convenient for you."

He waited. I saw his gaze go from my eyes to my mouth and knew without a doubt he remembered what that mouth had done, the pleasure it had given in action and in words. "At least let me read to you—it's new." He blushed. "But about something I've long felt."

"Did it ever occur to you that I might have grown tired of you reading aloud? Of your voice?" I could feel it in my ear, his lips, his head cocked toward mine as though his words were only for me. He stared at me. I knew my eyes betrayed me. "I haven't, but I could."

THE BED was new and high from the ground, high enough he had to lift me onto it, then slide me toward him as he undid my laces. I grabbed at his shirt but then held back, wanting to memorize his face. But I found I already knew it, knew the fold of stubbled skin where the back of his ear met his neck, knew his fingers, which I placed one after the next in my mouth, each in the same order I'd done years ago before sliding them inside myself.

He breathed hard, holding my head in both hands as though I were a statue and it was severed from my body.

"Before we go on—and I do wish to go on—possibly forever," he said, groaning as I licked his neck, "I would prefer no one knows I'm here with you . . . and no one ever knows."

I climbed astride him. "I'm your dirty secret?" I grabbed his head now, staring at him as I pressed against him.

He gripped my waist, moving me back and forth. "If that's how you choose to see it."

"Has it ever occurred to you, Crawford, that you're my dirty secret?"

He knew what I liked and held my wrists while tonguing my nipples. I knew his groan like the best, most important movement in a symphony, his lips on my ear reciting words he'd written about me, words that would be published, consumed, kept on shelves in libraries and other people's bedrooms. No matter how close he was, how deep he thrust into me, and how hard I gripped his shoulders, part of him would belong to the world. His words would remain after we were both gone. I held his mouth to mine and knew—I knew with shocking, stunning certainty, that I loved him and that this meeting would be our last as lovers.

I lay still, listening to his ragged breath. First I had thought I had no more passion for him. Then I'd thought I had infinite passion, insatiable desire.

"Do you not desire me again?" he asked, naked, sweating but ready for more.

I regarded him completely, from shaggy head to large toe, from past youth to present middle age. "Perhaps I still have that unquenchable thirst. But it's not for you." I stood, shaking. "My heart shattered in a million pieces long ago, and I've been claiming those pieces back in the form of objects and art ever since." I gathered my clothes and readied myself to leave. "I am truly grateful for the chance to see you again." I leaned to kiss his cheek. "And now, I have work to do."

· · ·

Mr. Bernard Berenson
Receipt of Sale Bonomi-Cereda Collection, Milan
 The Dauphin François, François Clouet
 Man Holding a Branch, Frans Hal
Due: 8,000 Lire

2nd January 1894
Berlin

Dear Isabella,
Thank you for the charming note you sent before heading out
to ride with your nephew. Yes, I have bought Giovanni Bellini's
Madonna Adoring the Sleeping Child for Theodore Davis, the copper
magnate I mentioned before. He is out of Newport. However, as
that can no longer be yours, I will certainly, as you suggest, gather
"as many and as much" of such depictions as I might find. And in
the meanwhile, there is a Tintoretto I wish you to buy. True, there
is another portrait of him by Titian (whom I know you admire),
yet this Tintoretto is more refined in feeling and brilliant in tone.
Please do not hesitate in your response—BB

2nd March 1894
Paris

Mrs. Gardner—
You use the expression hell-bent in reference to acquiring the
Tintoretto, alas your letter was posted later than the date you
wrote it—26th Jan v. 10th Feb—and as a result there is no chance
of it. Of all the people I know, you are the most enviable in spirit;
in your letters one may hear the music you host, see the fists fly
in the boxing match you view, and simply feel the desire to have
these great masters live with you. Alas, the art world cannot afford
the time the rare-book world does; it has a far faster pace and is
louder and more costly. I have every faith you might catch up,
however, so determined is your gait. Yours ever, BB

2nd May 1894
London

Dear Isabella—

A note of thanks for hosting me in Venice. It was the cause of some
jealousy from my studio mate, Albert Belleroche. He is a dear
friend; I enclose here one of our mutual sketching efforts, which
may bring to mind the duel I had with Denis. The men are not
dissimilar, actually. There may be talk in that regard, and while
tedious, it will detract from what they call me now, "painter of the
Jews." Venice was a welcome reprieve, and I remain, as ever, yours.

—J. S. Sargent

1st June 1894
Palazzo Barbaro

Maud, dear girl,

Will you do me the great favor of checking on 152 Beacon,
where Jack and I have shipped a number of items from Vienna,
Florence, and Venice? I suspect you will have to crawl through the
wreckage, but still, the floors will gleam! All thanks and know I
am working on a plan, or the plan of a plan. All Love—Isabella

9

I SAT AT the edge of the Grand Canal alone, Palazzo Barbaro a few feet behind me, its inhabitants asleep. I closed my eyes, head in my hands, to see if I knew the place well enough to walk it in my mind. To love a place, it had to speak to you at dawn when you were the only one awake, coffee with steaming milk in a bowl on your lap, first light coming through whatever woodwork or keyholes or roofing allowed; the Barbaro had an open-air courtyard and I loved it, yet on rainy mornings it collected puddles that wouldn't dry for days. And to love a place, the afternoon had to provide a space for shelter from July heat or bitter, dark November's seeping drag on the spirit. The Barbaro had a corner I liked; and when we rented, I lugged over a chair so I could sit on it in that corner, often with my feet propped up bare in summer or wrapped in a wool throw in autumn. And to love a place—for me to love a place—it had to have outside and inside both. And this was lacking slightly in the Palazzo Barbaro: a few palms in heavy stoneware pots in each courtyard corner were simply not enough for me.

For when I thought of my time with plants—ferns, daffodils, irises, the Public Garden in winter with snow bright with poinsettia, my father-in-law's orchids, Alhambra's sandy beach plums in green and pink, I came to understand that I had been learning about leaves

and blooms, shrubs and what to plant where, but really I had been cultivating growth.

I had grown life and lost it, found solace in a book of plants and then in plants themselves and then in books themselves. And now I was a fully realized but free-flowing vine of some sort. A tangled, dangling nasturtium, edible and fragile and coming back no matter the frost heaves or drought. But where to root?

I found myself close to the Grand Canal's morning murk when it hadn't decided about sun or rain. I was a sight: hair in a state of capitulation from its tight bun, dress in need of a thorough soaping. I had somehow lost a shoe. But I smiled. Surely this was the tumble-down after a night of fun, a game of blind postman in the courtyard, a scavenging hunt with Henry's latest serial as prizes, as though all the parties I'd missed in my youth were back with a vengeance. I ran my fingers on the rough stone wall and looked out at Ca' d'Oro, the Pala-zzo Santa Sofia with its Gothic arches and golden hue partly blocked by scaffolding; Baron Giorgio Franchetti was heavily restoring the place. It gave me pleasure to look at—there was a certain amount of ownership that came from such loving repair, as though one were stitching one's own skin, putting organs back in place.

Dear BB,

See us there, me and Jack, Mr. and Mrs. Anders Zorn side by side yes-terday in matching gondolas rowed by two brothers as though we'd planned for it. Dov'è tua sorella? *Where is your sister, I'd asked them, and they'd understood; she is home, in her place.* Il mio posto è qui. *My place is here.*

Did we row and traverse, kissing under the Bridge of Sighs for luck? We did. Do I feel with my steady Jack, lucky for everything, despite it all? That is the question we all ask at the end, I suppose—and I realize I have yet to reach that mark—but I do not feel lucky. If left to luck, a woman might have nothing of her own. I feel I have forged my own way in a world that cared little for my existence. There was not luck involved because I—

A voice behind me broke the quiet autumn moment. I craned my neck back to see.

"You seem to have lost a shoe," Bernard said.

"I was just composing a letter to you in my head," I told him. He

sat next to me for a moment before taking the few stone steps to the canal, braving the tide that covered the bottom stairs.

Triumphantly he raised his arm. "Hurrah!"

"Shoe trophy—you truly can find anything, BB."

"At your service," he said. "Though not today, I'm afraid."

"Ah, yes, your day of rest?" I asked.

He shook his head. "Day of Atonement. Yom Kippur. And fasting all the while."

"But you feasted only a few days ago," I said, thinking of the squash, the agrodolce, rise e bisi—a gentle dish of rice and peas that could not decide if it wanted to grow up to be a risotto or a soup, schie e polenta—small crabs from the lagoon that I sent back after seeing Berenson would not touch them.

"That was the New Year, Rosh Hashanah. A celebration of the harvest bounty, joy, et cetera."

"I doubt your books have 'et cetera' in them." I tried to secure my hair up, but it refused and Berenson lightly tucked it behind my ear.

"No mentions of fireworks either, though I've secured them for tonight," he said.

I turned to him. "Is that allowed? I would not want . . . I feel you've suffered, and I don't want you twisting and ignoring your traditions for the benefit of this—" I gestured to the palazzo, where everyone still slept or took trays of tea and toast in their rooms.

Berenson sat up straight, hands on his knees. "I only do what I'm comfortable with, what I'm able . . . and truth be told, a funny thing about Judaism is that one might be a Jew and not keep up with all the practices. It bends and twists for me." He paused. "But there is a . . . fire either innate to my genes, or the aftereffect of always fleeing. I suppose that is likely passed down the same way eye color might be. One learns how to adapt—how to hide or blend."

I stood up, shaking out my rumpled self. "The world does not seem to tolerate those who stand out."

He stood, too, nodding. "True. You have the ability now to stand out in rather an appreciated way, yet as I announce myself without trying, day-to-day, I don't feel the joy in it—only the fear."

I felt for him. I thought of being a young girl, of running home one dark night in Paris, of being scared at the world's fair. "I was afraid a long time."

"And now?"

"Less so. I have my shoe, after all."

"And the stained glass you bought yesterday." He smiled, thinking. "The other part of Yom Kippur, part of the Hebrew core, is memory." Our eyes met. "Perhaps that is what draws us together, Isabella. For I am bound to remember all those who came before me, Yizkor." He made sure I was following his words, together on an unmoving body of water, a still gondola in the morning light. "Jews are said to have long memories, but it's bigger than that. We are the living past."

I held my breath. "That is what I feel. All of those who came before me, and the selves I've gathered."

"You must have chairs for all of those people, chairs for an audience only you can see. Jews have this Yizkor, a sort of breathing, collective memory. Shared experience. When I find pieces for you, I am finding part of the world, and if one day you share those objects with others, you will commemorate us, the artists, and also memory itself." Berenson raked his hands through his hair to no avail. We both were doomed to spend the day displaying that we had met the dawn with hair to prove it. "Shall we go on a small buying romp?"

"Is it allowed? Will you atone as you go?"

"I am always atoning, always trying to correct myself if I've put my foot in it—shoe or not—and if I cannot eat until sundown, and you've no one to shock just now, we might as well pick up a set of glasses I saw just yesterday."

I looped my arm through his, and we were off.

WE ALL drank from the purchased set: seven gilded wine glasses with a cardinal's arms, each with substantial neck, the gold rims against our teeth as we traded stories, the cacophony of Venice's carnival competing with the pianist I'd hired.

Henry James wiped his lips on the serviette and swayed slightly

as he stood, full from cuttlefish, from twists of gemelli dotted through with capers and anchovies. "I've grown in the course of one meal," he said, and stretched.

"Certainly you're too big for Boston," I told him.

"I could say the same thing about you. The city can barely contain you. And yet you keep going back." He looked at me as the party dispersed; the men save for Zorn went to set off the fireworks. "You could house yourself permanently abroad?"

I looked at the Barbaro and my friend. "I could. But I am in some ways married to Boston. With its cobbled streets that threaten ankles and its cold-shouldered society, the barely there spring." I moved toward the stairs, where Zorn had beckoned me to join him. "Boston and I are both difficult and filled with history, steeped in quirks— Brahmins on one side, boxing matches and lions on the other. It's too late for me to divorce it and marry another." I held up my ringed hand. "We are forever destined to become one."

I climbed the stairs to my room to meet Zorn. I found my pace on the stone steps steady, as though pieces of a puzzle in my life were slowly coming to me. I did not have the vision in its entirety, but I was close.

He held his palette already dotted with his bulbs of paint. He used a limited palette: yellow ochre, black, and burnt sienna.

"Against that wall, I think," he said.

A boom from outside made me go to the window and fling open the shutters wide. The canal rippled with colors. "Not the wall," I said. "Here."

"Now stand just there." Zorn watched me. "Move your arms. Do it like this . . . like you're—how do you want to say it?—holding up the spaces."

I braced myself, but lightly, in the window frame—all of color and light, the memory of each Venice morning and night on my face as I smiled. Zorn stopped short, an audible gasp. He went to his case and removed a new vial of paint bought from the colorman who sold his wares in a square in the Cannaregio area. Zorn studied it as though it were one of those Dresden creatures from the deep. "It's not enough,"

he said. "My usual colors." I thought of the darkness on his *Omnibus*. "Not for this. Not for you." He arranged a dollop of cerulean on his palette and gave a satisfied nod. "This," Zorn said. "Now this is an Isabella palette."

"Sargent will be most jealous," I said, laughing.

"He can have you later in life. Give me this version of you, forever."

Slowly at first and then feverishly, he slathered emerald green, white with the lightest yellow for my dress, my pearls long and iridescent, a quick slash of red for the shooting burst in the dark sky.

I pressed my arms, memorizing this moment, wishing to share it with the world. "If someone were to slice me open, inside my heart they would find Venice," I said.

Zorn kept on with his brush and oil. "And what will you do with that heart?"

"Somehow bring it back to my own city."

12th October 1894
Palazzo Barbaro

Dear ISG—

Will I regret leaving you in Venice each time I do so? I suspect the answer is yes. We are aging—though seeing you with the Zorns one must wonder if you are in fact growing younger! Look at your smile as you plan. I shall hear your laugh over the roar and bang of fireworks all the way from London. Never let it be said that I do not know you. You have everything, you do everything, you enjoy everything. But the question remains: what will you do with this everything? —Henry James

15th February 1895
152 Beacon Street

Dear Mr. Berenson,

Here is the check for the Giottino. And on second thought, I <u>will</u> have the Guardi because I like it much. But Mr. Gardner wants to know if it can be had cheaper. In a day or two I will send a check for cost and your commission. I look forward to the arrival of your book; we've had an arrival, too, as Gus's wife, Constance, had

their baby, a girl in good health. Now please secure the Guardi!
Hastily Yours—Isabella

14th June 1895
Fiesole

Dear Mrs. Gardner—
I have seen clippings of gossip rags with you horse racing! I had
no idea you'd registered Green Hill with the jockey club. No
wonder you have a winning streak on the track as well as in your
acquisitions. I offer to you now *Madonna* by Giovanni Bellini. It is
most precious, its color unrivaled even by the artist's own work. I
have every reason to believe the owner will part with it for £1,350.
I do dream that your collection will be of great value, yet more
than that, of great meaning. —Ever Yours B. B.

25th June 1895
London

Mrs. Gardner—
Consider this note a bill of sale. Send me 600 guineas and I will
send to you the *Nocturne, Blue and Silver: Battersea Reach* for your
pleasure. I only make art, I do not attempt to solve the world's
woes. At least I know you will appreciate it. Yours—James
McNeill Whistler

19th June 1896
Fiesole

Mrs. Gardner—The gentleman who owns the Bellini of which I
wrote a mere five days ago has just written to say he will not part
with it for less than, £2,500! I know you are with the Zorns for
some months abroad, but please do let me know.
Yours in greatest haste—B. B.

19th January 1896
Villa Kraus, Florence

Dear Mrs. Gardner,
Your charming note comes to me still carrying Boston's chill.
I wish I could dispatch some of the golden weather here. If you
wish to get to the point of this letter, you may skip the next four

pages of my drivel. [pages 2, 3, 4] And now to the point of this letter; I am sending you a photograph of one of the most precious pictures in all existence, which, if not sold in the next month, goes to the National Gallery. The photograph in question is one of Rembrandt's very earliest paintings, 1629. He was 23. His earliest self, one might say, the before-est of him. The condition is perfect, note the grayish-green that signifies all his early work. Should you wish to buy it for £3,000, please respond with a cable that reads "Yes, Rembrandt." —BB

20th January 1896

To: B. Berenson, Villa Kraus, Fiesole, Florence
"Yes, Rembrandt."

10th March 1896, Town Topics—*Small dinner parties can be such fashionable fetes! Such was the case at yesterday's partie carrée, when one writer, one artist, and one socialite were treated to a dinner and a viewing of Isabella Stewart Gardner's latest "grab"—a Rembrandt purchased from the dealers Colnaghi & Co. in London through the Jewish-American art historian Bernard Berenson. With her growing household Musée one wonders if the dinners will soon have to involve even fewer guests to capitalize on space.*

IO

I UNPINNED MY hair. I removed stockings and garters, corset and sheath. I stood, naked, in front of the Rembrandt. It was true that there was, for me, room for only a certain amount of desire in my life. I had desired society and then children to the exclusion of all else. And then books and then Crawford. And now I had a choice. Keep desire for other people or fulfill a desire, a need, a requirement I had felt prickling my skin since the woman in the desert had given me a wrap. Since at the first impressionist exhibition Berthe Morisot had asked what it was I would do with my own life. Since my parents had taken me to Italy for the very first time and I had seen in quick succession a painting of a building seeming to float on water and then the thing itself in Venice. And that medicinal garden in London with Jack so many years before. And my father-in-law's greenhouse that was now mine, my skirts puddling around my knees as Amory and I played making a family out of wooden pegs.

I was making a different kind of family.

One of art and objects and memories and sheer pleasure at being alive in the world rather than sunk under the waves of a darkest ocean.

I had money. I had lust. I had something to give to other people, other women or girls who wandered the vast nothingness unfurled to us at birth.

I would give the world—or Boston at least—a place, and by doing so it would be as though I were giving the world my own body, my own mind. Here, I would say. Take me.

"THERE ISN'T room in the house," Jack said.

"You've said that before," I told him.

"Yes, but now . . . with the . . ."

We both smiled—wide, child-happy smiles—as we removed the thick brown paper from my latest purchase: the nineteenth in quick succession, including a Velázquez for £15,000 of which Sargent approved and said he coveted.

Berenson had written from Rome, the Hotel Hassler, offering me back this part of my heart. Now, in my very own house, where I'd had life ripped out of me, where I'd sat feeding a dog that untouched homemade New Year pudding, where I had hosted women who hated me and housed boys who were not of me but mine, I owned Titian's *The Rape of Europa.*

I had cabled YEUP, a code for Yes, Europa, and all five foot ten of her height and all six foot eight of her width hulked my house, my heart, my loins. I had the bill of sale for £20,000 plus an additional, £1,000 for Berenson, my other half, courting and finding for me.

"Are you in love?" asked Jack, amused and happy. He took my hand, squeezed it.

"Completely," I said. I meant it. "Do you recall that Paris trip? My first Worth gown? The colors . . . I should like to have the dress up on the wall with the painting." I turned to him. "Do you think that too odd, even for me?"

We stood looking, both of us dwarfed. "I think," Jack said, "it's perfect." He reached for my hand. "Do you ever think, Belle—Isabella—of perhaps having your own space?"

I turned to him, brow furrowed. "Away from you?"

"No. No. Not that." He took my hand, pulling me through 152 Beacon and the house it had eaten whole, pointing out objects, the paintings both hung and leaning against walls, the harpsichord and

sets of chairs from Venice, a small and beautiful painted desk I could not sit at for correspondence because it was surrounded by other objects. "What I mean is, have you considered it might be time for us . . ." He stopped and, well aware of his years and his years with me, looked right at me. "What is keeping you from opening your own Court of Art, your own, purpose-built place?"

I smiled at my husband and kissed his face. "Nothing. There's nothing keeping me from making my own Palace of Art, Jack." I pulled in a huge breath of night air. When life seemed to close in around you, there was always more, always space, always room in another house. And this time, I would build my own.

"IT's SIMPLY not possible," Willard Sears said.

I fixed my face, remembering Mr. Gilman's scorn decades before, out in front of 152 Beacon, where all I'd wanted was to design my own path. My voice now was firm, but I smiled, for I had designed my own path. Quite literally.

"I've always wanted a certain kind of life," I told him. He and Jack held their own against the wind over the barren stretch of land where we three stood. "Until now there's been a moat between us. But I find that dried now. And today I'm in it." I swung my arms wide into the March air. "It's 1898, and I'm living in the manner I only dreamed of." My boots began to sink into mud, but I led the men around the land. "I'm not an artist in stained clothes brooding in the country-side or obsessing over how to paint a perfect nose like my dear friend Sargent."

I had to almost shout to be heard over the wind. There was no one besides Mr. Sears and my husband to hear. "Twenty-two times he redid it. And then it's perfect and looks as though he barely thought about it." I stopped on a plot that was slightly elevated and that touched on Frederick Law Olmsted's Emerald Necklace. "I've toiled and struggled and redone noses, too, in my own way . . . and now it will look as though this was my plan all along." I held my hands out as though gripping the plot of land. "And maybe it was. Do you

know, Jack, that I said to Julia long ago, maybe when we were both fourteen, we'd seen a house in Italy not dissimilar to Barbaro, and I told her—she has the letter still I would wager—that if I had money of my own one day I would build a house and it would have a garden." Jack nodded. Mr. Sears tried to keep up with my pace. "Only then I didn't know about plants and the care they require, how people are much the same." I huddled the three of us so I could save my voice. "I mean to say I was raised in a society that did not ask me to consider. Did not ask me to wonder about myself and my own body as the world map of myself. And now I'm going to create it."

"You're a lucky woman, Mrs. Gardner," Mr. Sears said, mouth dour.

Jack and Mr. Sears went to measure the plot, and I spun round and round, dizzy with pleasure. I spoke more words to the wind: If you think about it, I went to see Lyman, and that woke me up. Jack swept me off with my broken heart to London, but I'd brought us to Dresden and, because of that, because of that meeting and a shared grief that I lured out of Lyman, I found Norton. And Norton opened up a world of intellect, which then empowered me to give a lecture series, to cultivate artists, and to find Berenson.

"It isn't luck!" I shouted to them. They waved back.

I was the one who brought all my old selves along to right here. I was the one who marched to the Public Garden and found Mr. Valentine and Mr. Louris and Mr. Grotberg, who asked me questions when no one else would.

Mr. Sears came back, shaking his head. "It simply cannot be done. And moreover, why would you? You've got a perfectly nice little collection of your own on Beacon Street. And it would require so little to make it a museum."

That rage, that fire, that desire unleashed by lions and Crawford built again in me. "Mr. Sears—you've done the Stone Chapel at Phillips Academy. The Old South Church on Copley Square. The Cyclorama, for God's sake—that marvel of a place. Are you saying this, my court, is too much for you?" It was another way of asking if I were too much for him. I went on. "I could always ask someone else—there is no shortage of architects here."

He gave me the look that I'd grown accustomed to in my life, a look from men who found me overwhelming, taxing.

"It's not too much for me," he said. "But it would be far easier for everyone if you picked a simpler place. Who will come to this wasteland?" He looked at the swampy grass.

"Exactly what was said of Back Bay before it filled in. Now it's so thickly settled with Brahmins, one can hardly recall its former rat-and-sludge."

He frowned. "And what is it you'd like me to do?"

I produced from my pocket a simple sketch I'd made and thought of Whistler's bridge studies. "You are my translator. Get it from here . . ." I tapped my head, "to there." I pointed to the Back Bay Fens. It was empty now, but I could see it; Jack and I would build a Venetian palace right here, rooting me once and forever to Boston.

25th April 1898
Green Hill

Dear Henry—

At last, the final installment of your *Screwing Turn*. I mean your *Turning Screw*. Truly a gothic wonder that will haunt me forever, just like its author. Thanks for the Collier's *Once a Week*. I'm sorry the magazines continue to favor such chopping of your work; I know they like a story to fit on a single page. I suppose we modern readers have little tolerance for long periods of quiet. But you, dear friend, have always shown tolerance for me and I for you. I report back that Gus is fighting in Spain; per my nephew, Spain is woefully ill-prepared, but as war is official as of yesterday, please keep him (and hopes for Cuba's independence) in your thoughts. Please won't you come to Boston soon—the Europa and I should both like a visit. Affectionately—Isabella

20th May 1898
Head of Westport

Dear Isabella—

Thank you for your latest letter, which, as per your request, I have already singed in last night's fire. I have received the $325 and am

bringing to you, as long promised, *The Stream*. Perhaps you will
refrain from burning it— see you shortly at the shore.

> Faithfully,
> Dodge MacKnight

> 30ᵗʰ August 1898
> Alhambra

Dear BB—

Your description of the sea picture makes me fairly ache for it!
Please do get for me *Storm on the Sea of Galilee*, for I should want it
to hang forever on the walls of the soon-to-be-built Fenway Court.
Such a painting will never be moved once I hang it. I desire so
that Rembrandt: such dark waters and toiling beset with light and
possibility. Is that not us all? Yours—Isabella

> 30ᵗʰ September 1898
> Farnese, Italy

BB—

Are all letters from Italy love letters? I write now from a small
town near Pitigliano, which is near Orvieto, where I bought prints
of the Orvieto Cathedral by Guglielmo Della Valle, 1791, ink on
paper. Pitigliano clings to the hillside with what appears to be
centuries-old effort; homes and winding balustrades rise up from
the rock like the giant tortoise I saw as a young woman in Lyman's
lab. I regarded this exoskeleton of a town with great admiration,
and took a few minutes to mourn Mr. Lyman's passing. He leaves
behind acres of protected land, his lab work, and, to some extent,
my changed self.

As for Italy? I love a small place filled with the smell of dough
rising and baking in Pitigliano's communal ovens, the Hebrew
shops there with ropes of onions and garlic hanging from doorways
like soundless bells. And the people in these towns. Is this not
why we travel still, to free ourselves from the quotidian rotation of
neighbors and sameness?

After your long missive regarding the van Dyck and the
Holbein Child, which I must have, I still care nothing for the
Crivelli. However, if you insist on its place with me, I shall

listen (I have ears as well as a mouth). Norton's son is starting an
American Academy of Art & School of Archeology. He's found
for us an actual painted ceiling! It depicts Roman mythology and
biblical scenes. We will ship the entire thing back to Boston. With
great affection, Isabella

1st October 1898
Florence

Dear Mr. Louris—
Might it amuse you to know: my husband has purchased for me
in Florence two stone lions from the 13th or 14th century—even
older than we are now! These beautiful creatures are now on their
way back to Boston, where they will forever have space in my new
home, and, of course, it is a place where you are always welcome.
—Isabella

14th October 1898
En route to Scotland

Dear Isabella—
I received the check for the Cellini and am most impressed with
your wide-ranging views. To think of a room named after a living
artist is most unusual; Mr. Dodge MacKnight surely will be
honored. I shall always respect you as most life enhancing for all
around you, even those you've yet to encounter. To mix Italian
masters and Okakura's Japanese works with ones from southern
Spain, chairs and needlework baskets with female suffrage in the
Garden of Eden, screens and stone basins, cupids and books—well,
I have long been of the opinion that you are the eighth wonder of
the world. Now all of Boston will know it. —BB

11th December 1898

My Dearest Isabella—I am so grieved for you about the loss of
your beloved Jack—

18th December 1898

Dear Mrs. Gardner, Will you accept my sincere condolences
regarding your husband's passing—

22nd December 1898

Isabella, dear girl, What sorrow finds you now and more mourning still about the halting of your house plans—

31st December 1898

Belle, oh Belle, such grief for you and for us all—

I tossed the cards into the fire along with my spirit. For who are we when we build a life with someone, seam together with them, only to come undone? I tossed cards into the fire. Then, a delivery. A wooden crate with life inside.

3rd January 1899
Public Garden

Dear Mrs. Jack,

I gather here a flowering jade and dusty miller for you, which may seem too festive for this terrible darkness that covers you now, but my hope is that you will find solace one day in their continual flowering—

Yours—Mr. Valentine

*18th August 1900—*Town Topics—*A Woman Unstoppable! After an understandable cessation in construction, a certain Gardner is plowing ahead. Isabella Stewart Gardner might be seen daily at the oversized and underwhelmingly situated spot in the Fens. Unless she builds a house for ghosts, our city must regard her choice as odd at best. Yet she persists! Mr. Willard Sears, familiar to Boston for his outstanding additions, told this reporter that the woman herself has been superintending each column, directing placements down to the smallest of bricks or stones. One grows weary for him and doubts whether such a "palace" will ever be finished or, like its chosen spot, will be vacant and forever unattended.*

*14th December 1902—*Boston Globe—*A new addition to Boston's Landscape! After plans and delays stretching from months into years,*

Mrs. Jack Gardner appears to have finally completed her quite mythical palace. Writer Henry James, a longtime friend, says, "She is not a woman, she is a locomotive!" And it is "full speed ahead" with the opening of what she is calling Fenway Court.

Join Me
In a New Year's Celebration
For the Opening of
Fenway Court
1ˢᵗ January 1903

~

No regrets
Isabella Stewart Gardner

II

FENWAY COURT. An atrium flooded with winter light. Palm trees and nasturtium vines in great tangled coils dangling from the stone balconies like Raphaelite tresses. Yellow Room with the first Matisse this country had seen, showcasing his fauvism, that wild-beast strength of color, hung near Whistler's *Nocturne, Blue and Silver: Battersea Reach* and his *Harmony in Blue and Silver: Trouville* in which I am always looking out at the sea, any sea, with that mix of hope and the crushing of it. Cloisters around the courtyard, each with stone benches, columns, sculptures. Blue Room with fabric-covered walls as though one is inside my dress and thus privy to letters (some snipped, others whole) and my Chinese chest and Zorn's *Omnibus* and Ralph's *Lido* and a photograph of Henry that he dismissed but that I hold dear. Dutch Room with my twenty-three-year-old Rembrandt and the Dutch sugar bowl gifted to me by the Horticultural Society, which sits sweetly near Peter Paul Rubens and Hans Holbein. And the MacKnight Room, where Sargent stays when he's in town, to view Dodge's work and his own, all lighted by frosted glass like the windows when he painted me. Chapel at the end of the Long Gallery with Nadar's photographic portrait of George Sand, incunables, Venetian basins and columns, painted ceilings, Chinese Loggia guiding me between outside and inside world with Roman

Head of Silenus with Liknon and Chinese *Votive Stele* and that Japanese *Foo Dog with Open Mouth* I bought on that trip: here my entire life's travels in each room. I wished Jack were here to see it.

"I see our matching Russian samovar!" Julia said, gleeful as she hugged me.

"And those glasses," Mrs. Zorn said. "From that night with the fireworks."

"And the figurines from Dresden," said Amory, in his Groton crest, who stood with his Gus, now a Massachusetts senator, and Gus's wife, Constance, and their nine-year-old daughter.

My ribbon basket, Japanese bowl, Italian tapestries, Spanish chairs, and desert shawl all organized at night as I lived alone in the fourth-floor apartment these past many months.

Everything was arranged in a conversation: between me and each item, and between the art and objects themselves. See how they look at one another? Oh, hello, *Mother and Child*, hello, flag with finial, hello *Storm on the Sea of Galilee* with your killing darkness and swath of light. Come over here, say the chairs I bought with the memory of having no one to dine with me on a New Year's Day such as this so many years ago. And another set filled with friends in Venice. Viewer, won't you do me the honor of considering the color of my Worth gown, now framed and positioned below *The Rape of Europa*?

I placed myself in the Short Gallery: near Mary Stuart, my great-grandmother in Scotland.

I am near a gondolier who might be all gondoliers forever looking out at Venice.

I am near John Lowell Gardner, my beloved husband.

I am near Dennis Bunker's versions of our nephews.

And near George Washington and Benjamin Franklin. Am I not deserving of such company?

In the Little Salon I surprise anyone who bothers to look closer: a tapestry of Paris, wool and silk and funny. True, there are seventeenth century gardens royal and regal but—surprise!—a glass of water thrown, soaking people walking. Seems like something I would do. So I bought it weeks ago.

I would keep adding, keep adjusting as need be to fit my belongings in Fenway Court.

See here my Rembrandt self-portrait from when he was twenty-three. Or *Lady and Gentleman in Black*. Visit again with *The Storm on the Sea of Galilee*, 1633, but always I think of the waves of grief, the mattress, that boat ride that was the beginning of swimming to shore and finding myself.

More chairs and a wooden stool that one might use for birthing, places for guests and ghosts alike here, objects that mattered and held stories, books I'd chased, an entire house and courtyard that took up space, impossible to ignore.

Guests tonight expected dinner, and I offered them instead tray after tray of champagne and doughnuts, sugar-dusted, raspberry-filled, crème dollop on top, or cinnamon, or anise-iced, or violet-dotted; I'd had two made specially in "limited palettes" of yellow ochre, burnt sienna, and white for Sargent and Zorn, who cheered each other and me.

Strains of Mozart and Bach, Chausson and Schumann would be heard as played by fifty orchestra members. Soon I would signal to have the great doors rolled apart so the lantern-lit interior courtyard would be showcased for all, with stone dolphin rescued from a seventeenth-century Venetian fountain, chrysanthemums like Bunker painted, cymbidium orchids, paperwhites, the flowering jade from Mr. Valentine, winter cyclamen, appearing tender but able to survive frost, flowering maples, blue hydrangea as though the courtyard is filled with still water, and my beloved heather. Gardens are always thinking about the future, and I trust these specimens to keep their promises.

Sounds of water from the fountain, the pleasant undercurrent of conversation, the flickering lights and scent of blooms—magic.

A moving bouquet of partygoers were all here not to see me— but to see what I'd made, which was another way of seeing me. The world's rough terrain through which I had hiked, the explorer of each heart I encountered. And while I knew I would speak and welcome everyone and then later sit alone with a glass of champagne and a ring of doughnut on my bare fingers, licking the sugar off and wiping

the rest on my dress, manners be damned, I stood watching for a moment.

Flowing into and out of the lanterned courtyard like gorgeous lifeblood were my guests, mere humans with their emotional rucksacks and errors, their lust and weaknesses all held in by corsets or belts and skin, protecting the fragile creatures underneath. And to those raw, open humans I pointed to the carving over the door.

C'est mon plaisir, I had told the stonemason to chip. *It's my pleasure.* I had been heating my private quarters at Fenway Court with a small fire, stoked by pages of my letters—goodbye to Joe, farewell to Crawford, who lived now in his own Italian villa, goodbye to so many letters exchanged with Henry, so lauded in his work, and to Bernard, whose expertise was now of international acclaim, his new book *Drawings of the Florentine Painters* a wild success, and goodbye to letters from Maud, who had founded the Society for the Arts and who was writing a book about her mother. Goodbye to Julia's words throughout my life and to Harriet's mere clutch of old memories.

A reporter, notebook in hand, came toward me now as I stood in the courtyard.

I rolled my eyes.

"So here we meet—face to face," he said.

I shook his hand.

He scratched into his pad. "Town Topics. From what I gather . . . there's no doubt to the building's magnificence, but there's no unifying style, nor arrangement by era or artist or country of provenance." He stared at me quizzically.

"There is actually," I told him. I waved to George Santayana, to Charles Loeser, to Maud and her murmuration of writers. I waved to Mr. Louris, who was working with Olmsted, creating a naturalistic zoo with native animals to add to Boston's Emerald Necklace. He waved two paws at me, and I smiled at Mr. Grotberg, who had, with Mr. Valentine, placed a large floating lotus flower in one of my fountains.

"Oh really? And what might the great unifying theme be here in this Fenway Court?"

"Me," I told him. "Isabella Stewart Gardner."

"The woman herself."

"You've seen fit to try and know me all these years—now pray look around and do it in earnest." I crossed my arms and motioned for the Boston Symphony Orchestra, who came at my invitation, to start. "Indeed. I do hope you've taken some doughnuts and champagne—perhaps it will make you ever the slightest bit sweeter on the page."

"Not that you care," he grinned.

"Not that I care a whiff." I smiled back.

"Isabella Stewart Gardner." He paused, serious. "You know, you've changed Boston."

"It's mutual, I think."

23rd September 1912—Town Topics—Boston's Very Own Isabella Stewart Gardner! Did she parade lions and shock our city's oldest names, taming everyone in her path? Since first appearing in Boston, her name has been on the lips of many. "The greatest need in our country is art," says none other than Isabella Stewart Gardner herself. Last spotted at the new Fenway Park—a location chosen after ISG herself made the land "acceptable" with her Fenway Court—wearing a self-embroidered hat that read "Oh, You Red Sox," Isabella went on to say, "We are a very young country and have very few opportunities of seeing beautiful things, works of art, so I determined to make it my life work if I could. Therefore, ever since my parents died I spend every cent and heartbeat bringing about the object of my life. I would like people—particularly women—to know that sometimes we are working on a goal and are not able for many reasons to speak that goal aloud. Sometimes it is hidden even from ourselves." The formidable woman came back to find me in the stands to add, "Fenway Court is to be for the education and enjoyment of the public forever."

EPILOGUE

17th July 1924
Fenway Court

Dear Berenson—
You will find instructions in the will, and I thank you now (as I will not be able to do so then) for carrying out my wishes. I thank you, especially, for your place in my life and for bringing me so many cherished masterpieces, including our long friendship.

You may note I dismantled the music room to make space for a Spanish Cloister. I wish you to know my knees are still raw from hours spent rearranging and creating patterns with Mexican tiles. I had installed light from below, and when I received a visitor, he asked if I'd made a shrine. True, it is a cloister bordered by stonework crescents, pillars on either side. I invited Thomas Jefferson Coolidge over and gave him a single piece of bread slathered with fig jam and topped with manchego to nibble as he regarded the space. So moved was he by the design I had made, he gave me a gift. Hanging here now and properly installed in the Spanish cloister is Sargent's *El Jaleo*, a dance I have wanted much of my adult life. A triumph.

This is what I know: we spend our lives accumulating, arranging, hoping to figure out suitable environments for our

emotional upheavals. All my life I have attempted to make and fashion the best of what was available to me.

I have long wondered what my role is: in the house, on the sidewalk near the magnolia Jack and I planted, in the greenhouse, the nursery, the tight cobbled streets of Dresden or London, Harvard lecture halls, the Grand Canal, the streets of Back Bay, which were filled in from swamp. Somehow, I feel that I, too, have been filled in.

Emptiness and awkwardness filled with swamp and wreckage and then, like the city of Boston itself, turned into stoic, understated elegance so that the examination of the self, like the Charles River, keeps flowing. I tried in vain to harness stagnancy and to solidify what was always a process. I remember Sargent talking about oil spreading on canvas and how he wanted to create motion from something that was motionless.

I tried to create lack of motion from something that always had movement within: life is meant to move forward. Now that the self-examination is ending and with it my days, I have made a decision. Nothing will be moved. Nothing will change. I have dealt with too much of it. All these years of emptiness, motherhood stripped away from me then added suddenly, my roles forever changing. Now everything shall remain fixed: from tapestries to Italian stone slab tables to *The Concert*. Do not consider moving anything: not even my final portrait now in the MacKnight Room. The painting is Sargent's final gift to me. Am I not my own ghost on that canvas? I fear it does not resemble the self I feel but rather the self that other people see now, old and withered as though everything good has already taken place. But everything I am and have been is still here, arranged out of order but in a way that makes perfect sense to me now. Is this my way of proclaiming immortality? Perhaps.

Perhaps mere foolishness or a joke that only I will find funny, as I did at so many dinner parties in my past, chuckling to myself. Now it pains me: what art will I never live to see? I wonder over the aching and exquisite unpainted canvases.

I shall, of course, leave the museum to Boston, which is, of course, leaving myself.

The walls are my bones, the artwork and objects contained within are blood, capillaries, veins of my body. And this will be a body on view forever.

The public will come in and out of Fenway Court, misfits and malcontents and those with fortune alike taking in exactly what I have chosen in order to make sense of a world that cannot pause, except perhaps here. Who are the people who have yet to come visit? Who are the ghosts and who are the future artists ?

Is it wrong to allow free entrance forever to those named Isabella?

Might they see this free entry as an unexpected gift? I imagine them wandering, all those Isabellas—unfettered in a cool, dark space, arriving suddenly in the expanse of this Venetian flower garden made of my plant friends, sunlight and wonder traipsing in, coating their fine hair or suited bodies with a moment of peace.

Oh, if only I could know those future girls arriving here, wondering just who they might become.

AUTHOR'S NOTE

The Isabella Stewart Gardner Museum opened on January 1, 1903. Until her death in 1924 Gardner continued to acquire and arrange her collection, which now comprises more than 7,500 paintings and other works of art, 1,500 rare books, and thousands of archival objects.

In 1990, thieves dressed as police officers broke in and stole invaluable pieces including *The Concert*, *Christ in the Storm on the Sea of Galilee*, and *Eagle Finial: Insignia of the First Regiment of Grenadiers of Foot of Napoleon's Imperial Guard*. Per Gardner's wish not to have anything moved, the empty frames still hang. The mystery has captivated Boston and the global art world. A ten-million-dollar reward is still offered.

ACKNOWLEDGMENTS

THIS IS a work of fiction. The history is real, but this is not a biography. Many details—Isabella's tragedies, travels, and relationships are from her life, but my portrayal of them is with a novelist's freedom. Other interactions have some truth—she was at a luncheon with Oscar Wilde—but what I depict did not happen as far as we know. And that phrase *as far as we know* is important. For as many details and documents were available to read as I researched and wrote, there are also gaps as there would be with any life, particularly one so largely lived.

The Isabella Stewart Gardner Museum is a phenomenal place with extensive archives and accessible information. Many of the objects I wrote about are in the museum, and their provenance is known and accounted for. There are other objects—the letter box, for example—that live at the museum but have no known date of acquisition or provenance. And, of course, the letter box's use in this novel is entirely fictional.

When I was writing about art and objects, I stayed true to the dates of their acquisition and the details surrounding their purchase. The beautiful bunch of glass grapes, however, the ones I revealed to be a gift from Henry James, exist at the museum without further information. So *as far as we know* it could've come from James or not.

Above all else, I wanted to portray Isabella Stewart Gardner as a strong, quirky, determined, brash, and ahead-of-her-time person who triumphed over loss. And I wanted to have that loss stay with her as losses do—so while there are so many Mother and Child works of art in the museum, my belief that there's a psychological reason behind the acquisition of those pieces is purely my artistic view.

While the backbone of the novel stays true to the timeline of Isabella Stewart Gardner's life and the creation of her museum, there are many parts of this work that are products of my imagination. There are too many truths and fictions to detail in this note, but one example is the first impressionist exhibit. It did take place as depicted in Paris and in that location—and Berthe Morisot did show there—but ISG was not in attendance. In those instances, I felt the history and overlap with the novel's version of Isabella would benefit the story on the page while staying true to Isabella's character (and her character arc). Another example is the accounts of Isabella either playing with lion cubs at the zoo or walking a lion down the Boston streets (neither of which is confirmed, though there are sketches of her from that time with a lion), but my account and the characters of the zookeeper, fountain caster, and Mr. Valentine are all fictional. While I read many letters Isabella exchanged with her friends, including those with her dear friend and frequent letter writer Henry James, the letters in the novel are of my own creation, with the exception of one particular line that Henry James wrote: *You have everything, you do everything, you enjoy everything.*

First and foremost, I wish to thank the Isabella Stewart Gardner Museum—since I began visiting as a young child, it has been a place of magic. I am also grateful for the museum's extensive catalog of art and rare books and the responsiveness of the archivist.

There are many texts that helped me in the research of this novel—some of those are listed here, with much gratitude: *Letters to Isabella Stewart Gardner*, by Henry James; *The Letters of Bernard Berenson and Isabella Stewart Gardner, 1887–1924*, edited by Rollin Van Nostrand Hadley; *The Memory Palace*, by Patricia Vigderman; *Isabella Stewart Gardner and Fenway Court*, by Morris Carter; *Mrs. Jack*, by

Louise Hall Tharp (page 43, Appleton anecdote, page 134: "Sargent had painted Mrs. Gardner all the way down to Crawford's Notch," among other information and insights); *The Art of Scandal*, by Douglass Shand-Tucci. Numerous websites and articles were helpful to me. Some of those are the following: the City of Boston government archives for information, images, and architectural renderings; Mimi Matthews, Home Things Past, American Violet Society, Child, Lydia Maria. *The Mother's Book.* Boston: Carter, Hendee, and Babcock, 1831. Scovil, Elizabeth Robinson. *Preparation for Motherhood. Elisabeth Robinson Scovil.* Philadelphia: H. Altemus, 1896. West, John. *Maidenhood and Motherhood; or the Phases of a Woman's Life.* Chicago: Law, King, & Law, 1887. Beach, Wooster. *Beach's Family Physician and Home Guide for the Treatment of the Diseases of Men, Women and Children on Reform Principles.* Cincinnati: Moore, Wilstach, Keys & Co., 1861. *Seventy-Five Receipts for Pastry, Cakes, and Sweetmeats*, Eliza Leslie. *Female Husbands: a Trans History.* Manion, Jen, Cambridge University Press, 2020. *18th Century Molly Houses—London's Gay Subculture. Shipboard: the 19th Century Emigrant Experience* State Library New South Wales, Rictor Norton (ed.), "Queen of Camp, 1874," *Homosexuality in Nineteenth-Century England: A Sourcebook*, 4 December 2018; expanded 30 October 2019, The British Newspaper Archive, *American Merchants and the China Opium Trade 1800–1840* by JM Downs, Rictor Norton, Ed., "The Mollies Club, 1709–10", *Homosexuality in Eighteenth-Century England: A Sourcebook.* 1 December 1999, updated 16 June 2008 *Southcoast Today* for information and photos of historic New Bedford, Rosemary Elliot's Thesis: Destructive But Sweet: Cigarette Smoking Among Women 1890–1990, Victoriana.com, Wentworthcoolidge.org, Gail Carriger for menu ideas, The New England Historical Society, Harvard Medical School archives, Harvard Museum of Natural History, Julie Codell "On the Grosvenor Gallery, 1877–90," Paul Freedman for his food history lecture at Yale University in May 2019, Victorian London Publication's Etiquette and Advice Manuals: The Ladies' and Gentleman's Model Letter Writer, c. 1870s. *Southcoast Today* "Where We Shopped," WBUR "New Exhibit Explains How Isabella Stewart Gardner Amassed Her Famous Art Collection," Alan Chong,

"The Concert," in the Eye of the Beholder, edited by Alan Chong et al. (Boston: ISGM and Beacon Press, 2003): 149 Boston Women's Heritage Trail Tour/Site, New York Public Library—history of the library/origins.

I am grateful to those who read early drafts, made suggestions, or offered their expertise and friendship. I wish to thank Heather Swain, Dawn Tripp, Mark Barr, Owen Egerton, Brendan Halpin, Kim Belliveau Arruda, Jen Shauna Callahan and Jessica Shattuck and Liz Gardner and the magic of the desert, John Borowicz, Wen LaBarre-Borowicz, Claire Messud, Rachel Kadish, Timothy Schaffert, Heidi Pitlor, Joanna Rakoff, Tova Mirvis, Rick Franklin, Josie Hughes, Maxine Charlton, Barbara Strauss, Peter Strauss, Ted Franklin, Dorian Lightbown, Liz Haas, Heather Woodcock, Ron Maclean, Lisa Borders, Maria Pinto, Tania Rodriguez, Erin McHugh, Karen Grotberg, the way back whens: my art history teacher Larry Pollans, JC Smith, JFC, and Connie Porter. Bookseller/cheerleader extraordinaire Mary Cotton, and Pie-Boy. Celia Johnson, Joshua Bodwell, Elizabeth Blachman, and everyone else at Godine, and my wonderful, dedicated agent, Esmond Harmsworth. And to Beverly and William Franklin, thank you for the magnolias, for Marlborough Street, and for everything else.

And of course, Ad, N, S, E, and A—my bests and mosts.

A NOTE ABOUT THE AUTHOR

A lifelong visitor to the Isabella Stewart Gardner Museum, Emily Franklin is the author of more than twenty novels and a poetry collection, *Tell Me How You Got Here*. Her award-winning work has appeared in the *New York Times*, the *Boston Globe*, *Guernica*, *JAMA*, and numerous literary magazines. She has been featured on NPR and named notable by the Association of Jewish Libraries. Franklin lives outside of Boston with her family, including two dogs large enough to be lions.

A NOTE ON THE TYPE

The Lioness of Boston has been set in Van Dijck. First released by Monotype in the late 1930s, Van Dijck is based on a seventeenth century type attributed to the Dutch printer, typefounder, type cutter, and type designer Christoffel van Dijck. It went on to influence eighteenth century English type designs, such as Caslon. The digital version of this graceful typeface was designed by Robin Nicholas.

Design & Composition by Brooke Koven